Faith, Gender, and Activism in the Punjab Conflict

Mallika Kaur

Faith, Gender, and Activism in the Punjab Conflict

The Wheat Fields Still Whisper

Mallika Kaur
San Mateo, CA, USA

ISBN 978-3-030-24673-0 ISBN 978-3-030-24674-7 (eBook)
https://doi.org/10.1007/978-3-030-24674-7

Cover illustration: Bilas Design

This Palgrave Macmillan imprint is published by the registered company Springer Nature Switzerland AG.
The registered company address is: Gewerbestrasse 11, 6330 Cham, Switzerland

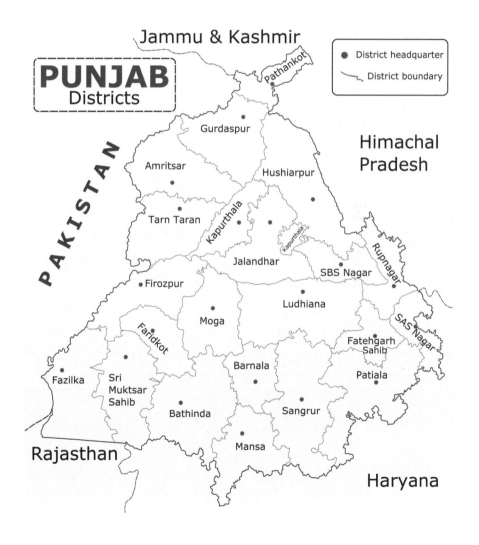

PUNJAB
Districts

District headquarter
District boundary

Jammu & Kashmir

PAKISTAN

Pathankot

Gurdaspur

Amritsar

Himachal
Pradesh

Tarn Taran

Hushiarpur

Kapurthala

Kapurthala

Jalandhar

SBS Nagar

Rupnagar

Firozpur

Ludhiana

SAS Nagar

Moga

Faridkot

Fatehgarh
Sahib

Fazilka

Sri
Muktsar
Sahib

Barnala

Patiala

Bathinda

Sangrur

Rajasthan

Mansa

Haryana

Unquestionably, to my parents

FOREWORD

The Wheatfields Still Whisper and the voices of the murdered, the tortured, the imprisoned, the dispossessed, the resisting, the expelled, and the returned still speak in this compelling volume. For the Sikh population of northern India's Punjab region, the century's arc from the late colonial to the current regime was and to some extent remains a journey across a battleground from which no village, no family—no man, woman, or child—could escape or leave unscathed.

Mallika Kaur harvests these voices with respect and empathy, with love and care, and also with a historically reflective eye that clearly sees the complex realities and wave patterns of that turbulent century.

Brilliantly and succinctly, she overlays the voices of this land with a sympathetic yet balanced account of its history. Different epochs rise and recede within that long history—the shared Indian drive toward decolonization in the first decades of the twentieth century; the uniquely horrific impact on the Punjab of the shameful British abandonment of the subcontinent to partition; the early Nehru years and their vacillation toward the Sikh homelands; the disastrous consequences of Indira Gandhi's partisan actions, leading to a regime that often resembled a ferocious military occupation—leading in turn to sporadic armed resistance with the inevitable consequence of yet harsher military and police treatment; and in the most recent decades the resurgent Hindu nationalism that leaves little breathing space for difference and dissent.

But endemic violence not only disrupts; over time it also constructs lives, communities, places, political affiliations, and—perhaps above all—gendered categories and identities. With impressive sensitivity, Kaur brings to vivid life the ways in which normative ideas of masculinity and heterosexuality are disseminated amid a pervasive context of militarism. Yet, the identity and capabilities of the victims (and not only the female victims) often is strengthened and their voice and agency created and maintained over generations. And again, Kaur does not tell the reader of these tragedies and survivals; she presents these histories through the people's own narratives.

Kaur's recount of that history is rigorously underpinned by her primary sources, many from the dominant Indian official and media documents.

It successfully exemplifies the hybrid approach of personal narrative and scholarly analysis. This—when well done, as here—in turn extends the stylistic scope of traditional oral history projects, framing the voices within the larger social history while in turn framing that history through the voiced lives of its subjects.

Kaur successfully engages interlocutors who had not spoken about their experiences in such personal terms before. The lessons/strategies/principles highlighted in each chapter work toward a prescription of "bringing human rights home," and respond to relevant discussions in the world of transitional justice and international human rights advocacy. This is highly relevant to India today, where access to human rights defenders is increasingly curtailed, and is a lesson for future work in increasingly unstable countries and regions.

The first word of the title is "Faith" and the first pillar of that faith is its deeply communal nature. Here is Kaur's entry in her introductory Glossary:

> "Singh": Common last name bequeathed to all Sikh males by Guru Gobind Singh in 1699, to replace family names denoting caste, cementing a casteless community.

This determined rupture of the almost immemorial straitjacket of caste, coupled with the demographic reality that it was "low-caste" and "untouchable" groups who were a large part of the population attracted to Sikhism, generated the strength of this community to hold together in adversity as it also guaranteed the adversity of the dominant population against its Sikh neighbors. Held in check by the British Raj, and then briefly by what I will mislabel as the secular humanism of a Gandhi and to a lesser degree of a Nehru, the role of the partition, which weakened the early concept of a secular nation that could accommodate its minority populations, also increased popular hostility toward the dissenting Sikhs until the catastrophes of 1984 burst the last restraints a civil society under law could maintain.

But external hostility and pressure can anneal as well as threaten; and Mallika Kaur's vivid and affecting narrative of this often tragic and elegiac history also tells, in equally vivid and affecting tones, a story of survival under pressure through three centuries to the present day.

Jackson H. Ralston Professor of Richard Buxbaum
International Law (Emeritus)
UC Berkeley School of Law
Berkeley, CA, USA

PREFACE

Punjab was one of the major armed conflicts in postcolonial India. In the two decades between 1975 and 1995, Punjab saw anywhere from 25,000 (according to the police estimates) to 250,000 (according to civil society estimates) killings. Just as the Sikh—a faith community established over 500 years ago—diaspora population surged in North America, my parents made the counterintuitive choice to move our family back to a boiling Punjab. Like other Sikh children of the 1980s, I experienced the confusing discomfort of conversations triggered shut even at the mere mention of certain words that evoke a vitriol we didn't birth. As an adult, when I began reading and trying to learn more, I often understood even less about the unspoken.

In my work as a lawyer, I became fascinated by the layers of stories that begin where our legal cases and human rights reports end. The events in Punjab had since been used as a blueprint to respond to dissent and rebellion in other parts of India. Outside of counterinsurgency tactics, I wondered about what other blueprints Punjab might provide. I began exploring the stories of people from within the region who had witnessed the worst years. The lives of human rights defenders particularly captivated me. This book is centered on the experiences of three activists who are credited with saving countless lives: Ajit Singh Bains, Baljit Kaur, and Inderjit Singh Jaijee. Their life stories refuse to be written as ordinary biographies: community memory, historical vignettes, and archival treasures push back against a singular narrative in this complicated region's contested history. I have approached this topic deeply and personally conscious of the strong feelings it evokes. At the same time, I have sought not to do Punjab's conflict the disservice of another hypersimplified account; I retain a transnational human rights and feminist lens.

This book was also undertaken to excavate the varied and hybrid roles assumed by Sikh women; their negotiating violence and trauma amid multiple responsibilities, while defying the stereotypes of a monolithic identity. Even when the violence disproportionately targeted the male body, it provoked the policing of the female body, and succeeded in profoundly affecting the community's entire body politic. This book highlights how attention to various

forms of gendered violence—direct and indirect—is necessary to end vicious cycles in conflict and post-conflict zones and bring inclusive security to Punjab, South Asia, and beyond.

Starting the conflict story in descending order from 1995 (the supposed end of Punjab's conflict), legal and nonlegal sources will allow the reader to scrapbook details, note absences, question what is known. To enable the layered and nuanced understanding advocated for by my interlocutors, each chapter also contains an interwoven section that traverses the earlier history of Punjab, starting from 1839, the transition from Sikh rule to British colonial rule. The two timelines, backward from 1995 and forward from 1839, converge in the final chapter, which marks the pivotal year of Punjab's conflict cauldron: 1984. Sikhs became key to India's identity politics post-1984. Once lionized in Indian history, they found themselves both antagonized and demonized. Ever since, the views on the Punjab conflict are deeply communalized, racialized, and entrenched.

Anyone can, and may, speak about the Punjab conflict. But who begins to speak for the people? I have attempted to let the stories speak for themselves: of ruptured families, disappeared children, parents-in-waiting; of a conflict economy with village-by-village kill lists, torture centers in plain sight, mass cremations; of state policy that actively fueled divisions and mistrust, created an enemy community, and stoked communal enmity to prevent everyday citizens from exhibiting everyday humanity; and of women and men who decided to challenge the status quo that paralyzed most others, created localized approaches where international promises had failed, and created hope for the brutalized.

These stories ask whether we are constantly pushed away from nuance, told singular accounts, seduced by gore, or stripped of our capacity for curiosity so that we may be languidly rocked between helplessness and complacency. The stories ask how succumbing to hyper-simplicity prevents our understanding of one another and our conflicts.

The intended audience for *The Wheat Fields Still Whisper* is large and varied, including scholars, lawyers, policymakers, activists, parents, and students. It is written to be accessible to anyone interested in but confounded by the diversity and disparity in the world's largest democracy. It is envisioned as relatable to anyone involved with transformative transitional justice, social change, human rights advocacy, or citizen movements.

With headline-making drug mafias, notoriously trigger-happy alcoholic men, a receding rate of education, and increasing violence against women, we are accustomed to the lament that no one in post-conflict Punjab stands for or against anything. Yet, not so long ago, women and men did stand. Appealing to this positive history, despite the current despair, I wished to foray into India again—a land where at least the non-wretched, but of the earth, can still intervene.

For all the complex mathematics to which my father has dedicated his life, his children have only ever been compelled to learn one simple arithmetic: "Every new victim is another victim. It does not cancel out." This book depends on human experience, on tragedy and survival, being taken at face value, not as bargaining chips in the game theory of power politics.

San Mateo, CA, USA Mallika Kaur

ACKNOWLEDGMENTS

I owe this project, like my life, to all those who spin fearless love cocoons wildly, urgently, generously, to buffer against hate, exclusion, dejection.

This book would have been impossible without the people across Punjab, and its diaspora, who opened their hearts to me, and bestowed on me the privilege of telling their collective story. For your patience with my curiosity, for your openness to be challenged in your opinions, for your steadfastness to your lived experiences, thank you. We do you grave injustice by assuming that since the stories are so hard, so buried, and made so invisible, you do not wish to speak. Once again—you defy the stereotypes of victimhood. Once again, I thank you.

In Punjab's taana-banaa-banaa-taana (cat's cradle) dance the little girls who grow up believing their silence will protect grown men, that their defiance may kill their brothers, yet that their own bodies are theirs to protect alone. The little boys who bear the weight of histories unexplained to them, but which dictate that they remain fearful while appearing fearless, remain carriers of name and honor even as they are deprived of free dreams and heartsongs. In it too hang the questions about conflict, democracy, security, just peace. Thanks to all those who have helped me question.

Thank you for sharing your inspirational lives and for giving serious consideration to my many, many queries into decades past: Inderjit Singh Jaijee, Baljit Kaur, and Justice Ajit Singh Bains.

I owe thanks to so many who believed in this project, then this book, through the many years. This was not an easy undertaking. Your solidarity, your interest, and your concern for my wellbeing made it doable. Forgive me, all those I am unable to name here.

For invaluable feedback on early, difficult, drafts that helped me better imagine, thanks to my friends and colleagues: Kavitha Selvaraj, Jenna Coughlin, Betsy Hoody, Jaspreet Singh, Lindsay Harris, and Nissa Rhee. Thanks to Harpreet Kaur Neelam who at different points spiritedly reminded me to name an(other) unnamed woman in history and stay true to my project despite word limits.

For generosity of humbly sharing their deep subject-matter expertise on law, human rights, and transitional justice: Naomi Roht-Arriaza, Rajvinder Bains, Cynthia Enloe, Andreas Feldmann, Angela P. Harris, and Marci Hoffman. For sound publishing advice and encouragement, Laurel E. Fletcher and Rory Stewart.

For modeling what creating space and mentorship should look like, Professor Richard Buxbaum.

For trusting to join me in classroom adventures, and teaching me, my students.

Thanks to public libraries everywhere and the librarians at UC Berkeley.

For unflinching solidarity and responding to late-night messages and clarifying questions when my brain was overloaded, Navkiran Kaur, Arjun Sheoran, Neha Sonawane, Guneet Ahuja, and Dipin Kaur.

For providing sangat, community, solidarity and love during the writing of this book, Gurjaspal Singh, Janmeet Singh, Prabhdev Singh, Akbir Kaur, Balbir Singh, Bhajan Singh, Harvinder Singh, Pritpal Singh Kochhar, Nancy Lemon, Kiran Chadha, Ginni Chadha, Manpreet Kaur Singh, and Mandeep Chadha. For being kindhearted and loving anchors, Nivika Khemani and Kavita Taneja. For family, Supreet and Narinder, proud parents to baby Guneeve; Harpreet, Nonia, Dilzafer, Parnaz; Surinder Kaur and Devinder Pal Singh (he who left us all too soon, and whose voice will always sing Rehraas in my ears).

For countless close reads, comics, and keen interest that kept me going, the incisive and artistic Puneet Singh. And Jaipreet Singh, for helping me begin, yet again.

Thanks to editor Megan Laddusaw at Palgrave Macmillan for seeing promise in this book project and championing its integrity. To Christine Pardue for helping actualize. To the peer reviewers for their comments.

To my Ramneek, for decades of sisterhood and heart-lightening.

To Manpreet, for being detail oriented when I am hurrying, for music, for bhangraa, for committing to happiness, for siblinghood, and for bringing me a younger sister, Ravleen.

To my partner and husband Prabhjot Singh, whose infuriating optimism never doubts any enterprise I announce, and who stays true to his name, bolstering me with faith in this world. This book would have never seen daylight without you.

To Azeeza Amrit Kaur for coming to this world as I was deeply concerned about birthing this book, and for bringing perspective, giggles, and buoyancy. You are the Guru's greatest gift: may you share your own gifts generously in your journey ahead.

In my journey, I draw on my first and forever feminist inspiration, the human rights defender Guru Nanak. You stood tall and created a community that has a tall order. I lean on the wisdom of womxn before me. And I think of the men who have touched my life at different points and who have helped me believe in healthy relationships while my work often encounters the most brutal faces of toxic masculinity.

For allowing me space and time to reel out, find center, then wander again, and for an unconditional love that flummoxes often, my parents. Minni Sarkaria, you truly have lived several lifetimes in one—and with fierce courage and dogged resilience. Karanbir Singh Sarkaria, you somehow continue to combine your genius with empathy and gritty integrity—a heavy burden, this extremely rare combination. I live in awe. The job of parenting never ends; I am reminded even more now as you both teach me, lovingly, to myself grow into a parent. May my daughter be a fraction as lucky as yours.

Finally, this is a book for advocates, crisis counselors, lawyers, students, teachers, and the many grassroots activists who work thankless jobs. It is for those who decide to engage with the world.

CONTENTS

1 Proem 1

2 Earth, Water, Pyre 21

3 Monu's Mummy 57

4 Jamuns 93

5 Next, Kill All the Lawyers 123

6 Holy of the Holy 151

7 Two Urns 181

8 Guavas and Gaslighting 205

9 Glasnost 233

10 Ten Thousand Pairs of Shoes 255

A Chronology 291

Glossary 297

Index 301

2. Storm Sauce Fire 41

4. About Shining

5. Enjoy

6. Faith All the Universe 194

6. Help of the Holy 184

7. We First 181

8. Prayer and confidence

9. Eternal 151

10. Ten Thousand Risks or Slaves 255

Conclusion

Glossary

Index

LIST OF PHOTOS

Photos 1.1
and 1.2 Rooftop walk & view, Jaijee house in winter, Chural, Punjab.
 (Photos by author) 7
Photo 1.3 The concurrent timelines running through the book's chapters 11
Photo 2.1 Jaswant S. Khalra, first from the left, 1986. (Photo from Khalra
 family archive) 23
Photo 2.2 Khalras on family vacation, 1992. (From Khalra family archive) 46
Photo 4.1 Chaman Lal showing the author family photos and reports about
 Gulshan's murder 99
Photo 5.1 Letter to Election Commissioner regarding 25,000 Special Police
 Officers recruited during 1992 election (Courtesy I.S. Jaijee
 archive) 129
Photo 5.2 Rally for Justice Bains on Parliament Hill, Ottawa, Canada, June
 5, 1992. (Photo courtesy Sandra Bains) 140
Photo 5.3 Justice Bains's letter to Punjab & Haryana High Court Bar
 Association. (From Justice Bains private archives) 141
Photo 5.4 Jeffrey Goodman with Rajvinder Bains, Justice Bains, and
 Rachpal Bains. (Photo courtesy Jeffrey Goodman) 145
Photo 5.5 Justice Bains addressing a gathering soon after his release; also
 seen, Baljit Kaur (in white). (Photo courtesy Jeffrey Goodman) 146
Photo 6.1 Telegram sent by D.S. Multani immediately after the abduction
 of his son, Balwant Singh Multani 173
Photo 7.1 Justice Bains's letter to Governor S.S. Ray, October 4, 1989.
 (Ajit Singh Bains personal archives) 187
Photo 7.2 MASR's statement seeking probe into MP Khudian's death, April
 1990. (From I.S. Jaijee personal archives) 191
Photo 8.1 Inderjit Singh and Daljit Kaur Jaijee. (From I.S. Jaijee personal
 archives) 208
Photo 10.1 Darbar Sahib, Amritsar. (Photo by author, 2016) 260
Photo 10.2 Letter from I.S. Jaijee to George Fernandes, Union Minister for
 Railways, seeking information about Sikhs killed on trains across
 India in November 1984. (From I.S. Jaijee personal archives) 279

CHAPTER 1

Proem

HE STILL FOLDS THE SKY ON HIS HEAD. Clouds have slid down the once dancing valleys, nesting in his eyes.

He is wearing those nondescript black Punjabi sandals with coiled ends and no arch support. He abruptly stops the shuffle, blue turban lifts, and he looks up through cloudy cataracts.

"I'm sorry, I am uneducated, I don't know the year …."

I mumble something about education having scant to do with schooling. He mumbles something about the bane of poverty.

"Nineteen ninety-one or ninety-two," comes a crisp voice.

"Yes, ninety-one or ninety-two," he says louder, not wanting attention paid to the voice. "My son," more quietly. He is not to be involved in this conversation, tacitly.

Also unsaid is why I, a lawyer focused on violence against women, am sitting on this achingly cold winter evening with six men, in a village 100 miles from my parents' home.

By 1992, my parents had done the unthinkable.

Leaping against the glorified American Dream, they wrapped up our tight Virginia apartment even tighter. They gifted kitchen essentials and tchotchkes to other grateful young immigrant families, sold the lesser obscure items in yard sales, packed all their books in shipping boxes collected by helpful neighbors. But whiffs of *The Washington Post* still rise from an even earlier packing.

My father, hair yet not grown out long on his head, and my mother with a small—attempted—ponytail, and me cross-plump-legged on their dining table, wrapping some holiday gifts: all in newsprint. The black ink smudging our hands slightly made it a bigger art fest. Papa's mathematician eyes

© Mallika Kaur 2019
M. Kaur, *Faith, Gender, and Activism in the Punjab Conflict*,
https://doi.org/10.1007/978-3-030-24674-7_1

gleamed a little as he made the perfect corners, while Mama kept my blabber at bay. Perhaps these gifts went to Stacey and Marsha next door, or to Lutfiyah and her kids. These were not for the other Punjabi and Indian families: those gifts would be packed shinier or maybe even in gleaming bags from the Dollar Store.

The later packing of the many, many books in many, many boxes is less clear in memory, but the unpacking in Chandigarh, Punjab, months later, remains crystal.

The pieces of America that landed at the gray gate of my grandfather's house—we never called it my Dadiji, my grandmother's house—were most exciting. I showed off mercilessly to neighborhood kids. Mama warned me but I again risked being boycotted by my playmates.

I remember unpacking My Little Ponies, all six of them—a precious imperfect set of hand-me-downs. I also decided to display all my toys from McDonald's Happy Meals. Hot Wheels and GI Joes from Manpreet were invited, till they caused another brouhaha and left in a huff—only to be invited back again, to be bossed again. His speed, my sass. The cooler sibling was, then, smaller. If I could only sit on him, I could have the whole world of our plastic friends dancing to my tune.

Only one time—though it must have happened so many times—I recall walking exactly between my father and his father, Dadaji. To the market, to buy a treat for the little émigrés. I tried to match their strides, two-to-one, six foot one and five foot eleven on either side. The dusty path was lined with congress grass—the stubborn white-capped weed became symbolic in years to come—and on the left, as we walked to the Sector 16 market, boys played cricket.

They must have been talking about something, but my heart was too happy to worry about trying to listen. Perhaps this unique abandon of a childhood otherwise spent trying to hear, untangle, and remember adult conversation makes this walk unique. I kicked little stones as we walked by the high fences that caged the shuttlecocks in the badminton courts of the Rose Club, where my Dadiji went to play tambola and my Dadaji sometimes went to pity the old gossips. How could they all while away time, these men, Dadaji would wonder, hardly silently. The president of the Cactus and Succulent Society of India, he was my model for social entrepreneurship and leadership for many early years. Papa, his turban-covered hair now regrown long in political defiance, walked beside Dadaji with a common mission that day: the Amul cheese tin. The kids were to enjoy something they thought they had left behind: processed cheese. And Dadaji was going to show Papa and me where to get it.

These men running the occasional domestic chore together have never left that path. Walking it alone, with friends, or with a forced companion since it was too unsafe for a girl to walk half a mile alone, for FataFat candy, for a new school register, for pencils, for just a walk, for an irrational plan to be seen by

the neighborhood crush—my father and grandfather have always walked by my side, many times shaking their heads, their turbans starched, their noses long, their jaws set.

We were reunited with our roots. Despite some tense comments the moving in had brought, I knew my grandparents were thrilled to have more life in the house. They reminded us several times about the burglary that had taken place a few months ago—Dadiji stressing how they were all alone when it happened, Dadaji stressing the cowards never made it downstairs to face his gun, which he would have drawn just as he had, like all Sikh Army retirees had, in 1984, when they anticipated the anti-Sikh pogroms spreading to Chandigarh.

Guddi, who at the time was helping my Dadiji, with a fractured arm, to bathe, clothe, and later sit in the sun and gossip, gasped and sighed with details about the burglary. She left just enough unknowns for the GI Joes to combat, aided by the pony with the rainbow mane, on a good day when Manpreet and I united to protect our new, forever home.

* * *

Just over two decades after my parents' return migration and my own re-migration, I now sat across from the cloudy-eyed man and his comrades. My neck hair rose through my thick black shawl and I dug into the dry ground with my boots.

I stared into his eyes. Dark mustard dust rose.

"Then the policemen yelled ... well ... it was a curse word."

I stare intently so that he knows I am not going anywhere. Regardless of the inappropriateness of the curse, it was ours to share today. Three furrows kaleidoscope to five as he leans forward to speak. He blinks at every word. First harder, then faster.

"Sister-fucker. Sister-fucker, you lie. They yelled this in front of everyone."

There. We were on. Where timeless love songs venerate the chaste silent speech of eyes, where chauvinism reads women's directness as an invitation to what isn't there, where good behavior dictates evasiveness between sexes, there, I time staring into men's eyes with the surgical precision women hone when refusing to give up on their worlds being co-opted.

He proceeds to tell me how he was abducted by the police, one final time. "I had just taken my morning wash under the tap and was going to tie my turban when they came. Yelling, 'Sister-fucker!' Gave me five or six blows and pushed me out front, and began nabbing family members too."

The bookkeeper of his village gurdwara, Sikh prayer and peoples' center, he had been taken several times before. "I had no other affiliation, I harbored no one. There was no case or anything. Just by virtue of being in gurdwara service, and being an amritdhari[1] Sikh, their eyes had landed on my bruise-blue turban."

This third time—or was it the fourth, he can't remember—he recalls the wet clothes clinging to his body as he was pulled away. It was the first time that women in his family were also taken by the police.

While he was being tortured in custody, fellow villagers sought help. "Our village thought: What? Such bezti, such dishonor that our ladies have been picked up too?[2] The entire village flowed."

In Malwa, the region demarcated southernmost by Punjab's defining rivers, cracked land blossoms in cotton, hearty millet, and where possible, golden wheat, while the local dialect lends fluid aspirations to human movement.

"This time, instead of coming to grovel at the police station, villagers went to the big house. Told the Jaijees this and this has happened ... that they'll kill the whole family."

He nods toward the black turban. Inderjit Singh Jaijee sits quietly in the courtyard by a 22-foot iron gate opening into the expanse of his freshly painted redbrick house. Here, 24 years meet again.

"And there was a lot of back and forth with the local police. Jaijee saab and his brother, a retired respected DIG of Police, demanded the release of the kids and women. I was kept longer."

He adjusts the hem of his kurta for phantom wrinkles as the furrows on his forehead recoil, reemerge, redistribute in double time.

"After several atrocities, I was allowed to hobble home. I could move with assistance. But my heart ... my heart had begun refusing to stand back up." His mustache rises for an embarrassed smile.

"Then, two days later, suddenly thirty-five or thirty-six cars surround the house. And the policemen come in. I said, Sorry, I just got released the other day. My boys were just released. What could we have done since then?"

"'No-no-no-no, you haven't done anyyy-thing,' says one policeman. 'I didn't say anything to you, did I?'"

"I shook my head before he could finish. I knew the routine. They had all the power."

"The other policemen erupted:
'I didn't either ...'
 'I didn't say anything either ...'
 'I didn't do anything,'
 'Me neither!'"

"So the bookkeeper of the gurdwara dies to this refrain, I thought! I watched my body limpen to their cacophony. Then, my ears stopped throbbing for a split second and I spoke up, thinking of my children: Please just tell me what I have done. ... Let me get a cot for you to sit. Just sit. Let's talk this out here, please!"

"Next thing I knew? Suddenly all the policemen are running about. Are themselves lugging cots on their heads, from our house, the neighbors' verandah. ... Not barking at the villagers. Just quietly arranging the cots. My end was going to be historic after all!"

"Then the head inspector called for the village headmen and said an agreement must be signed. The children did. I did. Thumbprints on whatever papers, thut-thut-thut-thut."

"And then the head inspector asked, 'So who beat you?'"

"I said quickly, Oh some bloody dacoits did"

"'Bastards!' the inspector yelled."

"As I opened one eye, I realized he was cursing at his own men! He bellowed, 'Don't you know what amrit is? You have no respect for the baptized Sikh?' Kept hurling abuses, lots of sisters-mothers too ... berating the junior officers. This was beyond anything I could fathom."

"'What can you say for yourselves?' he shouted. 'Are your black tongues stuck in your lying mouths now? I should hang you all upside down! I should do to you what you did to him.'"

"Then, just like that, honey dripped from his voice: 'Now, brother, pleeeease go ahead with your life, from today, no one will ever touch you'"

"The police are picking me up so often that my family is going hungry, I said."

"'Go on,' he said, 'now live your life.'"

His kurta deflates with the curl of his spine.

"And I have. But that is all thanks to this man."

He points all his fingers left, without lifting exhausted hands or eyes.

"Otherwise, our entire family would have been eliminated. But they never looked at our family again. And I started eating in peace again. The physical wounds heal, one goes on living. But not a single life in our home would be here today, without him. This is Jaijee saab's contribution. Write about this."

Another old man from the village, who was the headman at the time, nods.

"The true-hearted villagers stood in solidarity, but it took intervention from this man to rescue people. This one was a mysterious case. But, Jaijee's work has saved ten families just in our one village. Otherwise, these homes would be barren too. Almighty has returned color to our lives, we work, till, and eat in poverty but peace."

All eyes turn left.

"Here, we were able to intervene in time," says Jaijee. "These villagers are hearty. Through everything we have seen here."

"Oh, big brother, what has this house not seen?" The headman's pathos interrupts. "Through the white rule, through the Partition, through this."

While India and Pakistan celebrate 1947 as their year of independence, Punjabi grandparents speak of it as the year of Batwaraa—Partition—when everything was shredded in a span of weeks, forever. The plural voices of yogis, sufis, and gurus had fed the soul of the Punjabi for centuries. While even such nourishment is insufficient to overcome opportunistic criminality, it had supported peaceful coexistence during most of the British rule of

Punjab. Then the departing colonials drew a lethal line to which the national-ist leaders, itching for power, acquiesced. Punjab was partitioned to birth India and Pakistan, through the holocaust in which a million Punjabis were murdered. The blood of the Partition flows through the story of Punjab ever since.

Punjab was made a laboratory of postcolonial India's nation-building proj-ect: consolidation (with new borders, 1947); provision (Green Revolution agrarian experiments, 1950s–1960s); and discipline (militarily and socially through operations, 1980s–1990s). Sikhs, 2 percent of India, first constituted 33 percent of Punjab, and then after a redrawing of borders by New Delhi, 56 percent of Punjab, with Hindus, the majority religion in India, at a close sec-ond.[3] Today Punjab is 58 percent Sikh and 38 percent Hindu.[4] By 1984, a pivotal year in this story, Sikhs—a faith community founded 500 years ago and often visually identified by flowing hair, beards, turbans—found themselves socially and politically alienated.

"Each time there was another killing, we landed up to investigate," contin-ues Jaijee. "Any disappearance, we followed up. And during the Punjab elec-tions, starting in 1991, with the round that the Congress Party boycotted, we had a lot to follow up on."

"In those critical times, we were constantly sending information to senior government officials. I sent Mr. Seshan, the all-powerful chief election com-missioner, a telegram saying that the police gangs had picked up another man from my area. In this case, Seshan ordered the police to officially go and recover him and report in. But he … he got scared that the police have come again. They kept asking if the local police mistreated him. He, at the time, said, 'No, no, never, not at all!' He got worked up a little."

A kind smile is exchanged.

"The excesses of the government, jailing and killing of Sikhs, was a constant. … Twenty-nine candidates, twenty-six of them Akalis, had been killed before that pivotal 1991 Punjab election was postponed at the eleventh hour by the Center's Congress government. And then six months later, the militants[5] sup-posedly boycotted the rescheduled election. Akalis now backed out, and Congress participated to win. Not a single candidate was killed. If Akalis had participated, the entire middle rung of their leadership would have been wiped out. And yet, forever, Sikh separatists were associated with an election boycott. This was a turning point of the conflict. Killings of Sikhs spiked. But here, in this case, Seshan sent a big enough team to protect this man. It went like this, didn't it?"

"Yes, yes," he nods. "I was so worried. Why are the police, why are *they* pay-ing respects?"

The group of men join Jaijee in a slow chuckle.

"This house has witnessed everything. It must have thought it had seen it all, after what your father endured," says a man in a checkered chadraa, wrap-around, under a brown kurta.

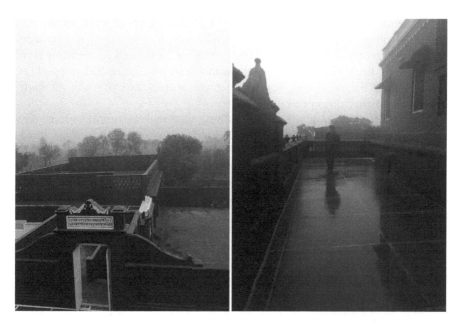

Photos 1.1 and 1.2 Rooftop walk & view, Jaijee house in winter, Chural, Punjab. (Photos by author)

They gaze ahead toward the guava trees, the tops blurred by smog, bottoms uniformly whitewashed against pestilence.

"My father, he consciously chose a path and endured the costs," says Jaijee, who always begins his own story with the retelling of beloved stories of his father (Photos 1.1 and 1.2).

"What we saw later across this land, was en masse punishment of unwitting people. My Pitaji's trouble started with the killings at Nankana Sahib in 1921. British had said there shouldn't be more agitations and Pitaji went ahead and sent rolls of black cloth to the villages, encouraging people to wear black turbans of resistance."

Inderjit Singh Jaijee pats his own turban. Never one for less than deliberate hand motions, Jaijee would repeat this gesture only once later in a very different conversation, recounting a UN conference in Vienna with the then finance minister and later Indian Prime Minister Manmohan Singh. Jaijee has himself always donned black, like his father.

"Now." Emptying a small glass of tea that has today replaced his habitual coffee in deference to his company, Jaijee looks around the circle: vacantly staring, noisily nose blowing, loudly swallowing, and wiping invisible perspiration.

"Perhaps we've talked enough about this for today? Now, let me ask you for some help." Jaijee clanks the glass on a wooden bench, painted another layer of cobalt green, proofing old wood.

They all lean forward.

"It seems ... a well has gone missing!" he twinkles. Just a yawn away from the men's village was the small village with a centuries-old well, Jaijee remembers. Three decades ago, following back roads to his father's home from New Delhi, where he worked with a multinational company, Jaijee had stopped his motorcycle at the villagette. The weather was stormy and this was the early 1980s in Punjab; caution was critical.

"I remember chatting with villagers by a well with beautiful old cobblestones. But here's what's perplexing. Yesterday, no one in the village knew where the well had been."

I thought back to the evening before: no other woman outside, premature dark of a premature winter, too many men already too intoxicated to answer even simpler questions. Now, Jaijee tries to rekindle this group's interest in the mystery.

"Oh wait, you see, Mr. Jaijee won't take no for an answer. That village will receive visits till it remembers what it did to that well," one guffaws.

"Oh yes, we should go warn them!"

"Yes, yes, don't make him call the higher-ups for that poor well now!"

"Oh, sister-fu—"

Jaijee arches an eyebrow and the man stops mid-word, interrupted in employing the erstwhile unsayable gendered curse that has now become common punctuation in spoken Punjabi. We break eye contact. The catharsis of transcending gender and age is over, for now.

The whitest beard in the group leans harder into his stick, speaking loud enough for himself to hear. "Police paying their respects! What a dangerous thing, those days."

* * *

"THOSE DAYS" ARE WHAT I SET OUT TO UNDERSTAND. An entire period packed too neatly into one word: militancy (and with passing time, terrorism), out of which peek mysterious questions.

The period from the late 1970s to mid-1990s that expanded the rural Punjabi lexicon to include "police encounters," when anywhere from 25,000 (police estimates) to 250,000 (civil society estimates) were killed. This period includes the deadly 1985–1995 "decade of disappearances," which saw families-in-waiting shuttling between detention centers, crematoria conducting secret incinerations, and shallower turns of irrigation canals that exposed discarded bodies. The period about which gaps in our understanding are at once hypervisible and invisible.

The official government story is of religious extremism by one uneducated ideologue that necessitated mass state response in 1984, prompting more misguided youth, backed by the ever-opportunistic neighbor Pakistan, spreading terror in the countryside, which was brought back from the brink only after New Delhi intervened and oversaw valiant counterinsurgency operations with Punjab Police sacrifices.

The opposing story is of a systematic program of elimination of Sikh power and pride since 1947, protested first peacefully—even as the state's treachery deepened—and then fiercely, under a saintly Sikh leader whose own gruesome killing during the assault across Punjab's religious sites in 1984 solidified the second-class status of Sikhs in India, which was then resisted by a militant movement, which in turn provided the government further pretext to hunt Sikhs for the next decade.

Would discounting both the narratives by about half arrive at the truth? Or are both quite insufficient?

In our world at once riveted and recoiled by violence, this book asks what might shift in our collective understanding and action if we spent nearly as much time fascinated by everyday people—like the deathly confused gurdwara bookkeeper—and unarmed human rights defenders—like Inderjit Singh Jaijee—as we are by the eroticism of violence and romanticism of resistance. Highlighting the fight against fatalism in a specific context, this book seeks to raise questions for the readers' own contexts and to disrupt today's general pessimism around citizen-activism in the face of oppression.

The book journeys with the lives of three protagonists of Punjab's hazardous human rights movement. Baljit Kaur, once a part-time Air France employee and full-time homemaker, who began documentation work with one of the few video cameras in Punjab in 1984, gaining access to condemned villages and homes during the curfewed years. Justice Ajit Singh Bains, known as a "communist judge" long before becoming the "people's judge," who would retort that he indeed had an unflinching stance on "terrorism" in Punjab: "I am against terrorists, in and out of uniform."[6] And Inderjit Singh Jaijee, once unknown in Punjab, setting motorcycling world records as far away as he could get from his heavy Jaijee family legacy, who would gravitate toward Punjab just as other elites were tilting away.

Internal armed conflicts across the world share in common the unpredictability of everyday issues turning the tide, the reliance on petty bureaucrats, the steadfast banality of evil, and the shameless obligations thrust on targeted peoples: to speak in unison and tell a linear story, subjected to the strictest scrutiny. Meanwhile, the state may present taradiddle that the media repeats and with which we must contend. Instead of continuing to try to understand Punjab's history from a defensive position, I decided to investigate: In Punjab, with its rich legacy of resisting oppression, where were the human rights defenders in the burning 1980s and 1990s?

Any outsider looking in on Punjab can see that the community most disadvantaged by the conflict, the Sikhs, have simultaneously held positions of visible power and privilege. The Punjabi farmers who routinely commit suicide seldom make media stories, compared to rich and powerful Punjabis in business, government, and Bollywood. While the turbaned ministers, army chiefs, or ambassadors at best avoid speaking about the conflict, those Sikhs most vociferous about it rarely unpack the visible contradictions. Seeming delusions and divisions among Sikhs have provided another convenient reason not to

have meaningful engagement with Punjab. The curious case of the conflicted Punjabi Sikh is compounded by the fact that most of the killings of Sikhs in Punjab were committed and overseen by other Sikhs serving in the government forces and/or private militias.

Conveniently packaging the Punjab story in violence-centric terms unites odd bedfellows today: journalists, academics, politicians, Punjab Police, as well as Khalistanis—most neutrally understood as Sikhs supporting self-determination but in common Indian terms dubbed "Sikh terrorists." This packaging is stitched with neat, absolute binaries: pro-India/anti-India; peaceful Sikh/militant Sikh; intellectual Sikh/village Sikh; modern Sikh/radical Sikh. It is secured with euphemisms: crossfires, mainstream, missing men, dishonored women.

Such telling of the Punjab story at once keeps the conflict ripe for more academic studies on violence and peace, bolsters the Punjab Police's arguments for continued resources, frees Punjabi Hindus from problematizing the pogrom politics carried out in their name, and creates a ready narrative for Khalistani Sikhs eager to transmit a history of grave injustice and bold rebellion to their next generation.

It does not account for the complexities within the Sikh community or diminish the antagonisms. It does not respond to the immediate intolerance that prevents any remedies for the conflict wrongs. It challenges neither the moral equivalence of some human rights accounts nor the chauvinism of some Khalistani accounts. It does not allow for any conversation about celebrating difference against deathly programs of assimilation. It does not challenge prevailing wisdom or pervasive inertia. It does not reach those who, like me, were born in the 1980s and have simply known that certain questions must never even be insinuated. It hounds hope.

There are other sides to the Punjab story. Of noncombatants committed to honoring "no-names," rather than debating the minutest machinations of "leaders." Of people who can recognize human loss as a tragedy rather than a bargaining chip: where no victim is canceled out by another based on their group/religious affiliation. Of people who brought human rights into homes that didn't yet employ that phrase.

Inderjit Singh Jaijee, Justice Bains, and Baljit Kaur are credited with saving countless lives in deadly times. They never forgot their relative fortune and safety. They invoke countless others to explain their own sense of outrage and right. In this spirit, their life stories refused to be written as ordinary oral histories. Heirloomed yarns, inherited memories, treasured records, meet collective biographical snapshots (hardly a hagiography—their limitations, desires, and failures make these people all the more human, all the more remarkable). The notes to each chapter cite the sources for kernels of fact; the interpretations, where not attributed to an interlocutor, are the author's.

It is perhaps more impossible than unfair to try to understand Punjab's conflict without recognizing the history—of movements, of bravado, of self-identity,

	Contemporary Timeline		Historical Timeline
Chapter 2	1995		1839 - 1917
Chapter 3	1994		1918 - 1935
Chapter 4	1993		1936 - 1947
Chapter 5	1992		1948 - 1959
Chapter 6	1991 - 1990		1960 - 1967
Chapter 7	1989		1968 - 1974
Chapter 8	1988 - 1987		1975 - 1981
Chapter 9	1986 - 1985		1982 - 1983
Chapter 10		1984	

Photo 1.3 The concurrent timelines running through the book's chapters

of promises, of uniqueness—of the land that lives in its progeny. Thus each chapter, while focusing on a conflict year,[7] contains an interwoven section that quickly traverses the earlier history of Punjab. As the reader begins Chap. 2 and travels back from 1995, the arguable end of the conflict, the earlier history of Punjab, starting in 1839 during the transition from Sikh rule to British colonial rule, will travel forward to embrace the reader. Like a loving relative, this embrace is pesky and inconvenient at times, but unavoidable. To understand Jaijee, Kaur, and Bains, understanding what they describe as their historical roots is essential. To understand why today there are even fewer people who persist, as these veterans have, understanding the roots of this conflict is essential. The two timelines, descending from 1995 and ascending from 1839, converge in the final chapter, marking the pivotal year of Punjab's conflicted recent history: 1984 (Photo 1.3). The readers' willingness to journey through these undulating layers will be the first act of solidarity with difference and pain, unknown and known.

These stories allow us to dive into the white spaces of newspaper items and legal files that made the headlines through the 1980s and 1990s and manufactured the consensus that informs policies today. The three protagonists bridged the gap between the killing fields of Punjab and the silenced elite beyond. These were people who used the priviledge of the very social class that most collaborated with oppressive forces. People who never gave up on the "international community," engaged it, and at the same time did not expectantly depend on it.

* * *

The entrenched views on Punjab's recent history have traveled far beyond its borders, far more significantly than the Bhangra dance beat, chicken tikka masala, turmeric milk naturopathy. While leaving Punjab for education—Chicago, Berkeley, Cambridge—gave me freedom both as a woman and as a Sikh, I was often yanked by the chains of biases against my identities.

I grew up in Punjab in the 1980s and 1990s among the middle and upper class of Sikhs, most of whom read their censored news in English, suppressed thoughts in Punjabi, and spent all means necessary to appear unaffected. Later, as a newly minted lawyer in the United States, the need for South Asia to have its own regional Human Rights Court or Commission consumed me. But my work soon made me increasingly intrigued by people's stories that remain unwritten and unexplored in many reports and cases, yet deeply inform everyday realities. How ordinary people choose to define or end one another's stories is vital, especially where a culture is not truly textually mediated or even institutionally mediated, least so during emergencies. How neighbors understand each other's different life stories has often been the difference between harbor and harm. Where prevailing wisdom has rendered certain historical facts as fictions, and certain identities as suspect, stories may darn social fabric.

As I was completing my master's degree, a faculty member at Harvard wrote to the chair of a prominent North American foundation, confident they would be interested in my work. Pat came the answer from a man of South Asian descent, whom I shall call Mr. X: The proposal focusing on stories around gendered violence in Punjab failed "dispassionate assessment," his email said, since "there are no cases and not even any mention of rapes against women related to that violence."

To Mr. X, I owe many thanks. Peeved, my feminist curiosity piqued, I spent the next several years in conversations that repeatedly destroyed his cocksure reply.

Mr. X had unsolicitedly also advised, "Unlike Punjab, there were some rapes in Kashmir. ... However, it is exceedingly difficult and quite sensitive to get anyone, including the victims themselves, to discuss these cases."

I have made several trips between Sukhna Lake, Chandigarh, Punjab and Dal Lake, Srinagar, Kashmir. When approached by tourists, these regions of complicated (re)colonialisms, conquests, and consequences remain indifferently docile; when approached with care and a promise of lenient love, they begin to part with the past and present.

I became an unannounced guest at Muzafer's doorstep in a village in district Baramulla, northern Kashmir, on Christmas 2010. We arrived there searching for his sister-in-law, whom villagers had identified as a "half widow"—wife of a person who has "disappeared." I had accompanied local civil society workers, one male, one female. As had happened earlier in the homes of three other half widows (we were informed that this village housed at least nine women with this designation of perpetual limbo), I was introduced quickly and incompletely, there was a bustle of activity to situate us in the home, in warmer surrounds, with kangris to protect against the subzero afternoon temperature.

As we sat down, Muzafer explained that his sister-in-law was away. Then in about 90 seconds he gave the details of his brother's disappearance: the date, the reason he remembered it had been at 7:20 in the evening, the name of the regiment that had come into their home, the officers, the make of the jeep, the major's demand for Rupees 50,000, their arranging the money, payment of part of the money, and then nothing: no news ever again. "In one day, *home* changes meaning forever." Muzafer looked up. I realized he was just about 30. I realized he stared only at me.

"Anyway, now what will happen? Nothing ever happens."

Silence. I had nothing to say. I was in absolute agreement.

"Where do you go with that notepad?" he asked, not expecting an answer.

I asked him whether he would like me to leave. My Kashmiri colleagues felt a need to defend, and began explaining the importance of gathering women's stories. But he and I had already discovered our commonality; we were both quite comfortable sitting in silence. Some bright-eyed children from the neighborhood peered gingerly through the window.

Finally, he commented on how these children had had so few school days in the past six months. With that began our hour-long conversations about the conflict that assailed his homeland. About the legal system that his eighth-grade education had deemed daunting, and then his social education had revealed farcical. About the political system that was decried by Indians for "spoiling" Kashmiris with relief and subsidies[8] and detested by Kashmiris for trying to buy hearts and minds after squashing hearts and minds. We discussed the philosophical debate between human rights and humanitarian work. Notorious WikiLeaks had only recently revealed a memo from the Red Cross about institutionalized torture.[9] We discussed the irony of concern with Muslim women's oppression by religious clothing, rather than their safety. Of the violence forced on their women's bodies by the conflict: by Indian soldiers, who were vociferously demonized, as well as by some of their own men, who were quietly borne in the name of community, honor, and a tomorrow that never came.

At some point, he insisted we have tea. "You all have come and you must have tea. Life goes on. I must have tea."

But before the first sip, he looked me straight in the eye. "It's about honesty, about your imaan. Either just decide you are going to speak the truth, speak what you see and hear, shout out in favor of justice, or just don't ..."

"Just don't interrupt what's left of people's lives," I finished his thought.

* * *

The Kashmir Valley boomeranged me back to questions for my flatland. The Punjab conflict's selective telling has also fed the fascination for violence—through its spectacular events, bookended often by the 1984 assassination of the Indian Prime Minister and the 1995 assassination of the Punjab Chief Minister. My questions about the unknown in-between led me to this book's protagonists.

In the common imagination of the armed conflict of Punjab, the men involved (as militants, separatists, and political leaders) are seen as irrational actors with monstrous tendencies. The women continue to be cast as vulnerable and victimized, but hardly ever as organizers, protestors, videographers, champions of rights.[10] Rarely excavated are the varied and hybrid roles assumed by Sikh women. Today's Punjab, with its sex ratios warped due to feticide and an increasing culture of machismo, reinforces a picture of disempowerment. Yet in this dismissed land live women who neither quote statistics nor preach work-life balance, but valiantly assert agency and defy prejudices with forgiving love. Their stories critically highlight how attention to various forms of gendered violence is a prerequisite for transition from conflict to a just peace.

Baljit Kaur's tireless documentation work in the 1980s and 1990s has been widely used, without much attribution, by international and national human rights groups. The lady who never states her accomplishments were twice as hard because she was a wife and mother, and who remains quiet about her personal tragedies, served steaming tea with courageous equanimity. On first meeting Baljit Kaur, I learnt about her current campaign to save a historical site from becoming a golf course. Hearing one who had made much recent history in Punjab speak passionately about preserving history, I happily witnessed resiliency at work.

Over subsequent teas, I heard stories of many of Kaur's comrades: the Rolls-Royce-driving former army colonel; the gynecologist who disbelieved in social niceties; the former army general; and her closest colleague in the most daunting times, former Punjab and Haryana High Court Judge, Justice Ajit Singh Bains. "All of us human rights activists in Punjab then, were all forty-five to fifty years old and above," she says. "Because it was easy for them to tie up younger people to some militancy-related charge. So we discouraged younger people working with us, especially being on the front end." One explanation also for Punjab's dearth of human rights voices today. "Perhaps they'll think it counterproductive to kill us, we thought."

During one meandering conversation with this doting grandmother of three about her choice to quit her job and focus on human rights documentation in Punjab, I heard chilling evidence about what continues to haunt Punjab.

"Those days, attending the last rites of boys who had been killed and declared militants, was actively discouraged. Justice Bains and I had made it, through a tight police cordon, for the bhog of three boys in Alorakh. Soon after we arrived, people came to tell us: They have taken Shamsher Singh too. And that if we don't do something, he will face the same fate."

"We left the bhog midway, and went to meet the area's DIG. At the police station, he instantly said, 'So you are coming from Alorakh?'"

"Our cars were always followed. This was all old news and old scare tactics. We just tried to focus him in on what was at hand: You have killed three, and now we are told a fourth boy is with you. We want to file a report to record he is with you."

"He looked worriedly at Justice Bains. 'No, no, no, we won't be killing him!'"

"What guarantee do we have?"

"And he leans back on his chair and yells to his peon. 'Bring them the list!'"

"So sure enough, the peon rustled about while we sat wondering what list would possibly convince us that the boy would be spared. There was a Godrej cupboard, and it creaked open like they do. And out came a list. It was marked by district, then the villages were listed alphabetically. Like Alorakh, and a number. It said, so-and-so village, number of boys wanted."

"Now the DIG looked at us and said, 'Satisfied? See, from Alorakh, it is all done.'"

"And so this list, just as it had come out, went back in. Right under our noses, the Godrej creaked shut. But we had seen it, the alphabetical death list! This same procedure must have been used in other districts. Ask Judge saab if he remembers more."

A springy 94-year-old Ajit Singh Bains recollects: "It was Baljit Kaur's tenacity. She was furious that we were coming from marking a triple murder, and a fourth was perhaps underway there. She relentlessly asked questions. The DIG was taken aback by her principled energy. He thought he would just quickly put the matter to rest. And out he brings a list and says, 'See, from Alorakh, we just needed those ones!'"

"So, this was just documented evidence of the plan we had been seeing playing out. The whole of Punjab was assigned like this to police officers. And normally, those listed were amritdharis, or retired army men, activists, schoolteachers, or gurdwara leaders. … You know, anyone who was literate, who could raise their voice."

"The listed were just those definitely marked by the top brass. Add to that the ones who succumbed to the trigger-happy or the extortionist cops. We don't know definitely when Shamsher Singh was released. But we were confident he wasn't killed, otherwise we would have received word from his village. They had no one else to call." He stops to scan my face for understanding.

In the 1980s, the Punjab Police force saw several "special" reconstructions. In the critical years when Punjab's state government was suspended and resuspended by India's central government, some officers who were themselves Punjabi Sikhs were handpicked as chief architects of the counterinsurgency. The officers had free reign to recruit vigilantes—often incentivized through a system of rewards—into the regular police force, enabling "disappearances" and fulfilled quotas from "kill lists," and in the process, non-regularizing the force. When policemen became perpetrators, victims of human rights abuses had little recourse.

"There's just so much we don't know," says Justice Bains. "And so much we know that wasn't recorded or preserved."

These conversations about those days led to others. And many of these stories' champions still alive are slowly fading. I asked for permission to begin recording our conversations. Videos and other near-extinct archives provided

by my interlocutors, forlorn legal case files, nefariously neat news reports, and stubborn community memory all dizzyingly danced in the procession of oral histories to these pages.

<p style="text-align:center">* * *</p>

But the journey of this book also began in my mother's womb. A 1984 baby, I grew with the growing alienations in Punjab.

The Indian Army's attack on Punjab in June 1984, epicentered at the heart of Sikhs, Darbar Sahib ("Golden Temple")—akin in significance to the Vatican, Mecca, Temple of David—had elicited a visceral reaction from religious, irreligious, and areligious Sikhs alike, and indeed many non-Sikhs. Yet, by the time I could crawl, the justified necessity of the June massacres had taken hold in the same psyche and Indians only referred to the murders by Indira Gandhi's army's code name Operation Bluestar. The political party responsible won a (still unbroken) record landslide national election victory a few months later, after anti-Sikh pogroms were unleashed immediately following the assassination of Prime Minister Indira Gandhi. And then any sympathy for Sikhs in the international community dissipated in the flames of Flight 182 from Canada, bombed allegedly by Sikh militants.

By the time I could speak, the militants enjoyed as much popular support in the rural countryside as the government's reattacks on Darbar Sahib did in the Indian "mainstream"; President's Rule was introduced in Punjab; and Sikh diaspora populations multiplied as people scurried out of Punjab.

Seven years old when Rajiv Gandhi was killed, I knew Sikhs, now categorized national enemies, were in imminent danger from another Gandhi death unless someone else could immediately be blamed. (It turned out to be a Tamil woman suicide bomber retaliating against Gandhi's support to Sri Lanka, actively quashing Tamil guerillas.)

By the time I could follow adult conversations, the various infiltrations and infighting in the militant cadres had wreaked havoc in the countryside; various organizations had successfully fueled distrust among Sikhs; Punjab's first elections in four years were first postponed by the government at the last minute and then subsequent polls were boycotted by "militants" under suspicious circumstances, forever rendering the handling of an electoral opportunity a heatedly debated mystery of the secessionist militancy.

Knowing that she could perhaps repeat a "Sikh view" to her best friend who was Sikh, but not to her other best friend who was a Punjabi Hindu, gradually makes a child doubt the validity of the minority view. More importantly, I knew when showing any awareness or interest was dangerous.

By the time I studied conflicts elsewhere in the world and returned to Punjab, I knew our conflict, within the borders of the world's largest democracy, had been long eclipsed by other grotesque happenings in India and the world.

On the heels of November 1984, thousands were killed and disfigured, but this time by a gas leak in the foreign-owned Union Carbide plant in Central

India's Bhopal region, and attention turned to one of the world's worst industrial disasters. Then, as Chernobyl was melting and mutating its citizenry under forced unawareness in 1986, Punjab's secessionist movement reached its true peak. While Mothers of Plaza de Mayo in Argentina were marching for the disappeared, Punjab's boys were practicing guerrilla warfare, which brought the Indian politicians to the negotiating table.

As the Berlin Wall fell, and the United States' unipolar moment began, Punjab's countryside was alight. The homespun militancy was as popular at the grassroots, as it was hounded by the state in 1989. By the time Yugoslavia was coming apart in 1991, the real threat of Punjab's militancy fragmenting the nation had been undone. As the world watched Mandela being elected in 1994, prisoners of conscience had been murdered in Punjab, chilling civil society. While the 100 days of genocide in Rwanda highlighted the horrific threshold of the so-called international community, Punjab was calling for international monitors to assist with counting its dead. But India declared a return of "normalcy" in Punjab, without any period of transition or justice.

Punjab's dead remain unaccounted. The June 1984 attack on Punjab[11] was farther away from the privileged sensibilities—foreign embassies, bureau offices, and civil rights organizations—that could not ignore the sights, smells, and screams of the later November 1984 pogrom by Rajiv Gandhi's Congress after the death of his mother, Indira Gandhi.[12] An estimated 10,000 never returned to claim their shoes, slipped off at gurdwara entrances across Punjab in June.[13] But the armed Sikh fighters in the gold-domed complex in Amritsar, totaling about 400, putting up a stiff fight for three days against the full Indian Army assault, have largely cemented Indian public imagination around the events: violent Sikhs. Suggestions for greater truth telling about civilian losses are considered suspect.

With any writing on any aspect of the story of turmoiled Punjab, the author is scrutinized with ardor for entrenched biases, dreaded fundamentalisms, and political motives. At the outset, there is the scrutiny of the name on the cover—the religion, caste, and ethnicity it suggests. Even recounting a short background of the Punjab conflict is fraught—it will have been immediately read for buzzwords: Bhindranwale, buses, terrorists, Paash. There are some immediate challenges posed to anyone speaking about the anti-Sikh violence of 1984 and beyond. That Hindus were pulled off Punjab buses and slaughtered by Sikh militants; that moderate Sikhs like the poet Paash were killed by Sikh fundamentalists; that Bhindranwale called for the genocide of Hindus; that Sikh militants were women haters; that Hindus who had borne a deep spiritual love for the Sikh Gurus were disrespected and endangered by the so-called faithful of the Sikh movement. Some truth, some propaganda, and a lot of oversimplification provide longevity to each of these challenges. Stating simply that *anyone* who committed violations should be condemned is often judged insufficient, because society has too long been polarized. Many of the tale-telling words are explored, at least contextualized, in the following chapters. Disbelieving in the

possibility or desirability of any entirely detached assessment of history, explicitly "I" will always join you in reacting to these layers of stories behind the news lines and court files.

Accepting absences, documenting distrust, accounting for hiccupping memories, this is a project in understanding complexity of conflict and resilience: how the lawyer's habitual attempt at triangulating facts can be impossible, often for the most improbable and pedestrian reasons; how the study of postcolonial India is paradoxically much more complicated because of a dearth of credible official records on major events of the last seven decades; how imperfect sources—multiple, often multi-year, interviews with dozens of people; over 100 hours of footage; and thousands of pages of private and public archives—together rebuke the politically expedient discourses.

India has increasingly been perfecting its default: fatalism. Silence around violence against the less powerful is steadfastly sanctioned. Whether around the violence against women in their own homes, or around the silent majority of India (the Dalits, so-called untouchables) considered doomed by divine caste, or around many areas of active internal armed conflict, like Chhattisgarh or Kashmir, increasingly accepted as permanent "disturbed areas," or around regions that are still reeling from devious abnormality, like Punjab, but presented, at all costs, as returned to "normalcy."

The diverse disparities in the Indian tinderbox likely have no exact comparative in the world (even if continental South America were one nation-state, it would have exponentially greater linguistic, cultural, and religious commonalities than India). Yet, experts agree, Punjab provided the blueprint for quelling citizen uprisings across India for all times to come. Particularly today, when India's political economy is in the limelight for its brazenly populist leader and its internal instability with respect to its women, minorities, media, scholars, and activists, the time is ripe to revisit India's handling of internal dissent.

The "Indian" regularly represented in media and international conferences and Bollywood and the powerful diaspora generally comes from a small cross-section, comprising India's "soft power." This class might not be the cross-section that throngs to the polls, but it does influence policy before and after. It is the India I grew up in, know, and the one I must reckon with.

There are many ways to tell Punjab's conflict story. May there be many more books! This one focuses on people who employed their influence to defend human rights rights in the face of brutality.

Notes

1. In deference to the first language of most interlocutors, Punjabi words and phrases, when employed, are not italicized but explained in the text or in the glossary, or both.
2. "Since Sikhs believe that all men and women of the *panth* are brothers and sister, insults of a sexual nature are taken both in a very personal way, as insults to one's family, and in a very political way, as attacks on one's nation. [...] Another

problem with the idea of sexual honor and the family, real or fictive, as a mechanism to protect it, is that it is linked also to the reciprocal idea of sexual shame. The honor/shame dynamic plays a role among Sikhs, as it does across the Mediterranean and Southwest Asian regions." Cynthia Keppley Mahmood, *Fighting for Faith and Nation: Dialogues with Sikh Militants* (Philadelphia: University of Pennsylvania Press, 1996), 224.

3. For an explanation about the series of events that led to 80 percent of India's Sikh population being in one state, Punjab, see: Khushwant Singh, *A History of the Sikhs. Volume II: 1839–2004* (New Delhi: Oxford University Press, 2006), 290–304.

4. Government of India, "Punjab Religion Census, 2011," Population Census, 2011. (Government census is conducted every ten years in India.)

5. Throughout this book, "militant" is used as a synonym for a combatant, in armed rebellion against the current government.

6. "I'm Against Terrorists, In and Out of Uniform," *Outlook India*, 11 June 1997.

7. Or years; see Photo 1.3.

8. See, for example, Navsharan Singh, "Thinking Reparations in the Context of Impunity," in *Landscapes of Fear: Understanding Impunity in India*, eds. Patrick Hoenig and Navsharan Singh (New Delhi: Zubaan, 2014). "Undoubtedly, huge sums of money are being pumped into these regions with extremely weak accountability mechanisms. Perhaps these unaccounted funds explain the cash flows in the hands of officials for buying out victims or families who want to pursue justice," 310.

9. Jason Burke, "WikiLeaks Cables: India Accused of Systematic Use of Torture in Kashmir," *The Guardian*, 16 December 2010.

10. Such marginalization of women's experiences during and after vicious cycles of political violence is of course not unique to Punjab. See, generally, Cynthia Enloe, *Bananas, Beaches and Bases: Making Feminist Sense of International Politics* (Los Angeles and Berkeley: University of California Press, revised 2014).

11. Referring to the June 1984 attack as "Operation Bluestar" is resisted in the interest of human rights; this usage itself perpetuates a one-sided narrative about the Punjab of the 1980s. Cf., "An important point to note is in fact how the image of [Argentina's] 'dirty war' has become so consolidated—especially in the English language—that many newspapers and even academic articles frequently use it to refer to the years of the dictatorship, without realizing that by doing so they are reproducing and perpetuating the justificatory military narratives on war and excess that legitimized both the military takeover and human rights violations." Francesca Lessa, *Memory and Transitional Justice in Argentina and Uruguay* (New York: Palgrave Macmillan, 2013), 221.

12. See, for example, Uma Chakravarti and Nandita Haksar, *The Delhi Riots: Three Days in the Life of a Nation* (New Delhi: Lancer International, 1987); Manoj Mitta, and H. S. Phoolka, *When a Tree Shook Delhi: The 1984 Carnage and Its Aftermath* (New Delhi: Lotus Collection, an imprint of Roli Books, 2007).

13. See, for example, Ram Narayan Kumar, "The Ghalughara: Operation Blue Star: A Retrospect," *The Sikh Review* 48, no. 6 (June 2000): 30–36.

Earth, Water, Pyre

Abstract This chapter introduces the reader to how protagonists Bains, Kaur, and Jaijee developed and strengthened different creative strategies—individual and collective—to respond to conflict violence. They worked cautiously with non-Punjabi allies; supported local leadership even when respectfully disagreeing with immediate tactics; and promoted the necessity to resist injustice as a cultural value.

The chapter begins in 1995 (popularly held to mark the end of the armed conflict), and the enforced disappearance of Jaswant Singh Khalra, the champion of Punjab's "disappeared." It traces the legal battle pursued by his wife and human rights defender, Paramjit Kaur Khalra. While highlighting the anatomy of impunity, this case also, Paramjit explains, exemplifies old-school Punjabi yaari, friendship, which Jaswant's allies and supporters have faithfully upheld for the many decades they have marched by her side.

As promised in Chap. 1, this chapter also journeys back to where the protagonists often begin recounting the saga of modern Punjab: the period of Sikh self-rule under Maharaja Ranjit Singh. From the close of Ranjit Singh's life in 1839, through the game of thrones that followed his death, British annexation of Punjab (making it the last in the Indian subcontinent to fall to colonials), World War I, to rising Sikh disaffection against the colonials, this chapter travels till 1917.

* * *

© Mallika Kaur 2019
M. Kaur, *Faith, Gender, and Activism in the Punjab Conflict*,
https://doi.org/10.1007/978-3-030-24674-7_2

ਸੁਪਨੇ ਵਿੱਚ ਤੁਸੀਂ ਮਿਲੇ ਅਸਾਨੂੰ, ਅਸਾਂ ਧਾ ਗਲਵੱਕੜੀ ਪਾਈ ,
ਨਿਰਾ ਨੂਰ ਤੁਸੀਂ ਹੱਥ ਨਾ ਆਏ, ਸਾਡੀ ਕੰਬਦੀ ਰਹੀ ਕਲਾਈ ...

In a dream had I chanced on Thee, but from my eager arms
You, pure light, slipped away
Only the tremble in my wrist remains ...
:VIR SINGH:

WHILE YOU ARE HERE, DON'T TALK ABOUT YOURSELF.
WE'LL DO THAT AFTER YOU'VE LEFT.

Jaswant Singh Khalra flipped on a light and tittered, reading the small placard he had pasted above the switch in their drawing room.

"Cheek has never run dry in the Khalra family," Paramjit Kaur said, watching him laugh. She had come to check if he needed anything for the night. Paramjit remembered that when he had brought that placard home, she had wondered aloud what visitors would think, and Jaswant had quipped that at least it would give folks something interesting to talk about. She now told herself, "At this time, we must focus on ignoring all the talk." She placed a tall stainless-steel glass of water next to the divaan, his makeshift bed by the door.

Quite early on in their marriage, Paramjit had become accustomed to Jaswant's disdain for the trappings of middle-class society. This was not entirely unexpected, unlike their wedding itself.

Jaswant, who was a well-known firebrand, had a close friend in common with Paramjit's younger brother, Gurbhajan. Gurbhajan, the charismatic student union leader towering over six feet two, was known as "Lamboo" through college, after the moniker of the ascendant actor Amitabh Bachchan (whose name after 1984 would make many Sikhs' skin crawl). Gurbhajan had visited Jaswant's village, Khalra, and was impressed by what he saw. So on June 28, 1981, after Paramjit and Gurbhajan had returned from college to their home village, Panj Garaahin in Moga, he spoke fondly of Jaswant and his activities. He asked his family, "Why not marry Paramjit to the capable Jaswant?"

"I simply said no," remembers Paramjit, sitting across from me 34 years later. "I had my heart set on further education. The mere mention of marriage left me distraught." As she worked herself up, insisting she wanted to study and to delay domestic life, her parents assured her it was only an idea, and Gurbhajan lovingly asked her to compose herself. No one brought it up again. But then the tractor fell on July 5, 1981.

Gurbhajan had been in the family's fields working alone, so no one heard his few and final wails when his tractor fatally tilted.

"They said his beautiful head remained intact." Paramjit remembers what was later reported by villagers who extricated his mangled body. "They took him to Faridkot hospital. ... I was beyond hearing many details."

"Lots of people were coming. Our relatives only realized Gurbhajan's great popularity as three buses from Amritsar rolled in, his friends, his teachers, his wardens. His final exam results came the same day as his cremation. He was twenty-two."

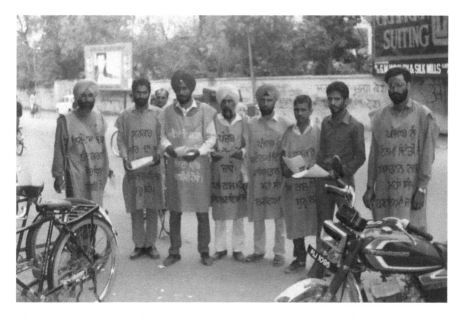

Photo 2.1 Jaswant S. Khalra, first from the left, 1986. (Photo from Khalra family archive)

As he was mourned, another murmur began spreading: "His last wish was to see Paramjit marry Jaswant."

Days after her brother's final rites, wedding planning commenced. "See, the family from Khalra came on hearing the horrific news. Jaswant Singh's father sat with my family. And let me tell you, I still don't know a better man who walked this earth. They aren't made like that man. When Jaswant Singh's respected father too asked my father when the relationship between our families would be solemnized, the wedding was finalized."

"But my state? Me, my two sisters, and our mother, we had lost all desires. I remember we just sat there, numb. We were broken. But, a wedding there was."

A month and a half later, she became Paramjit Kaur Khalra.

Jaswant's activities included everything but the domestic. The home, the extended family, and social obligations were largely Paramjit's domain, while he remained noninterfering. She finished her master's, gave birth to their daughter, got a full-time job, and gave birth to their son. Jaswant continued his work with unions, with the vegetable sellers, with the communists, with the indigent.

By the close of 1987, Jaswant had quit his job and dedicated himself to the struggle against the growing unrest in Punjab (Photo 2.1). His new collective, the Daman Virodhi Front, "Opposition to Repression," organized campaigns, including Jaswant's five-day hunger strike against the reported killings of civilian Hindus by unidentified armed militants.[1] He monitored police excesses and assisted with retrieving Sikh men whisked away without due process. He also charged the Sikh militancy with turning a blind eye to its rank's excesses. His affiliation was with the noncombatants.

In 1991, Jaswant went to London, invited by his older brothers. He was urged to apply for political asylum, given his human rights activities in the epicenter of the smoldering Punjab. But Jaswant returned to his heartland, and continued his work.

Jaswant's extended family, like others who could, had moved away from the villages, into the less unsafe cities. His sister, brother-in-law, and two nephews had left their village home in district Tarn Taran and moved near Jaswant's house in Amritsar. One evening, Paramjit and Jaswant puttered their scooter into his sister's driveway just as the police came, combing the neighborhood for militants. When their eyes fell on his young turbaned nephew, Jaswant began loudly reciting the boy's recent Khalsa College admission and earnestness for schoolwork. Paramjit could see that through his apparent focus, his mind was playing out several contingencies. "But the policemen walked away, to less strident homes, probably." Other than this encounter, no one in Jaswant's family was ever directly impacted by the conflict.

By 1994, Paramjit and Jaswant had moved into the developing middle-class neighborhood of Kabir Park, across from Guru Nanak Dev University, where Paramjit was a librarian. They invited new and old neighbors, family, and friends, and inaugurated their new house with a customary Sikh ceremony. With a bowed head, as the Guru Granth Sahib was opened, Jaswant smiled at the hukum, order of the day: A Sikh's heart is his true home, his house but a shelter, open for all. He told Paramjit he was glad their new living room doors opened out into the tiny garden, extending available space: "Who knows when one might just have to spread out white sheets there too for people to sit on." Paramjit was used to his odd declarations, which she now describes as the work of his third eye.

Soon, petrified visitors shuffled into the new Khalra home.

Piara Singh Sultanwind had once worked with Jaswant at the cooperative bank. "His family came to tell us he had been captured by the police, while on bank duty, but was later reported to have been killed in a police crossfire, 'encounter.' Another colleague, whose brother was a militant, had also gone missing."

This was no shock, given the times; but this shock had come knocking on Jaswant's door.

Rumors rustled the wheat fields. Piara Singh's family had heard about the Durgiana Mandir cremation ground and thought he may have been taken there. "Jaswant Singh, with his usual composure, made his way out there," says Paramjit. "He asked the attendant if one Piara Singh's body had been brought."

"'Oh, Sardarji, every day they are bringing eight or ten bodies!'"

"He asked how he would know if Piara Singh was there or whether the body was disposed of down a river or into a ditch?"

"'Oh, there is a register to check that.'"

Paramjit lifts her right hand, fingers clenching an invisible pencil.

"They would have left little trace of their massive crimes, were it not for the entries the municipal workers had to make in crematoria registers, documenting the purchase of the firewood for the pyres. These entries often noted name, village, familial background, even ostensible cause of death. The police were quite open about the details. And then, with all that information, at the end, the depraved label: Laawaris."

"Unidentified" pyres burnt aplenty; the first registers Jaswant viewed listed over 300 cremations from just the Durgiana Mandir cremation ground in 1992.[2]

"Jaswant Singh proceeded with great care. With him was Jaspal Singh Dhillon, the chairman of the Akali Dal, Human Rights Wing.[3] They engaged the crematoria attendants in banter, getting them the usual chaa-paani, and as they were busy eating, the team photocopied all the records of those supposedly missing."

The rumoring wind carried Khalra and Dhillon to other crematoria in their district, where they obtained similar records. By January, they had readied a list of illegal cremations from three crematoria and knew they must publicize it soon. The wind was unpredictable.

In a January 16, 1995, press release,[4] which was reproduced in full in vernacular Punjabi media, Khalra and Dhillon stated:

> The cases of 'disappeared' persons has been a source of constant concern for all human rights groups working in Punjab. An estimated 2000 families from the district of Amritsar alone, wait agonizingly for the return of their near and dear ones. Some families, who cannot bear the uncertainty any more, just want to know if their son, brother, husband, or daughter is dead or alive so that they can perform the last religious rites and accept the tragedy as the will of God.

The press release had accused the sitting Chief Minister for an upswing in crematoria traffic:

> During the 1st year of the Govt. of Mr. Beant Singh, 300 unclaimed bodies were brought to the Durgiana Mandir cremation grounds by the police department. Out of these 300 bodies, names of 112 have been given and the rest were declared as unidentified. 41 persons have been recorded to have died of bullet injuries or police encounters. No reason has been recorded for the cause of the death of 259 persons. Postmortems were conducted only on 24 bodies by the Amritsar Medical College. No postmortem was conducted on 276 bodies. 5 bodies of females, as per the record, out of which 3 names have been recorded.

Now, Jaswant and his colleagues filed a writ in the Punjab & Haryana High Court. Lightning-quick dismissal followed: the Court alleged the writ was "vague" and the petitioners lacked locus standi.[5]

Meanwhile, the director general of police, K.P.S. Gill, stormed into Amritsar to hold an urgent press conference.

"Jaswant Singh had thrown down a challenge." Paramjit's eyes flash. "K.P.S. came to Amritsar to try to rubbish the claims, saying, 'These supposedly dead boys are in foreign countries, smuggled out to earn dollars, while the poor police get charged with supposed disappearances.'"

Through their subsequent investigations, Khalra and Dhillon had estimated 25,000 bodies had been disposed of in crematoria across Punjab.

Attention to the Khalras intensified. Their home phone rang at odd hours. Many times, if Paramjit picked up, it clicked after a few quick obscenities; to Jaswant, detailed threats were conveyed.

Into the whirlwind came Ram Narayan Kumar, a human rights activist work-ing against impunity for State violence in Punjab since the early 1990s. Drawn to Khalra and Dhillon, he continued their source checking. "The attendants of the cremation grounds told me that the police often bought firewood for one or two bodies but dumped many more on a single pyre," Kumar later wrote.[6]

When Inderjit Singh Jaijee is later asked about his memories of Kumar, he takes an unhurried breath. "Yes, outside groups were helping. My sister Baljit worked closely with Ram Kumar too. Though, really, through that time, we had to remain very vigilant given our experience over a decade. Take Kumar—I had my doubts. He would meet the worst, the toughest of the reported terror-ists, the most hard-core, all of them now dead, of course. And he was largely untouched by the police. He was detained with me just once, and he would be stopped and harassed each time he left India, but only that. Anyway, his most earnest work was definitely with the Khalra investigation follow-up."

I am reminded of the bird and farmer parable that gained traction within Punjab's trust deficit. A little bird gets stuck in the mud one day. It begins nois-ily trying to catch the attention of passersby. A farmer hears the bird. He walks over to the muddy puddle. The bird quietens, in anticipation of help. The farmer bends down, beheads the bird, and enjoys a juicy dinner.

But Jaswant Singh Khalra was trusted homespun self-help.

"See, by 1995, a decade after 1984, after most of the bloodletting, things were a little calmer for civil society to start putting forward various estimates," says Jaijee. "The number of missing persons, per media sources, was close to fifty thousand. Khalra's findings were proving these so-called missings were in fact cold-blooded murders."

Enter Ajit Singh Sandhu. Soon after K.P.S. Gill rubbished all the grisly claims in the press, he posted policeman Sandhu to Khalra's region.[7]

"Sandhu had begun his legal career early!" notes Justice Ajit Singh Bains. "There was a case registered against him by a whistleblowing police officer in 1982; he later humiliated and tortured that reporting officer. Another case was registered against him in 1984, and so on. Sandhu's greed and cruelty was expedient to a larger plan, for over a decade."

"In our area, district Hoshiarpur, Sandhu and a gang of policemen had abducted Kuljit Singh Dhatt, a sarpanch, and killed him in custody in 1989."[8]

Dhatt's father-in-law was a three-time Olympic gold medalist for the Indian hockey team. Dhatt's brother's mother-in-law, the tall and stately Amar Kaur, was the sister of the famed anti-British crusader Bhagat Singh. She is remem-bered for her feisty outrage at the extralegal elimination of her relative, leading protests and helping file petitions, confident she had a voice in the country that annually celebrates her brother as a national hero. The first sign of respite for the Dhatt family came only in 1991, when Ajit Singh Sandhu, on the Supreme Court's intervention, was transferred from Hoshiarpur.

"It was the strong, well-connected Dhatt family that didn't cower, making this perhaps the earliest documented disappearance case in Punjab. It is still, to date, being litigated," Bains says.[9]

Sandhu's notoriety rose through the 1990s,[10] says Jaijee. "After much tyranny, he had been transferred out of Tarn Taran in 1993, post the Sarabjit Singh case. In that case the Supreme Court finally took *suo motu*—proactive—notice. Sandhu had killed a man twice."

Ram Narayan Kumar had recorded: "On 30 October 1993, police officials brought the supposedly dead body of Sarabjit Singh to the hospital for a post-mortem. A doctor at the hospital found out that the man with a bullet injury to his head was still breathing. Thereafter, the police officers took the injured Sarabjit Singh away, came back with his corpse, and forced a different doctor to fill in the autopsy report."[11]

On February 28, 1995, while the horror was still contemporaneous, Jaswant bellowed from newspaper headlines: "EVEN BY KILLING ME, POLICE NOW CAN'T CONCEAL THE TRUTH: KHALRA."[12] The Punjabi press flashed news of Jaswant's disclosures about the death threats he had received, and how he had been warned by a member of the Punjab Legislative Assembly that the police had now decided that should he not relent, they would make him disappear. "Where we have disappeared 25,000, what is 25,000 plus 1?"

Jaswant said in an article in the *Punjabi Tribune*. "Should they succeed in killing me, don't hold some police cat[13] or police sepoy responsible, my murderers are Chief Minister Beant Singh and head of his police, K.P.S. Gill."[14]

"This article was really his will, and a farewell note. He was clear and convinced." Paramjit's eyes gleam.

As Jaswant's name grew in human rights circles, and concern for his life also grew, he was invited abroad to provide evidence of the killings in Punjab and to seek refuge. His documentation exposed the ecosystem of impunity and contextualized the many individual asylum claims that had accelerated the Sikh diaspora population to the West since 1984.

Justice Bains remembers traveling to Canada with Jaswant. "I went with him in 1995. I was still on my temporary passport.[15] We were honored by the Canadian Parliament, they welcomed us. We exposed the dangers Khalra had attracted in collecting this damning evidence."

Jaswant's best-remembered public speech was made in April 1995, to a packed audience at the Dixie Gurdwara, in Ontario, Canada[16]:

There's an old fable about when the sun was first setting. As its distance narrowed to the horizon, the light on earth was diminishing. This made way for darkness to creep over the land. The people were afraid that when the sun would finally set, darkness would become permanent. No one would see anything. 'What will happen to us?' they said. ... Far, far, away, somewhere in a small hut a little lantern lifted its wick; it said 'I challenge the darkness. If not everywhere, but in my small corner I will not let the darkness settle itself around me.' With this wick's example many other little lanterns in other small huts lifted their wicks to the darkness and people were shocked that so many little lanterns illuminated the mask of darkness from taking over the earth. Now, I believe, that today when darkness with all its strength thrusts itself over the truth, if not anything else, I say, proud Punjab is the light that will challenge it.

Asylum was offered by Western governments, but Jaswant refused it. Protection for his family was promised, which Jaswant considered and declined. Relocation was deliberated, but rejected. Instead, Jaswant Singh came back to Kabir Park, Amritsar, in the summer of 1995, and began sleeping on the divaan by the front door.

He explained the decision to sleep outside to Paramjit only once. "If they come to get me," he told her, "I don't want them to have pretext to come into the bedroom, to you or the children."

"There were many reasons for them to come for him," explains Jaijee. "Khalra was pursuing four big cases. The issue of the twenty-five thousand clandestine cremations, of course. Then, the custodial killing of Panjwar's mother. Third, the Behla human shield case. And, fourth, the two thousand policemen killed by the police themselves, for not cooperating in terror."

Paramjit Singh Panjwar had become the leader of Khalistan Commando Force after the successive deaths of its original leaders, and had fled to Pakistan by 1992, trailed by a litany of charges. Mohinder Kaur, his 75-year-old mother, was killed by the police.

The village of Behla was the site of a 36-hour standoff, during which police used villagers to extract militants from a local home, pushing them into the line of fire. The bodies of the nine people were whisked away the next day, and the police allowed only one family to attend the last rites of an unwitting shield.[17] Anthropologist Joyce Pettigrew, who interviewed militants in Punjab, reports that a property dispute between two brothers in Behla had resulted in an invitation to local militants. In time, in return for the muscle exerted in this family fued, these militants constructed a hideout in the ancestral property: "The public as a whole were using the young guerrillas in their own internal conflicts whether within the family, or the village. Likewise the police were using these rivalries and feuds for their own purposes to create fear and distrust and divert the mainstream struggle."[18]

Discussing this assessment, Baljit Kaur says, "Besides misinformation and disinformation campaigns, there was also the reality of what war does to a social fabric. Regardless, the human rights concerns do not go away. Process, security, transparency, are all of what we saw Jaswant Khalra fighting for, what we all were fighting for."

Punjab policemen were sons of the same conflicted soil. Fratricidal killings never bode well, least of all for a police force being lauded for fighting anti-state militants. Jaswant's investigation into police-on-police murders, and recalcitrant or whistleblowing officers, would have questioned "morale," the sanctity of which K.P.S. Gill habitually dangled to ward off investigations into police resources or conduct.[19]

In the illegal cremations matter, "Jaswant Singh systematically worked through the courts. He had full faith that the legal court and the court of public opinion would weigh in favor of basic humanity," maintains Paramjit.

On April 3, 1995, a Delhi-based human rights group, Committee for Information and Initiative on Punjab (CIIP), moved another writ based on

Khalra and Dhillon's work, this time in the Supreme Court of India: "These bodies were cremated as 'unidentified' not because their identities were not known or not knowable or because there was no one to claim the dead, but as a matter of deliberate policy."[20]

That summer, Jaijee noted the transfers of various notorious policemen back to districts where they had earned their pips.[21]

> They were being sent to clean up any evidence that could be used against them. The police had really been reconfigured during the conflict, inducting men of little repute, some common criminals. There were a few gangs of the most ruthless criminal cops at the helm in the worst cases. … They linked back to the same few senior officials and larger policies set for Punjab. So increased pressure on these criminals was a dangerous thing.

Meanwhile, Jaswant and Paramjit went about their daily life. As she settled him in the front room every evening, Paramjit reminded herself to chalk this up to caution rather than premonition.

After a July trip abroad to continue advocacy (and again to politely reject offers to relocate), Jaswant decided to call another press conference. He reported that of the estimated 25,000 cremated, over 6000 were from Amritsar district alone, and while records existed in other crematoria, they were being actively concealed by the government.[22] Jaswant was being threatened openly, despite public support of highly placed allies like Justice Bains.

Days after, the Tarn Taran police released their own press releases to the vernacular media, warning the public of the dangerous Khalra—a former active leftist, now supported by foreign funds—carrying forth the agenda of militant groups bent on destroying the hard-won peace in Punjab. The police officials assured the public that Khalra's statement was all misinformation designed to destroy police morale.[23]

Paramjit leafs through some of these press clippings diligently arranged in a binder. "Jaswant Singh said, 'Wherever I go to investigate, families look at me worriedly, and I give them my contact information. I say, If someone comes to you, call me, and tell them you didn't start anything, Khalra came to talk to you, ask him. And now if they call me, and hear I have run away with my own family, what faith will people be left with? They'll say, he escaped and got us killed.' Jaswant Singh said, 'Our life is here, we can make it work here.'"

Then, August 1995 closed with a blast.

We heard school was canceled the next day. Chandigarh Secretariat, with the Open Hand Monument symbolizing the promise of "City Beautiful," had been attacked. Mama and I were strolling up and down outside the house at dusk. Our home happened to share the street with government houses—judges, bureaucrats, police officials. A turbaned security guard from a senior official's home walked over to respond to my mother's greeting, "Sat Sri Akaal!" No one in her neighborhood, or her range of vision, goes unnoticed by my mother; this endears her most to those rendered most invisible by societal custom.

"Sat Sri Akaal, how are you?"

She smiled. I stared, as we children always did, at the large sten gun casually slung across his shoulder.

He shuffled, as we began to walk ahead. "Mundiyaan ne chakk hi dithaa." The boys had lifted him, after all. Beant Singh, the Chief Minister, was killed by a human bomb.[24]

My mother walked ahead with me quietly.

The *boys* were not concealed for long. Rajoana, friend of the human bomb Dilawar Singh (both were policemen who had seen Punjab Police actions first-hand), never pled innocence. He declared they had committed a political assassination against a known terrorist politician of Punjab—ignoring the 15 others killed that day, the way collateral damage often is. Rumor mills churned, the ominous and larger conspiracy stories abounded.

One hundred and fifty miles away in Kabir Park, Jaswant and Paramjit felt particularly uneasy. Because of his work drawing attention to earlier killings, Jaswant was now a convenient target of sweeping police backlash in the wake of the assassination. He had visited Justice Bains in Chandigarh just a few days earlier. "He had come to tell me how the police threats had become more serious," explains Bains. He points to the floor: Jaswant had been right here in this home. "I advised a quick writ in the High Court, for his protection, and he said he would be back in a few days to do that. His family was in Amritsar."

Twenty years after the day Jaswant himself "disappeared" from his home—they came in broad daylight, abducting him from the front of his house—Paramjit focuses on his life's work and hers. But she allows herself one personal reflection: "I remember the days I knew poetry by heart ... then, life took over."

"Her life is marked by tenacity," says Justice Bains, who became Prosecution Witness 5 in the legal battle started by Paramjit in 1995.

"Without her grit, even such an obvious case would not have survived in the courts. It was all out in the open, in the papers, here, Canada, USA, UK, everywhere. And then, openly, with complete abandon, they picked him up from the threshold of his house. Justice, process, any semblance of law, fell into pitch dark."

* * *

PITCH-DARK LAMP POWDER WAS CAREFULLY SWIRLED with just the right amount of water and stored in small pots. Each afternoon, as the schoolboys took the long way home, wooden writing boards slung across their shoulders tapped their agile waists in tedious reminder. The boards were to be washed clean, coated with a new layer of yellow clay, dried, then lined and readied to accompany the inkpots to the next morning's lesson. But first, to stop for one of Mai Jeevi's treats. She prepared for their sojourns. Treats came with her takyaakalams, the favorite of her pet repeats: "British Raj is better than any future Indian Raj."

She would watch the sons, grandsons, and great grandsons spiritedly condemn colonial rule, and insist they were wasting their good years.

Jeevan Kaur, a great grandaunt by marriage, is fondly remembered as Mai Jeevi, Mother Jeevi, by Justice Bains.

"She lived on her own after her husband died," Justice Bains remembers of the great matriarch. "Mai Jeevi taught me the importance of positivity. I had several male role models and she never shied from telling me where she disagreed with my heroes. She had great influence on me, since she lived longer than the others, and always engaged actively with the children."

As an afterthought, he adds, "She had no biological children."

Bains's biological great grandmother also holds a place of pride in his family history.

"My grandfather Ram Singh was an only child. His father died when he was very young. His mother, a young widow, fled with him to her natal home, in Gillian village, because she couldn't trust her in-laws. Someone might have killed the boy."

The dark aspect of agrarian culture, land-grabs, blood feuds, doesn't faze Bains. A man of gastronomical routine, Bains returns to his glistening golden-brown plate. Gur Sawaiyaan, glass-noodles cooked with jaggery, a childhood treat, are now consumed every winter evening, after his long afternoon walk.

This history is fascinating to his son, Punjab & Haryana High Court lawyer Rajvinder Singh Bains, who is hearing about his great-great-grandmother's survival struggle for the first time. "So our entire family tree is thanks to that lady from Gillian! If she had not run with her small child, this entire family line would not have existed! That child would never have come back to Mahilpur and built the house."

The older Bains chuckles quietly. "Yes, Ram Singh completed his schooling in his maternal village and then returned to his father's village, claiming his inheritance. He built the Mahilpur house where we all grew up."

The 2000-year-old village of Mahilpur is in today's district of Hoshiarpur. It is nestled in the regional heart of Doaba—"two-waters"—as the land bracketed between rivers Beas and Sutlej is known.

"Our village is mentioned in the travelogues of seventh-century Chinese explorer Hsuan Tsang," says Justice Bains. "I believe Harsh Vardhan was from there and became the last Buddhist king of North India." Two centuries of Buddhist rule had been followed by the subsequent elimination of Buddhists, and they constitute less than 0.8 percent of India today.[25]

Then, Bains explains how, in the early eighteenth century, his ancestors became Sikhs and participated in battles against anti-Sikh forces: Mughals, Afghans, and British. Their history includes fighting in both Anglo-Sikh wars, on the side of the army loyal to Maharaja Ranjit Singh.

The rule of Ranjit Singh, of Koh-i-noor fame, had marked the only era of stable Punjabi self-rule: 1801–1839.

"The Sikh Kingdom was *the* exception to British rule across India." Bains raises a finger for emphasis. The British had established robust trade with India

during Mughal rule. By 1757, as Mughal power dwindled, the British expanded control. Within 50 years, virtually the entire subcontinent was under the British.[26]

Meanwhile, Sikhs had been surviving through a diffused power system. After the death of the tenth Sikh Guru, Gobind Singh in 1708, they had organized into different misls, bands of Sikhs, under different chieftains. The misls became adept at guerrilla warfare, having openly challenged the mammoth Mughal empire. The diffused power system of the Sikh misls served as an effective survival strategy for a century.[27] "But by the close of the eighteenth century, the misls themselves became the kind of aristocratic power against which Guru Gobind's Sikhs had been organized to protect the people," recounts Bains. In time, the squabbling Sikh misl chiefs had to accept the prominence of one among them. Ranjit Singh Shukerchakia, under the mentorship of his astute mother-in-law, Sada Kaur, had risen as a shrewd statesman.[28] Eighteen-year-old Ranjit Singh became Maharaja of Punjab in 1801.

Ranjit Singh weighed his relative strength vis-à-vis the British and agreed to consolidate his empire-building entirely "northward of the River Sutlej," per the 1809 Treaty of Lahore, declaring that "Perpetual friendship shall subsist between the British Government and the State of Lahore."[29]

"Punjab, under Ranjit Singh, had once stretched from Afghanistan, through all of Kashmir, Ladakh, and into Tibet. In the south, up till the Sutlej. Smaller kingdoms like Patiala were south of the demarcation of India from Punjab. Those cis-Sutlej states were formal British protectorates," Bains explains.

Ranjit Singh's 40-year raj of royal pomp and peculiarities was also marked by advancements such as the abolition of the death penalty, opening up of erstwhile treacherous trade routes, disciplining of the armed forces, and welcome security to Punjabis, native inhabitants of the plundered corridor into South Asia that was employed by Afghan, Turk, and other invaders.

The Sikh spirit, genuinely or strategically, was infused into the kingdom. New coins were minted with the seal of Guru Nanak, rather than the monarch, and the army retained its Khalsa name, the legacy of the last Sikh Guru. The physical grandeur of marble and gold leaf was added to the religious epicenter of the Sikhs, the Darbar Sahib in Amritsar, thus making it the "Golden Temple" to foreigners.[30] From other architectural niches across the kingdom, elaborate frescos of various sagas and sages sang a secular story. The Maharaja frequented various mosques, temples, and gurdwaras, commissioning work across divides, endearing himself to diverse subjects.

In 1807, he visited Patiala, camping at the site of the future gurdwara of Dukh Nivaran, as recorded in Justice R. S. Sarkaria's writings, preserved by G.S. Sarkaria[31]:

Maharaja Ranjit's Singh's forces, artillery and cavalry paraded for 2 or 3 days from Lehal camp up to Qila Mubarak Chawk. On the second day of festivities the Patiala ruler Sahib Singh informed the Maharaja that they would also give a display of some military feats and armour. With this very short notice, Dhoom Singh

was asked to show his feat. Dhoom Singh, riding at full gallop, with sword drawn, uttering a war cry, charged at the elephant on which Ranjit Singh was riding. In an instant Dhoom Singh cut and carried off on the tip of his sword the Kans (umbrella) that was hanging just above the head of Maharaja Ranjit Singh, thus demonstrating that he could behead his enemy in battle even if he were riding an elephant protected by the howdah. Ranjit Singh was so impressed that he asked for the surrender of Dhoom Singh's services to him and made it one of the preconditions of his withdrawal from Patiala. Dhoom Singh thus entered the service of Maharaja Ranjit Singh as an officer of his personal security staff.

Twenty-one-year-old Dhoom Singh moved to Lahore to start what would be three decades of service to the Maharaja, including at times as Ranjit Singh's personal emissary. And thus my great-great-great-great-grandfather was rewarded with the title Sarkaria, one loyal to the *Sarkar* (government of) *Khalsa*.

Loyalty was revered in Ranjit Singh's time and, even while British meddling continued, there were no serious betrayals and the colonials were astutely managed. "He had united it all, which quickly changed when he died ... but then, nothing lasts forever," says Bains.

In 1839, the indomitable Maharaja breathed his last. As Ranjit Singh's memorial was being intricately laid in red sandstone and white marble, his empire crumbled.

A multiact play unfolded over the following decade, starring the royal family, Sikh aristocracy, Hindu Dogra chieftains, the inflated Khalsa Army, and the hawkish British. Ranjit Singh left seven sons and a power vacuum.

The drama of decline was complete with debauchery and disease—first successor son Kharak Singh eventually died of tuberculosis; suspicious tragedies—grandson Nau Nihal's steely rule ended with an archway stone collapsing on his head; ambitious queens—for a few weeks Nau Nihal's mother, Gulab Kaur, wrestled control that was seen unbecoming of any woman, especially one with her acerbic tongue; assassinations—the Anglophile Sher Singh's severed head was showcased across what had been his kingdom earlier that morning; conniving courtesans who became go-betweens during palace intrigues; marriages of convenience; murderous suspicions; and mutinous soldiers who nevertheless created history in gallantly fighting the British.[32]

The colonial puppeteers—after positioning the aristocrats, royals, and chieftains against one another—then emerged from behind the curtain. Union Jack-flagged flatboats prepared to transgress the Sutlej border.

Ranjit Singh's only remaining and youngest son, eight-year-old Duleep Singh, kept the throne warm as it rocked violently with only more treachery as some of Ranjit Singh's closest confidants entered into secret deals with the British.

Then the prince was separated from his mother, Ranjit Singh's youngest queen, the feisty Rani Jindan. The desire to protect the legacy of Ranjit Singh was enough to regroup the soldiers around the beleaguered queen, despite their outrage at having been used as pawns in the game of thrones for almost a

decade. One last attempted uprising in Punjab in 1849 gave the British their excuse for complete annexation of Punjab. The Khalsa Army went down fighting fiercely. A British general wrote of their adversaries, "The reluctance of some of the old Khalsa veterans to surrender their arms was evident. Some could not restrain their tears; while on the faces of others, rage and hatred were visibly depicted."[33]

With the final curtain on the era of the Lion of Punjab, his population prepared for insecurity and hardship.

Duleep Singh was exiled from his kingdom, put under the tutelage of a British mentor, and later converted to Christianity.[34] Other smaller kings paid heed.

"Maharaja Jind had become a Christian. Maharaja Kapurthala became a Christian, though he later reconverted to Sikhism after having a male heir," says Jaijee, whose family history is intimately connected to the only royal family of Punjab, Patiala, that saw no Christian conversions. But Maharaja Patiala, Bhupinder Singh, chief spokesman in the Chamber of Princes, was otherwise a true-blue British ally.

The demographics of Punjab shifted quickly after the fall of Ranjit Singh's empire. The British census of 1855 reported the Sikh population as one-tenth of its size during the Maharaja's rule.[35]

To further thwart Ranjit Singh's luring legacy, the British made concerted efforts, both obvious, such as disbanding the surviving Khalsa soldiers, and subtle, including publications casting the Sikh Raj's art and architecture as only derivative or even entirely plunderous of earlier Mughal work.[36] Last to have fallen to the British, Punjab was for the longest time deftly contained.

The years following the dilution of the Sikh independent government witnessed the dilution of Sikh independent identity: While being assimilated into the Crown's machinery, Sikh gurdwaras also reverted to the rituals perpetuated by the Hindu priest class against which the ten Sikh Gurus (1469–1708) had revolted. The British sided with many corrupt gurdwara custodians who had wrested control of these properties.

Revolts against the colonial masters had begun brewing in various parts of their Indian empire. In 1857, while the British faced a series of uprisings elsewhere, Punjab remained unprovoked. News of uprisings traveled northwest but was managed swiftly by sealing Punjab. Containment was aided by Punjabis' recent memory. "Sikhs did not view the Mutiny as an attempt to force the British out of India, since the poorbias—sepoys of the Company's Bengal Army—were unlikely representatives of nationalist aspirations," writes Patwant Singh. In the British Army, poorbias had played a central role in the demise of the Sikh Kingdom just eight years earlier. "Nationalism, in fact, did not exist then. It began to flower almost half a century later and that too after the British integrated India, thus making it easier for Indians to think in national terms."[37]

According to my family's records, the British approached Dhoom Singh Sarkaria in 1857 to assist them with his well-tested cavalrymen, in return for the rank of subedar major and restoration of his estate. But the British treach-

ery against the Sikh Raj was fresh as dawn in Dhoom Singh's mind. He remained bereft of his estate.

Other significant Anglo-Sikh units played an active role when deployed to New Delhi, where the British ordered bloody retribution, after snuffing the armed threat. The last Mughal emperor who had briefly been rethroned by the mutineers was "ironically accused at a farcical trial of 'treason' by the usurpers of his own throne, and then banished to Burma with all his surviving male descendants."[38]

The vengeful British ethnic cleansing of Delhi Muslims (the majority population of the city till then) was followed by a steely shift in British attitude. The perpetrator of mass murder became increasingly spiteful toward his victim-survivor—a trend familiar to the streets of Delhi future.

In the post-1857 milieu, the British saw increased strategic value in divide and rule. Some races, including the Sikhs, were designated as "martial"—a label that to date continues to have consequences—others were categorized as unfit for military service.[39] As the British provided some preferential treatment to the Sikhs, the population began growing again.

"Sikh units in the army were encouraged and then mandated to keep their religious articles, their hair long and turbaned, their distinctive identity and morale seen beneficial to the Crown," says Baljit Kaur about British-Sikh relations.

"Further, there were favorable rural reforms, such as the development of a canal system across erstwhile deserts. This all boosted agriculture. And they sponsored colonial studies of Sikhism. The British temporarily won the confidence of the Punjabi rural population."[40]

Or at least a sizeable portion of it.

The same period saw Sikh reformer Ram Singh champion deritualization and decolonization. His followers, Naam-dharis, focused on Naam—the Name—shunned superstitions, and in austere homespun white khaddar, followed his direction of boycotting British goods and services, including government schools and jobs (a platform partly taken up 60 years later by Mohandas Gandhi). In 1872 the British disciplined these increasingly boisterous anticolonials: 66 were blown to bits after being tied to the mouths of cannons.[41]

Subsequent reformers began strategizing activity within British patronage. Sikh intellectuals organized against being spoken about only by assimilative outsiders who shrouded biases in cloaks of objectivity. This Sikh reclamation movement came to be known as "Singh Sabha."[42]

"My father was a proud Akali, the political arm of the Singh Sabha, and this would seal his fate," says Jaijee, whose childhood experiences have left him with the conviction that holding one's government accountable is a noble duty. "You see, Sikhs were always fewer in numbers, but they were, in the 1800s, the dominant force in north India, from Delhi to Peshawar. During British time, people moved away from their roots. And so then the Singh Sabha movement came, saying look back at your social revolution and do as the Gurus told you. One big reform was getting rid of the caste system that had crept back into Sikhi."

Jaijee pauses pointedly: casteism has a chokehold on the community again today.

Jaijee's father's love for the written word was another trait shared among the time's Sikh leaders. Education was prioritized—the palatial Khalsa College, Amritsar, was imagined and actualized, and progressive literature flourished—like Vir Singh's beloved novel *Sundari*, about a female protagonist eschewing societal shackles. Books and pamphlets were published; and newspapers thrived, including *The Tribune*, established in 1881. During this desired renaissance of Sikh ethos and action, the "Sikh Code of Conduct," Rehat Maryada, defining Sikh practices and ceremonies, birth to death, was codified through the largest yet community consensus in post-Guru Sikh history.

Schools, colleges, newspapers, and books were also created by another movement at the same time. A Hindu sect, the Arya Samaj, still the salient force in Punjab's politics today, had been launched by Dayananda Saraswati in 1875.[43] Saraswati drew on the growing volume of scholarship on ancient Sanskrit culture by the Europeans. He quickly appealed to the urban Hindus, seeking an explication of their identity consistent with modernity. Even as some of Saraswati's writings and teachings included shrill criticisms of so-called heterodox schools of thought, including Jainism, Buddhism, and Sikhism, the Arya Samajis and Sikhs loosely worked together in the early 1880s. The complicated cooperation was particularly aimed at countering the Muslim majority and staving off the inroads of Christianity. During this period, however, Samajis condescendingly came to treat Sikhs as another cult of Hinduism.

Saraswati's treatise, "Satyaratha Prakash," was banned by the British government for its derision of Prophet Mohammad. It also portrayed the Sikh Gurus as misguided and ill-educated simpletons, who had diverted people from the path to true wisdom contained in the ancient Vedas. Successive leaders of the Samaj virulently propagated that true spirituality was always rooted in the Hindu scriptures.[44] The nature of the earlier Buddhist, later Muslim, then Sikh, and now Christian-ruled land became widely propagated as only legitimately Hindu.

In this milieu of the British and Samajis, the Singh Sabha reforms met resistance from the conflicted Sikh population.[45] In gurdwaras, even the removal of idols—clearly held contrary to the Sikh faith since its inception—led to accusations of assaulting established practice. The participation of Muslims and low or no castes in gurdwara services, and especially partaking in amrit, led to furor by the new brahmins in the Sikh fold. Orders for excommunications were issued and aspersions were cast aplenty, often against the Singh Sabha's most sincere workers. Yet, eventually, the Singh Sabha movement succeeded in uniting and reenergizing many Sikhs, bringing a collective healing while under foreign rule.

"Our older relatives got angry at the caste-mixing Pitaji insisted on in our home kitchen." The Jaijee kitchen has always fed a large estate, family members, and workers. "They even stopped visiting. Over the years, they came back, of course. But when Pitaji decided to do it, it was a radical move. This was one of the reforms of the Singh Sabha that was highly valued by the masses."

British rule post-1857 had become rife with excesses. Anti-British sentiment grew in Punjab. The Namdharis fed to the British cannons were only the first of the Sikhs to witness violent death in the anticolonial struggle. The hangover of Punjab's canal colony success included mounting debt for the tillers, an outbreak of the plague, and sustained racism. To alleviate despair among the coreligionists and families of their primary soldier pool, the British eased some taxes and passed legislation, including the Land Alienation Act of 1900. The Act helpfully protected the rights of the tiller. But it cemented the divide between Jatts (farmer caste) and non-Jatts (deemed nontillers by caste rather than actual occupation).[46]

At the same time the British intensified intelligence gathering in Punjab, recognizing how the rise of the geopolitically important land could disrupt colonial hold.

A 1912 attempted assassination of the British viceroy as he rode an elephant in a parade in New Delhi provided the first explosive evidence of a networked underground anticolonial movement. "The secret societies in Maharashtra, the nationalist upsurge in Bengal, the Ghadr movement in Punjab, the anti-British activities abroad and the efforts for an armed uprising during the First World War took place at a time when there was no Congress movement in India," writes political journalist Manini Chatterjee.[47]

Justice Bains remembers another of his many revolutionary role models. "My Uncle Harjap Singh was one of the founding members of the Ghadr Party, which was established in 1913 in California." Sikhs had settled in the western United States since the beginning of the twentieth century, working on farms, in lumber mills, and laying railroad tracks.

Close to 8000 Party members journeyed to Punjab, burning with the desire for ghadr, rebellion. In 1914, these émigrés unleashed disruptive actions, including lootings and killings, to interrupt the colonial administration and to instigate a large-scale revolt in the British Indian Army.[48]

Sikhs from across Punjab had been actively recruited into the war effort, and would eventually constitute 100,000 men, one-fifth of all soldiers. Ram Singh Bains, the Justice's grandfather, had enlisted with enthusiasm. His education, up to the tenth grade, is believed to have further distinguished him from the many other Punjabi boys, equally fit and spirited. He rose to the rank of Rasaldaar, often the highest post for nonwhite soldiers in the British Army.[49]

As the clouds of World War I drew in, other Sikhs were organizing a sea journey to Canada that would become symbolic of racial discrimination for generations to come. The *Komagata Maru*, with 376 passengers, 346 of them Sikhs, sailed into Vancouver in 1914 and made her challenge to Canadian immigration restrictions. Only 22 passengers were allowed to disembark, as the ship remained marooned at dock for two months before it sailed back home with sick passengers and rotting cargo.[50] The rallying cry to action against dehumanizing discrimination carried across the oceans.

Increasingly disgruntled and restless soldiers in cantonments across Punjab were identified by the Ghadrites. A cascading mutiny was envisioned: the rise

of the Twenty-third Cavalry—followed by the mutiny of the Twenty-sixth—signaling to the Ghadrites in Bengal and beyond, including the Far East, from where the organizers of *Komagata Maru* hailed. But as conspiratorial cavalrymen from Amritsar marched to the magazine at Lahore, they were arrested. The minutest details of their plans had been leaked via the government's network of infiltrators.

The British raided the Ghadr headquarters in Lahore in February 1915. A few leaders had the chance to flee. One, Kartar Singh Sarabha, not yet 20, who had just completed a two-year stint in Berkeley, California, chose to stay in Punjab. During another attempt to incite mutiny, he was apprehended. He walked to the gallows,[51] a symbol of fearless fidelity, and a poet in the making.

> Seva desh di jindriye bari aukhi
> Gallan karniyaan dher saukhaliyan ne
> Jinhaan desh seva vich pair paayiyaa
> Uhnaa Lakh museebataan jhalliyan ne.[52]

> Serving the country is difficult work, O love
> Easier is the talk
> Tens of thousands of difficulties are endured
> By those who step up to walk the walk.

The challenges of the early Sikh revolutionaries would succeed in inspiring future revolutionaries. But by the curtain on World War I, the first phase of armed anticolonial struggle in Punjab had been scuppered.

In an army tunic, held by the Crown's belt and sash, with jet-black beard and a coiled mustache reaching toward his lofty starched turban, Ram Singh Bains stares back from a photograph.[53] Raised by a young widow who fled from the historic village of Mahilpur, his death in 1917 left a young widow in Mahilpur. Hukam Kaur raised one daughter and three sons—the eldest, Justice Bains's father, Gurbaksh Singh.

Justice Bains notes the hardships that necessitated strong optimism in the family's women. "My biological grandmother also worked very hard, but was always upbeat. She raised my father and his siblings and made sure they all got an education, no matter the odds she faced."

Gurbaksh Singh also joined the army, but unlike his father served a desk instead of standing battleground duty. Lettered men of those times would receive the honorific "Babu." Babu Gurbaksh Singh was married to Amrit Kaur of Bara Pind, Jalandhar; he would soon become an absentee father.

Justice Bains returns to more comforting childhood memories, of playing with his siblings and cousins, enjoying the security of village Mahilpur that holds the wisdom of his ancestors. In one of his sage-like reminiscences, he says, "In those times, there was a lot of cohesion. Everyone lived in joint families. There were mangoes that we would eat together. Now there are no mangoes left … and there is no closeness."

Then the man raised in the laps of a spirited great-grand aunt, grandmother, and mother, lets out a classic guffaw at the expressed gloom. "Mai Jeevi willed

her way till one hundred fourteen, on her own terms. She died in 1946, spared seeing the bloody handing of the reins from the colonials to the Indians."

He returns to fondly describing mangoes in the messy hands of greedy children.

* * *

"GREEDY CHILDREN THINKING ALL LADDOOS ARE ALIKE, I understand. But this was a grown man, demanding a box."

Paramjit Kaur Khalra remembers November 4, 2011, when the Supreme Court of India upheld life sentences against five policemen who carried out the orders for her husband's 1995 abduction.

One of the lawyer's clerks had run up to her, insisting on a celebratory box of sweets. "After the initial step back, I just turned to my nephew Ranaa and said, 'Give this guy money. He can go buy his box of laddoos. He's never shown such eagerness during the course of this battle, when we were running after lawyers, stumbling in and out of courtrooms. Our days of wanting laddoos are long gone, let him get his box!'"

"Imagine, no sense of what this has been, what this day means, what is happening."

The days of being married to the man whose beard's graying ends were just beginning to climb up to his mouth felt like another lifetime.

In early 1995, it had felt like truth telling: uncomfortable, emotional, yet liberating. "While I knew what snake pit he was thrusting his hands into, I somehow thought, It's just the facts about the cremations ... nothing wrong, nothing life-threatening, right?"

Then, in the heightened tension after the bomb blast that killed the Chief Minister on August 31, the couple had discussed a shared feeling of unease. Jaswant had visited Justice Bains and received advice about relocating his family to Chandigarh or farther.

On September 3, Jaswant instead went to visit his parents in his ancestral village Khalra, 30 miles from Amritsar and 6 miles from the line now dividing Punjab between India and Pakistan.

Jaswant Singh's father, Kartar Singh, was born while his own father was under house arrest imposed by the British. Grandfather Harnam Singh had been an early subversive, who had sailed on the historic *Komagata Maru* ship only to be returned. After his arrest during the Ghadr headquarters raid and subsequent acquittal in the Lahore Conspiracy Case of 1915, he had to stay in Khalra village till 1922.[54] He then went to Shanghai to continue diasporic revolutionary activities. He never returned. Kartar Singh had learned to accept his difficult fatherless childhood, telling himself that his father was on an important mission. Now, he recommended caution to his son on a mission.

The activist zeal had hardly skipped a generation. After Kartar Singh had been sent to an Arya Samaji secondary school, he protested against the school's assimilative values that subverted Sikh identity. He eventually graduated from

a Khalsa School, where he was admitted by his paternal grandfather, Aroor Singh, a member of the Singh Sabha movement. With Khalra moxie, Kartar Singh would later return to his village to build a school, free from communal leanings. To supplement the scant income from his land, he obtained a job with the Shiromani Gurdwara Parbandhak Committee (SGPC),[55] through his association with Master Tara Singh, the increasingly prominent Sikh Akali leader. Despite this personal connection, Kartar Singh chose instead to align himself with the local chapter of the Congress, deriding other parties for their obvious communal agendas.

By the time Jaswant Singh was born to Kartar Singh and Mukhtiar Kaur in 1952, countercurrent activity abounded in their home. Various campaigners, like land reformer Vinoba Bhave and former Vice President of India Krishan Kant, visited the Khalra home. Kartar Singh had grown disillusioned by the Congress Party for its shrouded caste and class agendas. He stopped voting for the party after the government subsumed control of his village school. In 1975, more bureaucratic insult came in the form of demands for additional documentary evidence about Kartar Singh's father as a condition for renewing freedom fighter's pension to the family. It was Jaswant, now in college, who insisted they refuse the touted honor, return the pension, and uphold the family legacy.

Corruption was on Jaswant's mind as he organized local campaigns on students' demands, or the raid on the pesticide shop selling government-subsidized goods on the black market, or the protest at the Khalra police station against the assault on an unprivileged-caste woman.[56] He had a short hybrid hiatus as a bank employee. Then, Jaswant had become preoccupied with police abuse cases.

Now in 1995, Kartar Singh told his son that the danger was closer than ever. A sub-inspector of the local police station had come to visit Kartar Singh, advising caution: His station had received informal orders to pick up Jaswant.

The warning conveyed to his father was not lost on Jaswant. He knew "informal orders" meant illegal abduction without a warrant or trace of process. He told his anxious father he would go visit the police station immediately. There, Jaswant offered himself up to the police, should they have any reason to arrest him. The local Station House Officer embarrassedly told Jaswant there was no reason. Before returning to Amritsar on September 4, Jaswant tried to appear unshaken and told Kartar Singh, "Does it really matter whether I die in my bed, or in an accident, rather than a martyr for my cause?"

The school session was in full swing for their children, ten-year-old Navkiran and eight-year-old Janmeet. Around 6:00 a.m., after seeing them off to school on September 6, Paramjit returned to her household chores. Their brother-in-law had stayed over the night before, and she heard Jaswant kick-start their scooter to drive him to the bus stop. Paramjit made breakfast and prepared for work. At around 8:00, soon after Jaswant returned, a family friend borrowed the scooter for the day. Paramjit then gave Jaswant his breakfast. As he was finishing, the gate clanked again and Rajiv Singh entered.

Rajiv, a longtime acquaintance of Jaswant's, had become a common fixture at the Khalra home. He carried a business card identifying himself as a journal-

ist. He had come to accompany Jaswant to his morning meeting with a journalist of the *Indian Express*, on the issue of clandestine cremations. As Rajiv settled into the drawing room, Paramjit heard Jaswant untangle the garden hose and reverse their car out the gate.

When she hurried out to walk to work, Jaswant was washing the car, half-dressed for the meeting. She rushed across the main road to the Guru Nanak Dev University and noted "present" in the library register at 9:05 a.m.

At 9:25 a.m., she received a message that there was an urgent call from home.

Rajiv informed her that a police party had come to the gate, grabbing at Jaswant, while a sky-blue Maruti van purred outside. Amid the crackle of walkie-talkies and the jostle, Jaswant asked to change into clothes and shoes, out of his damp vest and slippers. But the van pulled away just before Rajiv rang Paramjit's work.

Down the road, the van slowed; neighbor Kirpal Singh Randhawa was returning home. Jaswant craned out his neck to tell Randhawa he was being taken away by these policemen.

Rajiv met Paramjit halfway home from the university. Together, they rushed to the police station to report the abduction. The police would not formally register the report till 4:00 p.m.

As soon as she could rush home again, Paramjit grabbed her diary and walked to the phone booth in the market to make long-distance calls to Jaswant's brothers in England, his colleague Jaspal Singh Dhillon, Justice Bains, and the head of the SGPC, Gurcharan Singh Tohra, who sent an urgent telegram to the Supreme Court of India.[57]

As soon as Navkiran and Janmeet returned from school, Paramjit and Rajiv went to meet a senior police official, Bhatti. They were asked to return the next day. Paramjit sent urgent telegrams, including one to the new Chief Minister of Punjab.

Options for any remedy in Punjab felt dangerously compromised. By September 8 evening, Paramjit arrived in New Delhi. She went to the National Human Rights Commission, which asked her to approach the Supreme Court. She filed her writ petition on September 9.

By September 11, Supreme Court Justice Kuldip Singh had recognized SGPC chief Tohra's telegram to the Court as a petition for habeas corpus—produce the body—and gave the Punjab government a week to either produce Jaswant Singh Khalra or account for his whereabouts.

A flurry of affidavits from government officials assured the Court that while no stone was being left unturned, Khalra still had not appeared: perhaps he had become a victim of the militants? The police also filed an affidavit stating Khalra was not wanted in connection with any case: How then could the police have taken him?

As the Punjab government sought extensions, civil society continued campaigning, and a man named Kulwant Singh came to visit Paramjit. He said that while he had been held by the police, he had met another Sikh who explained

that he had been abducted from the Kabir Park neighborhood, and his name was Jaswant Singh Khalra.

"Despite all this, I witnessed the then Advocate General of Punjab, Sarin, throw his hands up in open court, saying the police had come back with squat, there was nothing Punjab government could do, feel free to hand over the investigation to the central government!" Paramjit allows her hands to fall back into her lap. This was just the beginning of her legal roller coaster.

Jaswant's original demand that the Punjab mass cremations case be entrusted to India's Central Bureau of Investigation was fulfilled two months after his own abduction. On November 15, 1995, the Supreme Court ordered the CBI to take charge of both the investigation into Khalra's disappearance and into the facts first alleged in the Khalra team's sensational press release: "It is horrifying to visualize that dead-bodies of large number of persons—allegedly thousands—could be cremated by the police unceremoniously with a label 'unidentified.' Our faith in democracy and the rule of law assures us that nothing of the type can ever happen in this country but the allegations in the Press-note—horrendous as they are—need thorough investigation."[58]

Then one Kikar Singh was released from his own month-long illegal detention.[59] He revealed that he too had met Jaswant Khalra in lockup on October 24, 1995, tortured, unable to use the restroom without assistance.

Meanwhile, a sensational Supreme Court order granted the prosecution of K.P.S. Gill: but it was for a sexual harassment case filed against him in 1988 by Rupan Deol-Bajaj, a senior bureaucrat.[60]

Despite all the searing evidence, 1996 opened with Paramjit, a team of Khalra's friends, and Punjab's human rights defenders redoubling efforts to make the courts respond to the urgency: Khalra was still not back home, the discovered crematoria lists were still where he had left them, and many undiscovered crematoria lists were likely being destroyed. Despite orders from the highest court and involvement of the country's venerated CBI, the weeks stretched into months.

"It was a battle from day one, even though I got started at minute one. First Khalra Action Committee was created. ... His friends. He was known as a friend's friend, keeping alive old-school Punjabi repute for lifelong yaari. And a handful of his friends returned the favor, with interest, after his abduction."

She arranges for my meeting one of them.

Through foggy bifocals, Gurbhej Singh starts telling me about Jaswant, his friend since the early 1970s. Paramjit had mentioned Gurbhej several times. "He would never forget a court date. Through the years, he would just call the day before and say, 'Okay, I am going, who else is?'"

Gurbhej brushes aside any such praise. "He was my friend. He was brilliant."

As he fondly remembers the days he met Khalra organizing with other young leftists, I cannot help ask him of the now embittered relationship between Punjab's "leftists" and "Sikhs."

"Oh, yes, you mean how today 'communist,' 'leftist' are seen as bad words in Sikh circles, and 'religion,' and 'Sikh,' seen as an epithet in Punjabi leftist

circles? False people with these labels have given these labels false connotations. There is a common agenda: antioppression. Any further philosophy, I never did think about it. Jaswant had it figured out. He thought, he planned, and off we went. Who cares about labels? Not the worker bees."

With a smile he then asks, "My yaar had gone missing, my friend whom I adored and trusted with my life. How was there even a question whether I would support his case in whatever way possible?"

Paramjit knows this was indeed not a given, especially in those days. Gurbhej does not mention how most people did not or could not rise to the challenge. "It was just his steadfast small group of friends, and my nephew, Jaswant Singh's elder sister's son," says Paramjit. "And right beside us were also some well-respected figures like Ajit Singh Bains and Baljit Kaur, who gave us a lot of loving support. Despite their profiles, the case did not pick up pace. The Action Committee kept banging its head against the system."

"My own spirit? It came from the outrage that we had received such a big jolt to our lives, and yet, we were being told, as citizens of this country, to just stand idly."

By the summer of 1996, the CBI report named Sandhu and eight junior officers responsible for Khalra's abduction. In the mass cremations case, a CBI interim report confirmed 984 illegal cremations in Tarn Taran, district Amritsar between 1984 and 1994.[61] The Supreme Court directed the CBI to continue all criminal investigations related to the Punjab mass cremations—though the CBI had repeatedly attempted to curtail its own mandate, asking the Court to transfer investigations against the Punjab Police to the Punjab Police. In December 1996, the CBI's final report confirmed 2097 illegal cremations, of which 585 bodies were fully identified, 274 partially identified, and 1238 unidentified by available documentation. Now the Supreme Court directed the quasi-judicial body, the National Human Rights Commission (NHRC) to handle all issues of identification and individual compensation to next of kin.[62]

The year 1996 would prove the high point in the cremations investigation; even the tip of the iceberg was chipped away during the following decade. The NHRC delayed, wary to proceed with the investigations, then limited its own mandate; the State dragged its heels, and challenged the Supreme Court order as opening a door to thousands of false compensation claims.[63]

"In Punjab, the Akali government had come into power in February 1997, after a decade," says Jaijee. "Its manifesto had promised action on what we had been demanding for years: a death census." The census form was first prepared in 1991 by Movement Against State Repression, the organization Jaijee coconvened with Baljit Kaur, and for which Justice Bains was the acting chairman. "For years, our call, conveyed to the UN also, was that Punjab's deaths in each village, by gunfire, by cremation, by canal, be documented. The suggestion was that the simple census be administered by a body with representatives from all political parties, overseen by international human rights groups familiar with Punjab—Asia Watch, today's Human Rights Watch, and Amnesty International. Mostly, it was a suggestion to correct historical perspective and to let some

light in. Our form was approved widely, the protocol thorough. So, again, with the new Akali government we made the demand that the toll in Punjab could not be limited to the registers Khalra was able to expose in his short life."

Paramjit agrees. "Jaswant Singh had gotten very little time to do his work, just lifted the curtain really. A lot of work had to follow."

Then, another life was cut short in a reported suicide.

On May 23, 1997, policeman Ajit Singh Sandhu was reported to have jumped before a speeding train. Sandhu had been suspended and arrested for the first time in 1996, seven years after the abduction and killing of Dhatt, the relative of freedom fighter Bhagat Singh.[64] Meanwhile, the Khalra charge sheet portended badly for him. Moreover, under the new Chief Minister of Punjab, K.P.S. Gill had been sent into retirement.

"Sandhu's rise was clearly up a mountain of corpses. I had documented forty-two cases of extrajudicial killings by him. Parallel to these, he had received promotions from Gill. Without Gill, Sandhu's protection was gone," explains Jaijee.

A 1997 news article quotes senior police officials lamenting that "with the change in perceptions, yesterday's successes against terrorism are today dubbed as excesses." It divulges a Rupees 5 crore [Rupees 50 million] secret fund set up by the Beant Singh administration, "much of which was diverted to provide the best legal aid to men facing terrorism and related cases," was now reduced to less than one-fifth with "minuscule" allocation to the litigation cell.[65]

In this new milieu, Sandhu reportedly felt increasingly cornered. "He always had a chip on his shoulder. He gave interviews begrudging the elite Indian Police Services boys' club, alleging he was being persecuted while the elite officers were untouched. I think he was going to name names—how high up, we don't know," says Jaijee.

"Meanwhile, K.P.S. had responded to the growing pressure over cremations by saying, well, perhaps those were bodies of migrant laborers from Bihar, as if that justified anything!" Jaijee narrates how in a later interview K.P.S. Gill then conjectured that these were perhaps bodies of Bangladeshis, caught crossing the border. "And in a May 1997 interview, he finally also said that some of the bodies may have been cremated by the police because of their ban on bhogs of militants. So, a blatant admission of how the police were preventing people from attending last rites! But with Sandhu's death, K.P.S. came offensively thundering against human rights activists, alleging their persecution of the poor policemen. He had starting shrieking for immediate immunity."

Jaijee explains why several people doubt that Sandhu in fact committed suicide, starting with Sandhu's wife's initial statement, alleging a conspiracy. "But a day later, she changed her tune, perhaps learning better or under duress." Striking to Jaijee remains Mrs. Sandhu's statements to the media that, not so long ago, her husband was a favorite of police and politicians alike. "There was a time when the president of the SGPC used to phone him to congratulate him on his daring actions. ... He approached Gurcharan Singh Tohra and other political leaders to stand by him. Tohra told him that he could not speak pub-

licly in his favor due to political compulsions," Jaijee reads from a newspaper report of June 1998.

"There was a saying about Tohra's role vis-à-vis the militancy, you know. Khalra was very close with him. It was said, anyone whom Tohra embraced, did not live very long after." Jaijee leaves it at that.

Whenever asked, since May 1997, what she makes of conspiracy theories around Sandhu's fate, Paramjit simply responds that if he is alive, folks should bring forth any evidence, so he can be tried.

Another death, this a certain suicide, softly registered the continuing disquiet in the tens of thousands Paramjit had come to represent.

On July 9, 1997, Ajaib Singh walked into the hallowed Darbar Sahib and bowed his head one last time before chugging the contents of a bottle. As the poison spread, the 55-year-old's body went forever limp to the hum of kirtan.

"Suicide is committed by those who have exhausted all alternatives,"[66] Ajaib Singh says in the note found in his pocket. He recounts how his son Kulwant Singh was abducted in 1991 by a police officer also named Ajaib Singh. He recalls the various courts and politicians he approached, including recently appointed Akali leader Parkash Singh Badal. Explaining his heartbreak at never hearing anything about his son's fate, receiving no body or ashes, he closes with an apology to anyone he may have hurt, including "My sister Paramjit Kaur, wife of Sardar Jaswant Singh Khalra." He asks to be cremated without ritual, and repents for opting for suicide against the Rehat Maryada, the Sikh Code of Conduct.

While parents like Ajaib Singh often visited Paramjit, the spoken sister of Punjab's disappeared, the strident backlash against human rights campaigners following Sandhu's death threatened to further derail the mass cremations case. The CCDP, Committee for Coordination of the Disappeared in Punjab, was created in November 1997 to champion the case.[67]

Then, a few months later, the Khalra case became more newsworthy again. The year 1998 brought in the man who would forever be known in the Khalra house as Kuldip Singh "Gavaah," Kuldip Singh "Witness."

In his statement recorded at the CBI headquarters in New Delhi in March 1998,[68] Kuldip Singh swore he was the gunman assigned to one of the accused officers in the Khalra case. He had come to this post via Kashmir—had been rewarded after tipping off Punjab Police about alleged Kashmiri Muslim militants hiding in Pathankot, Punjab's current bordering district with Kashmir. He recounted that around Diwali 1995, he had been entrusted keys to a room, and ordered to feed the special prisoner. Kuldip Singh describes an injured Jaswant, unable to eat or use the bathroom himself. He narrates Jaswant being taken in a van for further interrogation at an officer's house, where half an hour later, Kuldip Singh saw K.P.S. Gill enter. On the way back, Kuldip Singh overheard his senior officer tell Khalra that life would have been easier for Khalra, if only he had taken Gill's advice.

Then, said Kuldip Singh, he went home for the Diwali holidays. On his return, he resumed responsibility for feeding Khalra. On October 27, some officers arrived. Shortly after, Khalra was shot dead. His body was loaded into

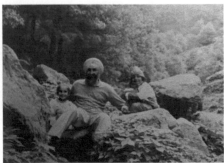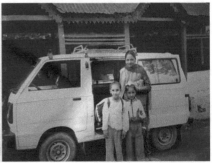

Photo 2.2 Khalras on family vacation, 1992. (From Khalra family archive)

a white van and dropped into flowing water at Harike. The policemen then went to Harike Irrigation Resthouse, where Ajit Singh Sandhu bought them dinner and liquor. Now, after Sandhu's death, Kuldip Singh said he felt safe coming forward.

Paramjit now opened the bay doors of her living room and spread white sheets on the floor, for mourners. But Jaswant's final prayers were held in the vast grounds of Dana Mandi in his village Khalra; approximately 20,000 people attended.

"We had then accepted he is no more. See, our tragedy in Punjab is that we don't know. Much more than the number cremated, there were more thrown down Punjab's rivers. Jaswant Singh is one of them too. We never received any personal information regarding that: just what we learned from witnesses in the court." (Photo 2.2)

The stench of the unknown festered in Punjab.

"The Akali government never fulfilled the promise of appointing any commission to look into the genesis of State terrorism or individual terrorism," Justice Bains explains. By summer 1998, CCDP's coalition of civil society groups took the matter into their own hands.

Reputed Supreme Court lawyer Indira Jaising roared open the August 8, 1998, People's Commission hearings in Chandigarh, to a somber and hopeful audience.[69] Reciting the history of the conflict, and the need for this three-judge commission outside the stalled system of the regular courts, she urged, "We need your opinion on right to life, but also right to die with dignity."

"Even a physical space for that commission in the summer of 1998 was a struggle," remembers Baljit Kaur about her role in actualizing this historic hearing. "There was a rental agreement with a hall that canceled at the last minute. Other venues wouldn't consider hosting due to fear of police. I took on the task of finding a venue. I went to the Sector Thirty-four gurdwara here in Chandigarh. I told them this event needed a hall, with chairs and tables, and it wouldn't be a religious program. They said, No problem, sister, this is an open house, we are not afraid. I'll never forget that!"

A panel of retired judges—Justice D.S. Tewatia, former Chief Justice of Calcutta High Court; Justice H. Suresh, Bombay High Court; and Justice Jaspal Singh, Delhi High Court—listened to three days of summary testimonies of cases documented by CCDP coalition.

"Hundreds of complaints were filed before the People's Commission. Notice was issued to the accused police officers. But none of them gave their versions before the commission," says Justice Bains. He believes that with lesser government interference, many police officers would have chosen to give their accounts, building toward truth and reconciliation.

Hopeful survivors walked up to the mic to address the Commission, as an enthusiastic videographer left the CCDP lawyers sweltering in the camera's bright lights. At one point toward the middle of day one, the video captures young children standing up from the center aisle, filing out of the hall. The judges have stopped to note that this is no place for children, this place of such stories. One lawyer quietly explains, "They are all from a school for orphans of the conflict, many of their parents are subjects of these cases."

"The commission was supposed to sit in Ludhiana next," remembers Baljit Kaur. "There were several philosophical issues coming up, besides the multiple personalities, and the overall environment of pressure. What I remember is that Kumar was of the view that the judiciary should not be spared, given their complicity. Others disagreed. ... If the courts too were antagonized, what recourse did we have? Justice Kuldip Singh was crucial to the commission. He was also of the view that the courts must be approached as allies. Anyway, Chandigarh hearings were a landmark moment for collective expression of our history."

Jaijee remembers other systemic efforts to scuttle the commission. "Some senior High Court lawyers who were government-minded, Anupam Gupta and all, rallied against the People's Commission. All political parties had had knee-jerk reactions."

In *Reduced to Ashes*, the seminal book detailing the lives behind the Khalra lists, Kumar et al. elucidate:

India has a long tradition of people's commissions and citizens' tribunals that have investigated and reported on human rights violations by state forces and generally influenced perspectives on governance, sociopolitical and economic justice. ... The Indian People's Tribunal has so far undertaken 11 such investigations and is affiliated with numerous other fact-finding commissions. And yet, in the case of the people's commission in Punjab, there was this petition that prayed for a writ under Article 226 to ban the first genuine initiative to investigate the reports of human rights violations in the state.[70]

In December 1999, the Punjab & Haryana High Court would pronounce an order against the Punjab People's Commission.[71]

The first and last session of the People's Commission had been dedicated to Jaswant Singh Khalra, whose own case inched along. The smoking-gun testimony by Kuldip Singh had urged little action; with her lawyers, Paramjit kept

filing petitions. "We had to take Jaswant Singh's work to some logical conclusion. The work of collecting and preserving and exposing. I think I took the right decision. People will say whatever they say. I don't know what people say now."

In January 1999, India's National Human Rights Commission confined its own mandate: it would only concern itself with 2097 bodies in three crematoria. When civil society appealed to the Supreme Court, it refused to get involved. In October, the Delhi-based CIIP group withdrew from the proceeding in protest against the developments in the cremations case: Punjab Police would now review the claims filed against itself.

"The glacial pace was lost on no one," says Paramjit. "Neither us, nor the accused police officers. Well, slowly, as one goes through something like this, Almighty gives bal-buddhi too, one gains resolve. One instance, I remember so vividly. My son was all of nine or ten. I would go to the gate to say bye-bye to him as he climbed into his autorickshaw. And I would tell him every day to take care, not talk to anyone who may approach him with anything; those days people scared me a lot, had even said to withdraw the kids from school. … But, this day, he looks at me very determined. Don't you worry, Mummy, the entire panth is with us! After a couple of seconds, I finally told him, Yes, the entire Sikh nation is with us, and then prayed for the same."

November 1999 saw a new strategy to highlight the Khalra name and related cases: Paramjit ran for Lok Sabha elections.

Baljit Kaur remembers, "We all went to support her, whatever different people thought of this decision. I campaigned for her. She had been a role model for so many. And it's okay. You couldn't boycott the system, you have to get into it, use it for change and for the people. So I was there. And Justice Bains came to Amritsar. She lost, but we were there to stand by her decision."

Paramjit smiles, remembering this support. "Look, it may not make immediate sense in hindsight, but we wanted attention to the cases. The fear was that this was falling into oblivion. So I was advised to run. We knew there was zero chance. Elections are corruption, elections are money. Our aim was a platform to raise the issues of the families of Punjab's disappeared."

Delays in the Khalra trial continued in a circus of witnesses falling ill, lawyers being ill, accused being unavailable, lawyers being away, and Paramjit with Jaswant's close friends and associates traveling Amritsar to Patiala, Amritsar to Delhi, Amritsar to Chandigarh, for all Court dates and legal meetings regardless.

Delays in the mass cremation case came with a new wrinkle: 18 families were suddenly offered compensation. All 18 refused the money and again demanded consistent and meaningful action in all cases. The CIIP group got involved again: even the 2097 cases to which the NHRC had originally limited itself needed follow-through.[72]

Another accused police officer, Ashok Kumar, died of natural causes in 2003.

"In the usual pattern, the delay benefited the accused officers," says Rajvinder Singh Bains, Justice Bains's son, who had remained a lead lawyer on the case since 1995.

"Others came and went, but Rajvinder Bains struggled with us," says Paramjit. "I don't care to name which other lawyers sold out at which points. The times were such. The men behind the crime are such. But he is his father's son. A human rights champion."

"My mother moved in to care for the children." Gurbachan Kaur, nearly 90 years old, still spends part of the year in the Khalra home, sharply observing all comings and goings, generous with her blessings and adages.

"There would be days I would head to Chandigarh in morning, take a train to Delhi, and if I was able to catch a bus, come back home to Amritsar at night. My seventeen-year-old nephew, Ranaa, was my male travel companion. His own education was sacrificed. There is no question about his sacrifice. My kids somehow continued their schooling and were growing up. They understood slowly that Mummy was doing something. That was a difficult time. ... It passed."

Part of the difficulty were the men in uniform who kept appearing, asking Paramjit to change her testimony. Then there were the aspersions against Paramjit's testimony, including the filing of a 1998 police case against her, by the earlier whistleblowing police officer Kuldip Singh, who charged that Paramjit and other Khalra supporters had coerced his statement against the accused. Later, Kuldip Singh would testify before the Court about how the accused police officers had made him register this false case after detaining him, visiting his in-laws, offering inducements (including weapons), and threatening him and his wife. The Court would dismiss the case against Paramjit.

In February 2005, Kuldip Singh's statement was recorded before the CBI Court, Patiala. In March, the Court dismissed Paramjit's appeal, first filed in January 2000, to summon K.P.S. Gill, implicated directly by Kuldip Singh. In November 2005, a decade after Jaswant's disappearance, the Court convicted six of the seven junior officers accused, two with life sentences, four with seven-year sentences.[73]

"The web of backstories of all the witnesses shows how even getting this far was remarkable," explains Rajvinder Bains.

Kulwant Singh, who spoke with Jaswant in custody the day he was abducted, would be constantly harassed and discredited for being an opium addict— Kulwant Singh's supposed drug bust was also the alibi evidence of three of the nine officers originally accused in Khalra's case. The former Lance Naik, who had spent 18 years serving the Indian Army, remained both a confessed opium addict and a steadfast witness through the trial.

The other eyewitness, Kikar Singh, would approach the Supreme Court reporting intimidation, including being ousted from his agricultural property: "I am being pressurized by the Punjab Police to turn hostile."[74] Kikar Singh's illegal detention in 1995—during which he said he met Khalra—was confirmed by the High Court, awarding Singh Rupees 25,000 in reparations.[75] But in the Khalra trial, he eventually had to be declared a "hostile witness" by the prosecution.

"I didn't miss any court date; that is why I finally had to quit my library job too. At the Patiala Court, for the CBI trial, I had to keep an eye out for the constant intimidation of witnesses, and their unpredictability," explains Paramjit.

The legal files belie the extent of this unpredictability.

Harinderpal Singh Sidhu was the Khalras' next-door neighbor. "Well, his story really shows how there is some higher plan always," says Paramjit, who is never fatalistic nor faithless.

"See, these neighbors had seen things the day of kidnapping, but over time Mr. Sidhu, we heard, had been convinced to give a statement in favor of the policemen. One day, we reach CBI Court Patiala and are told by the CBI lawyer that word is that Sidhu is being brought by the police to testify for the defense. So, we begin running helter-skelter, hoping we could stop him and prevail on him, beg him, before he walks into court and lies for the police. We couldn't find him anywhere."

"Then, ten o' clock comes. Sidhu is called. No one appears. Again he is called, and our hearts are pounding, but again, nothing. He didn't show up at all."

"I finally get back home to Amritsar around midnight. Next morning, as I step out to begin the day, I see lots of cars. We were neighbors. We knew their people. And one of his female relative tells me, 'Didn't you hear? He had gone for some work to Patiala the night before, and fell from the third floor of the place he was staying. He is severely hurt.'"

"So basically, the police had driven him the night before and had put him up somewhere. We heard there was alcohol involved in keeping him malleable. Somewhere in the merriment, there was an accident and he fell off the balcony. … He is, till date, bed-bound. Still lives next door. Sometimes I hear him."

"So, at times people come and get distraught talking to me and wonder, Is there an Almighty watching, accounting? What can I say? It all is before you. It does not mean we sit back and do nothing. But it does mean there is a force bigger than us, and we can't forget that!"

She pushes forward a tray of snacks, insists, and then reminds me lunch will follow, she had kneaded the dough in the morning. With the children now living in North America, she doesn't go out to eat the famed Amritsari street food as often. But she has planned something to make up for that at home, she says, and smiles. We then quip about how Navkiran and Janmeet's FitBits may not allow for many of the fried treats anyway, and she beams while feigning annoyance at our generation's fitness kicks.

She then again shakes her head. "Yes, it is sad that he is totally dependent on his family, to feed him, clothe him. And, it is also sad that he fell for police inducements then." Paramjit doesn't relish telling the story of this one hostile witness who happened not to remain another obstacle in her long journey.

"Some stories, and the depth of conspiracy, were not clear even to us in the eye of the storm, till many years later," says Rajvinder Bains. He remembers that it was right before Paramjit's own testimony in the CBI Patiala Court that a strange conversation began unraveling the role of Rajiv Singh, the man on the spot when Jaswant was abducted.

"A CBI lawyer rushed over to report that he had just overheard Rajiv telling Mrs. Khalra not to identify the defendant policemen, and to just explain she vaguely knew that police had taken Mr. Khalra. This was years into the case, when her testimony was finally to be recorded! Of course, I got to the witness room and reassured her to speak the truth. But after that day, various things began adding up."

Rajiv, who had accompanied Mrs. Khalra for the first police report, had been her sole advisor on the spot. That first police report too had not named anyone, on Rajiv's advice, even as other eyewitnesses that day had caught glimpses of familiar local policemen.

"He became a confidant: at the right place, at the right time," explains Rajvinder. He remembers how the trusted Rajiv would come to Chandigarh to speak with him and take the responsibility of conveying trial strategies to Jaswant's group of friends, but by the time things played out in the Court, much felt lost in transit. The suspicion around him grew also when Rajvinder gained a High Court order in August 2004 directing the Court to complete the trial in six months. "Rajiv and another fellow lashed out at me, asking, Who asked you to pursue this strategy?!"

But after his failed attempt to convince Paramjit not to identify the accused, he was weeded out of the core group. Yet the exposed Rajiv continued pressure on key witness Kuldip Singh, the opportunistic but now vulnerable former gunman. "Eventually, one CBI officer took it upon himself to bring Kuldip Singh from his house to court at the crack of dawn, without informing anyone else, to prevent more contamination," remembers Rajvinder.

"The infiltration into the heart of the Khalra trial team shows that they were up against more than the few lower-ranking cops who finally got convicted," explains Baljit Kaur.

The convicted policemen appealed to the High Court, while Paramjit's lawyers applied for enhanced sentences. Paramjit also continued appeals to the CBI to investigate and charge K.P.S. Gill. Eventually, in 2006, after no reply, Paramjit's lawyers filed in the High Court for mandamus to direct CBI on K.P.S.'s command or direct responsibility.

This murder would not have been possible without the direct involvement of K.P.S. Gill because in the year 1995, after SSP, only DGP mattered. Thus, there is a prima facie case for further investigation into K.P.S. Gill's direct role in the abduction and murder of Jaswant Singh Khalra because: K.P.S. Gill had motive to kill Khalra; he knew about the plan to abduct and murder Khalra; he participated in the crimes against Khalra; he purposefully failed to rescue Khalra or order Khalra's release; and he refused to punish the police officers who committed those crimes.[76]

In 2007, the High Court in Chandigarh upheld the sentences of five of the six accused in the Khalra case, increasing all punishments to life terms.[77] The Supreme Court upheld the sentences in 2011.[78]

"If, like the Khalra case, maybe ten to fifteen human rights cases had been fought, this era's real news would have come out and spread." Before congratulating herself further, Paramjit stops. "All women I talked to, everyone wanted cases heard. But who was listening? Also, yes, in areas like Amritsar, many people just internalized their men's deaths as martyrdoms but, where they are more educated, in Hoshiarpur, in Chandigarh, people pursued legal cases too. What did they get for that? Years of insecurity, uncertainty, and then? Likely, acquittals."

In April 2012, the mass cremations case was declared complete. Compensation was ordered in 1513 cases: 1245 of the 2097 identified by the National Human Rights Commission plus 143 of the remaining identified by its subcommission in 2007, and another 125 by a subsequent and final subcommission in 2008.[79] There were no criminal convictions[80] for the thousands to whom Jaswant Khalra had married his own fate.[81] They remained murdererless murders.[82]

"And in the Khalra case too, many murderers remained loose," says Jaijee. "So the issue of impunity, it will raise its head, again and again."

Paramjit's case against K.P.S. Gill came to an unofficial close with the death of witness Kuldip Singh in 2012. "We cornered K.P.S. by the law," she says. "We know the State backed him, exhibited in how he was given all this extra security and all the invitations to places when any other minority was to be suppressed, like after the 2002 anti-Muslim massacres in Gujarat. Some think of him as brave too. ... But in the people's court, anyone talking about violations will talk about Gill and how he was directly involved in forwarding the policy of killing and disposing of tens of thousands."

On May 26, 2017, newspapers across India reported the natural death of K.P.S. Gill, recounting his common moniker "Supercop," even as nonmainstream sources noted his more notorious title as the "Butcher of Punjab."[83]

"Though people know, they have so many everyday problems," says Paramjit. "The lack of administration. The corruption. Political mafias for drugs. And a police force that has become accustomed to the taste of human blood. Every month or two, again, some big encounter is mentioned in the news and connected somehow to 'the Sikh movement.' Meanwhile I meet women survivors of the violence, like old mothers of boys who were killed, doing menial work to earn daily rotis. But, it is the land of Guru-Shaheeds. A miracle could still happen. Till then, we keep living our lives the best we can."

"This is perhaps all to be expected. What else happens to a population after such conflict? This was no neat closure. In many ways, it was just the beginning."

NOTES

1. Ram Narayan Kumar, Amrik Singh, Ashok Aggarwal, and Jaskaran Kaur, *Reduced to Ashes: The Insurgency and Human Rights in Punjab* (Kathmandu, Nepal: South Asian Forum for Human Rights, 2003), 47–48.
2. Kumar et al., *Reduced to Ashes*, 54.

3. Displaying willingness to speak when few would, Jaswant was appointed general secretary of the wing in January 1995.

4. Reproduced in Kumar et al., *Reduced to Ashes*, 603–05.

5. "The dismissal of Khalra's petition by the High Court, against the established principles of public interest litigation, indicated the difficulties of applying the rationality of law and respect for facts in the face of political prejudice and the rhetoric of national interest that considered the issues of human rights in Punjab to be irrelevant." Kumar et al., *Reduced to Ashes*, 4.

6. Kumar et al., *Reduced to Ashes*, 5.

7. Inderjit Singh Jaijee, *Politics of Genocide: Punjab, 1984–1998* (Delhi, India: Ajanta Publications, 2002), 99.

8. See, for example, Amnesty International, 1991, "India: Human Rights Violations in Punjab: Use and Abuse of the Law," 28, on Dhatt abduction.

9. See, for example, Harpreet Kaur, "Expedite Kuljit Dhatt Case Appeal, Apex Court Tells HC," *Hindustan Times*, July 24, 2015. (After the family appealed for enhancement of the five-year sentences given to junior cops, 25 years after the murder).

10. Jaijee, *Politics of Genocide*, 98.

11. Kumar et al., *Reduced to Ashes*, 5.

12. "ਸਾਨੂੰ ਮਾਰਕੇ ਵੀ ਹੁਣ ਪੁਲਿਸ ਤੋਂ ਸੱਚ ਤੇ ਪਰਦਾ ਨਹੀਂ ਪਾ ਹੋਣਾ: ਖਾਲੜਾ," *Punjabi Tribune*, February 27, 1995.

13. A term used for those sponsored by the State to infiltrate and kill militants and others.

14. *Punjabi Tribune*, February 27, 1995.

15. See Chap. 5 ("Next Kill All the Lawyers").

16. Jaswant Singh Khalra, speech in Ontario, *Canada*, available at: https://www.youtube.com/watch?v=ktfuGXpi5qw&feature=youtu.be. Published on May 31, 2008.

17. Joyce Pettigrew, *The Sikhs of the Punjab: Unheard Voices of State and Guerilla Violence* (London: Zed Books, 1995), 118–19; Jaijee, *Politics of Genocide*, 126–28.

18. Pettigrew, *The Sikhs of the Punjab*, 119.

19. Long after the armed conflict, K.P.S. Gill continued using the same rationale. See, for example, "Virk's Arrest Will Affect Morale of Cops: Gill," *Express News Service*, September 16, 2007.

20. Kumar et al., *Reduced to Ashes*, 5.

21. Jaijee, *Politics of Genocide*, 101.

22. "Cops Cremated Bodies without Sanction," July 28, 1995, from Khalra family archive.

23. "ਤਰਨਤਾਰਨ ਪੁਲਿਸ ਨੇ ਰਿਟਾਂ ਵਾਪਸ ਕਰਾਉਣ ਲਈ ਕੋਈ ਦਬਾਅ ਨਹੀਂ ਪਾਇਆ," *Akali Patrika*, August 4, 1995.

24. See, for example, Mark Juergensmeyer, *Terror in the Mind of God* (Berkeley: University of California Press, 2000), 84–85.

25. For further reading on persecution of Buddhism by Brahmin kings and godmen see: Lalmani Joshi, *Studies in the Buddhist Culture of India* (New Delhi: Motilal Banarsidass, 1967; rev. 1977); Charles Eliot, *Hinduism and Buddhism: A Historical Sketch, Volume 2* (London: Routledge & Kegan, 1921).

26. Rajmohan Gandhi, *Punjab: A History from Aurangzeb to Mountbatten* (New Delhi: Aleph Book Company, 2013), 131.

27. They fought their way north of river Sutlej, till four misls administered Lahore in 1765. Below the Sutlej, the misls consolidated several holdings, as far south

as rivers Ganga and Jamuna and were coming in and out of the Mughal capital of Delhi, at will. See, Gurharpal Singh, *Ethnic conflict in India: A case-study of Punjab* (New York: St. Martin's Press, 2000), 81.

28. See, for example, Sangat Singh, *The Sikhs in History*, 2nd ed. (New Delhi: Uncommon Books, 1996), 115.

29. Khushwant Singh, *A History of the Sikhs, Vol I; 1469–1839*, 2nd ed. (New Delhi: Oxford University Press, 1999), 362.

30. Khushwant Singh, *History of the Sikhs, Volume I*, 362.

31. My grandfather's brother, Gurmukh Singh Sarkaria, drafted his memoirs, incorporating family archives. On file with author.

32. See, Khushwant Singh, *A History of the Sikhs, Vol II; 1839–2004* (New Delhi: Oxford University Press, 1999), 3–38.

33. Khushwant Singh, *A History of the Sikhs II*, 81.

34. See, Patwant Singh, *The Sikhs*, 1999 (London: John Murray Publishers, 1999), 160–62.

35. Sangat Singh, *The Sikhs in History*, 133.

36. See, for example, Nadhra Shahbaz Khan, *The Samadhi of Maharaja Ranjit Singh in Lahore: A Summation of Sikh Architectural and Decorative Practices* (Studies in Asian Art and Culture, 2018).

37. See, Patwant Singh, *The Sikhs*, 169–70.

38. Ahmed Ali, *Twilight in Delhi: A Novel*, 7th ed. (New Delhi: Rupa, 2007).

39. Khushwant Singh, *A History of the Sikhs II*, 114.

40. See generally, Imran Ali, "Canal Colonization and Socio-Economic Change," in Indu Banga, ed., *Five Punjabi centuries: policy, economy, society, and culture, c. 1500–1990: essays for J.S. Grewal* (Delhi: Manohar, 1997), 341–57 (also notes the canal colonization project involved caste-based land grants, and political calculus including reward grants for politically elite Sikh families).

41. See, Patwant Singh, *The Sikhs*, 169–70.

42. See, Ganda Singh (ed.), *The Singh Sabha and Other Socio-Religious Movements in the Punjab 1850–1925* (Patiala: Punjabi University, 1973).

43. "The first blow to Hindu-Sikh unity was struck by Arya Samaj. In 1877 Swami Dayanand Saraswati visited Punjab … launched his shudhi (purification) movement to bring breakaway Hindus including Sikhs back into the Hindu fold." Khushwant Singh, "Genesis of the Hindu-Sikh Divide," in *The Punjab Story: Reissued on the 20th Anniversary of Operation Bluestar* (New Delhi: Roli Books, 2004), 6.

44. See, for example, Patwant Singh, *The Sikhs*, 181–82.

45. On internal rifts and philosophical differences, see, for example, "Sikh Politics and Religion: The Bhasaur Singh Sabha," in Banga, ed., *Five Punjabi Centuries*, 140–56.

46. Sir Malcolm Darling, *The Punjab Peasant in Prosperity and Debt*, 4th ed. Reprint (New Delhi: Manohar Book Service, 1977), 207.

47. Manini Chatterjee, *Do and Die: The Chittagong Uprising, 1930–34* (New Delhi: Penguin Books, 1999), 273.

48. See, Harjot Oberoi, 2009. "Ghadar Movement and Its Anarchist Genealogy." *Economic and Political Weekly* 44 (50): 40–46.

49. Khoji Kafir, *Manukhi Hakkan da Masiha: Justice Ajit Singh Bains* (Amritsar: Singh Brothers, 2010), 63.

50. Khushwant Singh, *A History of the Sikhs II*, 178–79.

51. Though many civilians were tried in the subsequent Lahore Conspiracy Cases, very few capital sentences were delivered. Most death sentences were awarded and executed in military courts. See also, Chap. 3, note 7.
52. Popular song attributed to Sarabha.
53. Khoji Kafir, *Manukhi Hakkan da Masiha*, photos.
54. Kumar et al., *Reduced to Ashes*, 15.
55. See Glossary.
56. Kumar et al., 24.
57. *Mrs. Paramjit Kaur v. State of Punjab & Ors.*, 1996 SCC (7) 20, November 15, 1995.
58. *Mrs. Paramjit Kaur v. State of Punjab & Ors.*, 1996 SCC (7) 20, November 15, 1995.
59. See, *Harbans Singh v. State of Punjab and Ors.*, Crl. W. P. 1127/1995.
60. See, for example, Ramesh Vinayak, "Conviction of supercop K.P.S. Gill turns spotlight on sexual-harassment offences," *India Today*, August 31, 1996.
61. Kumar et al., 9.
62. *Paramjit Kaur v. State of Punjab & Ors.*, Writ Petition (Crl.) No. 497/95, Supreme Court of India, December 12, 1996.
63. "India: A vital opportunity to end impunity in Punjab," Amnesty International, ASA 20/024/1999, January 8, 1999; Kumar et al., 124–25.
64. See, note 9; Jaijee, *Politics of Genocide*, 99.
65. Ramesh Vinayak, "Top officer's suicide indicates crisis in Punjab Police force," *India Today*, June 9, 1997.
66. Gurtej Singh, CHAKRAVYUH: *Web of Indian Secularism* (Chandigarh: Institute of Sikh Studies, 2000), 130–31.
67. Kumar et al., *Reduced to Ashes*, 3.
68. Closure report filed by Investigating Officer K.S. Joshi, 22.9.99, In the Court of Special Magistrate, Patiala, in Khalra case file, on file with author.
69. In April 1997, at a large public gathering in Jalandhar, a call had resounded for a Punjab People's Truth Commission. See, Jaijee, *Politics of Genocide*, 315. Baljit Kaur archived a video recording of the proceedings.
70. See Kumar et al., *Reduced to Ashes*, 113–14.
71. On opposition to the Commission by senior lawyers and Punjab & Haryana High Court, See, for example, Anupam Gupta, "HC shows the door to people's panel," *The Tribune*, December 27, 1999.
72. Kumar et al., *Reduced to Ashes*, XIII.
73. Judgment, Sessions Court, *State (CBI) v. Ajit Singh Sandhu & Others*, Case No. 49-T of 9.5.1998/30.11.2001, November 18, 2005.
74. Affidavit of Kikar Singh, In the Supreme Court of India, *Mrs. Paramjit Kaur v. State of Punjab*, Writ Petition (Criminal) No. 497 of 1995, August 29, 1996.
75. Order in matter of Crl. W. P. 1127/1995, High Court of Punjab and Haryana, March 6, 1998.
76. *Paramjit Kaur v. State of Punjab & Ors.*, Petition under article 226/227 of Constitution of India, High Court of Punjab and Haryana, September 6, 2006.
77. *Amarjit Singh v. CBI*, Judgment in matter of Criminal Appeal No. 863-DB of 2005, High Court of Punjab and Haryana, October 16, 2007.
78. *Prithipal Singh* etc. *v. State of Punjab and Anr.*, (2012)1SCC10, November 4, 2011.

79. See, National Human Rights Commission, *NHRC recommends Rs. 27,94,00,000/-* to the families of victims of Punjab Mass Cremation Case, New Delhi, April 3, 2012, available at: http://nhrc.nic.in/press-release/nhrc-recommends-rs-279400000-families-victims-punjab-mass-cremation-case (accessed on February 10, 2019).

80. A handful of exceptions are the struggling cases discussed in Chap. 4.

81. "How can there be a guarantee of non-reoccurrence when there is no knowledge of what occurred?" Ram Narayan Kumar, "The Matter of Mass Cremations in Punjab: A Window into the State of Impunity in India," in *Landscapes of Fear*, eds. Patrick Hoenig and Navsharan Singh (New Delhi: Zubaan, 2014), 227.

82. Amnesty, de jure or de facto, is a rather common obstacle in post-conflict and transitional justice contexts (though Punjab has never been recognized as transitioning, rather hastily declared "normal"). See, for example, Naomi Roht-Arriaza, *The Pinochet Effect: Transnational Justice in the Age of Human Rights* (Philadelphia: University of Pennsylvania Press, 2005), 72. "The aim of investigation became simply finding out the fate of the disappeared person, not putting anyone in jail. What a cruel irony for the families!" In describing post-dictatorship Chile, Roht-Arriaza then notes ways in which exceptional Chilean judges did manage to shift the onus back on the State that was claiming complete amnesty for its officers. One of this seminal book's central conclusions is that international attention (like the sensational arrest of Chilean dictator Pinochet) and some transnational trials are beneficial precisely when they prompt shifts in attitude in the home countries—such as emboldening judges who are "norm entrepreneurs"—which matters the most for affected populations.

83. Who continued self-congratulatory writing, disconnected from reality, but perhaps fitting for one who entirely escaped the law. See, for example, "The comprehensive defeat of this terrorist movement is unique in history, leaving behind no ideological lees, no residual rage, no reservoir of sullen hostility." "Foreword," in *The Punjab Story* (New Delhi: Roli Books, 2004), ix.

Monu's Mummy

Abstract This chapter highlights how Bains, Kaur, and Jaijee did not out-right reject violence in the violent Gandhian India, but did call out wrongs by all combatants. They also avoided speaking for experiences that were not their own.

The chapter builds up to one of the most famed nonviolent acts of defiance by a Sikh militant, Mr. Dhami, at a 1994 police press conference in Chandigarh. Mrs. Kulbir Kaur Dhami, who was kept in a secret torture camp with Mr. Dhami and their five-year-old son, exposes the project of impunity. Her story challenges prevalent narratives simplifying Sikh women as hapless bystanders of the militancy as well as of Sikh men as simple-minded aggressors. The chapter follows the interlocutors' lead in respecting victim-survivors and not doubting their alternating needs for silence and breaking the silence.

The chapter then segues to the earlier history of Punjab, particularly the various indigenous Sikh movements of the 1920s that sparked an anticolonial frenzy, and closes in 1935, when Punjab was becoming a beacon of inspiration for the subcontinent, as well as a growing threat to majoritarian forces.

* * *

© Mallika Kaur 2019
M. Kaur, *Faith, Gender, and Activism in the Punjab Conflict*,
https://doi.org/10.1007/978-3-030-24674-7_3

Thus, during those nineteen years of torture and slavery,
did this soul rise and fall at the same time.
Light entered on the one side, and darkness on the other.
:VICTOR HUGO:

THE DINNER TABLE WAS UNDERDRESSED, going for an understated Massachusetts elegance tonight. It was aware that most of the 16 women around it had never been in such surroundings. It awed seamlessly.

A seminar during my final year of graduate work had provided this opportunity to interact with women peace builders from around the world. As ginger motions with forks and some knives cut through the crisp iceberg lettuce course, we all shared what brought us to this work: a disappeared son; hearing about others' sons; discovering prostitution at a local army base; family legacies of resistance; rage at the double and triple whammy for women during wars; the privilege of being still alive and still curious.

A Sri Lankan mother of a disappeared soldier spoke about going with her 23-year-old Tamil driver to find a Tamil Tiger rebel camp, informing them, "I came to see for myself, your claws and teeth," and then staying as a protected guest for five days. A Liberian woman recounted how in her country, where Charles Taylor—handpicked by the U.S. government—had wreaked vengeance, the women who had survived armed gangs now lived with rampant domestic violence. A Ugandan woman introduced "night commuters," the thousands of children who walked to sleep in city centers, to evade abductions. A Sudanese woman recounted the repeated rape and pillage of internally displaced people, years after we had again yelled "Never Again" against the ravages in Darfur. An Afghani woman explained the 25 percent quota for women in the new Constitution, and the challenge now of finding socially aware biological women to fill the legislative seats. All exemplifying the need for "inclusive security," the need for women's participation at decision-making tables in order to better architect structural, sustainable change.[1]

Someone read a couplet, others clapped. I snapped a bread stick, at once sickened and heartened by the exchanges. Could we really encapsulate the immeasurable in a quick poetic abstract?

"Writing poetry after Auschwitz is barbaric"—Adorno wrote after World War II. "Mad Ireland hurt you into poetry," Auden later wrote in tribute to the indomitable Yeats. Both as true as unsatisfactory.

I snapped the breadstick again to match the memory of the rectangular pieces that floated on thick vegetable soup in Punjabi winters.

"So ... she is a *spinn-stir*?"

I was dunking homemade croutons in hearty broth that marked our predinner winter routine, which I cherished for the fried bread and my mother for the extra vegetables.

My grandmother's frown deepened through her chin. I must have responded with unconscious imitation. But tonight, no one was in the mood to repeat the usual wonder over how genetics had reproduced not only much of her physicality but also her mannerisms.

In my father's study still stands the black-and-white photograph of four women. Three tall and tough women stare straight into the camera, caped with starched chunnis over their heads. In front of them, on a small stool, sits the scowling child. Hair pasted to her head—I can smell the sesame oil in that picture each time, the pungency my Dadiji embraced till the end—she looks up to the rare camera. How she looked just like me at that age, my father said every time: a solace and a siren, at different points of life.

"Yes, spinster. It's the feminine noun of bachelor, remember?"

Even distracted, my schoolteacher mother, who never misses a teaching moment, must have told me in Punjabi, with all the operative nouns in English. Such has been the fate of our mother tongue. As with most mothers, no one takes her place, no matter how little we may attend to her. Instead, she has adopted new words and phrases, expanding herself, staying relevant to our needs, against our limitations.

Then, more definitively, "Where's this coming from? You don't need to call anyone that. It's not polite, it's not like saying bachelor."

I was now sorry for choosing this particular line of prattle that had been triggered while staring down at the new, sunmica-topped wooden stools on which lay my soup bowl, allowed in front of the TV only on an especially cold night. We had bought these stools from a woman who chose never to marry, worked independently like a man, dressed practically like a man. So she must be a spinster forever, I thought. Even imagining anything else would come much later. It was only 1994 in Chandigarh.

Everything else was relatively per routine in Dadaji's house. His and her woolen nightclothes, his long, checkered, woolen lohi shawl that I would brush against when particularly brave, thick socks on feet outstretched close to the blower—the prized unit in the house that didn't have the menacing orange coiled heating rods, and suavely blew warm air through its sleek six-inch frame. As I crept my naked feet closer, ready to be yelled at to wear socks instead of sticking skin into electricity, no one muttered. Something was clearly wrong.

I looked up at my grandfather. Instead of his milk-chocolate-brown woolen cap, he still wore his turban, taut and ready. He was expecting someone.

Papa was out. He had been gone long. Mama darted between getting dinner for her in-laws and her children, securing doors for the night, cleaning the kitchen, and straining to hear the clank of the front gate. Only her dinner plate was untouched. My mother's enviable spirit in the face of challenges is nourished by experience and a higher power, my adult years have taught me. But right then, she seemed most vulnerable, her chiseled features making every frown more poignant. And so I had thought asking questions would help keep the mysterious angst at bay.

As croutons bobbed, my grandmother couldn't help herself. "I mean, why did he have to go with that man? Doesn't he know? What time is it again?"

My grandfather did not respond with his usual gruff snubbing of anything that resembled womanly worry. He let Dadiji carry on for a while.

Then, either after another ill-timed question from me or my brother Manpreet's well-timed imaginary cricket shots that were second nature through secondary school, Dadaji had had enough.

"That's it! I'm trying to watch TV. He'll come home if you just let me watch the television."

The contrariness to basic Aristotelian logic had to be spotted in silence; only Papa encouraged debates on reason regardless of the mood.

No one said anything now. His bite could be worse; we all took Dadaji's holler at face value. The TV blared uninterrupted.

Till the gate creaked.

I remember Papa walking through the front door.

I snapped the breadstick again till it crumbled. Embarrassed, I looked up, readying for my turn to introduce my own interest in women, conflict, and survival, while I thought very hard if I remembered anything else about that 1994 evening when my father joined a colleague for a meeting of Sikh intellectuals on human rights abuses in Punjab.

"Punjab is divided between India and Pakistan today," I began, bringing my head back to the dinner from which my heart had excused itself. The dissonance was familiar. The ladies around the table, the admirable women waging peace, smiled.

Strangely, I remembered little about Papa's return: Dadiji didn't start the lament, Dadaji didn't ask any questions but stared at the television, and Mama asked Papa if he had eaten. Nothing happened at all, after all. Suddenly everyone realized how late it was. Papa walked us up the stairs to our beds.

How that night's worst outcome had been lived over and over and over again by too many Punjab families, I would truly learn almost two decades later.

* * *

"TWO DECADES LATER, HERE I AM, SPEAKING about Punjab's armed struggle again. But the few women combatants, they too need to be heard. For that, you must speak with her."

Baljit Kaur had already dialed a number and handed me her phone. She looked amused as I hung up after an all-business exchange.

"This, you'll find interesting," she predicted of my scheduled conversation with the woman she had befriended over the years, one whose past and present are poles apart from hers.

"Look, only fifteen to twenty of those women directly involved in the movement survived. And note, she was ordered security by the High Court when she was finally released," explains Justice Ajit Singh Bains. "The High Court had by then finally granted some inquires. She was an eyewitness to so much in those illegal detention dungeons."

Her own abduction could be traced back to a letter.

"I would learn much later of the unmailed letter found in my husband's pocket." On May 19, 1993, Kulbir Kaur was certain of the security of her new haven in the lap of the mountains that echoed children's prayers every regimented dawn and dusk. So certain, that even when the Sikh boarding school's administrators told her that a Punjab Police team had arrived, and was there something she wanted to confide, Kulbir didn't think twice before shaking her

head. Kulbir worked as a hostel warden's assistant; her son, Ranbir Singh Rana, was a student in Upper Kindergarten.

She continued concealing her identity as the policemen yelled questions.

"Husband's name?"

"R.K. Singh."

"R.K. Singh?"

"Yes, Ram Krishan Singh!"

"And I got two tight slaps. Then the police shoved me into their vehicle, along with my five-year-old son."

"For some time later I kept thinking, maybe, maybe if I had been less confident and confided in the Baru Sahib school administrators, it would have saved at least my Bulbul, that's what we called my little son."

Within a year, other clandestine letters convinced her it would not have done so.

When Kulbir Kaur and Kanwar Pal Singh Dhami decided in 1993 to retreat to a quiet life, it was obvious they could not lie low together. Nor was settling in this Punjab an option after the five years of living in that Punjab. In 1984, they had both crossed the border into Pakistan. At different times.

Kulbir had grown up in a Sikh family that was reawakened in 1978 by events in Amritsar, over 60 miles from her Dhamian Kalan village, in Hoshiarpur district. "The gruesome killings of innocent Sikhs as they peacefully marched against the Nirankari sect leader who was committing sacrilege, bore into my family's heart, as it did so many others."

"By 1981, I had received amrit, baptized by my conscious choice, committed to resisting injustices against the Sikhs. I was not part of any group or such thing. Jarnail Singh Bhindranwale was a revolutionary preacher. He used to come to our area, and along with all villagers, we were mesmerized by his sermons and calls for social change, for closer connection with the divine, for being upright and aware."

She explains how his band of men would come for weeks, staying village to village, "we felt connected to the Almighty through their kirtan and stories. Not affiliated with any group or anything. The groupism came much later."

"I was soon also influenced by the fact that Sikh activists would openly come to our village. I was in BA final year, Government College, Hoshiarpur."

Then one day in 1984 there was a police raid in Kulbir's college. "The police had gotten wind about the help our village extended to Sikhs on the run, and here they were. The principal intervened and said no girl here is involved in things like that. He made the police leave. But then. Then, the village headman and my father talked. It was decided that my education be suspended."

"I was so mad. I hadn't even done anything. Just because I was politically aware and outspoken, my education was being discontinued?"

Kulbir stares at her left hand that has rotated out in animation. She smiles at the intensity that rushes back with her memory, and sips from the small orange polka-dotted cup in her right hand. This thick tea is sweetened with jaggery, unrefined from sugarcane, not the artificial stuff, she says, and waits for me to try it. (It takes another cup of tea for me to confess I'm only accustomed to

drinking unsweetened dark tea—goraa, white people's, tea, we agree.) Her Hoshiarpur is famous for its dense fields of sugarcane, from where its juicy length is quickly stripped, squared, boiled, mashed, and churned, often on the roadside, the sweet fumes filling the passing vehicles, as large lumps of goodness congeal on kerosene stoves.

"My blood was young and hot. My brother was also involved with the local boys. But for an unmarried girl, it was considered the ultimate dishonor to her family if she were to be taken by the police. So, I was being kept at home. I kept thinking, I should just leave home, I was so mad. But, then, when I did leave, it was unplanned and I was unprepared."

Kanwar Pal Singh Dhami grew up in a village a mile and a half from Kulbir's. By the time the police visit destroyed Kulbir's education plans, Kanwar Pal was already living "underground."

"His family had always told him, scared him as much as they could, that police torture is unbearable, he must not pay heed to romantic ideas carried by the then small number of armed Sikh boys. I am talking about right before 1984. So, despite his sympathies, he remained a householder."

"But one day, a Sikh militant took his motorbike. He had had a second motorbike, and wrote off the first one, did not bother to report it either. The police apparently got hold of this stolen bike, perhaps of the man too. And they knew it was Kanwar Pal Singh's."

"On his part, he had simply gone with the flow, avoiding trouble. But the police had their eye on him now, and he had to flee home. His curious sympathy for the Sikh cause became active involvement. He joined a local group of men and then later went to Sant Bhindranwale. He began living in Amritsar."

While Bhindranwale himself never demanded Khalistan, or separation from India, the spirit that rose in his heyday activated movements for social, economic, and political change.[2] Dhami coconvened one of the early groups: Akal Federation. Established in November 1982, its mission statement included "political freedom" for Sikhs. Their activists faced imprisonment, harassment, and torture. Dhami became a wanted man.

Meanwhile, his wife, a schoolteacher, raised their children back home. She was Kulbir's sister, 20 years her senior. "She was always more like a mother to me, and then tied the knot with Dhami saab through an arranged marriage. But soon her children and she spent much time with us. My parents helped after he left home." Though not as educated or connected as Kanwar Pal's more white-collar "service family," Kulbir's "farming family" managed comfortably, she says.

In May 1984, Kulbir's tayaji, her father's older brother, had bought a new tractor and decided to go pay grateful obeisance at the Darbar Sahib, Amritsar. A trolley was laden with grain and vegetables—the 24-hour free gurdwara kitchen at Darbar Sahib that serves food to 40,000–100,000 people every day is still actualized by such donations. Sikhs' obligation to society is believed to be at least das-vandh, or a tithe, a tenth part, of their incomes.

Kulbir and five other family members set out toward Amritsar in the tractor-trolley. "We had no idea what we were rolling into. Curfew was declared across Punjab. We got there at twelve thirty in the afternoon on June 1, and wasn't it about twelve forty that the first bullets were fired?"

Kulbir was 21 years old then, hard as it is to tell from her wrinkleless face today. The tight-wrapped black turban around her head accentuates her piercing eyes, which stare far away again. Always sans jewelry and makeup, she is now without the customary chunni, sitting among women in the sweltering heat. She lifts a black-and-white crinkly chunni to fold it thrice, without looking, and places it back on a chair.

"When we were little, our Phapaji would always tell us nighttime stories about the heroics of Sikh forefathers and foremothers. My Phapaji's voice always floated in our heads as we slept, feeling comforted, connected to something bigger, imagining valor in the face of extreme adversity. But 1984, nothing could have prepared one to even imagine that."

She quickly recites a sequence of events embedded in her mind's eye over three decades of witnessing and repeating to her students, to friends, to advocates, to the media, to anyone she thinks is genuinely interested in an eyewitness account.

"I've seen a lot. My habit is to speak from what I've seen. I've seen children's things lying in pools of blood in the parikarma."

When the curfew was relaxed, she was shuffled from one house to another. She was eventually reunited with her sister, her sister's two children, her brother-in-law, her cousins. Then again, in the fog of the assault, they were all scattered. "The family I was staying with, they said 'We'll take you to our relatives in Sultanvind.'" The eight-hundred-year-old village was only six miles from Darbar Sahib. "My sister's two little kids were with us and we were worried sick. On the way there, we met with my cousins and Mr. Dhami again. Mr. Dhami was incognito, but it was him all right."

In the rest of Punjab, it was difficult for people to glean what was happening or how the army was faring in the war launched on the Darbar Sahib and dozens of other gurdwaras across Punjab. News was strictly censored; newspapers, when they did resume, at times appeared with entirely blank pages, and the radio and TV churned out tightly controlled sound bites. But the extent of the onslaught was estimated from a number of signs across Punjab: especially the heavy army presence and the iron grip curfew on civilian movement, implemented with shoot-at-sight orders against Sikhs daring to transgress.[3]

And so, Kulbir's remaining family in Hoshiarpur began losing hope. "We were stuck. For seventeen days, we were in one set of clothes, barefoot. How can one forget that? I remember being in a house with twenty-five people, and sharing one packet of bread. What were our hosts to do? They were a small family of four, this is what they had."

"That the army would launch an attack on its own people like this, we didn't imagine even of a foreign army. Things an armed assault has nothing to do with—the innocent pilgrims, or the library of all ancient Sikh archives in the

Darbar Sahib complex. How was that a military target, especially days after the Sikh fighters were dead? If just killing Sant Bhindranwale was the objective, there was enough military technology, in those days too, to do this cleanly, easily. I witnessed them deliberately provoke an entire nation."

Her eyebrows arched, she now recoils the finger that has risen to the sky. "Talking about 1984 and just what I saw in Amritsar can take a month to tell! So, back to my story. For two weeks, no vehicle moved. Then it was decided that my sister and her kids would go back. She was picked up by the army on the way, our ultimate fear. But eventually, after some detention, she got home."

Her sister's homecoming was a strange surprise to their family, who had just tearfully completed the last prayers for the lives of all six who had left home on May 31. "And Mr. Dhami's younger uncle, haunted by the thoughts that his brother's family had so perished, had suffered a heart attack. They had performed his last rites too."

"When my family learnt that I was alive, a message was sent to Amritsar, through a village boy, that I should take care, that the situation is very bad, don't return home yet."

"I was in the meantime helping hide my brother-in-law, who was a known and wanted face. I would help take messages back and forth to others, from where he was staying. Then, someone informed the army that this one single woman comes and goes, there must be others hiding inside this house. So, like a hundred men, army and CRPF, raided that house."

"As luck would have it, I had a very high fever that night. They somehow didn't think it prudent to lift me from my stupor. They took Mr. Dhami. I was able to scuttle from that house a few hours later, before the army came back for me. But we thought he was lost forever now."

Then came a slip of paper: *Kulwinder Singh. Pind Rasulpura.*

Kulbir smiles, her lower lip, as always, pursed. "See, he wanted to send us a message that his identity was still secret, and the army camp just thought him another turbaned Sikh, like the thousands rounded up in the camps after the assault. Mr. Dhami wanted us to come get him, before his game was up. Apparently, some major in that camp had helped him get that slip out."

This would hardly be the last man in uniform awed into helping the daring Kanwar Pal Singh Dhami.

"From reading this slip in his handwriting, we understood. Five or six of us got together and went to the camps, saying we were looking for a missing man from our village, our village of Rasulpura."

"There he was—tied to a pole, where he had been for sixteen hours. But somehow, in our cacophony at that time, they let him go."

"Even as we rushed home, we knew they would realize that they had been given a fake name. Sure enough, just as we left one hiding place, the army raided it. Then we barely got to the next safe house, and again they came. And so on. The men around me started talking about escaping across the border to Pakistan, to receive support and avenge 1984. Now remember, my family had also told me not to come back. I decided I would cross too."

"The first two points where we tried to enter the border, there was much Indian Army. Our Hoshiarpur district has no border or anything. I just followed locals used to this terrain. I went with four others. Mr. Dhami was in another group. On July 7, 1984, I set foot in Pakistan."

"We had heard Pakistanis were giving arms. And the Pakistanis, who had spread this rumor, apparently thought lots of people would get up and come. They thought that, but that didn't happen."

Various things were said and heard about Pakistan during that time. Mr. G.S. Grewal, who would later twice become advocate general of Punjab, is Inderjit Singh Jaijee's college friend. "He was quite close to the Akali leaders then, talk to him," Jaijee says before I go visit Mr. Grewal.

Grewal remembers the months before 1984, when—unlike Jaijee, who was working a corporate job in New Delhi—he would regularly visit leaders Longowal and Bhindranwale. Grewal lowers his voice, even in 2015, when he explains the fear Bhindranwale commanded. "Everyone showed him deference. I remember sitting and eating langar with him and his men. There was a solid amount of ghee in their daal, and they ate a solid amount of food. They were big men. No one crossed Bhindranwale. For example, they had this dish of milk, he would take one gulp and pass it along for others. My friend who was there with me just let it slip out, 'This is not the Guru's way, this is ritual!' And that was not looked upon kindly."

"I also remember that Bhindranwale expressed faith that if the army invaded, Pakistan would come to Sikhs' aid. I voiced my incredulity at this. And he said, 'No, they will help ward off the Indian Army.' And Shabeg Singh, his military commander, would tell me the same thing. They said, 'We've been promised this!'"

"I didn't have patience for his pride, but somehow I never offended Bhindranwale either. I did tell him, with certainty, that Pakistan won't be coming. That I did."

Kulbir's cherished memory of Bhindranwale is perhaps not so different: a charismatic preacher, against the grain, commanding a band of brothers, who not only inspired loyalty till death, but also knowingly went to his own, for the principles he had preached from village to village.

From the Pakistani government, Kulbir says she never expected any principled response, and doubts any of the other battling Sikhs did either. "Look, everyone has their motives. The Pakistanis' supposed 'help' to us wasn't about our victory, ever. It was about supporting the enemies of an enemy. But that support was also by their own plan. First off, once we got there, we thought we would be able to regroup, arm, and just return, right? But they wouldn't let us return."

"All the men around me were in suspended animation. And then the Sikhs at home fought with those who finally got back. They said, 'Why didn't you come back sooner? Where is our reinforcement?' But Pakistanis had their own plan."

Kulbir maintains the political landscape would have been entirely different if Pakistan had in fact supported the heightened Sikh spirit for change. "Look, Sikhs were so emotional that they just started grabbing what they could, even a dandaa off a tree, and rushed to Amritsar, in jathaas, groups of people abandoning concern about what would happen to them. ... People just wanted to do Something!" She contrasts the common Sikh's knee-jerk reactions with the central government's methodical preplanning.

Kulbir was surrounded by Sikh men who had crossed the border, but no other Sikh women. "I had been in Amritsar by fate that June ... all that led to my crossing over. And in Pakistan, was a looming threat of being sent to a jail. They sent many Sikhs to jails, per whatever plans they had. Imagining the atmosphere alone in a jail; nothing good could come for a woman. The various Singhs around suggested that I needed to stay with them. The decent way out, they proposed, was that I be married to Mr. Dhami."

In Lahore, Guru Arjun, the founder of Darbar Sahib, had breathed his last in 1606. At his martyrdom site, a gilded dome marks a gurdwara commissioned by Maharaja Ranjit Singh. In 1984, under this dome, barely 35 miles from the bleeding golden domes of Amritsar, Kulbir was married to her brother-in-law.

They would survive in Pakistan for five years. She doesn't offer details about this time. She has spent a lifetime protecting information that may be injurious to others.

In late 1989, Kulbir returned to east Punjab, still with revolution in her heart.

"Understand this about the militancy. We are talking mostly about young men, boys. No technique taught, no training. No central command, often no discipline, but jazbaat, spirit, resounding in their bodies. If someone had taken the reins, some true person had taken their hand, then really, we would have shown India the result of attacking the Darbar Sahib."

"These were generally men. And I'll say about a hundred women in the armed movement. And there was little leadership. That's why it all went the way it did. But."

She leans forward for emphasis.

"But, let's not forget: People run long movements, better ones in some ways than ours, right? But, in a short period, look what all happened. The Prime Minister, the Chief Minister—what else is a country made of? The army chief. ... Those who commanded mass killings were killed. What was decided, was done. We have to recognize that they avenged the injustice. And where they committed injustices, we also called them out. Though, no one hears about that, do they? Victors write history."

"Anyway, they began to faction, first by orchestration and then natural unraveling. So one group, the Sangha group, had broken away from Bhindranwale Tiger Force and had been sucked dry, with no weapons, and all their men were hiding deep underground. I was tasked with going back to find and help them."

"As I went to villages, with their names and the given code words, unsurprisingly, people wouldn't trust me. I had landed at the height of mistrust, after five years away, and encountered much hostility. In one home, some ladies said

I must be a spy and cornered me and started beating me. I knew, from their manner, that they would only respond to strength." Then she shakes her head in bemusement.

"Those were some strong, angry ladies!" And this time she laughs to display her bottom row of discolored unaligned teeth. "Okay, so as harshly as I could, I told them not to invite consequences, that so-and-so is the name of the Singh I have a message for, and such-and-such is the code word. I finally did get out of that situation, but really, people were full of rage, fear, and hope for freedom, all at once."

"It's not like we have jungles here; we have people," Baljit Kaur always explains of her beloved flatland. "There are no valleys or caves or deep forests to hide in. It's the people-jungle. The militants depended on hiding among people. We, as human rights people, made it known we would not meet them, but we would hear about their attitudes, and feats, and we would visit when militants' entire families, or even their extended families and friends, were targeted in retributive killings."

In the early conflict years, even as all dense sugarcane fields were ordered to be razed by the police—clearing possible cover for the militants; roads were dotted by garrisons; and civilian lands occupied by checkpoints; the doors of homes, many times the number of militants, remained open and available.

"Now, the victor's history is unquestioned. But look, it was clear this movement flourished for as long as it had people's support," remarks Kulbir. "I'll tell you, the Singhs I saw up close those days, they really ridiculed death. They played hide-and-seek with life. A scooter whooshing here—into a small street there—into a home there—police here—turned over there—and always with ultimate faith in their higher power. Raids here, raids there, I saw the whole frenzy."

Does she discredit accounts of militant abuses on civilians?

"Young blood. Angry and armed."

Met with my silence, she elaborates with the tone of one bored with elucidating the self-evident. "In villages, personal, petty animosities were at times settled through them. Soon, the infighting also escalated as many older, wiser leaders were killed. But there was lots of systematic infiltration. See, first local police also used to give us support. Later, how, who knows what planning went into it, they had police families attacked. Like one policeman's family of nine was killed in the Amritsar-Tarn Taran area. That was by the government. All that, of course, triggered consequences."

And the allegations of violence against women by gun-toting militants?

She explains her studied silence around sexual violence as her commitment to sisterhood. "I'm not saying there were no boys who committed abuses just for their own egos or misguided machismo. But, also, see, some women prefer not revealing this, they prefer not being talked about, even after their deaths."[4]

I have witnessed silence as a conscious choice, as a form of resistance, an act of reclaiming agency, not only in South Asia, but from survivors of gendered violence across the United States: women fleeing domestic violence; female

academics having endured workplace sexual harassment; mothers protecting their children; black and brown women choosing not to involve the State machinery, including the police and courts, against "their own" men. As much as the space and option to speak out constitutes justice for some women, being allowed silence and privacy against being prodded to speak is justice for others. At the same time, sadly, across the world, prevailing cultures complicate the notion of what constitutes a woman's true "choice." Picking between silence and speaking is hardly just allowed to be a matter of individual circumstance and personality.[5]

So, I catch myself arching an eyebrow, and Kulbir continues: "Okay, look, I'm not saying there weren't unfortunate marriages. Like going into a home for food and then asking for a girl they found pretty. And very few sensible parents wanted to give their daughters to militants. Once they were so married, the poor girls also went and lived in the fields, following in his wake, till he was killed. Between 1984 and 1992, I would say that, like, eighty out of the one hundred women in the movement were married like this, with half information or consent, basically."

"But then, remember too, those women wanted to be part of history, and marriage was the condition. They married daring. They married death. It was all young blood, and mind you, these boys were mighty attractive too. There was adoration, there was the romance of their commitment to revolution."[6]

She explains how the young boys are not respected for everything, but rather for staking everything. "Hasn't it been our ethos, to celebrate those who refuse to kowtow?"

* * *

To kowtow to the newest masters of India had been, unsurprisingly, the price for continuing to reign over one's kingdom.

"Those who spread anticolonial sentiment provoked the displeasure of the cis-Sutlej kings who had submitted before the British," says Jaijee of his father's disobedience. Local royals in Punjab, like royals elsewhere in India, were allowed to retain their rule provided they loyally served colonial ends.

Sikh impatience and impertinence against the British had grown after World War I. Sikh soldiers had returned to the reality of racially segregated life, maltreatment of their people, and to stories of internments, deportations, and hangings of close to 5000 Sikhs.[7] Their spirits fell from their high of having won the war for the British. Colonial vigilance intensified over the veteran land while Punjab bore increased taxes, a deadly outbreak of influenza, and the failure of monsoon rains (always a catalyst for Punjabi agrarian unrest).

In 1919, changes to the criminal laws caused popular agitation. Strikes had been met with police shootings in many cities. In Punjab, protesters continued civil disobedience against repressive laws. Two popular leaders were detained. As citizens marched, police backlash killed half a dozen and wounded scores, inciting the remaining to riot against British persons and property. In this milieu, the brigadier general who would become symbolic for British terrorism ever after, R.E.H. Dyer, deployed to Amritsar.

The next day was Vaisakhi, a high holiday. Dyer had proclaimed a state of emergency, prohibiting all meetings. These orders were unknown to many, especially villagers traveling to the Darbar Sahib for celebrations. Weary travelers walked across to the shady garden, bagh, called Jallianwala, to rest before journeying home.

Hearing of a gathering, Dyer marched his platoon to the garden, blocking its only entrance and exit. Without warning or any opportunity for the peaceful crowd to disburse, he ordered soldiers to open fire. In the ensuing stampede, many of the panicked civilians even jumped to their deaths in the garden's wells.

The firing, aimed at maximum civilian casualties, killed at least 379 per the list of dead—the only official list available even now—compiled by the deputy commissioner of Amritsar in the following six months. About 50 of the women, men, and children killed had Muslim names, 100 Sikh, the rest Hindu. Number 49 on this interfaith and intercaste list of unwitting martyrs for India's freedom was "Vaso Mal son of Sidhi Mal." "Sohn Lal, son of Vaso Mal," was number 51. Sohn Lal was nine years old.[8]

Martial law was imposed, water and electricity was cut from Punjab, and Punjab was cut from the world.[9] During the seven weeks after the Jallianwala Bagh massacre, 1200 more people were killed and three times as many injured. Racial tensions escalated: every colored person was an enemy of the British. Lahore, once the capital of the Lion of Punjab, saw public floggings. The agenda of humiliation was carried out efficiently. The haughty Irish Lieutenant Governor of Punjab, Michael O'Dwyer, approved of General Dyer's action in the garden. O'Dwyer continued to drum up the threat posed by the victims, the natives who had to be reined in by force.

Winston Churchill, addressing the British Parliament in 1920, declared the massacre "an extraordinary event, a monstrous event, an event which stands in singular and sinister isolation."[10] At the same time, a sizeable portion of the British public collected funds for General Dyer, whose pension had been rescinded. (Rudyard Kipling, the Nobel Prize–winning author of *Kim, The Jungle Book*, and much about India, was a lead in this effort for Dyer.[11])

In Punjab, Sikhs summoned urgent meetings and announced sustained noncooperation with the British and derision for collaborators. In November 1920, the creation of the Shiromani Gurdwara Parbandhak Committee (SGPC) was announced at the Akal Takht, the Sikh high command, located less than a mile from Jallianwala Bagh. To bolster the SGPC's efforts, the Akali Dal, band of immortals, was formed. The British actions in Jallianwala Bagh had created as much resistance as terror.

The Sikh and Punjabi response was by no means uniform. General Dyer, after the bloodbath, began pacifying and turning some Sikh leaders. He had arranged for himself to be invited to Darbar Sahib and honored by these Sikhs.

This travesty of normalcy gnawed at many other Sikhs. It ignited rebellion in men like Justice Bain's father, Babu Gurbaksh Singh. He chose the freedom struggle over his desk job. He would spend nine years in jail. Amrit Kaur raised her seven children, the first, Ajit Singh Bains, born in 1922, with her mother-in-law's widow's pension, some support from her natal family, and selling her jewelry.

Meanwhile, Punjab royals put their allegiance to the British on obvious display. The English viceroy officiated the crowning ceremonies of their male heirs. Then, Ripudaman Singh of Nabha transgressed this practice: his ceremony was 'officiated' by the Guru Granth Sahib, the venerated Sikh scripture.

The tenth Sikh Guru (1666–1708) had ordained that Sikhs would owe all allegiance not to any one human but to the shared power of Guru Granth (scripture containing the compiled teachings) and the Guru Panth (Sikhs who live by these teachings). Thus had culminated the Gurus' project of bestowing all power to the people. Forever after, in defiance of any earthly monarch, the Guru Panth runs the Sikh gurdwara to afford all respect to the Guru Granth. Each gurdwara is arranged after a royal court: At the center of the room, there is a raised platform above which a chandoa, an upside-down cloth umbrella, hangs in deference, and below which typically a person waves a chaur, or whisk, over the center of all attention: the Guru Granth Sahib.

Maharaja Nabha's crowning ceremony before the Guru Granth Sahib was in challenge to the colonizers.

"Pitaji was friends with Ripudaman Singh, Maharaja Nabha, who was a solid Sikh," says Jaijee. "They had donned black turbans, and distributed black turbans, in the agitation against the carnage at Nankana Sahib."

Nankana, birthplace of Guru Nanak, was marked by a prominent gurdwara. The caretaker of the Nankana Sahib gurdwara, Narain Daas, was one of the corrupted gurdwara custodians who thrived under the British but was increasingly reviled by ordinary Sikhs.

"See, when the Mughals had put a price on every Sikh's head, people who were not turbaned and thus less at risk became the gurdwara caretakers," explains Jaijee. "Many continued under Maharaja Ranjit Singh's time too, enjoying prestige. Naturally, some of them became corrupt, especially post the Sikh Raj."

These caretakers, mahants, expanded their control of the gurdwaras under the British. "It did not occur to [the British] that the mahant of a gurdwara was in exactly the same position as the vicar of a church in whom no proprietary rights were vested," writes Khushwant Singh.[12] Sikh concerns around gurdwara administration had gone unheeded for decades.

In an egregious and especially insulting case, in historic Nankana Sahib, the mahant lived with a concubine, invited dancing girls into the premises, and ran the gurdwara like a fiefdom. In 1921, the newly created SGPC decided to send Sikhs to protest. These Sikhs were trapped by the mahant's hired goons, well-armed and kill-ready. The massacre of more than 100 Sikhs and their unceremonious mass burning enflamed Sikhs across Punjab. Black turbans were donned in protest. (For these murders, the British government soon sentenced three men to life imprisonment, including the mahant.)

Then, in 1922, in a garden about 15 miles from Jallianwala, another protest brewed. A gurdwara had been reclaimed by the Sikhs, but the local mahant claimed proprietary control over the surrounding bagh, garden, and its trees, which were utilized by the Sikhs for firewood to cook langar. British police

arrested a handful of Sikhs and sentenced them to prison for trespassing. Police batons and arrests greeted more Sikh protesters, including rising Akali leader Tara Singh. Jathaas, groups of Sikhs, now formed, each vowing steadfast non-violence at the Akal Takht in Amritsar, before marching to the bleeding Guru-ka-bagh to court abuse and arrest. Reverend C.F. Andrews, who visited the site of protest, noted the Sikh protesters were steadfast, committed to nonviolence till death, and that they were "Christlike."[13]

In large steel cauldrons, women heated fine sand. They then carefully poured it into cloth baggies; simmering sand to treat bruised bodies. Jaijee's mother, Rajinder Kaur, is remembered to have been involved with this support system for the protesting Akali men, who had disallowed women from facing the jack-boots and batons in person.

After weeks of sustained protest, with over 5000 arrests and close to 1000 severe injuries, the government arranged a way out: the land was leased away from the mahant, who made a statement that he no longer required police protection, allowing police withdrawal. The Sikh masses, felt rejuvenated by the powerful show of common call and response.

Daring acts of defiance were also witnessed from a more firebrand group, the Babbar Akalis. They captured attention through daredevil feats; Dhanna Singh, for example, surprised his captors by exploding a hand grenade in his armpit, while his hands were shackled.

Like the Ghadr, the Babbars' movement was short-lived. But the Punjabi Sikh masses were charged. When the Maharaja of Nabha was effectively dethroned by the British, Sikhs declared "Nabha Day" and organized nonstop readings of the Guru Granth Sahib to feed their active dissent. In village Jaito, such reading was interrupted by the police, leading to protests, followed by arrests and increased momentum throughout Punjab.

"Far from keeping his head down like the British wanted, Pitaji now sent men for the Jaito protests from this house. And one got injured badly. Whenever someone would speak about the protest, this chap would raise his shirt to show his scar. You know why? Because he was hit in front, right on his chest! Mein bhajiyaa naahin, I didn't run, he would declare, thumping his chest." As always, Jaijee's eyes twinkle at stories of valor.

The events in Nankana Sahib, Guru-ka-Bagh, Jaito, and elsewhere together constituted the Gurdwara Reform Movement of the 1920s, during which Sikhs sought to reclaim their practice and affairs at all costs: over 30,000 were jailed and 400 died in five years.[14] At the same time, Sikhs began reckoning with majoritarianism.

From the Government of India Act of 1919, to the debates around a sepa-rate electorate for Sikhs (already granted to Hindus and Muslims) and their percentage of representation, through the various roundtable conferences in the United Kingdom, Sikhs began contending with the reality of their poor representation in any Indian electoral system. Relatedly, Sikhs began overtly resisting being swept under the Hindu umbrella; for example, the famed monograph *Hum Hindu Naahin*, We Are Not Hindus, by Kahn Singh Nabha,

was widely circulated.[15] At the same time, Sikhs' nonviolent heroics earned praise from the most prominent Indian politicians of the time, including Mohandas Gandhi.[16]

As early as 1928, despite accounts today of the bonhomie between different communities against the common British enemy, leaders like Puran Singh had raised the loud alarm that self-governance of deeply divided India may mean tyrannical government by the very few.

> I would request you not to be so small as to be partial in any way to any community and not to be so large as to give over India into the hands of one powerful community and thus reduce the other minor communities to eternal slavery even under democratic Institutions.[17]

This line of argument saw democracy simply as the herd vote in a society that could not rid itself of the machinations of a few armed with the divine right of caste.

"Officially the Congress Party was caste-blind," remembers Justice Bains. It aimed for broader popularity than other revolutionary groups.

By 1925, some Ghadrites would travel to India by way of a year in Russia and then a long trek. Justice Bains remembers, "My Uncle Harjap walked on foot to Uzbekistan, Iran, Afghanistan, and entered India, then was apprehended and put under house arrest." The nature of the Ghadr Party had been recently altered with the influence of the communists of the day—then most active and concentrated in the United States and Western Europe—who had forged contact with the remaining Ghadrites in North America.

Though the Ghadr Party did not survive long after, the newfound communist ideology of some of these last Ghadrites spread with some success. The most famous Punjabi communist, Bhagat Singh, would march to the gallows in Lahore in 1931, at age 23, condemned for waging war against the State through use of violence. His last written petition lays out his vision for an India where the working class is freed of exploitation by both the British and Indian "parasites."[18]

Meanwhile, the Congress Party had been increasing in size and spirit through its safer and secular calls. It had even convinced one group of Akali leaders to enlist and channel their own nonviolent struggle under its larger banner, Justice Bains says.

Bains's father, the former desk worker in the British Army, had first courted arrest with the Akalis during the Gurdwara Reform Movement. On being released from jail in 1927, Gurbaksh Singh was only more determined to serve his people against the colonial government, and joined the Congress Party. The next eight years would see a series of imprisonments. His family, including the future Justice, would become as used to his long absences as to raids and searches of their house.

"In British territory all over India, you already had the active Congress and Muslim League, but in the princely states, no political activity was allowed,"

says Jaijee. "So in the states, revolutionaries started the Praja Mandal movement by 1928. Over in our area, Patiala state, my father had commenced the Praja Mandal. Soon after, he was arrested."

Jaijee's ancestors had fought alongside the founder of Patiala, Ala Singh, and generally enjoyed the patronage of the royal family. H.S. Jaijee's great-grandfather Bakshi Bir Singh led the Patiala forces fighting with Ochterlony in the Anglo-Gorkha War, 1814–1816. This victory had been crucial for the British to cement their gains in North India. It also enormously extended the territories of Patiala state deep into the cis-Sutlej hills. H.S. Jaijee's grandfather had been a judge in the royal court, and his father, who died very young, an excise commissioner. Yet, in 1928, the Chural home was surrounded by state police. When H.S. Jaijee asked the police their cause, the reply was simple: "The Maharaja knows why."[19]

H.S. Jaijee was known for his habit of saying an ardaas in front of the Guru Granth Sahib each time he left or entered his Chural home. Now, handcuffed, he requested a minute for an ardaas. His request was denied. It would be ten years before he would stand in Chural again.

"The thing that upset the government most was that my father had helped the Maharaja of Nabha. Maharaja Patiala wouldn't stand for that," says the youngest Jaijee son, relaying the family history as he sees it.

The police refused to stand on ceremony: the women's quarters of the Chural home were brusquely searched, and the lady of the house was turned out barefoot.

Jaijee recounts what he heard about the family's abrupt uprooting. "When my mother and older sister came out of the house, as they stepped out, they had some little jewelry on them. They were told by the magistrate, 'This is state property!' He pointed to the jewelry."

As the oldest Jaijee daughter, Mohinder Kaur, proceeded to step into the horse-pulled tonga, she was stopped again. "She was maybe ten years old. And he said, 'Take off your shoes, this is state property!' So extreme was the venom. Then they went penniless to the station. There, the station house master felt so embarrassed to see Jaijee's wife and family in this condition, he bought tickets for my mother to travel to Sangrur. That was my mother's maternal home. We spent a lot of time there during exile."

Inderjit Singh Jaijee was born three years into the exile, in 1931. Baljit Kaur was born in 1935. She says, "We were five brothers and three sisters and a youngest brother, who died very young in Delhi, during the exile. My father had been married before, but that Beeji died early, and a few years later, my father remarried. Anyhow, it was irrelevant to us kids, we children from both mothers grew up together, one unit."

The youngest surviving child of the couple remembers growing up only amid graceful grit. "We were never subdued, there was an openness in our upbringing. Like my mother, when things were tight, she just kept a brave front and there was no complaining. My brothers, I remember, they had their khaki shorts and white shirts. Two or three sets of those. But they would always

be washed, ironed, starched. No compromise, no excuses. I must say, at one time, the going wasn't so good in Amritsar, and I have a memory about my brother Balbir. He had to go to school, and had outgrown or outworn his shoes. And my mother sternly said, 'Just keep going barefoot, till we can get you chappals.'"

Mrs. Jaijee led their challenge to the Maharaja in court, often accompanied by her eldest son, Wazir Singh. "My mother used to go for each hearing," says Jaijee.

School and games preoccupied the children, while the adults discussed prison, resistance, political organizing, and royal vendetta. The family spent a considerable amount of time in Amritsar. Once, brother Balbir could not find his siblings. He looked around till he saw a breathing bundle of blankets on a homespun jute day bed. He tiptoed over, then pounced. "I found you, found you," he is remembered to have chanted, jumping on someone's legs.

A groggy and surprised Master Tara Singh emerged from the blankets. Tara Singh—then very popular amongst Sikhs but later to be second-guessed, rebuked, ridiculed, and even derided by many—was the Akali leader of the day. While the family lived in Amritsar, he was a close confidant.

At the same time, Jaijee remembers some tensions with Tara Singh. Of the family's decision to move from Amritsar to Delhi, he says, "It seemed to my father that Master Tara Singh was softening toward Maharaja Patiala, on some matters important to Sikhs. That apparently caused a schism. He decided to move, for safety and also for friendship. To maintain their friendship."

No matter where the family moved, Chural had a special pull.

"We children would get to visit Chural sometimes. In those days, villagers looked after each other. Three times villagers prevented our lands from being auctioned off by the government. They would simply block access to the village. We used to stand with each other in those times."

"The entire time in Amritsar, my father also received strong support from local Sikhs. He ran Praja Mandal there for a while, and Sardar Thikriwala was its president, in absentia."

Sardar Seva Singh Thikriwala would spend the rest of his life imprisoned. After he died in 1935, his daughter was married—to mark continuing friendship and solidarity with the struggle—to Wazir Singh, the eldest Jaijee son. But another Jaijee marriage a few years later would become the talk of Punjabi Sikh circles for all times to come.

* * *

"FOR ALL TIMES TO COME, THIS SHOULD AT LEAST FEATURE as a clear and unsanitized chapter of our history. People writing histories today, they make me so mad! They are writing as if there was just one face to the people involved. Or they are writing about things they don't know. And one-sided is not good for the next generation either; people were real, human," says Kulbir, adjusting the hem of her kurta.

"I have known the big leaders, the famous militants, okay? Like, what they liked to eat, what they wore, they were real people. Look, we respect them because they gave up their lives, with honor, that's what we have to respect."

"Bad things happened too. Many were young, many had hardly seen life, just teenagers on the run from police violence turned fighters. So they also fell for things like, What should we do to get publicity, to get our name in the newspaper? So hanging a body from a tree. What kind of humanity or movement is that? All of that was complete nonsense, and was called out too. The inhumane impunity of the State, though, that was impervious to any questioning."

"It was a war, so account for that too. But as soon as police infiltrators came into the picture, things went downhill faster and faster."

So, by 1993, Kanwar Pal Singh Dhami was pursuing work at a friend's transport company in India's westernmost state of Gujarat. Kulbir took their young son, Ranbir Singh, to the state northeast of Punjab, Himachal, where a Sikh flag flew over a residential school, Baru Sahib, nestled in the foothills of the Himalayas. Kulbir began working in the hostel and enrolled Ranbir in school. In touch with Kanwar Pal through occasional letters, Kulbir was increasingly distanced from the movement spiraling down.

Then, on May 17, commandos landed at Kanwar Pal Singh's work. His friend's business partner, they would later learn, had tipped off the Punjab Police. In Kanwar Pal's pocket was an unmailed letter addressed to Baru Sahib.

On May 19, 1993, a police party arrived for Kulbir. A letter she wrote from behind bars details what transpired.[20]

As they nabbed my child that morning, I asked, What possibly could his fault be? They said they didn't know, these were sahib's orders.

Then, in the police vehicle, Inspector Ramnath started with dirty abuses. I warned him to stop this foul mouthing, and to follow the law. He yanked out his revolver, hit me, and then put the gun's nostril on my forehead, "Should I explain the law to you now?"

My child, witnessing this, began to cry.

I turned to the lady ASI in the vehicle to complain and she advised I stop speaking back to the Inspector and wait till we get to Tarn Taran and speak with his superiors.

We reached CIA Staff Tarn Taran that evening and Paramjit Singh Teja, DSP Bhikivind [...] took me to where SSP Ajit Singh Sandhu was holding court. At that time, all the police officers of Tarn Taran were sitting there. Jathedar [honorific for Kanwar Pal Singh Dhami] was lying flat on the ground, in very bad condition, with his legs injured down to his ankles, and blood flowing.

Presenting me, DSP Bhikivind said, "This is his Singhni, and she has a complaint that she was cursed at and treated contrary to the laws of India and Punjab!"

"Oh really? This female pimp has come to teach us the law?"

After two-three slaps, the SSP signaled to Ramnath, who unleashed a barrage of curses.

Then, finally the DSP said, "Now tell us, haven't we given your wife her due welcome?"

At this, Jathedar laughed: "You haven't done anything manly and neither is anyone else sitting here a real man. No one intervened on the attack against a woman. You are all imbeciles. You look like Sikhs, carrying the external identity, but shame on you"

He was stripped absolutely naked and a roller was applied ... with six policemen on a pipe put across him. Now, Jathedar was letting out weird sorts of screams. ... Meanwhile, I would be taunted, and occasionally slapped, as I was made to watch

Every three hours, a new party came to relieve the first torture party. Electric shocks, hanging upside down with a rope, pulling legs apart, rollers, beating with sticks ... his entire body was injured. ... Then, on the bloody wounds, electric currents would be applied. ... Still, when they asked him, "Now, how do you feel?" he would manage to laugh out

Like this, word about him spread. Not just in CIA Staff, but other parts of Punjab too. Various officers came, then one DIG came and told SSP Sandhu to notch this up, so Jathedar stops laughing. ... So DSP Paramjit asked his high command for permission to torture me in front of Jathedar

I was pulled into a special chair made for applying electric currents with ease. My hands were tied behind my back with my chunni. My legs tied to the chair's legs. A lady constable was called and ordered to start applying the current. It was applied to my eyes, tongue, ears. My teeth, clenched shut, and then they would slap, slap, slap, till I awoke.

My teeth were shaken, blood was flowing, and when things got really bad, then that Davinder constable revolted, and refused to apply more current. "There is some limit to cruelty, I can't do more," she pleaded.

Angry, the DSP called lady constable Sutinder. She followed orders, but soon enough, like Davinder, also refused.

Then ASI Ravinder Kaur was ordered to come forward. ... First she derided the two female constables. Then, she said, "I have finished countless like this one. That's how I am an ASI. Chandi [Hindu goddess of vengeance] *comes to me, and then I can't control my anger."*

She tortured me senseless ... destroyed my teeth. Jathedar was taunted, "Now laugh!"

... he started cursing and they started raining sticks on his body

His body could not take this. Now he kept falling, it was thought he was dying now. They had to inform the high command.

... IG Borders, DS Bhatti came. He was livid. He said Dhami should not die so soon

Finally, when Jathedar came to, IG Bhatti told him, give us even one of the five [militants you meet] and we let you go Jathedar refused. He asked to be killed instead.

Bhatti said, "I love children. But don't you force me to throw yours and your wife down a river"

Later, infuriated, Bhatti ordered Jathedar be beaten again.

Kulbir, Kanwar Pal, and five-year-old Ranbir Dhami would be in illegal, incommunicado custody, with no official arrest shown on books anywhere, for almost 11 months, some together, others apart.

"For a little while, the Dhamis had believed that if only they could get word out about where they were, Sikh leaders would come looking for them and Indian courts would rescue them," explains Baljit Kaur.

Kulbir elaborates, "See, our son, he was so little, he would be allowed to wander outside the cell some. We got him to steal some paper and a pen. And we started writing letters about where we were, what was happening to us. To the Jathedar of the Akal Takht, saying, 'Help us, and help us now.'"

One of the letters, written to the Akal Takht in the ninth month of their illegal custody, is dated February 24, 1994:

> *As Sikhs, we grew up with examples of Mughals, especially Aurangzeb, but the atrocities they committed, they committed per their law of shari'a, and out in the open ... but today, though we have faced equal, or more, hardship, it is all behind a curtain*
>
> *So many times we have asked to be brought out in public and punished ... it's a huge pity the people doing this are in Sikh garb. ... The Sikh community is the victim of a deep conspiracy. The ones orchestrating this, sit back and enjoy. A 5-year-old child is with us. India has broken its own Constitutional provisions and laws ... and of course international norms.*

"We know at least one letter was even hand-delivered to Akal Takht Jathedar Manjit Singh. We were being kept in Ropar. The person who delivered it is still alive. But nothing happened, no raid was requested. All he had to do was get a lawyer to go to court and allege there was this illegal detention center in Ropar."

Kulbir explains that these letters survive because she intended them to.

"See, the people taking them out were asked to make copies, and I made copies when I could. It wasn't one letter, it was smuggling out as many as we could. Written on paper upon paper our son would bring for us, and, to tell you the truth, these policemen were so very sure of their invisibility that papers, appeals, process didn't scare them; they didn't care, they were confident nothing would come of it, or of us. They were sure we would be dead soon enough."

"We gave letters to people who had themselves been picked up, tortured, but eventually released after some well-wisher paid the police. We also smuggled out some with the help of one policewoman. A year after I was released, I tried to find her. I learnt she had been killed. She paid a very heavy price for our friendship. If I had known, I would have at least immortalized her in my letters."

"All this one thinks about now, about all the others who were killed."

"I'll give you a booklet, if you want to read about more women too. I had compiled it right after I was released. I only have one copy myself now. I am no writer, I haven't been able to tell these stories; these letters were my witnessing, as it happened."

This booklet is the compilation of 26 letters written by the Dhamis.

"Through our own broken bodies rang the screams of so many others detained there, dehumanized there," remarks Kulbir reflecting on what she had penned over two decades ago, summer of 1993:

> *As we tiptoed around, when allowed to take a wash, or wash clothes, we saw the brutality. Old men, old babas, would call out in pain, and recount how their properties had been confiscated. How the police have usurped their lands, their vehicles, even beddings from their homes, and have not spared gurdwaras from lootings. ... These men called to me, muttering, rendered unhinged by police torture. What could I do to help them, though. One baba was the famous Kar Sevaa Baba, Charan Singh. ... I later witnessed some of the policemen leave in the vehicle stolen from him, headed to Pathankot. Then we heard they had met with a dreaded accident, the car was totaled and many seriously injured. One man's backbone was crushed and it is understood he will remain bedridden for life. Some policemen called this the curse of the strong baba.*

Since divine interventions were scarce, Kulbir held on to the hope of being discovered and legally charged soon. In a 1994 letter addressed to K.P.S. Gill, she recounts their anticipation when Gill visited the CIA center.

> *You had been invited and awaited on June 1993. All sorts of preparations were made. … Ajit Singh Sandhu had ordered the junior officers to each bring singing girls, and also cash. … There was, we heard, some sort of sabhiyacharak cultural festival earlier that day, and later, the special party was to follow. We heard the singing, the drinking. … you danced, and eventually left for Chandigarh with one of the girls ….*
>
> *We sat on the other side, waiting. Hoping you would come, you would see. And our arrest would at least be recorded.*

Through the summer of 1993, Kulbir kept experiencing heartbreak.

> *Gurpreet Kaur, from Shafipur, near Tarn Taran—I can never forget. Her only crime? She was the wife of militant Baljinder Singh, with whom she had spent like fifteen days. She was picked up and kept in illegal custody for eight months. Then, she had run away from custody with another woman, only to be caught again. She now attempted suicide by taking some pills. … She was all pukey and dying when the police threw her in my cell. I cared for her. After two days, she was feeling better. Then, suddenly, policeman Teg Bahadur Singh snatched her away ….*
>
> *She was taken back to Bhikivind and handcuffed in a men's center. Mr. Dhami was in detention there, and saw her. He saw my chappals on her feet and asked about me. That is how he learnt I was still alive … they kept telling him otherwise, threatening him, torturing him ….*
>
> *Three nights later, a DSP and Inspector CIA Bhikivind, Ravi Bhushan, came for Gurpreet. … And that was the end. She had told me that she knew she would die … her only hope was not to be touched by male police. When she was taken, there was no female constable with them.*

Kulbir explains it was no surprise Gurpreet was wearing her sandals. The few clothes, shoes, and basic essentials were often shared among detainees.

"It's not like they had told me, Go pack a trunk please. And pack the kiddo's trunk. And in those eleven months, no clothes were provided to us, we were often barefoot, and given where they were hiding us, often rats played on our bodies at night, or snakes crawled into the cell."

In a largely male secret center, how did the women manage their monthly cycle? Menstrual blood remains a topic of women's whispers even today; and Kulbir drops her voice after a short pause.

"No one asks. … Imagine though! How we managed! Even I haven't thought about it consciously now. But it was a nightmare then. Everything was set up to humiliate us. How did we manage? Some of the women employees there took pity sometimes and brought us stuff. Or we just sat there and tried to wash it away. Or used to pull out cotton from the quilts they gave us … but you had to balance that against not having a quilt to keep you warm at night. … We barely had a chance to wash and dry clothes, and they couldn't care less … we were half dead, really."

By August 15, which marks the Partition and is celebrated in India as Independence Day, the police revealed why the Dhamis were still alive. "They wanted us to play a 'surrender' charade ... for Mr. Dhami, the dreaded Khalistani, to declare before media that the movement had failed, that he had given himself up to the valorous police, and all that. But in August, the torture marks on us were too visible. They had to postpone their grand plan."

Kulbir says the police also repeatedly showed them letterheads of various militant groups, boasting that the police could have anything announced, at any time. The screws continued to tighten. And not only on the Dhamis. "Countless screams and scenes merge together now," remarks Kulbir.

In her chronicles, she vividly describes men like Manjit Singh. Wide hands, broad shoulders, he was just as strong mentally: he refused to cry out during torture. As he hung naked and was abused, his silence begot resentment from the torturers who wanted to hear a cry, a "Hai."

"He was accused of something like transporting a gun in his milk drum for some militant. So now, okay, try him. But what was this? Eliminating a person because he refuses to say Hai? But none of this was surprising then."

Then Kulbir heard a relative of the Punjab Chief Minister Beant Singh had been attacked, allegedly by Sikh militants seeking retribution for the scorched-earth campaigns ordered by the Chief Minister.

News of the militant attack came, don't know if it happened or not. But CIA Staff in Ropar got orders that action was needed, scapegoats were needed. Four Singhs were needed. Now there was a haunting silence and fear. ... Four men were made to bathe. Manjit Singh was allowed to bathe for the first time in months. ... Then in front of us, their physical features and any marks were noted down. After this, their hands tied behind their backs, their heads covered, they were thrown into a vehicle. ... Around four or five o'clock the vehicles left, and around nine o'clock the staff returned ... their celebrations ensued ... alcohol flowed.

Even those with cases before courts did not at times escape a similar fate. "Cut off his jewelry," Kulbir heard in October 1993. She then witnessed an ironsmith brought in to cut prison chains off a 24-year-old militant. Meanwhile, the senior officers taunted the other prisoners that courts and judges held no hope for them—as was being demonstrated.

The essential bright line in the Indian criminal process between "judicial remand" (prison after court appearance) versus "police remand" (jail under purview of arresting police, before court) had been bloodily blurred. The Dhamis' sustained plea for a court date, conveyed in each of their smuggled letters, began to feel more pointless. They were not the only ones losing hope.

Kulbir writes of police commandos expressing desperate shame. Many felt their new job requirements had forced them to become executioners. She remembers the several female constables whom she befriended: "They were forced to watch torture. On various occasions they came crying, and we talked, and they unburdened their hearts. Like when they were mocked and made to walk by where naked men were being humiliated. Or made to attend when prostitutes were brought in and treated disgustingly. It was very dirty."

Many of these constables were widows of police officers who had been killed on duty. The women had received their jobs on compassionate grounds, an otherwise coveted reparation for fallen servicemen because of the security and perks of a government job in India. "They would lament, what good is this employment? It is so shameful … but if we quit, who'll feed our fatherless kids?"

By 1994, with the reduced threat of the militancy, the Center began slowly curtailing the hitherto unlimited funds of the Punjab Police. Another of Kulbir's surviving letters explains a scheme devised in response:

Kabal Singh had been serving the police's purposes as a police cat. He was living right there, right in front of our eyes, in CIA Staff. Now, the police gave him a foreign revolver and sent him to Delhi. …Then, they arranged for the Delhi police to arrest him, and the news came, Look, we have caught a Pakistani trained terrorist! Spread panic in Delhi that he was there to kill important people. … Radio, TV, and other media carried and were made to carry this news, that a great travesty had been averted. Then, Punjab police requested his transfer, saying they needed him for further interrogation regarding weapons and such. … This was granted. We saw a police party leave to retrieve him from Delhi. Then, near Ropar, he was officially reported to have escaped. … But we saw him walk into CIA Staff with the police party. He walked by our cell, and he gave my child some Jalebi sweets. I laughed on seeing this and said "Per the papers you have escaped from the police!" He cursed the police and said, "These bastards have had me escape countless times … the awards they claim for themselves, and for us, they aren't even happy sharing a cup of tea."

As winter gusted into their secret cells, Kulbir survived with the warmth of new friendships. One old woman, who provided her maternal strength during detention, was the mother of a police constable. Her other son had joined the militancy. The constable brother had convinced the militant brother to surrender to a senior police officer who had promised legal process. Soon after the surrender, the militant brother was killed and the mother arrested with a facetious, "Where is your son?" She was often told by the detaining police officers that they knew her son was dead by police bullet, but on paper he had been shown as an absconding militant, and she, an accomplice. "This is what happens when you go against police establishment."

January 26 marks Republic Day in India, and on this national holiday, again, Dhami was being prepared to act out the surrender. At the last minute, Dhami declined, further incensing the police officers.

"Meanwhile, none of our leaders had done anything with the information we had smuggled out to them. They too perhaps thought we wouldn't live to tell."

While I was caged, I heard news about Women's Day, and the spirited celebrations in the world outside … about the rights and protections of women. I had written so many letters to male leaders, and was exhausted. I thought I would write to a woman leader, as a woman. I wrote to Bimla Dang. These communist leaders are persuasive orators too.

"It is true they were kept in secret custody, but that does not mean no one knew of their plight," says Baljit Kaur. "Through their sheer willpower they had managed to inform the highest Sikh body, the Akal Takht, about where they were. And informed other leaders. Somehow, the more inhumanity they saw, the more they just resisted, with their young child too!"

In a March 11, 1994 letter, the Dhamis gave full custody of their son to Iqbal Singh of Baru Sahib, and provided information about a family member who could bear any expenses if needed, *but please under no circumstances should this child return.*

Remembers Kulbir, "A few months into the detention, some slightly sympathetic policemen agreed to take him back to Baru Sahib and leave him there, spare him the torture. What happened? Baru Sahib refused to take him! Not only had they done nothing to report his abduction, or mine ... they refused to take him back from their own doorstep."

Kulbir wrote again:

Couldn't you keep him as an orphan? Have so many funds coming in for orphans. There are so many religious and enlightened people running this organization. ... What do they have to say to this?

Young Ranbir regularly heard and saw depravity. The mango tree outside the Dhamis' cell was only ever laden with human bodies, suspended for torture. At times, Ranbir was able to sneak water to the prisoners.

Another boy in the secret cells developed the routine of paying obeisance to this tree.

From Chamkaur Sahib fair they had picked up two Amritdhari boys, Dalit Sikhs, who sold karaas and kirpaans, and had no involvement at all. They spent months with us. One of them would wake up every morning, and addressing the tree as Amb Sahib, would bow in front of it. He said, this is no ordinary tree.

"Our biggest fear was that we too would die without a murmur."

The Punjab Police now specialized in "encounter killings." In 1994, Kuldip Singh Manak, a whistleblowing Punjab Police constable, filed a writ in the High Court, requesting a CBI investigation into all the fake encounters to which he had been an eyewitness. A judicial opinion 14 years later, during which time Manak himself faced persecution, noted the conveniently uniform pattern of "encounters" in Punjab:

This has been followed as a usual and routine practice by the Punjab Police either to show that a terrorist while being carried from one place to another had escaped or died in an encounter while the police party was taking a particular person and [was] ambushed by a terrorist outfit. The strange phenomena as would be noticeable in all these cases would be that none of the police officials would even receive a scratch while bullets are fired leading to deaths of some terrorists. Is it normally possible? I say nothing in this regard.

Perhaps, the police is not aware of what happens during ambush as it is yet to encounter any real one.[21]

The Dhamis began hatching a plan to protect against dying in a fake encounter. "When again the surrender charade was mentioned, Mr. Dhami began to show the police signs of resignation. Internally, we had stood up with Ranbir and done a secret ardaas, standing before the Guru, accepting the death that would come to us. I was pregnant, too, at that time."

On March 26, Kanwar Pal Dhami was taken to the famous Holla Mohalla at Anandpur Sahib, for his anticipated "surrender." Against the traditional Sikh martial arts showcase at that year's Holla Mohalla, other orchestrated police games played out, but Kanwar Pal was ultimately told by one of the policemen that his big announcement would have to wait: Director General of Police (DGP) K.P.S. Gill had had too much to drink the night before and was unable to attend.[22]

Then, on March 29, a large press conference was called at the residence-cum-mess of K.P.S. Gill. A puffed Gill sat in front of the photographers, reporters, and a TV crew to announce the police's victory over the dreaded Dhami. Correspondents craned their necks to report another fatal nail in the militancy coffin.

Dhami began addressing the press. He departed wildly from his script. He declared his continued love for his cause of Sikh freedom, informing the press this was all a charade, how he and his wife and child were all being held in illegal custody, their lives on the line.

"If it weren't for the daring quick thinking Dhami showed in front of Chandigarh's press, they would also have been killed," says Jaijee.

"There was certainly an uproar," remembers Justice Bains. "Dhami had effectively saved his life and his family's by daring to take this chance. As muzzled and petrified as it still was in 1994, the press had to report this sensational volte-face."

Not everyone in the Dhami family survived, though.

"They were so mad, so embarrassed, so dumbstruck," remembers Kulbir. "They couldn't kill us, could they? But they would get pretty close! After that press conference, we were ushered out of the secret cells. To a court, you are thinking? No! Somewhere unknown, in front of a judge, where the police said, 'They are alive.' The judge did nothing to protect us. That intervening night on the way to a jail, they took us somewhere, and we were tortured mercilessly. I begged them not to hurt my baby. I began bleeding and miscarried that night."

Kulbir would spend three weeks in hospital bleeding and recovering from this retributive torture.

Then, from Patiala Jail, she continued letter writing, attempting to alert the world to the continued threat and listing the various other cases to which they could testify. The Dhamis were eventually transferred to Burail, a jail near Chandigarh, closer to their lawyers and the High Court.

"Oh, let me tell you about Kanwar Pal Dhami in Burail," says Jaijee, who was arrested 17 times and sent to jail five times during the 1980s and 1990s. "Usually I was taken to the police station in a huff, made to sit for about half a

day, while they shuffled papers, and later in the evening, often sent home, fewer times, sent to jail. Once, they took me straight to Burail Jail. It was very interesting."

Jaijee leans forward with a grin: "My wife Daljit, she was also there, because she had, as she often would, just followed in a car behind. And the jailer starts talking very politely, sharing his wife was also from my wife's area, and all that."

"'We'll take very good care of you, Sardar saab, don't worry. We'll give you the best accommodation.'"

"What would that be?"

"'We'll put you in the special cell with Mr. Dhami and you won't be disturbed.'"

"Do you have your listening devices in place then? I laughed. He laughed."

"'Okay, then we'll keep you someplace else.'"

"And so I stayed far away from the prized prisoner they were waiting to implicate further. I must have been in for ten to twelve days that time. On average it used to be a week. Of course, no legal case was filed. No case was ever filed."

Jaijee's daughter Harman remembers that her father was always conscious of the comparatively grotesque conditions of most other detainees. "He never expressed any fear or resentment. It was taken in the course of things. He always had bigger things to focus on," she remembers.

"You know, I was in first or second year of college. And got a call. Papa was calling to tell me he had been arrested again and I should come drop off a gadaa and chaddar. Not, bring this aunty-uncle, or find your mother, or bring so-and-so with you. We were raised to be determined to be fearless in that sense. My bigger worry was locating the appropriate bedding he had asked for!"

"My father has always been extremely forward-thinking. The father of two daughters, and the usual retrograde things people say, but he didn't curtail us at all."

Harman's ever effervescent face lights up more, as she sips a cup of green tea in a room adorned with family photographs of her mother, elder sister, and niece, who are no more.

"We saw documents lying about, related to his work, but other than that, the individual cases were not discussed. Remember, my mother was a senior government officer. They were already on very tricky ground with my father's activities."

On July 10, 1994, an explosive scandal put the government in the dock. Punjab Governor Surendra Nath had been killed in a plane crash. The press soon began to reveal large amounts of cash recovered from his residence in Chandigarh.

"Part of the plan to break up the Sikhs had been to pump various sects, various deras," Jaijee conjectures. "And Surendra Nath for one had been busy boosting the deras. Sachaa Sauda, Radhaswami, all came into prominence, and money, around then!"[23]

While speculation continued for months, investigative journalists writing in February 1995 revealed the unsurprising nature of the coffers:

> Commonly known as the Discretionary Fund, the amount, which varies from Rs 50 lakh to even Rs 50 crore, is available to the governor to be used as payment to sources and informers. As a former governor revealed: "The source can be political, he could be a terrorist, a gun-runner or an agent willing to cross the border into Pakistan."
>
> Though the governors have to get the money sanctioned from the central government, giving reasons why they are asking for sums which run into crores, once they get the money, misuse cannot be ruled out because all the governors have to do is make a note saying the money was used to pay a political source or a terrorist, as the case may be.[24]

The summer of 1994 continued ringing with reports of "final" police victories over the militants. Explains Jaijee, "They were mopping up so the larger system could claim supremacy over the militancy. Trying to reap some final rewards, the police began announcing killings of boys they had already killed, or of those who had run far away from the militancy. And so, there was a criminal dissonance between who they declared dead and who they killed. That's how dead men later started walking back to Punjab!" Jaijee has documented several cases of such undead.[25]

But the crime that had every media house's attention that summer is the one also registered in my childhood memory by the victim's slender face, mop of curly hair, and foreign name: Katia. A 24-year-old French female tourist in Chandigarh had reportedly been abducted and sexually abused by one Gurkirat Singh, accompanied by heavily armed bodyguards. Gurkirat Singh was the grandson of Chief Minister Beant Singh.

The sexual nature of the crime, generally reported in the news as "molestation," and the Caucasian victim-survivor, provided endless titillation for the press and politicians alike. The woman's name and her passport-size photo became ubiquitous. Opposition politicians reportedly sang parodies about the case, including one that mimicked a popular recent Bollywood song about a spoilt, rowdy son.[26] Chauvinistically, it focused entirely on the problem posed for the alleged rapist's high-profile family. Conveniently, it coupled rape and sexual frustration for unmarried men; rape and dishonor for women.

The "Katia case" also allowed for airing of a litany of allegations against Beant Singh's grandsons, including Gurkirat. After Beant Singh became Chief Minister through the notorious 1992 election, they had on many occasions employed their armed guard as immediate shield, and familial connection as absolute right, to violate citizens and then vitiate complaints.[27]

Forwarding herself as an eyewitness to several hitherto unsolved cases during Chief Minister Beant Singh's reign, Kulbir Dhami continued her voluminous letter writing.

Rajvinder Bains explains that the litigation of Punjab's human rights cases had only become possible around that same time. "The court also started

interfering, only after ninety-four. Before that we were also discouraged, and had stopped filing. Then in ninety-four, judges were rotated and one third of High Court judges came from outside Punjab. They started taking action, interfering in the police's activities."

There is a pause to muse how the language used by the State has been internalized: interference.

"I think it was after Venkatachaliah became the Chief Justice of India. He came here in ninety-three and heard about the impunity. He later introduced the policy of transferring judges out of their home state. And then the High Court resumed taking the petitions, ordering inquiries, and at least transferring some accused police officers. Really any case that has seen any light, is after 1994 and 1995."

"The essential right of habeas corpus was de facto suspended for years before that. Of course it was there in formal law all along," explains Rajvinder.

On August 25, 1994, Kulbir Dhami wrote to Justice Ranganath Misra, chairman of India's National Human Rights Commission (NHRC), also a new phenomenon. India adopted the Protection of Human Rights Act (PHRA) in 1993, under sustained pressures, internally and internationally, over rights violations in Punjab, Kashmir, and its northeast border states. Under the PHRA, the quasi-judicial body of the NHRC was institutionalized, officially commencing work on October 12, 1993.

In her letter to the NHRC Chairman, Kulbir recounts Advocate Kulwant Singh's case, about which she had learned the most damning details during detention in Patiala Jail.

Harpreet Singh Lucky, from Ropar, mustache-sprouting youth, who used to sit at his Dad's shop and pass his time. ... He was in illegal police custody, being tortured mercilessly. ... Around the same time, Advocate Kulwant Singh had died under torture at police hands. And to erase any evidence, his wife and baby were killed too. People, especially the Bar Association, were raising noise around this case. The police needed a confession. Harpreet Singh Lucky was chosen. He was told that, should he not stand by the police version of his confession, he would be killed the way he had seen others killed, and all his relatives would meet the same fate. So a police conference was called and Lakhi confessed the murder of Kulwant Singh and his family. Then, he was slapped with TADA and sent away to Patiala Jail ... he was not allowed to meet anyone from outside.

In an earlier letter, Kulbir had described the fate of the police constable, Prithi, widely known to have killed Advocate Kulwant Singh's toddler son.

Since then he has been mentally imbalanced, a little crazy. He remains intoxicated all the time. He has tried to commit suicide on several occasions, because it is very well known in the entire Staff that the two-year-old won't leave him in peace. Just a little while ago, he jumped off a roof, his body was injured, but he survived. [Senior police officers] locked him in a cell, wherefrom he would loudly cry out curses. "The Inquiries are still on in the courts, bastards, and you have me handcuffed! Keep treating me like this, and I will tell all."

Kulbir's own son continued to be displaced, with no remedy for his trauma, and she wrote to the NHRC Chairman:

We weren't kept by human beings for those eleven months. … But now, can we disclose what all we withstood, all that we have witnessed? Instead, we've had TADA slapped on us. But there should be some limit to shamelessness, that a child who saw his sixth birthday in secret illegal custody, has also been charged under TADA. This may be the youngest TADA case ever.

The notorious TADA—Terrorist and Disruptive Activities (Prevention) Act—was liberally employed against Sikhs in Punjab. Its provisions allowed secret witnesses, shifted the burden of proof to the accused to prove their innocence, and admitted confessions before the police as damning evidence in the courts, thereby incentivizing and normalizing admissions by torture.[28]

TADA was eventually repealed in 1994, after being decried as incompatible with human rights standards by several national and international organizations.[29] TADA's repeal was unsurprisingly not retroactive, and was not followed by any corrective laws. Those charged under TADA have to continue to defend themselves under TADA, even today.[30]

"It destroyed things forever," says Kulbir. "That was its aim. Take my children. After the press conference, after our existence was impossible to ignore, Ranbir was released, bailed out by my father-in-law, and then for one year he just survived going relative to relative. At some point, the Jathedar of the Akal Takht sent a message to Baru Sahib to take him back. … This time they did. He grew up there, till ninth grade. Then, he came to Chandigarh. They had expelled him. They had used their disciplining on him too; they said he had behavior issues. He has had back issues since."

"And I had a daughter before the abduction in 1993. Her, I had left with friends when I went under an alias to Baru Sahib. Well, in the years she lived away, she was told, 'Look, look, your mother didn't take you because you are a girl!' That just sat heavily in her heart. She always felt I abandoned her."

Only when pushed to elaborate on the reason why the girl child was left behind, Kulbir says, "Well, Baru Sahib had promised children could study for free if the mother worked there. But when I got there, they realized my daughter was only a few months. I had to leave her, so I could work, and the older child could begin school. I had no other means then."

She sips water and continues. "I tried. Once back, I tried hard. I even told relatives, No one take her in. She will have to come take me up on my offer, live with me, and be reunited with me. That didn't work either. Last year, she got married. … She never understood. Only my youngest son, who was born later, only he got to stay close to me, and was raised by me, and lives here with me."

She is done talking about her immediate family. Her voice amplifies again:

"At that time, we thought it was for something, for a change that naturally had to follow this kind of injustice. Khalistan was a common ask, it was a com-

monly accepted call. It was not some dirty word, but a real political option. At that time, we were part of that call, we had lost our all for that call."

In April 1994, Sikh representatives had submitted a memo to the Secretary General of the United Nations on his India visit:

> In this hour of crisis, the Sikh nation appeals through you to the nations of the world. ... Demilitarisation and decolonisation of Punjab is crucial and indispensable if the Sikh people are to enjoy full freedom and exercise their economic, social, and cultural rights, in accordance with the UN Declaration on the Granting of Independence to Colonial Countries and Peoples, and seeks an independent sovereign state to break the shackles of apartheid, slavery, colonialism, and a retrograde political system and structure.[31]

Then, in May 1994, in preparation for the 1995 election, key Punjab players signed an "Amritsar Declaration," forwarding their collective call for freedom for the Sikh community to practice its faith without any interference.[32] "See, there was a lot of horse-trading and infiltration at the political party level too, and some leaders had begun to make deals with the Center, so this was an effort to bring everyone on the same page again, and reiterate the Sikh bottom line," explains Jaijee.

As soon as she was released from jail in 1997—exonerated of any and all criminal charges—Kulbir witnessed that the political rhetoric did not translate into practical relief for families like hers. The promise she had made to Monu's Mummy felt all the more imperative:

> *A most haunting spirit is of Surinder Kaur, young Monu's Mummy. She had been taken away right from me ... her son, she had left in my lap. ... Surinder was a principal of a school in Tarn Taran, with 400 students. ... Her husband had been in the Indian Army and now worked as security in a bank in Amritsar. He was picked up under allegations of harboring militants. And so the family was brought here, young child in tow. They were accused of sheltering Ramesh, a Hindu Pandit boy who had joined the Sikh militancy. She was tortured a lot. Four times a day they would take her. She wanted no men to touch her body. But that is what happened.*
>
> *It was about eight PM, they took her away, dragging her while beating her. And she kept yelling for Monu, saying to me, he is now your responsibility. ... They killed her that night. Even one of the policemen was crying. He said, "We told her to do paath, and as she prayed, shot her." When she was killed, she was wearing one of my suits. Some policemen would taunt me, Well, she took your turn. ... The next day, her husband and other men were taken, at two or three in the morning. I read about their supposed encounter killings in the papers. Didn't see anything about Surinder Kaur.*

In another letter, Kulbir recounts how after Surinder Kaur's murder a Hindu officer from the Central Reserve Police Force (CRPF) remarked, "Once, one Draupadi was pulled by hair, and her clothes grabbed at ... but here, this is happening every single day." In the Hindu mythological epic, Mahabharata, Draupadi's dishonorable treatment was seen as a justified cause for the war of the worlds.

"Monu's Mummy and I had vowed in jail that should one of us survive, we would care for the other's child. I couldn't stop thinking about that." Kulbir went to find Monu after she was released. After many inquiries, she located him, living with relatives. "I realized he was doing better there than in an orphanage. I felt a little assured. And they told me they would make sure he kept in touch with me. I returned, but kept thinking, there are so many other children of the conflict whom no relative will even grudgingly take in, what about them?"

Kulbir began searching for a space to open an orphanage. She went to the SGPC in Amritsar and was offered a free space in Anandpur Sahib. Her lawyers refused. "They said, we can't go chasing after you, should something happen. You need to stay safe here, in Chandigarh."

In Chandigarh's satellite city, Mohali, she found one willing landlord who rented his house for her orphanage. The SGPC promised food rations would be covered by nearby gurdwaras Amb Sahib and Nada Sahib. "So in March 1997, I moved right into this house. Have been here ever since. That April, their first day of school, the children went from here."

Baljit Kaur remembers how the creation of this now famous GurAsra, Gur-Reliant, Orphanage, was hardly certain in those days. "Remember what time we are talking about. Renting to the famous, or infamous, Dhamis meant being on the radar. The landlord was an ordinary Sikh, a bravehearted Sikh. Just did what was right, wanted no accolades—such people too silently live amidst us!"

Kulbir Dhami is no stranger to controversy and aspersions, long after her legal exoneration. Her orphanage, she says, is her strength and her witness.

"Even today, there are young children no one will shelter, because they are caught up in the government's renewed interest in some so-called Khalistani case," explains Justice Bains, who remains a board member of GurAsra Trust.

For example, one of Kulbir's millennial residents is a young girl who was left homeless when her father was arrested for shielding Narain Singh Chaura. Narain Singh had led the Akal Federation after Dhami had to flee. Then he spent much of his time, after his own release in 1997, exposing human rights violations. He volunteered for Bains's Punjab Human Rights Organization (PHRO) as well as the Committee for Coordination on Disappearances in Punjab, documenting disappearances and secret cremations in his Gurdaspur district.

"We would hear how he sat and wrote eighteen hours a day sometimes. At a stretch. That was his commitment. After the fighting had worn down, he continued exerting through his pen. He exemplified the idea of saint-soldier," says Kulbir.

His pen had attracted malevolence since the 1980s. A 1989 video by Baljit Kaur records her trip with Justice Bains to Narain Singh's ancestral Chaura village soon after a police cordon-and-seal operation.

Justice Bains remembers this well. "Yes, their village was on the border with Pakistan. It was very hot, politically and physically, very hot when we went. I think August. And the car wouldn't go to their village in those days. It stopped two kilometers in advance. ... I told Bibi Baljit, 'You stay, let me go see.' And she said, 'Not at all, I'm walking over with you!' She is very tough."

In their video, Justice Bains and Baljit Kaur are audibly shaken by their interviews in the immediate aftermath of the collective punishment.

A man describes the belts used against the villagers, made to lie prostrate on the ground for public flogging. "Most boys here, their legs, their backs have been peeled ... their buttocks."

Meanwhile, their homes, where their wives and children hid, were looted. "They took flour, they took the rice, they took the pulses and the masalas we had stored in the kitchen. The police took our dishes."

Other villagers explain the repeated violence against Narain Singh's old father and various family members. Later, women quietly point Baljit Kaur to large iron locks on old doors whose carvings speak to a time where design rather than defense was the primary concern. "Many many people have just fled; there is so much fear. The cattle are roaming around without their masters, and animals are dying hungry."

This was one of several times Narain Singh's extended family was tortured as punishment for his activities. Over the years, his parents, wife, young sons, brother, brother's wife, and nephews would face a slew of arrests, charges, and detention. Narain Singh himself would continue defending against a litany of charges.

"He's tough as nails, and his steadfast wife is perhaps even tougher!" says Rajvinder Bains, who has represented Narain Singh a few times out of the near dozen times he has faced trial. Mostly, Narain Singh has self-represented, and successfully. The activist-writer has also authored eight books.

"But especially since 2010, there had been increased worry for Narain Singh's safety, given that latest roundup," explains Rajvinder Bains. In yet another period of "heightened security threats"—the cyclical occurrence in Punjab, often timed around political events and largely attributed to "cross-border" and resurgent "Sikh extremism"[33]—2010 saw the arrests of alleged militants in connection with the seizure of over 15 kilograms of RDX explosives and other weapons. Five higher-profile "terrorists" were reported as the masterminds for "trying to revive terrorism in Punjab."[34] Narain Singh was the sixth alleged conspirator, and went into hiding, fearing he would be murdered.

His fears were not unfounded. Of the other five arrested in 2010, Pal Singh, a French national, was tortured and spent two years in jail pending trial; Kulwant Singh reported torture, leading to an inquiry being ordered by the High Court, during which period he died in custody, of severe burns, ostensibly a suicide; and Sohanjit Singh was tortured and died in police custody, his death also called a suicide.[35]

Says Rajvinder Bains, "Narain Singh had made the mistake of not surrendering himself, but he was following his survival instincts. What happened after he was caught in 2013 exemplifies why he deeply distrusted the system." In 2013, he was arrested, and denied a physician to tend to injuries and infections he maintained he received due to torture by police under the command of then Punjab DGP Sumedh Singh Saini. Narain Singh would not receive bail till 2018. Several others were arrested in connection with his 2010–2013 time underground, accused of sheltering him. One such accused's daughter lives at Kulbir's orphanage.

"It's not really over, the continued hounding, the police justifying their existence," says Baljit Kaur. "And so the work that seemed short-term, emergency work of starting an orphanage while society was maddened with hatred even for the children of those killed and then blamed for their own deaths—that has remained Mrs. Dhami's full-time work. Because little other relief ever came to these families."

Monu and Kulbir lost touch for years. "But then, some years ago, I received a surprise call from a grown Monu in Australia. He talked for so long. He asked me anything I remembered about his parents. I remembered it all, of course. But when he pressed for how they were killed, who did it, I told him, Betaa, let this go. The fact that you survived makes us all happy. But I won't tell you about their end. I want you to thrive."

"You know, we don't want a young person to get angry and start down any journey that gets them in trouble. Because there is no justice to be had, even today. We just want these few survivors to now live their lives."

NOTES

1. See, Swanee Hunt and Cristina Posa, "Women Waging Peace," *Foreign Policy*, 124 (May/June 2001): 38–47.
2. See, Mark Tully and Satish Jacob, *Amritsar: Mrs Gandhi's Last Battle* (New Delhi: Rupa, 1985), 52–72; Iqbal Singh, *Punjab Under Siege: A Critical Analysis* (New York: Allen, McMillan, and Enderson, 1986); Subash Kirparkar, "Operation Bluestar: An Eyewitness Account," in *The Punjab Story: Reissued on the 20th Anniversary of Operation Bluestar* (New Delhi: Roli Books, 2004), 104–07.
3. See generally, Chap. 10.
4. While fewer accounts of sexual violence made it to the media and human rights reports (e.g. Punjab Human Rights Organization, "The Rape of Punjab: Indian State's Indignities on Sikh Women and Children" (1989); Jaijee, *Politics of Genocide*, 200–03), such accounts are well-known among Sikhs of Punjab. The stories are often told with pseudonyms, and without details or after extracting promises of confidentiality, on verifying the strength of the interviewer's solidarity. Indeed, generally, euphemisms abound in describing incidents of sexual violence, and as a protective measure most people speak of cases they have "heard of," generally "in another village," far enough from their village or villages where their own daughters may be married. See also, Cynthia Keppley Mahmood, "The Princess and the Lion," in *Fighting for Faith and Nation: Dialogues with Sikh Militants* (Philadelphia: University of Pennsylvania Press, 1996), 213–34. The punishing process in the exceptional cases where women did report rape, and then doggedly pursue their rapists, further confirmed for the community the futility of entering systems that would only revictimize. See, Roxanna Altholz, Angana Chatterji, Laurel Fletcher, Mallika Kaur, "Access to Justice for Women: India's Response to Sexual Violence in Conflict and Social Upheaval" (Berkeley: International Human Rights Law Clinic, 2015) ("In Punjab, [the victim] filed her initial complaint in 1989 and, the court issued the convictions in 1997—eight years later. During those eight years, [the victim] attended more than 80 court hearings and lived in hiding for fear of retribution while officers allegedly tortured her family members and burned her home." The report notes, "While the three officers were convicted of rape, the process was lengthy, onerous, and

dangerous for the victim and her family. The police department failed to properly investigate the incident or discipline the officers. Additionally, there is no evidence available that the acts of intimidation or torture suffered by the victim's family were investigated and those responsible punished.")

5. For her wise exposition on "Choice," Joan Williams, *Unbending Gender: Why Family and Work Conflict and What to Do About It* (New York: Oxford University Press, 2001).
6. The few accounts of these women militants quickly ascribe to them male-like tendencies, reinforcing the hypermasculinization of the Sikh movement. See, for example, Laurent Gayer, "'Princesses' among the 'Lions': The Militant Careers of Sikh Female Fighters," *Sikh Formations: Religion, Culture, Theory* 8, no. 1 (2012): 1–19.
7. Khushwant Singh, *History of the Sikhs, Volume II: 1839–2004* (New Delhi: Oxford University Press, 1999), 161–62. An overwhelming number of those hanged for the failed Ghadr were army mutineers. In the frequent retelling of the Ghadr, perhaps because this is done in Punjab almost exclusively by today's leftists, there is hardly any mention of these (almost exclusively Sikh) hangings of mutineers.
8. K.S. Sarkaria, "Sohn Lal s/o Vaso Mall," March 21, 2015, citing from "List of persons killed in the Jhallianwala Bagh on 13th April 1919," compiled in November 1919.
9. See, Rajmohan Gandhi, *Punjab: A History from Aurangzeb to Mountbatten* (New Delhi, India: Aleph Book Company, 2013), 285–86.
10. Meghnad Desai, *The Rediscovery of India* (New Delhi, India: Penguin, 2009), 139.
11. See, Gandhi, *Punjab*, 286.
12. Khushwant Singh, *History of the Sikhs, Volume II*, 197.
13. Khushwant Singh, *History of the Sikhs, Volume II*, 203–04.
14. Paul Wallace, "Religious and Secular Politics in Punjab: The Sikh Dilemma in Competing Political Systems," in *Political Dynamics and Crisis in Punjab*, Paul Wallace and Surendra Chopra, eds. (Amritsar: Guru Nanak Dev University, 1988), 12.
15. See, J.S. Grewal, "Sikh Identity, the Akalis and Khalistan," in *Punjab in Prosperity & Violence: Administration, Politics and Social Change 1947–1997*, J. S. Grewal and Indu Banga, eds. (New York: K.K. Publishers: 1998), 89–91.
16. See, for example, G.K.C. Reddy, ed., *Army Action in Punjab: Prelude and Aftermath* (New Delhi: Samata Era, 1984), 75.
17. Gurtej Singh, *Chakravyuh: Web of Indian Secularism* (Chandigarh, India: Institute of Sikh Studies, 2000), 38.
18. Bhagat Singh, Letter to the Punjab Governor, available at http://www.shahidbhagatsingh.org/index.asp?link=bhagat_petition.
19. See, Karamjit Singh Aujla, *Ankhile Sardar Di Gaurav Gathaa* (Ludhiana, India: Seva Lehar Parkashan, 2011), 128.
20. From Dhamis, *Sachaai ki Hai?* (What Is the Truth?), compiled letters from 1993 to 1994. On file with author.
21. *Satwant Singh Manak v. State of Punjab*, Judgment in matter of C.M. No. 20940 of 2007 & Civil Writ Petition No. 14941 of 1994, April 1, 2008.
22. On Gill, also see, for example, "I wondered afterward whether it becomes easier or more difficult to do what Gill does—round up the angry young men, supervise the interrogations and torture and killings, take the war to the enemy—if

you think like this. Gill seemed to find some solace in it, or else in his whisky. To me, this sort of nihilism was more chilling even than the purposeful, visible state murder in the Sri Lankan jungles." Steve Coll, *On the Grand Trunk Road: A Journey into South Asia* (New York: Random House, 1994), 172.

23. Sants and Babas [holy men] and their deras [centers] had been around since much before. "[T]he phenomenon of deras is … as old as the Sikh faith. During the period of the historic gurus, different deras of udasis, minas, dhirmalias, ramraiyas, handali, and that of massandis cropped up. All these earlier deras were primarily the outcome of the disgruntled and unsuccessful attempts of the 'fake' claimants to the title of guru [internal citations omitted]. Apart from these, there were many more deras that came up at different intervals on the long and tortuous consolidation of the Sikh religion." Ronki Ram, "Social Exclusion, Resistance and Deras: Exploring the Myth of Casteless Sikh Society in Punjab," *Economic and Political Weekly* 42, no. 4 (2007): 4066–74, 4067. However, dera's resources, political party-backing, and related clout and significance to electoral politics grew through the conflict years. Today, many of the estimated 10,000 deras in Punjab are all the more significant to electoral politics because they have become centers of Dalit organizing and thus sway prominent voter banks; of all Indian states, Punjab today has the highest population proportion of Dalits. Favor to one dera over another is not simply along caste lines either. Some deras remain politically inconvenient, particularly when they challenge powerful elites. For example, hundreds of followers of a Kabirpanthi dera, led by one Baba Rampal—who fell foul it seems of overwhelmingly Arya Samaji activists—have recently been jailed and even charged for "sedition." See, for example, "Sant Rampal: All You Need to Know About the Kabir Panth Leader Accused of Murder, Sedition," *India Today*, August 29, 2017.

24. Ramesh Vinayak and Harinder Baweja, "Pay-off Secrets," *India Today magazine*, Special Report, February 15, 1995.
25. See, Jaijee, *Politics of Genocide*, 124.
26. See, Praveen Swami, "Grandsons on the Rampage," *The Week*, September 25, 1994, 36.
27. See, for example, "Grandsons on the Rampage," 37.
28. Amnesty International, International Secretariat, *India: Human Rights Violations in the Punjab: Use and Abuse of the Law* (Amnesty International, 1991), 34–35.
29. See *Lawless Roads, A Report on TADA: 1985–1993* (Delhi, India: People's Union for Democratic Rights, September 1993); Ujjwal Kumar Singh, *The State, Democracy and Anti-Terror Laws in India* (New Delhi, India: SAGE Publications India), 2007.
30. See, for example, Anju Agnihotri Chaba, "We Pleaded a Lot to Court, Said He Couldn't Look After Himself," *Indian Express*, October 18, 2015.
31. Jaijee, *Politics of Genocide*, 341.
32. See, Gurharpal Singh, "India's Akali-BJP Alliance: The 1997 Legislative Assembly Elections," *Asian Survey* 38, no. 4 (April 1998): 398–409, 402.
33. See, for example, "Punjab Police: Fabricating Terrorism Through Illegal Detention and Torture: June 2005-August 2005," *Ensaaf*, October 5, 2005.
34. "Punjab Police Recover 15 kg RDX, ammunition," *IANS*, August 1, 2010.
35. See, "Jail Inmate Succumbs to Burns," *The Tribune*, February 15, 2012; "SAD for CBI Probe into KCF Ultra's Death in Custody," *Zeenews*, March 16, 2011.

Jamuns

Abstract This chapter shows the protagonists' steadfastness in the face of the emerging reality of the post–Cold War world. They must themselves be the lighthouses their people seek; their lifetimes have witnessed Western powers' realpolitik, heralding destruction for locals; as well as divisive tactics by local powerfuls, cementing expedient enmity that outlasts generations.

The chapter opens with a reprieve from the tortured Punjab of the 1990s, traveling to the boisterous Punjab of 1938. It closes with a million murders and the largest forced migration in human history: the Partition of British India in August 1947.

The chapter traces the fight launched in 1993 by a Hindu of Tarn Taran, Punjab: Chaman Lal. While the world's experts, including India's large delegation, met at the United Nation's World Human Rights Conference in June 1993, Lal's 20-year-old son, a vegetable vendor, was abducted. The banality of police impunity and the dire consequences to people's leaders and rights defenders are highlighted.

* * *

© Mallika Kaur 2019
M. Kaur, *Faith, Gender, and Activism in the Punjab Conflict*,
https://doi.org/10.1007/978-3-030-24674-7_4

"Hope" is the thing with feathers—
That perches in the soul—
And sings the tune without the words—
And never stops—at all—
:EMILY DICKINSON:

H.S. JAIJEE'S TEN-YEAR BANISHMENT FROM HIS HOME IN the Kingdom of Patiala ended in 1938 with the marriage of the Maharaja of Patiala. Newly crowned Maharaja Yadavindra Singh was wed to Mohinder Kaur, the oldest Jaijee daughter. In a sharp turn of events, the daughter of a prominent antiroyalist joined the haughty royal family.

Waris Shah (1722–1798), penned the most beloved poetic rendition of the classic Punjabi epic of Heer and Ranjha, which has forever provided inspiration and aspiration to Punjabi lovers. Heer and Ranjha, promised to each other but separated by Heer's marriage to another, epitomize the struggle of young love against society, of maddening devotion against damning mores. Waris Shah's two youngbloods would remain beloved across all communities. The similarly star-crossed Punjabi lovers, Sassi and Punnu, Sohni and Mehiwal, Mirza and Sahiba, are also immortalized for their love (never resulting in marriage) and, moreover, their sacrifice. Punjabis remain eternally besotted by tragic daring love. This trait, for many, lies at the heart of Punjab's history.

Mohinder Kaur's masterfully arranged royal wedding was celebrated as testament to an entirely different kind of love. Her nuptials sealed a resolution between the Akali political party of the Sikhs and the royal family of Patiala—throughout the reign of Maharaja Yadavindra Singh's father, Maharaja Bhupinder Singh, the royals had been viewed as dangerously diverging from Sikh tenets. Bhupinder Singh had earned the ire of Sikh leaders for his persecution of political reformers like Jaijee and Praja Mandal's president Seva Singh Thikriwala, who died in the Maharaja's jail.

"It was very hard for a revolutionary to marry his daughter to the ruling family," says Inderjit Singh Jaijee. But various Singh Sabha leaders and prominent Akalis intervened to broker the union immediately after the death of Maharaja Bhupinder Singh. What better way to prove Patiala royalty's Sikh sincerity than a solemn union with the prominent Sikh leader of the region?

But the Jaijee family was chosen for more than their dissident distinction. H.S. Jaijee's father-in-law and Maharaja Bhupinder Singh's (first) father-in-law were high-ranking Sardars in Jind State. "They were both Paggwatt brothers," says Inderjit Jaijee. Brothers by turban, by solemn word, rather than unpredictable blood.

"There was a fear that Maharaja was unhappy with his wife and might give the kingdom, the largest Sikh kingdom, to a concubine's son. My father's party, the Praja Mandal, passed a resolution that the heir apparent could not be changed, it had to be prince Yadavindra Singh. They took the stance as a Sikh matter."

Tippler and licentious though he was, Maharaja Bhupinder Singh bestowed his kingdom with more than his penchant for style and sports—the Patiala-shahi paggh as much as the Patiala peg,[1] polo, and his beloved cricket. Seen as one of the raucous boys, he also kept the British at bay. The Maharaja remained a strong, even if internally scorned, representative for Sikhs (including at the 1930–1931 Round Table Conferences in London, where the British Viceroy invited Indians to deliberate new constitutional recommendations).[2]

"Maharaja Bhupinder Singh died in 1938," Inderjit Singh Jaijee recounts. "Maharani and her people came straightaway to my father and said, 'Please come back from exile.' And with the comeback, there was also an offer of marriage, which my father declined. He said, 'All these years I have been fighting the Maharaja, now you think I will give my daughter?'"

Yadavindra Singh's mother visited with Jaijee's mother. Akali leader Master Tara Singh was involved.

"And much later, when I was older, I heard from Tara Singh how my father had been convinced. He said he reminded my father that Maharaja Jind had become a Christian. Maharaja Nabha had been in exile, died, and his son was taken to England like Ranjit Singh's Crown Prince Duleep Singh. Maharaja Kapurthala had converted. He said our only hope to retain this largest Sikh kingdom was this marriage. 'Don't say no to this marriage. Don't let Patiala go this way. This is much more than a marriage.'"

"And you know, the other person who influenced my father was Sardar Atma Singh Sarkaria. All along, he had acted as an adviser and elder brother to my father. I can't imagine my father did it if Tayaji didn't agree with this reasoning too, because he had much influence."

Atma Singh Sarkaria was my father's paternal grandfather. Jaijee remembers him as Tayaji, father's older brother. He has fond memories of my great-grandfather, whom I have only now learned more about.

In early conversations, while traveling in 2009 with Jaijee to Punjab's villages that had been affected by debt-induced suicides, I would hear about Tayaji, a fond character of his childhood memories. Then we realized that his Tayaji was indeed my father's Babaji. I had embarrassingly little with which to reciprocate regarding my family's Patiala history, but Jaijee's eyes smiled nonetheless. I saw my father's uncle, Gurmukh Singh Sarkaria, a few months later in Santa Rosa, California, and mentioned my work with Mr. Jaijee and my rediscovery of our families' connection. Unlike my Dadaji's steely forward focus on excellence in the present and future, his younger brother Gurmukh always also had a penchant for the family's past. Age had blurred this river dam engineer's memory, but a smile immediately rounded his cheeks upon hearing the Jaijee name: it reminded him of some of his happiest days at Narwana.

"Yes, Jaijees had an estate in Chural, near Jakhal railway station, not very far from Narwana," he began.

Atma Singh Sarkaria, a London-trained engineer, was posted as subdivision officer in the canal colony of Narwana through the 1930s, till his retirement as an executive engineer. The elaborate canal system in Punjab had expanded

arable land[3] and created local jobs: monitoring the ebbs and flows of the newly tamed rivers. The children particularly enjoyed their father's posting for the colony's large vegetable gardens, orchards, and open expanses overseen by the eagles, hawks, kites, parrots, parakeets, vultures, and egrets perched on the big tahli trees.

Gurmukh Chachaji's eyes shrank the distance between his California home and the Narwana compound. The brothers stealing peacocks' eggs and placing them to hatch under surprised hens in their coop, or duck hunting without permission and returning to a flogging by their disciplinarian father; gorging the succulent guavas, curvy mangoes, or sunny pomelos; being held to practical but exacting standards of good Sikh boys, forbidden from ritual or superstition no matter its attendant adventure; and scurrying after pythons, kraits, vipers, and gopher snakes—particularly, that grand cobra that had petrified passersby and eventually met the business end of their father's shotgun.

Black buck antelopes, rabbits, jackals, mongooses, and the menagerie of memories had distracted us from other details about the Jaijees that afternoon. Then, a few weeks later, Gurmukh Chachaji's assiduous lifelong partner and keeper of records, Harriet Sarkaria, mailed me some pages from his draft memoir that included memories of the Sarkaria connection to the royal match. "My father and a Patiala noble, Kishen Singh Deodhiwale, who was a confidant of the Maharaja and his mother, the Raj Mata, suggested H.S. Jeji's daughter Mohinder Kaur Jeji as a match. To keep the news secret, brother Jaswant drove our own black Morris car from Patiala to Churral and brought the prospective bride to Patiala for the Raj Mata's and the Maharaja's approval."

The royal wedding, the Sikh Anand Karaj, was arranged for August. As a precondition set by H.S. Jaijee, Yadavindra Singh first had to undergo the only other ceremony held more sacred for a Sikh: Amrit Sanchaar, his initiation as a Khalsa. A 101-gun salute then marked the completion of the Anand Karaj that followed: the Jaijee daughter walked around the Guru Granth Sahib four times, following the son of the man who had imprisoned her father, dishonored their family, and exiled them from their home for a decade.

"The wedding was held in Chail, since the plains of Patiala were still too hot," says Baljit Kaur, who was only three years old when her eldest sister began her very public life. With its whispering chir pines and towering deodars, the hill station of Chail had been jolted into the limelight decades before when it became Maharaja Patiala's chosen site for his summer retreat.

In 1938, Chail witnessed the oldest Jaijee daughter becoming the newest Maharani of Patiala. Carrying a studded tiara, she would stare into a camera with studied composure. Her choice or desire in the matter of the marriage remains unquestioned. Her name is now Mehtab Kaur—Mohinder Kaur Jaijee has been renamed in her in-law's house, her permanent home.

The Jaijees maintain that much less than ending a family's romance with revolution, the wedding changed the playing field for the Sikhs of Patiala. Beyond the royal sycophants, the Sikhs of Punjab reportedly celebrated the union: H.S. Jaijee was seen as having saved the "eclipsed flame of Sikhi in the

house of Patiala."[4] H.S. Jaijee's large-heartedness in forgiving his own persecution for the greater good was commended.

The larger Sikh community was meanwhile feeling increasingly beleaguered across the subcontinent with rising sentiment against the British, looming war in Europe, polarization of the two larger communities, and the objections by both to minority safeguards for Sikh representation, even in Punjab.[5] Sikh allegiances were split and often, in hindsight, nonstrategic.

The year 1936 had brought a Congress conference in Justice Ajit Singh Bains's village Mahilpur, in Doaba. Bains noted in personal logs: "Jawaharlal Nehru and his sister Vijaya Lakshmi Pandit attended that conference in which thousands of people gathered. My father was the main organizer. ... Pandit Nehru called on my Uncle Harjap Singh in his house."

Uncle Harjap Singh had been under house arrest since his capture upon entering India in the late 1920s. While so detained, he gained political momentum. "He ran for the Punjab Legislative Assembly, Lahore, on a Congress ticket in the 1937 elections, under the Government of India Act, 1935. He was the only Congress candidate elected unopposed in the whole of the Punjab," says Justice Bains.

While the Congress had won a resounding poll victory across most of India, it won less than 10 percent of the vote in Punjab.[6] In this first election under the 1935 act, the two parties contending for Sikh votes were the Congress and the Unionists. The majority of Sikhs rejected both. The Congress was increasingly displaying an Arya Samaj ideology and was thus viewed as anti-Sikh, while the Unionists' caste-based agrarian platform was seen as preferential to Muslim Jatts over Sikh Jatts.[7] "In Punjab, a Unionist government under Sikander Hyat Khan was established, and lasted through the remaining British rule. It was very pro-farmer, and made some very positive changes," says Bains, who is hardly shy about his own pro-Jatt stance.

Through these political trials and errors, Justice Bains was raised largely by his hardworking mother, Amrit Kaur, who struggled to ensure his schooling.

In 1938, post-wedding, the Jaijee family moved back to the ancestral home in Chural village, Patiala State, for good. The matter of the return of the family's fortunes was an accepted corollary.

* * *

"AN ACCEPTED COROLLARY TO CROSSING THE POLICE THOSE DAYS was losing all your money or your life." Chaman Lal's eyes blaze from his bony face. "We didn't have the money."

As he hawked door-to-door through the tight lanes of Tarn Taran city, Gulshan Kumar had witnessed a local man harassing young schoolgirls. Chaman Lal explains that Gulshan, eldest of his seven children, was 20 years old in May 1993.

"We had arranged his wedding for the next month, and were preparing, you know, what we could. ... It was the same house then."

His hands stretch out to the eight-by-ten-foot mud verandah where we sit on a braided jute bed, where his family members, overflowing from the two smaller adjoining rooms, sleep at night. He encourages me to pick up another matthi. On my arrival, his younger daughter-in-law had quickly scurried off to bring these from the nearby store. I had noticed only a small saucepan of rice boiling on the kerosene burner lighting her dingy kitchen, eight slipper-steps by eight slipper-steps.

"First eat beti, then I'll tell you more."

As some flaky matthi biscuit bits escape from my mouth to my lap, the white turban and dhoti-wearing Chaman Lal shifts forward to continue telling me the backstory I had never read in any of the reports about his son's case (Photo 4.1).

"This scoundrel teasing the local schoolgirls was some Balwant Singh, a lawyer. One day, Gulshan told him to stop the misbehavior. There was a nasty exchange. And this scoundrel was furious, he threatened that police officer Dilbhag Singh was a classmate of his, and that he could have Gulshan put away forever in a terrorism case."

A very believable threat in 1993.

Punjab was still under AFSPA—the Armed Forces (Punjab and Chandigarh) Special Powers Act—affording extraordinary protections to men in uniform, while the TADA afforded little protection to the accused. An alphabet soup of laws had normalized prolonged detentions and expedient disposals.

New Year's Day 1993 was marred by the murder, after the disappearance, of Gurdev Singh Kaunke.

"He had been the acting Jathedaar after 1986, since the community's appointed Jathedaar was in jail," explains Justice Bains. The Jathedaar, or leader, of Akal Takht, the highest Sikh seat, was arguably the most visible Sikh. "And in 1992, after years in and out of prison, he was the front-runner for the position."

Village Kaunke is in district Ludhiana, the industrial hub of Punjab on National Highway 1, halfway between Chandigarh and Amritsar. Gurdev Singh's father had staggered into a sleepier Ludhiana district during the Partition of 1947. He remained unsettled by the trauma, turned to the bottle, and died of alcoholism when Gurdev Singh was an infant. His mother died a few years later. Relatives raised the young orphan who would one day enshrine their village in Sikh history.

Gurdev Singh Kaunke's life cycle resembled that of many of his contemporaries of that blighted Punjab: raised in the 1970s, old enough to comprehend the attack in June 1984, motivated to protest, met with repression, strengthened in resolve as a Sikh, marked by the police. But towering at almost seven feet, athletic, and steadfast in his commitments, Kaunke had earned high distinction among the Sikh masses in the traumatized countryside. He was said to resemble Jarnail Singh Bhindranwale in physique and character.

Since his teenage years, Kaunke had been a member of the Damdami Taksaal, the Sikh seminary that Bhindranwale came to head in 1977.[8] In June 1984, when Bhindranwale met his death in the Darbar Sahib, Gurdev Singh was 90 miles away in village Kaunke. He organized Sikhs in his area to march to Amritsar. This resulted in his first prolonged arrest and confinement.

Photo 4.1 Chaman Lal showing the author family photos and reports about Gulshan's murder

As Gurdev Singh became more outspoken against State violence, his wife, Gurmail Kaur, and their children began to accept police and prisons as a recurring part of life. By his release in 1988, the Darbar Sahib complex was home to armed men of various stripes and many unsavory elements, against whom Gurdev Singh barely hid his derision. Army operation "Black Thunder II" would soon highlight the contaminated conglomerate of men inside the complex, whom the press lumped as "Sikh militants." Kaunke was arrested again after vociferously opposing the government forces' deceit and vindictiveness

during this operation (unlike a previous Jathedaar, Kirpal Singh, who had vouched for the army's good behavior immediately after the bloodbath of 1984; later Kirpal Singh insisted he had faced TV cameras with a gun on his back and his child in the army's grip).

Lack of compromise, whether with Sikh leaders or the government or police, had won the disciplined Kaunke veneration. The lore of his physical prowess included his resistance under torture against infamous police officer Sumedh Singh Saini.[9] Knowing well the Sikh anathema to tobacco, Saini reportedly smoked his cigarettes in the faces of his captive. Kaunke is remembered to have slapped the stunned Saini, welcoming more retribution.[10] With his growing reputation, Kaunke's imprisonment for nine months during the pivotal elections in 1991–1992 was unsurprising. In October 1992, Gurdev Singh Kaunke returned to his village and began recovering from prolonged illness and maltreatment in prison.

Then, the media reported another attack on a bus. Buses had become a site of bloody propaganda in Punjab. Since 1983, Punjab Roadways buses were routinely stopped by armed men, at times in uniform, at times unidentifiable, and at times suspiciously outspoken about their Sikh affiliations. Singling out passengers by religion or perceived religiosity was not uncommon. Petrified passengers were humiliated, violated, and sometimes taken away, other times killed. Some of the dead were further dehumanized through carnage photos flashed in the media, while others were never heard about again. Almost all the murders remained unsolved,[11] but the media and the court of public opinion were convinced: Sikh militants were habitually pulling Hindus from buses to unleash animalistic anger. This bus, attacked on December 2, 1992, had been stopped soon after it left Jagraon, the subdistrict compromising village Kaunke. Seventeen Hindus were killed, the newspapers broadcasted.[12]

Hardly as strident was the report of the 19 people killed immediately afterward in an "encounter." In Makhu town, Firozpur district, the police produced bodies of "nineteen terrorists" allegedly responsible for the bus massacre. Crumpled turbans told a different story. Sikh leaders Simranjit Singh Mann and Parkash Singh Badal soon held a press conference highlighting telltale signs of the police "encounter" having been staged: empty alcohol bottles and glasses, and turbans used as hand ties before drunken target practice.[13] The tragedy of the Hindu deaths remained unresolved, while the number of total deaths had doubled.

On December 20, the Kaunke family was marking a personal tragedy. Gurdev Singh's infant grandson had died. Relatives and friends were gathered to condole when the police party arrived: Gurdev Singh was needed for questioning in relation to the bus killings two weeks earlier. Waiting for him to attend the infant's last rites was declared out of the question because senior police officers had traveled from far to question him; local police had to take him immediately. Gurdev Singh calmed his family and left. He was released after some hours.

On December 25, 1992, the police arrived at the village again. Gurdev Singh was leading a prayer session with his adoring congregation. The police

waited for him to finish his sermon; he spoke about death in the Sikh tradition. Then he walked home. The police waited for him to bathe, finish his daily prayers, and eat. His disciplined routine was well known and even silently admired by junior police officers. Then with 200 Sikhs following him, the Jathedaar walked toward the policemen. This time, he said to his Sikhs, it was a final farewell.

Soon a few witnesses to his condition in custody began reporting back to his wife, Gurmail Kaur. She rushed from police station to lawyers to the courts, fearing the worst. Meanwhile, for Gurdev Singh, death would have been more desirable, a policeman who observed his torture explained to human rights activist Ram Narayan Kumar years later, on condition of anonymity.

> I am giving you an eyewitness account. Gurdev Singh was huddled on the floor of a cell under a blanket. He had twisted himself into a knot. Swaran Singh abused the SHO Gurmeet Singh because he had given a blanket and heater in the cell. Immediately, Swaran Singh had the blanket removed and Sodhi and Channan Singh started kicking him with their boots. When blood started flowing, Swaran Singh looked at me and said: "Twade Jathedar da peshab nikal gaya!"—Your Jathedar has pissed out! He emphasized: "Twade Jathedar da!" He was taunting me for my sympathies with Gurdev Singh. I told him: "Peshab nahin nikla, uska khoon nikal gaya hai! Jan bhi nikal jayegi!"—He has not pissed out. His blood is flowing. Soon life too will ebb away![14]

Gurmail Kaur's contacts revealed that SSP (Senior Superintendent of Police) Swaran Singh was promising that a case against Gurdev Singh would be filed soon and he would be brought before a judicial magistrate within 24 hours— Swaran Singh, the officer whose given name had come to be followed by his preferred torture instrument: ghotnaa, a large roller, moved by several police-men over the bare legs of a detainee, crushing muscle, nerve, bone.

Gurmail Kaur was not going by SSP Ghotnaa's word. By the night of January 1, 1993, she had already been to the highest court in the state and had now brought back to village Kaunke a warrant officer (an officer appointed by the High Court in response to her writ of habeas corpus, a writ to produce the body, dead or alive).

The warrant officer insisted he must return to Chandigarh as soon as possi-ble, and made hurried police station visits. Police delay, dithering, failure to open a certain locked room, and even the presence of tortured inmates in many jail cells did not faze the warrant officer. He left to report to the High Court his inability to locate Gurdev Singh Kaunke.

Gurdev Singh was never heard from again. Neither were some of his close followers, who had been arrested the day after him. The anonymous police officer described the banality of the gore:

> In my opinion, [Swaran Singh] decided to kill Kaunke so that his transfer would get deferred. He used to do such things whenever there was a rumor of his trans-fer, or whenever he had to attend a meeting of the SSPs with the DGP. You can

check up that before such meetings with Gill, three or four hundred Sikhs used to die in Punjab. Every SSP had to report: I have killed fourteen, fifteen, and ten! The other who said I have killed twenty-eight was appreciated more. One who wanted to outsmart all had to report thirty-one. The night before the meeting with Gill, Sikhs of Punjab died so that the SSPs could vie among themselves to demonstrate their anti-terrorist achievements.[15]

In 1998, when the Akali government was in power, human rights groups urged an enquiry into the Kaunke case, given the corroborating evidence even by police officers. Now Darshan Singh Hathur, an officer on duty during Kaunke's killing, was speaking on the record. He narrated a story that could be well triangulated. The blanket covering the naked body of the Sikh nation's Jathedaar solemnly reappeared.

"Swaran Singh went away after dumping Gurdev Singh's body in the Sutlaj," Hathur told Ram Narayan Kumar. "A story of escape from custody was concocted to explain away his disappearance. ... If Gurdev Singh had really escaped, the entire police force of Jagraon would have been mobilized to apprehend him again. Nothing was done. No attempt was made to search for him. The government imposed restrictions on the public gathering under section 144 of Cr. P. C. at his village Kaunke."[16]

The new Chief Minister of Punjab, Parkash Singh Badal, knew this restriction well: he himself had been arrested while attempting to visit the Kaunke family on January 5, 1993. Now, Badal appointed a one-man commission to inquire into Kaunke's end. The sealed report by B.P. Tiwari, an ADGP (Additional Director General of Police) was handed to the government in May 1999.

Yet another witness came forward in 2000.[17] But the government's Tiwari report from the year before remained secret.[18] Gurmail Kaur's High Court petition still languished hopelessly; it would eventually be dismissed in 2003.

* * *

Back in 1993, "cleanup" operations continued across Punjab. "The police were very brazenly killing," says Justice Bains. "There were also a few remaining genuine encounters." By 1993 "death by cop" in an actual shootout had become poignantly rare. One significant exception was the police and paramilitary's final gunfight with militant leader Gurbachan Singh Manochahal on February 28, which saw the death of seven of Manochahal's men and twelve policemen.

The timing of Manochahal's encounter is instructive, writes anthropologist Joyce Pettigrew, whose description of Manochahal includes deadly egotism, nefarious greed, and betrayal of competing (and often more principled) militants. "The state could live with, as well as utilise, Manochahal's obsession to have the Tarn Taran area as his own personal fiefdom, until they no longer needed his services," she writes.[19]

Manochahal is revered in some Sikh circles. As much as stories of extortion by his parents—profiteering on his name—were verified to me by some villagers who knew his family, being bequeathed Amrit from his hand was also remembered as extra special, and being associated with his village as most fortuitous. Uncontested is the fate of his family members, noncombatants: 17 relatives, including his father, mother, and brother, were killed by the police.[20]

Just about two months before his death, on December 31, Punjabi daily *Ajit* had published a poem by Manochahal: "How Can I Wish Anyone Happy New Year?" A curious editorial comment accompanies: "Today in Ajit's office we have found two poems by Panthic Committee and B.T.F. Chief Baba Gurbachan Singh Manochahal, about whom the newspapers are printing all sorts of things these days. One of these verses is related to the new year and being printed below." The poems just appeared in the offices? This newspaper was printed 50 miles from his ostensible fiefdom in Tarn Taran area. Manochahal's lore—despite the fear of direct association with him, say by having received poems from him directly—may have had as much to do with the bandolier of bullets strapped across his body in his many photographs, as with the pen always seen tucked in the front pocket of his kurta shirt.

The Punjab Police had continued claiming large rewards for kills,[21] records of which contributed to Jaijee's assiduous dossier of deaths. The work took him to Europe in the summer of 1993.

"May I come over there?" a still black-bearded Jaijee is heard asking in a video time-stamped 19.5.1993.[22] He motions to the front seat from where he has just been introduced to a small, closed group of British parliamentarians. Classic confidence or his bad ear already giving him trouble? Probably both.

"What we find surprising is suddenly the government is releasing figures. Why? We believe these are numbers killed not by militants but by the government. So releasing because, one, rewards for police. Two, to strike terror. Three, to cover up extrajudicial killings. Four, to account for disappearances."

"There was a question in Punjab Assembly regarding the number of people held under TADA. ... The CM said, in October 1992, 15,500 prisoners were held under TADA. Not clear from beginning or at this very point. Parliament last year said 14,500 people."

But, the white men around the room are trying too hard to signal patience. He is losing his audience.

The videographer is also searching for more animation around the room. A red polka-dot chunni. There is one woman in the room. She is sitting in the outer ring of chairs, so she must be a community member accompanying Jaijee. I sense from the nature of the draping that she wore this scarf on her head especially for this meeting, as a mark of respect and belonging with the Sikh men— something some Sikh women continue to do at community events even today. Covering one's head and the Guru's gift of hair is gender-neutral identity dress. But, in practice, head coverings are much less commonplace for Sikh women. Culturally and socially, female Sikh identity has not been as prioritized as male identity, even as women fulfill the charge of transmitting Sikh culture and ethos

to future generations. There is comparatively little discussion (at the familial or communal level) around the unique Sikh female identity—and when there is, the voices of Sikh women themselves are often missing or rendered unheard.[23] Women are readily admonished, whether for caring too much or too little about their visual representation in the community. Through the generations, some Sikh women have rejected head coverings (and some have chosen not to keep the long, unshorn hair) in an act of defiance, or to challenge other social oppressions. Many others, never having considered themselves as respected potential carriers of the faith identity—unlike their male peers—have made their dress choice as a simple matter of fashion and cultural expectations of beauty. More recently, Sikh women have led efforts to reclaim their identity, some even wearing turbans or other head coverings, exemplifying faith-based feminism.

Did this polka-dotted lady wait for the precise right moment to volunteer her way into the group of Sikh men attending the prestigious closed meeting? Or was she perhaps the driving force behind the meeting, pushing from behind? Or, did the men look around before leaving for their meeting and realize the lack of a Sikh female presence, and recruit her to attend? Sikh teaching is egalitarian, after all, no matter if men take up most of the mic time and meeting space in our political arena. A lady may be summoned to balance out the group just right—silently negotiating her power as a representative against her appearance as a token—whether then, or today.

I rewind the video to refocus:

"So twenty thousand prisoners under TADA and so many other laws are there too. ... So reasonable to assume that there are sixty to seventy thousand Sikh prisoners."

Jaijee now turns to the damning statistics about rewards to the forces on the human hunt. "In an answer to question by PM in Parliament, on rewards, since 1991, 68 officers promoted and 41,684 given gallantry awards. Remember, this does not include the paramilitaries or army or vigilantes, and unofficial rewards given to the informers ... 100,000–150,000 people rewarded against militancy since 1991."

Minute 12:00. Looks like his audience has lost interest? But, for the dead, speak he must. About the ambushes that miraculously kill only the one militant, but no police officers, each and every time. About bodies disposed of in the canal system (laid out by his audience's ancestors in colonized India). "And let me tell you of what kind of people are in there ... Khudian, a member of Parliament, like the House of Commons. Then, the head of the Akal Takht. A young lawyer, his wife and kid. Car was found in the canal. ... Bar was on strike for two months."

They sit up in attention.

But don't they want the numbers, the large impact? The individual experiences were just a handful of cases more personal to Jaijee.

"One police district said, 151 militants killed and 91 unidentified."

The first question Jaijee receives is about the Bar Council strike that followed the killing of the lawyer whose car was found in a canal.

"To clarify, it was a strike in three places, Punjab, Haryana, and …?"

"Chan-di-garh. Ended two months ago." His stiffness betrays his convent boarding-school education in British India. Surely they have picked up on the more pressing points?

Question 2. "Difficulty is, knowing what we *can* do? When Amnesty International and Asia Watch have been blocked …."

Jaijee's ready for this.

"First, visit. Second, we have a proforma for census of killings. Requested as early as ninety-one. Our letters to the CM go unanswered. If you could support that request, if not through the UN, then through a friendly country that could supervise?"

As Jaijee pauses to read their response, Iqbal Singh, the British Sikh who helped organize this meeting, speaks. "Yes, a parliamentary Punjab group perhaps. To counter the disinformation by the high commissioner on Kashmir, Assam, Punjab. And connect aid to India's human rights record."

A few more murmurs. It's soon time to close.

"Disappearances," a parliamentarian says, "I think would be the most urgent issue." Jaijee affirms. He has of course just highlighted many other urgencies, for many situations that are not shrouded in the unknown. But with the Latin American context of the 1980s, there is growing recognition of the collective and continuing nature of disappearances. Starting with attention to ending this cruel crime would be deeply meaningful to the thousands of families Jaijee has met.

A young Sikh next to the polka-dotted colleague can hold back no longer. The confidence of his long black beard and large round turban, which had fearfully fallen out of fashion in Punjab then—as more and more men of such turbans were associated with militancy—suggest he is British and not visiting. His accent confirms.

"This is genocide. Like Bosnia. Like the Kurds. So not to just raise the issue in Parliament, but an international peace-keeping force is needed there, like for the other situations."

While it seems like a stretch even for that time, his polite outburst has forced the issue of double standards, which does not seem to be lost on the busy gentlemen.

"Yes, we've heard what you've said."

The meeting adjourns.

While Bosnia's "problem from hell"[24] finally acquired more direct action, Punjab's own inferno had also attracted some world attention, and thus India's increased obfuscation. As the video camera focuses on a corridor conversation after the official meeting, a parliamentarian is heard telling Jaijee, "It would be quite nice if the Indian high commissioner would merely reply to my letters. I have written him seven times in the last year and he has ignored them all."

Jaijee well knew the deafening silence by the class of Indians that rise to ranks such as the recalcitrant high commissioner's. Such matters were simply not to be discussed in most English-speaking schools, clubs, and living rooms.

I was having a good school year in 1993. I was well settled after my parents' remigration, was succeeding academically, and was published in *The Tribune* newspaper for the very first time, about my experiences volunteering with the most ignored segment of the population I had ever personally met, at the Special Olympics hosted at Punjab University. Not till Ingeborg asked my father a seemingly abrupt question was I reminded of other goings-on, about which I knew very little.

My parents had met the vivacious Ingeborg in Bonn, Germany, during the year Papa was a visiting researcher at the Max Planck Institut für Mathematik. Now, on her Punjab visit, she wanted to see the "real India," as much as some of my mother's friends wanted to bake her real Black Forest cakes. My mother, an insider-outsider herself, found nothing wrong with either interest, and cheerfully obliged both. "I never want to sit in the front seat of a car here," Ingeborg declared, when things got too real. "I definitely never want to get sick here," she said after seeing a real hospital, which we ourselves avoided, instead paying private doctors. And, "I couldn't help thinking how much anger you must have felt toward this professor to whose office I had you take me, right?" My father looked perplexed at her question. She elaborated, "Right there, right behind her shoulder, she had a big portrait of Indira Gandhi, while things Gandhi started are still boiling so."

"Ohh ... that is common here. Oh, yes." My father was momentarily stunned at his own newly practiced ability to unsee the seen to get through daily life in India. He, the one who had given Ingeborg her lessons in Punjab politics long after the children's bedtimes. They then proceeded with a discussion that I again missed, having been coaxed into the next room by Mama.

Almost a decade after Indira Gandhi's assassination, her death was not to be trifled with. Attracting attention to the multitudes of deaths that followed remained daunting. Jaijee and his team remained adamantly upbeat, no matter the audience. Exasperation could be a tool, but never a way of life.

During his Europe trip, Jaijee attracted allies, despite the times. India and the United Kingdom had just signed an extradition agreement in 1993. The odds were looking increasingly daunting for Sikhs seeking asylum or advocating for change back home. A parliamentarian told Jaijee, "There are ways in which UN can get into large, invaluable countries like India, China, Indonesia, which seem to escape the brunt of the world's criticism because we depend on them so much for business. I mean, that is at the heart of it, isn't it? When Mr. Major went to India recently it was because he wanted to sell them five hundred million dollars' worth of warplanes. That is the sad reality. It's that business, that dirty business, that makes it very difficult for us to raise human rights!"

Jaijee nods at the summary of realpolitik. Then, he sought actionable next steps.

"One of the Lords, he came to me after the talk, when snacks were being served. He said, 'Your talk was well documented, I am impressed, go talk to the

United Nations.' I said, I don't know anyone there. He said, 'Would you like to go?' I said, of course! So he arranged that."

"When I went to Geneva and met the first chap I had been introduced to, he said, 'Mr. Jaijee, we are preparing for the world human rights conference. We have little time right now. How much time do you need?' I said, Five minutes! He said, 'Only five minutes?' I told him that I have my documents in order, you can just take them after a brief statement. He browsed through quickly and kept me there for an hour and a half! And during that time he also called his colleagues."

"And then, Chauhan arranged for me to talk to the German House. In Cologne. And then to the Dutch."

Chauhan was the checkered British Sikh whose demands for Khalistan and Sikh separatism came much earlier than the Punjabi movement. A communist. A government agent. Zail Singh's man. A Sikh stalwart. An agent provocateur. Chauhan has been described in a rainbow of terms. Jaijee and Bains simply maintain that his energy in connecting them with influential leaders was commendable; they only allude to some of his personal interests in doing so. The gossip around Chauhan was less interesting to them and the possible conspiracy was beyond their control.

"Then I went back to London. And there was my invitation for the Conference on Human Rights. But there were twenty days till the conference. I had my return ticket to India. But the British Parliamentarians advised me, 'Don't go. The Indians will never let you come back!' So I stayed put in London. See, people were willing to help."

And so, Jaijee went to Vienna in June 1993 for the second-ever UN World Conference on Human Rights, the first since the Cold War. The Indian government's delegation was led by Finance Minister Manmohan Singh.

"Other folks from Punjab had also been sent. Three MPs were given the duty purely to follow me around. Every session I went into, they went into."

He responds to my arched eyebrow. "Of course, I found that hilarious. What surveillance? They already knew what I was going to say. We were saying it at home the same way!" Human rights groups and their families were under constant surveillance, open to accusation and assault.

"Overall, I was surprised how many people India had sent in the contingent. And they didn't really say anything. Oh, one spoke up when I was speaking in a session and said, 'Moreover, sir, I want to tell you, he is the real uncle of Amarinder Singh!' Real uncle! Amarinder had quit Congress then, so the real uncle was still a threat."

Amarinder Singh is the older son of Jaijee's sister, the Maharani of Patiala. This Maharaja had an on-again, off-again relationship with the Congress Party through the 1980s and 1990s, later to become the Congress Chief Minister of Punjab (2002–2007; 2017–present).

"Manmohan Singh was just the face. When the last body meeting took place, he was on the dais. He was the poster man. Did he say anything of importance? No!"

But what he said was instructive. In his book, Jaijee recounts:

> The economic expert (recently turned Human Rights expert) declared: "There are no ethnic peoples in India. My government recognises no such category. India has only backward sections." The implication is that these "backward sections" have no distinct religio-cultural identity and when they progress and come on par with the rest of Indian society they will share the same religio-cultural identity as the majority.
>
> It is with similar interest in mind that the Indian Constitution made Hindu law applicable to the Sikhs, Buddhists, and Jains. Only belatedly has the Supreme Court pointed out to the Indian government the advisability of promulgating a uniform civil code.

The plan, exposed in the 1993 statement, to delegate indigenous peoples as backward and then speed up development, has now come to its combustible consequence. Once Prime Minister, Manmohan Singh would in 2010 declare the armed resistance in the states with significant populations of "backward classes," as the "single greatest internal security challenge in India."[25]

"Oh that conference was Manmohan Singh's litmus test, for his willingness to be an intelligent face for the brutal state," says Jaijee. "He has largely been happy as a figurehead. I met him briefly in Vienna. ... We greeted each other and I just stopped and patted my hand to my turban. That was enough. He knew, I knew. He was sent there just because of that, his turban. Hand-picked to symbolize all is well with turbaned Sikhs in India, even as mass murders were underway."

* * *

And on June 22, 1993, across the globe in Punjab, the young vegetable vendor Gulshan Kumar was made another unwitting victim.

The family had been preparing for his wedding scheduled three days later, explains Chaman Lal. They had by now shaken off the ominous threats against Gulshan for intervening on the schoolgirls' harassment.

"Suddenly, countless men descended on the home in the middle of the night. And then all the men in the family were beaten, in this verandah," says Chaman Lal. "Dilbagh Singh had brought his police team. Gulshan Kumar was especially targeted. As startled neighbors gathered, the police began loudly shouting about some stolen goods."

"Did they find something? No stolen goods, of course! But they stole three of our gold rings, one watch, and four hundred seventy-five rupees."

Lal and his sons were taken to the police station, while neighbors intervened to stop the police from taking Lal's 18-year-old daughter, Inderjit. "They were trying to pull her along too and people said, 'No, this is highly shameful, she's like our daughter, don't dishonor her!' She was spared."

Intervention by a group of locals—Chaman Lal had lived in this same house since 1947—eventually led to the release of all but Gulshan. "They said to

bring two lakh rupees if we wanted Gulshan back. And we had experienced and seen so much brutality in there."

He lifts his arms to the sky. "Young girls, Punjab's daughters, hung naked, and humiliated in these so-called jails. Strung up, by their arms, in so much pain and shame in front of their husbands and brothers! You are like a daughter, I wouldn't say this if I hadn't seen it with my own eyes."

Lal remembers the torn, spread-eagled legs of boys, unable to walk afterward, including Gulshan Kumar. The police had told the protesting locals to be patient: they were waiting for Gulshan to recover before he could go home.

From June 22 to July 22, Lal kept visiting the jail, taking food for his injured Gulshan. He visited any senior police officials he could access and tried to negotiate the Rupees 200,000 demanded: an astronomical amount for this family even now, much more then. He witnessed his son's deterioration. On July 22, Gulshan could not swallow what Chaman Lal tried putting in his mouth. Lal rushed home to bring back some tea.

"At the door, a Sikh policeman told me, there's no need for this now, but maybe you'll catch a glimpse at the hospital. Thanks to his tip, I ran there. The doctor who did the postmortem, she even recognized my Gulshan. Karnail Kaur. He used to sell vegetables to her."

The bodies were being recorded as "encounter deaths."

A common stencil was colored in for each false "encounter;" the creativity in the police story was inversely proportional to their arrogance. The sequence replayed odiously: boys taken in full view of witnesses were later reported to have sprung on hapless police parties who were forced to kill them in gunfights.[26]

"Jarnail Singh, Karnail Singh," Chaman Lal outstretches his pinky and ring fingers. "Two brothers. And then there was Harjinder Singh. See, after I was beaten away from the hospital, I followed the policemen to the cremation ground. They yelled … but they were busy. I watched and wailed. First Gulshan Kumar. Then Jarnail Singh. On top of him Karnail Singh, then Harjinder Singh. Pile of bodies, small pile of wood, rubber tires, and mitti-da-tel, kerosene. That's it, just like that."

"I saw four dead bodies there, bruised, bullet-ridden. The policemen saw me and pushed me away. … They were the judges, they were the executioners, they believed themselves all-powerful." As he stared at the smoldering skeletons, the policemen threatened him. "If you tell anyone, we are going to slap a terrorism case on you too."

The next day, newspapers published an "encounter" story in which a Jarnail Singh and three unidentified militants were reported killed by the police. Lal saw Gulshan's body in the accompanying photograph.

Lal appealed to senior police officers that his son's murder be recorded as a civilian killing. He was threatened with the same fate as Gulshan's. About nine weeks later, Lal's wife died of a heart attack. Lal became a single father with six children's safety to consider.

Two years later, Gulshan Kumar appeared on Khalra's crematoria list.[27]

"Reading the Urdu newspaper one day, I stopped. There were human rights folks speaking out about secret cremations! I read that Justice Ajit Singh Bains

was encouraging families to come forward. ... I ran to Amritsar for this meeting. I went straight to Khalra's Kabir Park House. Justice Ajit Singh Bains was known everywhere for the boys he had returned to their families."[28] He trails off. Now, families yearned for at least information about dead boys, declared in police records as "lawaaris," unidentified, unwanted.

Lal stepped forward as a witness and the CBI recorded his statement on November 22, 1996. Grave threats, accompanied with inducements, followed. He was repeatedly summoned by police officers and advised to accept some money and strike a "compromise."

In 1999, the CBI validated Lal's account, concluding that five policemen were prima facie guilty of abduction and extralegal killing.

The CBI noted how the police version listed six independent witnesses. "But none of the police papers of the said case file supported the presence of any such witnesses at the scene of encounter." Moreover, when the CBI spoke to those listed, five out of the six "denied to have ever visited the scene of encounter or ever identified the deceased."

The story of the 90-minute firefight was ridden with lacunae, said the CBI: "there is no mention in the case filed about how many rounds have been fired by each member of the police party nor about the recoupment of ammunition, if at all used in the encounter. ... That, none of the police officials who had participated in the alleged said encounter had sustained any injury, while on the other hand, the four militants had died." Further, the CBI noted the ammunition reportedly recovered from the said militants had in fact been planted by the police. The CBI concluded that "there was actually no involvement of Shri Gulshan Kumar [...] the said case was registered on 7.7.1993, i.e., the period when Shri Gulshan Kumar was very much in the custody of the [police]."[29]

The accused police rejected all the CBI findings and forwarded that on the night of July 22, 1993, a regular police checkpoint had been set up when men on two scooters were seen approaching. Instead of stopping, they dropped into a nearby ditch, assumed positions, and began firing. The police had to retaliate and 90 minutes of intense gunfighting later, four bodies were recovered from the ditch.

The police's defense petition states 11,752 people were killed in Punjab between 1981 and 1999, including 1783 police and security personnel. It narrates a version of the Punjab conflict and stresses the difficulty of police postings in Punjab.[30] The petition reminds the Court that the Punjab Disturbed Areas Act (DAA) of 1983, providing wide powers to the police, applied in this case.[31]

Districts Amritsar, Gurdaspur, and Firozpur were still deemed "disturbed areas" by the central government as per a notification dated March 1989. The distinction had been lifted from the rest of Punjab after six years of the DAA (1983–1989). So here, where the stolen scooters of the four thieves—soon to be dubbed, without explanation, "terrorists"—met the brave policemen, the defense insisted, only the central government's "sanction" could permit prosecution.

The issue of sanction paralyzed the prosecution of the case. In the sanction seesaw, the case has traveled from trial court in Patiala, to High Court in

Chandigarh, to Supreme Court in Delhi, to trial court in Patiala, and to the High Court in Chandigarh.

What is sanction?

Legally put, it is the official permission required before a government employee can be tried by any court for an alleged offense "committed by him while acting or purporting to act in the discharge of his official duty."[32] Plainly put, it remains the armored tricolored Indian flag over officers in areas marked for citizen disciplining.

Indeed, since 1989, the central government had issued notices that only it, and not the Punjab state, could issue sanctions.

The CBI countered that sufficient evidence about the series of events between Gulshan's June 22 abduction and July 22 encounter, ruled out application of DAA, and the regular Criminal Procedure Code (section 197) applied. That is, the defendant policemen's actions were simply criminal, unrelated to a conflict in the "disturbed area."

The trial court agreed. The defense petition was dismissed on January 31, 2000. The police appealed to the High Court, which also found sanction was not needed since the police's actions did not fall within the purview of "while acting or purporting to act in discharge of official duty."

The convicted officers now approached the Supreme Court of India. They again highlighted mayhem in Punjab within which the dutiful officers were persevering: how 25,000 civilians and 1800 police were killed in the 1980s; how these policemen had encountered the stolen scooters in 1993; and how the lower courts had made grave errors.

On July 20, 2001, the Supreme Court put a stay on the case. No prosecution would continue. The matter of sanction would first be considered and decided.

It seemed clear that abduction, extortion, elimination, and secret cremation were not official duty, and thus prosecution for these acts would not require sanction.

But an affidavit by the central government encouraged the Court to grant blanket amnesty for the officers. It reasoned this was necessary for the sake of "morale," keeping in mind antimilitancy operations in other parts of the country.[33]

On the calendar of the highest court of the land, where the constitutionality of the central government's argument was to be adjudicated, Chaman Lal's case was listed and relisted. The case file notes "place the matter after": four weeks; six weeks; four months; eight weeks; after summer vacation.

Then in 2016, 15 years after the stay had first been placed on the case, a Supreme Court panel rendered an unexpected verdict. In a sudden flourish that the lawyers had not expected that day, irritated judges noted the case has been stagnant for a while. A decision was announced lifting the stay on the Gulshan Kumar case and 37 similar Punjab cremation cases.[34] "The facts are more or less similar in all the cases," the Court quickly notes.

While the Court makes no written note, much less inquiry or indication of remorse about the multiple-year delay, it clearly holds that legal precedent is

clear that "occasion or opportunity" while in uniform is not enough to warrant immunity. The Court orders trial should proceed.

In May 2016, I sit with Chaman Lal and explain that the case is coming back to CBI Court, Patiala, for trial. He is now 101 years old. "I should stay alive, right?" he laughs, and then breaks into a hooting cough. He is recovering from pneumonia.

"See, I said I wouldn't die without seeing this through. … His life was taken by those meant to protect him." Chaman Lal shivered a little in the sweltering heat. "Another summer, we are closer to his death anniversary." He pauses for a minute as his map of wrinkles again attests to his labored advocacy.

"I have no fear! Daughter, I have been enticed, beaten, threatened, jailed by police for too long to fear them. Last time was just six months ago that they came to coax me to withdraw the case."

"What matters is, I am part of the human rights movement. That I have worked with lawyers like Rajvinder Bains and Justice Bains, who himself went to jail at a grand old age. These are the people of mettle. I have now written a will saying that if I die fighting this, Khalra Mission Organization will carry it on."

"There was no Sikh terrorism here. There was no Hindu terrorism. This was state terrorism and police and politicians filling personal coffers."

As he begins to speak about what sustained him in his long fight, he raises his hand. "Wait, it's not that I *had fought*. I am fighting. I will keep fighting. I will die fighting."

"Look, those killed in Punjab are the twenty-five thousand Khalra estimated through his work. Plus one. Khalra himself. Who were these people killed? Citizens of this country. And who were those people who killed them? I lived through British police. Now, here is our brown police. What was the role given to them? Killing or protecting? What is their job?"

It was precisely this question that the Court was to untangle again in the trial resuming on July 2, 2016. On June 30, 2016, Chaman Lal breathed his last.

The trial resumes in Patiala. Gulshan's brother continues the family's fight. Officer Devinder Singh is excused due to ill health. Officer Balbir Singh is dead. The police contest the trial at each hearing. Court dates come and go: April 18, 2016; August 30, 2016; September 26, 2016, when the judge notes that the accused are only trying to avoid trial.

On October 7, 2016, the Court order notes that the summons for two of the plaintiff's witnesses had been returned: they were deceased. Another plaintiff's witness had moved house more than eight years ago. Yet another witness could not be found to be served. Now Officer Dilbagh Singh has asked to continue trial till the end of the year, so he may attend police training for his induction into the coveted Indian Police Services. The judge refuses to continue beyond October 15, 2016.

Frustrated by a trial judge adamant about proceeding, police lawyers approach the High Court. The sanction seesaw tilts again. The High Court in Chandigarh stayed the trial—23 years after Gulshan's abduction—again.

In December 2017, secret cremations silently screamed from newspapers again. An investigative report by the Punjab Documentation and Advocacy Project revealed new evidence of 8257 extralegal killings during the period from 1984 to 1995, through recently obtained records of "previously unknown, unclaimed, unidentified mass cremations."[35]

On December 20, 2017, the High Court lifted the stay and the prosecution was again ordered to "expeditiously" commence in 27 cases, all arising from petitions from the early 1990s.[36]

The trial resumed. Then it was stayed again by the High Court in August 2018.

Will it again soon travel to Delhi, live there for a few decades, and return home to Punjab after all the parties have passed? Chaman Lal's is one of the only three dozen cases from the Khalra list of thousands to ever be examined for criminal liability. Others remain murdererless murders.[37] All remain the Punjab conflict's stubborn stains.

* * *

STUBBORN STAINS FOLLOW RIPE JAMUNS EVERYWHERE, starting with the ground they hit, heavy. As summer peaks, the evergreen jamun trees become laden with the deep purple oblong berry of the *Syzygium cumini* tree, native to south and southeast Asia. Then vendors with pyramids of jamuns, generously salted to counter the tannins, appear on the roadsides. The acidic berry purples the tongue and dries the mouth. Breathing in through the teeth, feeling the cool astringency against the blistering heat, renders the fruit worthwhile again. Without any such ritual, fallen jamuns are devoured by appreciative birds and insects. In the Chural house, the rows of tall leathery-leaved jamun trees were always companioned by peacocks. Their fanned prance would harm the standing crop. Any harm to the peacocks was however forbidden by H.S. Jaijee.

The patriarch is fondly remembered as a benefactor of all life on his farm. As many as 150 men worked on the farm, and H.S. Jaijee is remembered to have taken personal pride in recalling each name. His principle of fairly paying a laborer his daily wage ("before the sweat on his back has dried," he would say) endeared him to the working poor, who are usually made to grovel for what is rightfully theirs. He believed in providing alms without aplomb: "Even the left hand must not know when the right gives charity."

In particular, H.S. Jaijee's deep regard for the faithful—of any faith—has become local legend. Once, a supervisor complained against a Muslim worker who would not refrain from reading namaaz during work hours. Jaijee went to meet the offending laborer. He then declared that from then on this man's work was only to focus on reading the Koran; many of the other Muslim workers didn't know how, so he would read on behalf of all. H.S. Jaijee didn't know at that time how many more fervent prayers would soon flood his Chural house, following the war that started a world away.

As Britain entered World War II, Sikh leaders conflictedly managed the community's strategic position in the colonial army—the appeal of having

Khalsa regiments in the Army was undiminished, and the recent abuses by the British were unforgotten. On March 13, 1940, Sir Michael O'Dwyer, the Lieutenant Governor of Punjab during the 1919 bloodbath in Jallianwala Bagh, was assassinated. Illustrating the potency of the Sikh memory, Udham Singh had traveled to London, entered Caxton Hall during a meeting, and opened fire on his target, fulfilling the desire of many in his generation.

Meanwhile, tensions had further escalated between Sikhs and the two majority communities. Muslim leaders had articulated the need for a separate Muslim state after decolonization: Pakistan. The idea of an unbridgeable schism between Muslims and non-Muslims, a "two-nation theory," was not new. As early as 1923, Hindu ideologue V.D. Savarkar had defined Hindus as "one and a nation," including Sikhs, Jains, Buddhists, all "originally Hindu," distinguishing from Muslims, who owed holy allegiance to a civilization different from the common Sanskriti civilization of the others.[38] By 1940, the call for Muslim separation from the Hindu-dominated Indian National Congress came from a former Congress loyalist: Muhammad Ali Jinnah. British-educated, anglicized Muslim leader Jinnah had diverged from Congress leaders Nehru and Gandhi after disagreements over the Congress's overtly Hindu messaging, as well as Gandhi's creation of the cult of the "Mahatma." After more than two decades of increasing fissures, Jinnah's Muslim League called for a separate Muslim country. Punjab, being a Muslim majority province on the whole, was one of the obvious targets of this proposal. Sikhs thus rejected the proposal from the get-go.

As British delegations visited during the war years, taking the temperature of the colony they were increasingly eager to exit, their openness to the Muslim League's proposal became more evident to Sikh leaders. "Events began to move so fast that they had little time to sit back, take stock of the situation, and then present a united front of Sikh political opinion," writes Khushwant Singh.[39] While opposing the idea of Pakistan, Sikh leaders forwarded demands for a third independent state for Sikhs.[40] They insisted their first preference was a united India, but that if the Muslims were to get Pakistan, then Sikhs must have their own country. In communicating this vision, Sikh leaders alternately called it Sikhistan, Azad Punjab, or Khalistan.

In hindsight, the defensive and timorous nature of these calls is blamed for the Britishers' quick dismissal of the Sikh proposal. But contemporaneous British accounts exhibit another deciding factor: numbers. Models of power-sharing not entirely dependent on arithmetic had been relatively harmoniously practiced in the past, particularly between Sikhs, Muslims, and Hindus in Punjab. But through British rule, numeric population had increasingly become the primary basis for communities' relative power.[41] The *Statesman* reported Sir Stafford Cripps's speech in the British Parliament in July 1946 regarding the Cabinet Mission's work in India: "'The difficulty arises, not from anyone's underestimation of the importance of the Sikh community, but from the inescapable geographical facts of the situation. What the Sikhs demand is some special treatment analogous to that given the Muslims. The Sikhs, however, are

a much smaller community, 5,500,000 against 90,000,000, and are not geo-graphically situated so that any area […] can be carved out in which they would find themselves in a majority.'"[42]

Meanwhile, news of the final Sikh sacrifices for the Crown traveled home slowly. Justice Bain's uncle, Bakhtawar Singh, had been on the war front.

"An Army messenger came to our house in 1945," Justice Bains's younger brother Harmohinder Singh Bains recounts. "He brought Uncle's personal effects and the news of his torturous death. I remember our grandmother going mad with grief. Mai Jeevi began spinning all around. … He had been barely thirty or thirty-one then. His wife was about twenty-seven and had three kids. She stayed tough, but lost her eyesight early, people said out of grief. Mai Jeevi, however, she couldn't recover. She kept saying, Bakhtawar Singh, you didn't eat, how can I? She stopped eating."

When Justice Bains was 24 years old, his beloved Mai Jeevi breathed her last. Jeevi was 114 years old, still a subject of her preferred rulers, the British—just barely.

The exorbitant cost of the war had further increased British weariness with India. Under the new Prime Minister Clement Richard Attlee, elections were being organized in the winter of 1945–1946: there was an urgent need to find Indian political successors who could take the subcontinent off British hands.

Continued Sikh opposition to the demand for Pakistan remained a losing battle. Panic in the Sikh minority community mounted, especially at the end of 1946, when leading Congressmen rapidly moved to at least privately accepting the need for Partition, which they had so vociferously opposed. Partition—involving the unnatural ripping of Punjab in the west and Bengal in the east—was in the politically expedient interest of the nationalist politicians, be they Congressmen or Muslim Leaguers.[43]

By 1946, the British Viceroy was inviting the Congress leaders to form a gov-ernment. Congress continued to cajole the Sikhs. "The Congress failed to win over Jinnah but succeed in persuading the Sikhs to give up their opposition."[44]

Through these years, Justice Bains's father had become increasingly frus-trated with the Congress. Gurbaksh Singh looked for other outlets that would walk the Congress's talk. By 1946, with the encouragement of leader Harkishen Singh Surjeet, he had become a card-carrying member of the Communist Party of India. He took charge of running the Urdu communist newspapers. He had meanwhile also been elected, unopposed, as the sarpanch of his beloved village Mahilpur, a position he would hold for the rest of his life.

Justice Bains remembers the political activism in his home. "The entire group associated with my father, they were for independence. Against the gov-ernment, and against any government's oppression of the people." The eco-nomic situation in the Bains home remained tight and Bains's uncle, Sardara Singh, offered to take him to Lucknow in 1946. "He worried I too might get arrested like my role models around me, and my mother favored the move." Bains laughs before recounting the adventures of starting college in Lucknow, 350 miles from Punjab.

Jaijee was at that time tucked away at a prestigious British boarding school in the Himalayas: Bishop Cotton School, Shimla. "Should I tell you my connection with Dyer?" Jaijee asks and politely waits for the obvious answer. R.E.H. Dyer, an Anglo-Indian, was the army officer who had supervised the bloodbath at Jallianwala Bagh.

"When I was there, in about forty-five, forty-six, the talk of Indian freedom from British was quite prevalent. And there were few Indians in the school. The headmaster, to get the pulse, called me one day to the large school auditorium, where they had a listing of the distinguished old boys. He asked, 'Read these names, Jaijee. What do you think?'"

"I said, I don't recognize many, but I think these are all of men who have done a lot for the country. I had also seen Dyer's name. So I said, Yes, Dyer I recognize, he killed many Indians."

"The headmaster said quickly, 'Yes, perhaps this name shouldn't be there, should it?' But he just said that. He had gotten a sense of things. They didn't remove it or anything. I remember this clearly."

The exit of the British after 300 years of rule over India—and shy of 100 years over Punjab—was imminent. And so, by the time the jamun trees were in full bloom in early summer of 1947, the entire landscape of Punjab was being colored forever.

It is as fanciful to say that the British found and then corrupted a perfectly harmonious India—the extermination of the Buddhists in India in the ninth century stands silent witness, as do the various bloodbaths by the Mughal Empire in the sixteenth and seventeenth centuries—as it is to believe that the British sahibs had no choice but to leave the populations to slaughter one another in 1947.

Prime Minister Attlee declared on February 20, 1947, that the British administrators would leave by June 1948 at the latest. He also announced a politically green but impeccably blue-blooded Viceroy to oversee this imperial fade-out: Lord Mountbatten. The colonials underplayed the grave news of communal violence triggered by rumors about the Partition. August 1946 had brought massacres to Calcutta, followed by turmoil in Bombay, Ahmedabad, and other cities. By winter 1946, the first targeted massacre of Sikhs—till then not targeted in the Hindu-Muslim violence—took place in the North-West Frontier Province. Each side heard selective stories of murder and rape and began preparing for retribution. Meanwhile, Mountbatten blithely assured a "peaceful" division of the country, even as the precursor violence in January 1947 was rapidly spiraling into what would be "the Hobbesian nightmare that existed when the state disappeared away with its law and order machinery."[45]

Then in June 1947, Viceroy Mountbatten made an astounding declaration: the British exit was expedited and August 15, 1947, was the new (arbitrary) date.

The British did not want to manage the unfolding civil war, and the Indian leaders, ironing out details of their respective fiefdoms, did not calm the masses. The nationalist leaders—almost all British-trained barristers—engaging in the negotiations rejected a confederation status or dominion status offered by the

British. Such a system of weighted representation and partial democracy would have resulted in systems like Australia and Canada, which would not bring grand political victory. Instead, these leaders fanned their respective peoples' insecurities and outrage, soon to result in a holocaust.

"India was really a British concept," says Justice Bains. "Otherwise, there were forty to fifty states ... and many independent princely states. And the British, as they consolidated power, they named it India."

"The Brahman-Baaniya castes that came to dominate the Congress Party and later India would never have been able to do this. But their fate turned with the new Anglo structures and ideas ... then they, the Nehrus and Gandhis, wanted to hold on to power, not caring what madness the Partition would unleash. ... Even now, the only resolution to all the issues across India is a federated, united states of India structure. The British didn't care to stay long enough to allow this. They left us in deathly chaos."

Notes Ahmed Ali, the novelist whose own family was once displaced from Delhi during the Britishers' violence against Delhi Muslims in 1857,[46] and then again, permanently this time, in 1947, "The British found an escape and left in a hurry, degrading East to the Third World, leaving behind a series of intangible ethnic, social, politico-economic and geographical problems, a crisis of identity into local and refugee, and a burden of hatred that will keep the countries of South, Southeast and Far East Asia involved for generations to come."[47]

"During Partition, both sides went mad," Justice Bains repeats several times.

The explosive violence of the Partition has often been considered best contained in a pithy story by Saadat Manto. The prolific and controversial Samrala-born Manto had migrated to Pakistan after the Partition. In "Toba Tek Singh," Manto describes the quandaries around the repatriation of detainees of an insane asylum, post-Partition.

"Another Muslim inmate from Chiniot, an erstwhile adherent of the Muslim League who bathed fifteen or sixteen times a day, suddenly gave up bathing. As his name was Mohammed Ali, he one day proclaimed that he was none other than Quaid-e-Azam Mohammed Ali Jinnah. Taking a cue from him a Sikh announced that he was Master Tara Singh, the leader of the Sikhs. This could have led to open violence. But before any harm could be done the two lunatics were declared dangerous and locked up in separate cells."[48]

But the largest forced migration in history would unfold without any intervention: British officers headed home while Indian soldiers and officers joined the murderous chaos, along communal lines.

With less than two months to spare, Sir Cyril Radcliffe had been appointed to draw the boundaries of the new India. Eventually, 62 percent of Punjab's area was designated as Pakistan: half of the Sikh population was on the wrong side of that line.[49] Sikhs and Hindus had to travel to India and Muslims to Pakistan. Seas of millions traveled from their homes to their unseen new countries, often falling prey to marauding mobs en route. 17 million migrated; one to two million perished. No more than eight Britishers were reported to have lost their lives.[50]

"Had people not resisted and voluntarily left, maybe the number of people killed would be much lower. But that is not the psyche of the peasant who is tied to the land for good or bad. At the end of the day, the Punjab was bloodied, partitioned and cleansed," notes historian Ishtiaq Ahmed.[51]

Lifelong friendships became liabilities as the desire for retributive killings spread till it almost became sport. Harmohinder Singh Bains, Justice Bains's brother, recounts a story the Justice himself, far away in Lucknow then, does not recall hearing firsthand:

"As headman, my father had success in saving Muslim lives in the village. There were thirty to forty Muslim families. Father took them to relief camps when it was safe. But later, one Muslim, who had stayed behind, was most unexpectedly murdered. His best friend, a Sikh, did it. The Kaazi—we called him Kaazi, I don't know his name. The Kaazi would never open his door, since he was living in such fear. Then his friend, this Kulwant Singh, went to his door one day. The Kaazi opened the door, only to see Singh had brought other men with him. Kaazi ran upstairs. They tromped after him. They killed him. And killed his father too, who was old and bedridden. Kulwant Singh was dubbed Golimaar by everyone in the village after that. That's why I even remember this."

Kulwant Singh's freedom from any punishment for cold-blooded murders raises no questions for anyone who lived through the birth of the nations in 1947: "The culture of impunity was, albeit silently, put into place so that demands for judicial redress could not even be proposed."[52]

The new Indian government quelled the violence once it reached into New Delhi, and prevented loss of life beyond. Punjab had already been desecrated.

The violence of the Partition had been genocidal, targeting the elderly, children, and women. Approximately 75,000 women were terrorized through rape,[53] many disfigured through sadistic violence.[54] Many women were also kept as "bounty" in India or Pakistan—when released later, they were often considered "dishonored" and not accepted by their respective families on the other side of the new border.[55]

H.S. Jaijee is remembered to have arranged the reunification of many Muslim families. "My father was in the hills as the news of the violence spread," Inderjit Singh Jaijee says. "He rushed back to Chural. He sent out his men to quell any tensions and protect Muslims. Muslims began gathering at the house. Our house, our farm, turned into a refugee center."

However, as Ishtiaq Ahmed points out, Patiala State as a whole probably witnessed mass killings in 1947, sometimes by soldiers of the state equipped with armored cars and machine guns. But the widespread killings only began after Maharaja Patiala received forceful instructions from New Delhi in late August, wrote R.S. Sarkaria, my Dadaji's brother.[56] The later Justice of the Indian Supreme Court, was in 1947 posted as a civil subjudge of Bathinda, in Patiala state.[57] He notes how Maharaja of Patiala Yadavindra Singh had ordered his government to protect the remaining Muslims while providing for incoming non-Muslim refugees. Sardar Patel, Home Minister of India, then ordered

Bathinda city administration to lift the imposed curfew (restricting crowds and movement) and steer out all remaining Muslims. R.S. Sarkaria writes that he refused to be the one to lift the curfew, because it was the only thing keeping marauders at bay—he was himself housing about 20 Muslims in his residence. When the curfew was lifted regardless, within two hours murderous mobs swept through, massacring four thousand Muslim men, women, and children, he writes.

From the Jaijee estate, many escorts were arranged to Pakistan, but over a thousand Muslims did not move and wanted to continue living under Jaijee's protection. "Pitaji did not approve of people converting to Sikhi either. 'Not something you do out of fear,' he said. 'Keeping your faith is your primary duty and right,' he always said." An estimated one-third of these families converted from Islam. The Jaijees also resettled close to eight thousand refugees from what was now Pakistan, sheltering them for several months.

Hindus and Sikhs moving from vast farmlands in west Punjab (now in Pakistan), had to start life anew. Farmlands in east Punjab were inferior in size and quality: "The Hindus and Sikhs had left behind 67 lac acres of the very best agricultural land; the Muslims of east Punjab left behind only 47 lac acres of comparatively poor soil."[58]

Dazed survivors slowly refamiliarized themselves with the amputated Punjab; Guru Nanak's birthplace was now in Pakistan, wherein also now fell Ranjit Singh's Lahore Court. The disastrous new border left either side of Punjab claiming two and a half rivers. The land of five (punj) rivers (aabs) was to reflect tragic irony in its very name.

Bengalis have retained "West Bengal" as their official state name, in commitment to their missing half, East Bengal, which first constituted East Pakistan, and, since 1971,[59] modern-day Bangladesh. East Punjab and West Bengal, on the two opposite sides of the modern Indian state, hold on to their uniquely brutal experiences of 1947, while the one million to two million deaths and colossal forced migration[60] are never marked with any national acknowledgment on August 15, the national holiday of parades and felicitation, the day India was decolonized at exorbitant human cost.

"We have lost music in our countryside," Inderjit Jaijee, now 86 years old, tells me on a still summer night from the balcony of his Chural home. "A symptom, a cause, or the desired effect." He remembers the lost leitmotif; sometimes, still, a wizened old man in a flowing beard can achingly recite Wari Shah's epic, *Heer-Ranjha*, of about 600 verses, with a bright tear in his eye.

Everything was shredded in a span of weeks, forever. Of the over one million lives lost, 31 were Chaman Lal's family members in Lahore.

"I was thirty-two years old during the batwaraa," Lal tells me, sitting in his courtyard. Punjabi grandparents speak of 1947 only as the year of batwaraa, Partition, never azaadi, independence.

He received the small plot of land in Tarn Taran city in lieu of the family's agrarian fields, now in Pakistan. He built the two-room quarters where he brought his bride, and soon welcomed their firstborn, Gulshan Kumar.

NOTES

1. "We heard the English team were served 'Patiala Pegs' of scotch whiskey at dinner the night before the match and had bad hangovers the next day, so the Patiala team won. Several years later I learned that a Patiala Peg is two fingers of whiskey, that is between the stretched forefinger and the little finger, nearly 5 inches or a glass full!"—G.S. Sarkaria, *Memoirs*, on file with author.
2. Khushwant Singh, *A History of the Sikhs, Vol II; 1839–2004* (New Delhi: Oxford University Press, 1999), 228–29.
3. In 1916–1917, 5. 8 million acres were irrigated as compared with 10 million acres in 1928–1929, 11 million acres in 1936–1937, and 12.5 million acres in 1943–1944. Bhagwan Josh, *Communist Movements in Punjab, 1926–1947* (Delhi: Anupama Publications, 1979).
4. Sadhu Singh, "Portrait of a Bold Gursikh," *Abstracts of Sikh Studies* XV, no. 4 (October–December 2013).
5. See, for example, Khushwant Singh, *A History of the Sikhs II*, 216–33.
6. Khushwant Singh, 233.
7. See, for example, Rajmohan Gandhi, *Punjab: A History from Aurangzeb to Mountbatten* (New Delhi: Aleph Book Company, 2013), 299.
8. On Taksaal, See Cynthia Keppley Mahmood, in *Fighting for Faith and Nation: Dialogues with Sikh Militants* (Philadelphia: University of Pennsylvania Press, 1996), 51–56.
9. See, for example, Dinesh Kumar, "SSP Strikes Terror in Mohali," *Times of India News Service*, July 28, 1991.
10. Ram Narayan Kumar, *Terror in Punjab: Narratives, Knowledge and Truth* (Delhi: Shipra Publications, 2008), 61.
11. And remain shrouded in secrecy ever since. See, for example, Tribune News Service, "RTI Panel Refuses Info on Communal Killings," Chandigarh, July 5, 2018 (announcing the government decision to dispose of "a Case Seeking Information on Incidents in Which Members of the Hindu Community Were Pulled out of Buses And Killed Between 1984 and 1995").
12. Kumar, *Terror in Punjab*, 63.
13. Kumar, 63.
14. Kumar, 74–75
15. Kumar, 73.
16. Kumar, 69–70.
17. Jaspal Singh Heran, "Witness Claims Kaonke Was Killed By Police," *The Indian Express*, October 14, 2000.
18. See, Ajay Bharadwaj, "Investigations on Kaonke Hang Fire," *The Times of India*, January 10, 2001.
19. Joyce Pettigrew, *The Sikhs of the Punjab: Unheard Voices of State and Guerilla Violence* (London: Zed Books, 1995), 87.
20. Ram Narayan Kumar, Amrik Singh, Ashok Aggarwal, and Jaskaran Kaur, *Reduced to Ashes: The Insurgency and Human Rights in Punjab* (Kathmandu, Nepal: South Asian Forum for Human Rights, 2003), 346.
21. See, "India: Break the Cycle of Impunity and Torture in Punjab," Amnesty International (2003). Rewards varied based on the categorization of the militant killed, but the range stretched from 50,000 Rupees to 500,000 Rupees.
22. "Mr Jaijee's opening remarks," Baljit Kaur, video archive.

23. See, Mallika Kaur, Harpreet Kaur Neelam, Kirpa Kaur, "Sikh Feminism and SAFAR: Daring to Celebrate an Egalitarian Tradition," *Guernica Magazine*, December 12, 2014.

24. Samantha Power, *"A Problem from Hell": America and the Age of Genocide* (New York: Basic Books, 2013).

25. Arundhati Roy, *Field Notes on Democracy: Listening to Grasshoppers* (Chicago, IL: Haymarket Books, 2009).

26. See repeated patterns in the cases recorded in Kumar, *Reduced to Ashes*.

27. Kumar et al., "Summaries of Cases of Illegal Cremations Included in the CBI Lists," in *Reduced to Ashes*, 363.

28. See, Chap. 9 regarding work of Bains Committee.

29. Charge sheet Report, Ch. No. 34/7.5.99, *State (CBI) v. Dilbagh Singh & others*. In the Court of A.S. Virk, Special Judicial Magistrate.

30. Application dated 14.12.99, in Court of S.K. Garg, Addl. District & Sessions Judge Patiala, in *Balbir Singh & Ors. v. State of Punjab*, Special Leave Petition (Crl.) No. 2236 of 2001, Supreme Court of India.

31. See, Punjab Disturbed Areas Act, 1983, Section 4.

32. Section 197 The Code of Criminal Procedure, 1973, Section 197 (1).

33. "Affidavit on behalf of the Union of India by Orders of this Hon'ble Court Dated 22nd November 2001," in *Balbir Singh & Ors. v. State of Punjab*, Special Leave Petition (Crl.) No. 2236 of 2001, Supreme Court of India.

34. *Devinder Singh & Ors v. State of Punjab*, Crim. App. No. 190 of 2003, Supreme Court of India, April 25, 2016.

35. Punjab Documentation and Advocacy Project, "New Evidence of 8257 cases of Disappearances, Mass Killings, Fake Encounters and Illegal Cremations in Punjab: Release of Investigative Report and People's Tribunal Findings to be Petitioned to the Supreme Court of India," Press Release, November 2017.

36. *Arjan Singh & others v. CBI & others*, CRR No. 3854 of 2016, Punjab & Haryana High Court, December 20, 2017.

37. Thanks to *The Diplomat* for originally publishing an initial story about this unfinished case. Mallika Kaur, "Punjab: Murders Without Murderers," *The Diplomat*, December 15, 2017.

38. V.D. Savarkar, *Hindutva: Who Is a Hindu?*, sixth ed. (New Delhi: Bharti Sahitya Sadan, 1989).

39. Khushwant Singh, *History of the Sikhs: Volume II*, 240–41.

40. See, J.S. Grewal, "Sikh Identity, the Akalis and Khalistan," in *Punjab in Prosperity & Violence: Administration, Politics and Social Change 1947–1997*, J. S. Grewal and Indu Banga, eds. (New York: K.K. Publishers: 1998), 65–68.

41. "The British introduced the notion of the rule of majority, that is, that neither property nor prowess mattered as much as numbers. And in the matter of numbers the Sikhs were a bare 12–13 percent of the population of the Punjab and a little over 1 percent of the population of India." Khushwant Singh, *History of the Sikhs: Volume II*, 286.

42. Khushwant Singh, *History of the Sikhs, Volume II*, 258–59.

43. Gurharpal Singh, *Ethnic conflict in India: A case-study of Punjab* (New York: St. Martin's Press, 2000), 65.

44. Khushwant Singh, *History of the Sikhs, Volume II*, 259.

45. Ishtiaq Ahmed, *The Punjab Bloodied, Partitioned and Cleansed: Unravelling the 1947 Tragedy Through Secret British Reports and First-Person Accounts* (Delhi: Rupa, 2011; Karachi: OUP, 2012), 670. Ahmed's book is a unique attempt to

give a comprehensive account of these fateful months from the various points of view of the surviving victims, and occasionally perpetrators, of the crimes. For details up to August 15, 1947, he frequently also cites fortnightly reports of the Governor and various ICS officers. Neither India nor Pakistan has released from secrecy such reports about killings after this date.

46. See, William Dalrymple, *The Last Mughal* (New York: Vintage, 2007), (revealing the extent of butchery, after studying Indian archives for details about this "first war of independence"). Also see Chap. 2.

47. Ahmed Ali, *Twilight in Delhi: A Novel*, 7th ed. (New Delhi: Rupa, 2007), xix.

48. Saadat Hasan Manto, "Toba Tek Singh," *South Asia Citizens Web*, available at: http://www.sacw.net/partition/tobateksingh.html.

49. Khushwant Singh, *History of the Sikhs, Volume II*, 274–75.

50. Yasmin Khan, *The Great Partition: The Making of India and Pakistan* (New Haven, CT: Yale University Press, 2008), on Mountbatten's confidential orders against British Army units intervening anywhere, except to save British lives. Instead, the Punjab Boundary Force, "a toothless and dreadfully inadequate response to Partition's violence," which included "at most, 25,000 men," was in existence for "thirty-two days in Punjab," 128–29.

51. Ishtiaq Ahmed, "The Punjab Bloodied, Partitioned and Cleansed in 1947: How and Why," Lecture delivered on February 26, 2013, Occasional Publication 46, (New Delhi: India International Center).

52. See, Uma Chakravarti, "The Law as Feminist Horizon: Challenging Impunity, Pursuing Justice," in *Landscapes of Fear*, Patrick Hoenig and Navsharan Singh, eds. (New Delhi: Zubaan, 2014), 253.

53. Urvashi, Butalia, *The Other Side of Silence: Voices from the Partition of India* (Delhi: Viking 1998), 3.

54. See, for example, Yasmin Khan, *The Great Partition*, 133–35. As horrific accounts and rumors announced the approaching vortex of violence from one location to the next, some men chose to kill family members who they predicted would be unable to escape and make it safely to their designated new countries. Women and children, and to a much lesser extent men, jumped into wells or bowed before their own relatives—grandfathers, fathers, husbands, brothers—submitting to death by sword or gun. Such submission was considered an honorable death and explained by families as "martyrdom" for the sake of purity—personal and communal. See, Butalia, *Other Side of Silence*, 153–71, for an in-depth exposition into such acts of violence that have since 1947 silently haunted family histories.

55. See, Uma Chakravarti, "Law as Feminist Horizon," in *Landscapes of Fear*, 252–53; Pippa Virdee, *From the Ashes of 1947: Reimagining Punjab* (Cambridge: Cambridge University Press, 2018), 166–208.

56. R.S. Sarkaria Memoirs, written close to end of life; on file with author. Considering that both the nation-states birthed by the 1947 holocaust continue to sit on all official records of these killings of 1947 post their independence, such personal histories are the only kind of records available.

57. See, Ahmed, *The Punjab Bloodied, Partitioned and Cleansed*, 614–15 (account of how R.S. Sarkaria assisted Muslims fleeing for their lives, separated from their families).

58. Khushwant Singh, *History of the Sikhs II*, 281.

59. Often described as South Asia's "second Partition," the creation of present Bangladesh was marked by mass murders and widespread sexual violence.

60. See, for example, Butalia, *Other Side of Silence*.

Next, Kill All the Lawyers

Abstract This chapter examines how the protagonists accepted personal risk as a part of their chosen mission, but without a desire for martyrdom; how, having witnessed Punjab rebuild itself painfully after its 1947 Partition, they honored self-preservation and survival.

The chapter details how in 1992 retired High Court Justice Ajit Singh Bains was kidnapped from outside the elite Chandigarh Golf Club and joined the multitudes of Punjab's "disappeared." The abduction came immediately on the heels of the swearing-in of a new state government, which also oversaw a spike in killings. The reader will thus witness the throes of a critical pivot in Punjab conflict history: the mysterious boycott of the 1992 election, which followed the 1991 election that was postponed by the Indian government. We see how events that were even then shrouded in mystery are today peddled as history.

The earlier timeline returns to the newly partitioned Punjab of 1948, dizzied with resettlements and reunifications amidst titanic loss. Pre-Partition assurances to Sikh politicians immediately met new resistance by the postcolonial government, thus seeding the next decade-long civil disobedience movement in Punjab.

<div align="center">* * *</div>

© Mallika Kaur 2019
M. Kaur, *Faith, Gender, and Activism in the Punjab Conflict*,
https://doi.org/10.1007/978-3-030-24674-7_5

> *It is forbidden to kill;*
> *therefore all murderers are punished*
> *unless they kill in large numbers*
> *and to the sound of trumpets.*
> :VOLTAIRE:

DOGGED ROUTINE HAD SERVED JUSTICE AJIT SINGH BAINS FAITHFULLY FOR 71 YEARS. So, despite Punjab's daily upheavals and his resulting unpredictable schedule, he retained a morning habit for a semblance of normalcy: his game at the elite Chandigarh Golf Club. On April 3, 1992, after his regular game, he climbed into his car to leave the golf course for the quick drive home: in symmetrically laid out Chandigarh, his Sector 2 was about a mile from the club in Sector 7. A minute into the drive, his car was forced to a stop, sandwiched between two vans. A police officer jumped out of the front van and snatched the justice's car keys. Just past the Punjab Governor's house, on Chandigarh's poshest road, the retired Justice of the Punjab and Haryana High Court was whisked away.

Justice Bains was taken to the Sector 11 police station. Across the main road, in his home, his family had just begun to notice his uncharacteristic delay.

The Justice, in handcuffs, was soon traveling again, in the police jeep. No papers had been presented, no charges had been read. Then the jeep bounced through increasingly empty roads, outside city limits. He was off-loaded briefly in a police station in Mohali before being transported again.

"After lunch, when he wasn't in the club, his car wasn't seen, and he wasn't at home, we knew it was serious," remembers the Justice's son, Rajvinder. The family launched their search. Bains had now joined the ranks of Punjab's "disappeared." By late evening, his family heard from sources that he was being moved site to site.

"What was going on in my mind? Nothing," Justice Bains says. "Those days, they could really do anything ... State terror was at its height." His voice drops. "I just thought, let's see, whatever is going to happen, is going to happen now."

Three months earlier, journalist Ram Singh Billing, a regional secretary of the Justice's human rights group, Punjab Human Rights Organization (PHRO), had disappeared. He was on a Punjab Roadways bus that stopped at a police barricade, was searched, and flagged ahead after Billing was disembarked. He was next seen in a police station. Billing managed to slip his card to a man who had come in search of a family member. The card was carried back to Billing's parents, who arranged for senior panchayat members to go to the police station. They all saw Billing. But they were directed to speak with the Sangrur SSP. The SSP first feigned no knowledge of Billing and then expressed an inability to intervene. Billing was never seen again.[1]

Now, a day after being abducted outside the Golf Club, Justice Bains was taken to CIA Staff Ropar. At this particularly notorious center, he was kept standing outside in the sun, verbally harassed, and manhandled. He was also given a tour of the routine torture apparatuses.

"Some journalists had told us that he was probably taken to the nearby Sector 11 police station," remembers Rajvinder. "We had gone there. He wasn't there. In fact, they denied they had any interest in him. So what we did almost immediately was file a habeas corpus petition in the High Court. It was taken up the next day. Notice was issued. A warrant officer was assigned by the Court." As the family searched with the court-appointed officer, Mrs. Bains learned from a senior bureaucrat that she should enquire about the Justice's whereabouts from the SSP at Ropar. SSP Ropar told her that they could come and meet the Justice there at 5:00 p.m. Ropar was an hour's drive from Chandigarh. She went, accompanied by Rajvinder, her daughters, and her elder son-in-law. They were made to wait outside the SSP's residence for an hour, and then told that the Justice had already been released. Incensed, they arrived back only to find their house had been raided while they were away. They caught a glimpse of the handcuffed Justice in the police party's reversing vehicle.

"They ransacked the entire house, office. They took away a little bit of money, I used to just put some in the drawer. They took that. So I was personally annoyed they took five thousand or maybe seven thousand rupees." Rajvinder smiles.

"Oh, they got plenty! How have you forgotten? The pinnis, Tanny?" Rajvinder's childhood nickname has stuck. She does not reciprocate her son's laugh at her outburst, remembering the stolen sweet treats she had made for him.

"And it was Tanny's former class fellow, the policeman in Ropar who had carried out the whole plan. Leaving us out to dry there, while they were tearing our house apart here."

To deliberately leave one in limbo without purpose, like an already parched cloth on the clothesline, conveys high disrespect.

"And they shamelessly ate those pinnis in the house. I had made them specially for Tanny. Imagine!"

The Justice's second wife, and 20 years his junior, remembers that day clearly. Her eyes flash challengingly. She and the Justice are a study in contrasts, I had been told, and now witnessed.

Rajvinder adds, "Yes, they also took some jewelry, et cetera. Whatever they could get their hands on. But in terms of the case, they desperately just took anything that said PHRO. Oh, and I didn't have many cases then, so whatever else they messed around with, they left my files mostly. ... But they took any loose papers that they saw and declared as 'Khalistani literature!' They took letters sent to my father from Gurmit Singh Aulakh's U.S.-based Council of Khalistan. These were later attached to the charge sheet as supposed smoking gun evidence!" Rajvinder breaks into his father's hearty laugh.

"Aulakh's letters were mass mailers, that included news of active militants and often had the word 'Khalistan' on practically every page. There wasn't much more than that for the police to pilfer from our house!"

His mother frowns again.

"They were lucky their plan worked ... getting maximum number of family members out of the way. You think it would have been so easy for them if I were home? When my younger son-in-law, who was the only one at home,

protested, his room was not searched." But when he had offered the 71-year-old handcuffed Justice a chair, the commanding inspector snapped, "You busy yourself with serving us water!"

There were outside witnesses to the raid. These included the former Advocate General of Punjab, G.S. Grewal, whose home is a few houses from the Bainses.

Says Grewal, "I was going in my car, then saw there was a raid going on in their house. Honestly, I also thought, Why get stuck in this? See it had already come in papers he had been taken in. ... But then again, I thought, as a neighbor, if I won't, then how will we ask others to stand as witnesses?"

"The police let me in because one officer said, 'Make him a witness to attest that a legitimate search is being done.' And what do I see inside? He is standing there, and the policeman is sitting. And I said, this is Justice Bains. He is a heart patient. And then the policeman retorted, 'Oh, he can drink a drum of alcohol every night, what sort of a heart patient is he?'"

"I said, keeping my cool, Whatever it is, he is a heart patient."

Grewal remembers that when he told the officer that by Supreme Court precedence the Justice should not be in heavy handcuffs, he was curtly told, "Supreme Court has its own way and the police has its own way."

"See, this was a critical time for Sikhs," says Grewal. "And given what Justice Bains was doing for human rights, well, his arrest was an opportunity for revenge against him and those who supported him."

The Justice's family eventually met him at Anandpur Sahib, two days after his abduction. "When we met," says Mrs. Bains, "he said something to me like, Take care of the children. And I was so mad. He was sitting there in his dirty golf kit. Our house had been raided. The lies. It was all just too much. I told him, Stop talking like this, nothing is going to happen to you. We are going to show them, they are not above the law. Stay in high spirits!"

Those seeking to defend the defender would meet a series of immediate obstacles. Baljit Kaur remembers her closest colleague's scary abduction: "First, they abduct him in broad daylight, no warrant, no cause, nothing. Refuse to admit they have taken him. When that becomes impossible, you know, with even BBC reporting on this, then they lie about from where he was taken, to create a bogus case."

While the Justice had in fact been taken on April 3 from Chandigarh, the official police records showed him arrested for seditious activities on April 4 in Anandpur Sahib. The Punjab Police were perfecting what has since become a common strategy when an illegal abduction is uncovered: falsifying the time and location of the actual nabbing. Besides adding insult to injury, the strategy plants doubt and distrust in the new arrestee's already jittery social circle.

No golfing friends, no Sector 2 neighbors (other than Grewal), and only few relatives came calling. Police versions about the Justice's arrest began appearing in the English dailies. Rajvinder can't help laughing again. "The genius story was that he was just standing there in Anandpur Sahib, yelling Khalistani slogans! Yes, he had been to Anandpur Sahib. But that was a few *weeks* before, for a meeting regarding the election boycott."

The infamous "boycott"[2] continues to be regarded as a critical pivot in Punjab's conflict history, with vehement disagreements over whether it was the greatest gamble or folly.

"The first boycott was in 1991, by the government, in fact," says Inderjit Singh Jaijee. "The government in New Delhi had fallen, and the entire country was due for election. Punjab had not had an election since 1987, when President's Rule was declared."[3]

The collapse of the National Front government had created a window of engagement between the government in New Delhi and militant leaders in Punjab. By now, militant groups "had emerged as the most significant political force in Sikh politics."[4] They had a tight grip in rural Punjab and ran parallel processes, including village dispute resolution, and issued strict codes of conduct, such as antidowry (celebrated by many) and for female dress codes (derided especially in the cities).

New Prime Minister Chandra Shekhar was amenable to Punjab polls: it was understood that a pro-militant government would win,[5] but the negotiations were said to involve an agreement that the victorious militants would not declare Khalistan.[6] Shekhar's parleys were not acceptable to most other political parties, particularly the Congress. In May 1991, Rajiv Gandhi promised that should his party win a parliamentary majority, he would ensure canceling state polls in Punjab.[7]

"Citing serious security concerns in Punjab, the Election Commission declared that Punjab's polls would take place two weeks after the rest of the states," Jaijee remembers of the election scheduled for June 1991. "But before Punjab could go to these delayed polls, the Congress Party had come to power at the Center and was able to formally declare the election postponed. See, whenever a candidate dies a violent death, polling for that seat is countermanded. And in 1991, there were mass killings of candidates."

Jaijee's organization, Movement Against State Repression, MASR, compiled a list of 29 candidates killed, ostensibly by militant bullets.

Says Jaijee, "First the narrative was, Look, the Akalis support the militant anarchy, do not allow elections. But then in 1991 we saw Akalis of various hues running for elections. And they kept being killed. Twenty-nine candidates died, twenty-six of them Sikhs. … And the convenient explanation was, The militants are doing this. But who was benefitting from knocking out candidates who generally supported the militants? Who didn't want Akalis to win? Shouldn't these questions be asked?"

Political scientist Gurharpal Singh notes, "The postponement had profound consequences. Confidence in the state administration was shaken as Governor Malhotra resigned in protest. Sikh leaders from all spectrums made common cause against the government's decision. At a meeting in Anandpur in early September, they decided to boycott any future polls on the grounds that the central government could not guarantee that it would be 'free and fair.'"[8]

The election bloodshed did not end in June 1991. An estimated 50 more candidates died in the following months, according to some human rights groups.[9] Candidate Avtar Singh Shutrana's fate would become emblematic for

times to come; photographs of his disfigured body traveled through Punjab, to the halls of the U.S. Congress, and beyond. On June 27, village neighbors had witnessed Avtar Singh being taken by the police. By July 2, a newspaper reported that he had drowned in a canal when he attempted escape by jumping from a police truck. An amended version a few days later stated he died in police-militant crossfire.[10]

Only a month earlier, in an article titled "Encounters Made to Order," even a mainstream Delhi-based newspaper, *The Hindu*, had wondered, "Isn't it baffling why militants are seeking out situations in which they kill only their comrades? ... Moreover, while policemen are dying in large numbers in other encounters with the militants, in these cases not one policeman has ever been hurt. ... A local lawyer says the militants value the lives of their comrades immensely and do not undertake a rescue operation unless they are certain of success."[11]

The villagers caught the police conducting a hurried cremation and fought for Avtar Singh's body. Then, someone managed to take photographs: disjointed limbs, burn marks on his hands and feet, a scorched arm, electric iron burns across his body. The photos shrieked death by torture.

Jaijee had obtained copies of the photographs from another human rights campaigner: Dr. Sukhjeet Kaur Gill. Dr. Gill often worked alongside Kaur, Jaijee, and Bains, but was closest to another activist, Narinder Singh. "It was a personality thing, nothing more," says Rajvinder. "They were quite similar, she and Major General Narinder Singh: disciplinarians, very staunch Sikhs. See, Daddy, Baljit Aunty, may sit and take a drink in the evening, but Dr. Gill and General Narinder Singh shunned alcohol. They were also very organized. And Daddy ... well, as you've seen, he was quite the opposite!"

A successful gynecologist, Sukhjeet Kaur had taken early retirement after 1984. "I thought, if no well-educated Sikhs leave their professions, our advocacy won't go far," she says in 2015. "Once you have two, three degrees behind your name, when you go to meet some official, you send in your card, people will not deny you. Instead, they wonder, why is she running around on these issues? I strongly felt well-educated Sikhs have to come out to meet the world's people!"

"You know how I got those photographs of Avtar Singh? Were dropped in my letter box. See, the countryside respected, responded to the work. I would be sent things, time to time. Then we started the investigation into this election death too."

A violent six months later, another election was scheduled for February 1992. In November 1991, Punjab saw the largest military buildup since 1984, writes Gurharpal Singh: "250,000 security and police personnel were mobilized. This total consisted of thirty-four army brigades of 150,000 soldiers, 40,000 paramilitaries ... 53,000 police personnel, 20,000 home guards, and 1200 special police officers"[12] (Photo 5.1).

"And this time, the Akalis backed out of the election," says Jaijee. "And this time, no one was killed. It obviously wasn't that they were Congress-loving, these militants. So what is the explanation? If Akalis had participated, the entire middle rung of their leadership would have been wiped out."

H. No. 314
Sector 44A
Chandigarh
To, 25, January '92

The Election Commissioner of India,
Nirvachan Sadan,
Ashoka Road,
New Delhi

Sub: Recruitment of 25,000 SPOS during Elections

Dear Sir,

Induction of 25,900 SPOS during Elections, as per report in
the Newspaper, would form a corupt practice under the
Election Law. At a per mansem salary of approximately
1,000/- , the expenditure will be 2.5 Crores. If the SPOS
are permitted for 2 months, the expenditure will be 5 Crores.
This means that @ Rs.100/- per vote candidates would be in a
position to purchase 5 lakhs votes. There would be no control
over this expenditure except procurement of receipts from
the SPOS which can be easily done.

Assuming that the money is rightfully spent the employed
25,000 SPOS would obviously vote for their pay masters.

You are requested to kindly issue instructions prohibiting
the recruitment of SPOS during Election period.

 Yours sincerely,

 (Inderjit Singh Jaijee)
 Former MLA Punjab

 Mohinderjit Singh Sethi
 Former Advocate General Punjab

NOT INSURED

Photo 5.1 Letter to Election Commissioner regarding 25,000 Special Police Officers
recruited during 1992 election (Courtesy I.S. Jaijee archive)

"Considering the Sikh community's resentment against the Centre at that
time, outwardly the call for boycott did not seem inappropriate or strange. The
community rallied around the Akalis in enforcing the boycott"[13]—Jaijee still
maintains what he wrote, though he had not joined the boycott calls. He
believes the call was highly suspicious, led by players with vested interests, and
joined by several knowing and unknowing collaborators.

The suspicions and convictions around the 1992 boycott may have strengthened in hindsight.

Dr. Sukhjeet Kaur Gill says, "It was a terrible mistake. You know my habit, my disease? I always analyze everything ... think how it will play out in the long run. Do other people do that? Very few. I kept saying, if we can stop elections forever, then okay. But if we can't, then this is giving up power in enemy hands. And the enemy is strong, and then they will eradicate. Instead, I said, let's identify good people, create a group of twenty-five to thirty that can come together, and slowly build a government. It would still involve deaths, but not like what I could see would happen this way, with this boycott."

Baljit Kaur's assessment is not much different, though she believes many of those responding to the boycott call were caught in the fog of the conflict. "At that time, they could have come into the Assembly and announced increased autonomy, even Khalistan. That election was called off because state agencies wanted the boycott, they didn't want the militants to come into power. And who pushed for the boycott? It was Tohra. And the Babbar Khalsa group. They had been infiltrated too. And the farmer unions called for it, like union leader Lakhowal."

"Many of these people were used as tools, and may not even have known it. ... But anyway, it was a mistake. And now the mistake is that people say that the Sikhs asked for the boycott. It was the State that wanted the boycott, clearly."

Certainly, what is today peddled as history was even then shrouded in mystery.

While many Sikhs ardently supported the principle of boycotting the electoral system that was widely perceived as rigged, a few Sikh leaders claimed the boycott was also rigged. Being anti-boycott while pro-Sikh was neither easy nor safe, says Gurtej Singh, who had held the distinction of serving in two of the elite Indian bureaucratic services before 1984: Indian Administrative Services and Indian Police Services. But soon after the 1984 attacks, the former IPS and IAS officer was forced underground. In the early 1990s, he had just resumed life back in Chandigarh. He was a vocal critic of the 1992 boycott.

"It was by far the biggest blunder in recent Sikh history," he says. "Participating in the elections could have resolved many of our problems and could have put us on the path of resolving the rest. It could have eventually changed the course of our history. I was in negotiations with Chandra Shekhar [Prime Minister] in 1991 to push for elections in the Punjab. He did order them, but unfortunately these were postponed at the last minute. And for persuading him to call the elections I was called names by several prominent political leaders. I had suspected that the elections in the Punjab would be cancelled later and had filed a writ in the High Court to avert the tragedy. Sadly, I could not convince the court."

"In the 1992 elections, I went around with two or three others to request all Sikh political factions to participate. Their response was to dub me an agent of the government." Gurtej Singh has still not been able to live that down in some Sikh circles. "Some alleged that I was planning to become the Chief Minister. One doesn't descend to CM's chair from the sky! ... But in our world people can say anything about anyone. I tried to convince them that the gov-

ernment is unwilling to hold elections just to keep them at a safe distance from political power and they were obliging it with a boycott to achieve the same end." He maintains that the various Sikh factions played into the hands of a larger game.

Appointed as Professor of Sikhism by the SGPC body, Gurtej Singh has remained outspoken about the larger realpolitik games, including Pakistan's role in the rapid decline of the militancy. "Benazir Bhutto later made a statement to the BBC in an interview that she had saved India from a disaster by giving exact information to Rajiv Gandhi, that lead to the mass elimination of Sikh militants in a short time. To silence the skeptics, she also stated that she had given the information in a one to one meeting and that, 'there wasn't a fly on the wall' when she did it. Immediately after that she was assassinated while addressing an election meeting. At least one prominent Pakistani intellectual, Brigadier Usman Khalid, theorised that she paid the price of betraying her country's strategic interest."

Nonmilitant Sikh leaders and hundreds of Akali party workers continued to be arrested under TADA while rallies and protests were severely curtailed by heavy deployments across Punjab.[14] Various influential Sikh leaders were also missing—in hiding or in unknown detention—including many of those associated with the boycott. "The famous Bittu was still in custody then, since 1988," says Jaijee. "When they had to get the election boycotted, they did it in his name. Maybe they just used Bittu's name. But then he should clarify. He never has."

Sukhjeet Kaur remembers being away from the compounding confusion in 1992 and 1993. The Sikh diaspora had fully caught up with the dossiers of death in Punjab, was spiritedly activated, and rife with calls for Khalistan, justice, and/or retribution. Sukhjeet Kaur was touring the United States, speaking on the reality she had witnessed in Punjab, and refusing recommendations she not return to Punjab given her outspokenness.

"In California once, so many people came to my talk. Plus, so many government informers from our community only. I said there too, Everything I am saying will be conveyed to the Indian Embassy, but I don't care. I'm asking for nothing too complicated. I am just asking that we have a right to live! If they can't give us the right there, to live with dignity, only then it becomes a fight for something else."

"And some of our foolish boys come asking later, hot under the collar, Doctor Sahib, tussi Khalistan naahin kihaa! You didn't mention the word Khalistan, was their issue." She breaks into a chuckle. "Kakaji, I told them, I just said we have right to live and I'm saying U.S. government should press Indian government to guarantee that. Spell it out yourself! They were dedicated boys and all, but really, people don't analyze things."

The Delhi government's analysis meanwhile was crystal clear, says Jaijee. "The Khalistanis are winning, Narasimha Rao said, we can't allow an election." Rao, home minister in Rajiv Gandhi's cabinet, had become Prime Minister after Rajiv's assassination. The maximum Sikh deaths, post-1947, would take place during Rao's tenure.[15]

Sikhs across India had frozen with fear on May 21, 1991, as news spread that Rajiv Gandhi had been blown up by a human bomb. I pieced together through quiet conversations between the adults that a Sikh acquaintance had called about the assassination. He had said it was far away in South India and fortunately not by Sikhs (massacred in the thousands by Rajiv's loyalists in 1984, when his mother Indira Gandhi was reported to have been assassinated by her Sikh bodyguards). I was told not to ask any questions or repeat anything I heard about this phone call.

On Prime Minister Narasimha Rao's role in Punjab, Jaijee said, "Sheshan, the Election Commissioner who had doctored the 1991 election and postponed it under Gandhi, now successfully followed the bidding of Rao. And that second boycott was a turning point. Had a true election been allowed, militants would have come in. ... But in 1992, Beant Singh was sworn in as Chief Minister and the killings escalated. Congress had won without contest, with single-digit election participation, on the urban Hindu vote. With that flimsy mandate, still the government in New Delhi, with the thunderous media, projected the results as a popular mandate to stamp out the militancy!"

Voter turnout was in fact 24.3 and 21.5 percent for the state and parliamentary elections, respectively, writes Gurharpal Singh. "In the main, the Congress did exceptionally well in the urban constituencies and the accusation that its success rests entirely on the 'Hindu vote' is perhaps an overstatement."[16] But the Sikh peasantry was only nominally represented in these results. They would continue to bear the worst brunt of these results. "The aggregate number of state assembly votes for the party was only 10 percent of the total electorate, and this support was heavily drawn from urban areas with nominal representation of the Sikh peasantry."[17]

Beant Singh was the central government's choice for Chief Minister.

"With Beant Singh came the bloodiest time in Punjab," says Justice Bains. "This was no shock, given his record, given these elections and why he was chosen. People hadn't voted for him."

In March 1992, a significant media exposé, "Watery Grave for Punjab's Militants," publicized the government's common means of human disposal.

"See, I had gone with Justice Bains and Bhai Ashok Bagrian, who also worked with us, and we saw some bodies in the dried-up riverbed," says Jaijee. "When we talked to local panchayats and those who cleaned the canals, we learnt these were coming downstream from a torture center. I had seen three bodies dredged up with beards and faces having marks. And they were telling us about fifteen more."

"I began working on convincing outside correspondents to come from Delhi. It took ten to twelve days. I took them along and we traveled seventeen kilometers up and down riverbed. Found seventeen bodies in seventeen kilometers."

"Then the next week, I took a *Telegraph* correspondent and we saw nineteen bodies in nineteen kilometers." He stops and says slowly, "In Punjab, there are over five thousand kilometers of river."

While not every kilometer of the canal system was equally defaced, it is pertinent that the canals Jaijee himself began investigating were in Malwa area: the least "militancy-affected," area by all estimates. "So, one can estimate how many boys met such an inhumane end. See, Amnesty, U.S. Congress, all had raised this issue. It was well known, really. But now the correspondents could report what they eyewitnessed."

Violence had intensified across Punjab. Militant assaults increased against what they viewed as an illegitimate new government, while the distinction between militants, infiltrators, and profiteers became extremely blurred. In Beant Singh's government, KPS Gill thrived as the Director General of Police. Nineteen ninety-two would become the year Jaswant Singh Khalra's later press release would identify as quickening crematoria traffic. Policemen, soldiers, and their operatives were protected, rewarded, and posthumously lauded for curbing terrorism. Unsalaried combatants meanwhile met unsung ends—Beant Singh's government had even banned gatherings for any alleged militant's bhog, funeral.[18]

Gurharpal Singh notes, "These years were a critical turning point in the militants' campaign for Khalistan. From the high watermark of 1991, when the militants appeared to be winning the 'civil war' in Punjab, the security forces were able to make a decisive breakthrough by June 1992, which ultimately led to the militants' crushing defeat."[19]

Singh explains that while the Punjab Police and K.P.S. Gill took credit for the ultimate quashing of the militancy, the pivotal role of the Indian Army was unquestionable and strategically underplayed:

> In reality anti-terrorism triumphed because of the massive security cordon thrown around Punjab after Operation Rakshak II. ... The key role in this operation was played by the army, which was instructed to 'put the fear of God into the minds of terrorists.' Learning from previous operations in Punjab—Blue Star (1984), Woodrose (1984), Brasstacks (1987), and Rakshak I (1990/1)—the army was deployed as an 'aid to civil power' in which, although it carried out major anti-terrorist operations, the Punjab police were given the official recognition. ... Actually, the army captured many terrorists, including some prominent ones, who were all handed to the Punjab Police [with] the army taking no credit nor claiming reward money.[20]

Yet, to date, the Punjab Police's claims have made it seem that Punjab is distinct from other conflicts, such as Kashmir and Manipur, because Punjab's own force managed the maximum number of operations against its people.

K.S. Dhillon, former Director General of Police of Punjab, writes about the 1992 turning point: "Somewhat mysteriously, the Punjab militancy, which had seemed unbeatable until as late as March 1991, came to an abrupt end by 1992 amidst the showering of fulsome praise on a triumphant Punjab police."

"What was happening," says Baljit Kaur, "was unchecked terrorizing of the countryside. Anyone could be declared a terrorist: someone distantly related to a militant, someone harboring a militant, someone the local police or their agents had to settle scores with. And also anyone who had been legally fighting for human rights, like Justice Bains."

The justice's arrest contributed to the suffocating fear and portended badly for all. "It had an impact," says Rajvinder. "They calculated the silencing effect it would have. But it didn't work perfectly either. For more than a month, lawyers went on strike while he was jailed."

"Though, despite Bar strikes and the international solidarity, not a single one of his colleagues said anything in support. Not even in private. And the police were trying to turn anyone and everyone against him. Like they asked our neighbors' gardener to become a witness and to say armed people used to come to our house. He remained steadfast, a poor man, who refused them. Then they went to Daddy's village Mahilpur to find someone corruptible. Couldn't."

"But the elite judicial colleagues. The neighbors. Not so steadfast. Most people thought, 'Must be a dangerous man when so much police came raiding his house!'"

Then Rajvinder remembers an exception to the shameful showing by the judicial circle. "There was one single magistrate from Haryana, Divan Chand, who came to see him in jail. Daddy asked him, 'Why have you come in these conditions?' And he said, 'Someone like me could never have even joined this service were it not for you.'"

"Though Daddy had helped recruit many others too, he was the only one who came. Otherwise, senior lawyers, my own senior colleagues, including one who had known the family intimately for two generations, didn't come. Daddy's old friends came—from before judgeship. Which says something about what kind of people the bench attracts, or any position of influence attracts. It was very, very clear that all prejudgeship friends were real. And then all his real friends were his friends after retirement, Baljit Aunty and all. Rest were too fearful."

Rachpal Bains scoffs recounting the various social pressures and police intimidations. "My home telephone often rang asking me, advising me to *compromise* with Beant Singh, or else the whole family will pay. I cursed at them. I'm not one of those people who will pretend I was all polite to the brutes!"

It would take almost five months to get the judge released and back to his routine. Rachpal Bains adds, "We did retrieve his beloved car before though." The afternoon after the abduction, the family had received a call from a police inspector in Mohali. He encouraged them to come pick up the vehicle. He parroted that it had been left by Justice Bains on the way to Anandpur Sahib the day before. He said he didn't know more, he had simply been entrusted with its safekeeping.

* * *

ENTRUSTED WITH ITS SAFEKEEPING, THE OLD SIKH MAN had carefully propped the Swiss luxury car on four bricks. The owners were long gone: in what they had thought a temporary migration to Pakistan. Possessions impossible to bury in the mud floors, behind loose bricks, down family wells, were given to trusted neighbors. The car's tires had predictably deflated. Not that the keeper knew how to drive. But the old Sikh knew when he saw splendor from a lost era. And the car displayed outside his home in a sleepy village near Patiala always fascinated my father and his cousins. At that age, they only heard euphemistic stories of the recently disinherited and disappeared Muslim co-inhabitants. The tumultuous months of 1947 had stretched into years.

In this Punjab dizzied by titanic loss, pre-Partition assurances to Sikh politicians were meeting new resistance by the postcolonial state.

When in 1948 Sikh leaders demanded the separate electorate and special status they had been promised, they were quickly rebuked.[21] Outright dismissals and attempts at subsuming the Sikh identity within the majority Hindu umbrella (including by an at-best callous Article 25 of the Constitution per which reference to "Hindus" shall also imply Sikhs, Jains, Buddhists), would eventually lead to Sikhs in the Constituent Assembly declaring their community's unequivocal opposition. No Sikh representative ever signed the Indian Constitution.[22]

Incoming refugees who had survived the ravages of the marauders had then faced the wrath of the monsoon and attendant cholera in makeshift camps. In October 1947, the refugee population in east (Indian) Punjab camps was over 720,000.[23] Informal private rehabilitation camps and efforts (like H.S. Jaijee's in his Chural estate) were much needed.

Farmers from west Punjab began slowly settling into the much smaller and poorer lands in east Punjab.[24] Soon, the desire to rebuild subsumed the refugees, many of whom were keen to counter their constant flashbacks of the colossal losses. As the agrarian and mercantile sector of east Punjab began to flourish through dogged innovation, and Sikhs reclaimed their place of pride as a community that never begs, political demands began rapidly resurfacing. Moreover, Sikhs were now in a majority in crucial geographic areas.[25] Punjab's princely states had been merged into a single unit in 1948: the Patiala and East Punjab States Union, PEPSU, with Maharaja Patiala Yadavindra Singh at the helm.[26] PEPSU represented a Sikh reconsolidation.

"All were together," says Jaijee. "All Akalis. And they won elections and then Sardar Gian Singh Rarewala was made the Chief Minister. And that was the last time … the last hurrah, now looking back. The last time Sikhs had some self-governance."

The Akali Dal-led PEPSU government lasted nine months before it was dismissed and President's Rule was declared by New Delhi in 1953.

"The multi-racial, -lingual, -tribal, and -religious character of Indian people was all being centralized post-forty-seven," says Justice Bains. "Sikhs never signed the supreme law of the land because all the legitimate asks by the Sikhs

and minorities were being dismissed outright." The retired Justice had been away from Punjab during several turbulently decisive years.

"My uncle had taken me away from Punjab before Partition. Even when Uncle was transferred out, since I liked Lucknow a lot, I stayed. And I lived in a Hindu mandir for a year. Yes! You won't believe it, the priest there said the rent was one rupee a month! And there was one more person like me. Brij Bihari Nayak, from Jhansi, he was my class fellow. We both lived there. Then, I went to hostel for four years and finished my MA in Law."

"I came to Punjab, to Lyallpur Khalsa College, Jalandhar as a lecturer in 1950. See, some leftist boys. … In colleges there weren't many leftists, mostly just communal organizing. So these were a few leftist boys. They came to know about me and said come here, there is a vacant position and you are qualified. Meet the principal. But don't let him find out that we asked you!"

"So I met with the principal and then told him my education, my village and all, and he said, 'Okay, I am satisfied. How much salary do you want?'"

"I said, I don't know. Whatever you give others, give me also …."

"So he said two hundred twenty rupees."

"And Principal saab used to have a tongaa. Big deal those day, horse-pulled tongaa to go across the college! We got in that and went to the president of the management committee to confirm my appointment. So that is how I started. I taught there for three years, before they dismissed me in 1953."

"The managing committee fired us. Four or five of us. All leftists. The students were all with us. They all went on strike in our favor. The newspapers covered it … We used to teach well, and we got these boys all excited too!"

"Those fired, we all ended up meeting Partap Singh Kairon, who was already a minister. He offered, 'I'll admit you as BDOs [Block Development Officers].' I said, No, thank you. And I told the others too, Don't do it. I mean, what were we going to get by becoming civil servants? I thought it was now time for me to go back home to Hoshiarpur, and perhaps do something with my law degree!"

Meanwhile, the politics of language-based identity had swept over Punjab. "The Indian National Congress had committed itself to the principle of linguistic provinces," writes Khushwant Singh. "But after independence, its attitude to the subject changed—inasmuch as it concerned the Punjab and the Sikhs."[27] New Delhi's quick snubbing of the Sikh linguistic demand seeded the next decade-long movement in Punjab.

Language recognition was also clearly linked to a Sikh-majority area, as promised before independence (Nehru's 1946 speech was often cited: "The brave Sikhs are entitled to special consideration. I see nothing wrong with an area and a setup in the north wherein the Sikhs can also experience the glow of freedom."[28])

"Various Indians began quickly experiencing how the Westphalian model may not work well for them. India is a collection of distinct nations and peoples," says Jaijee in 2016. There are over 400 living languages in India today.

During the 1951 census, Arya Samaj workers had campaigned to persuade Punjabi-speaking Hindus to disown their mother tongue and declare it as Hindi for purposes of the census. (This campaign would be much more spirited and successful by the next census, a decade later, in 1961.)[29]

The government-appointed 1953 States Reorganization Commission had no Sikh representative and outright rejected a Punjabi-speaking state. By 1955, the Punjabi Suba Movement was in full swing: Sikhs, led by Akalis, mobilized to rebut the government's claim that majority Punjabis were not interested in a Punjabi-speaking state. Protest marches from Darbar Sahib were becoming common and Akali leaders like Tara Singh began being arrested, released, and rearrested after more protests.

PEPSU was officially merged with the rest of Punjab in 1956. According to historian Khushwant Singh, this was the result of the government realizing "the unpleasant reality that the notion of a Sikh state had been reactivated in the minds of Sikhs and PEPSU had in fact become the nucleus of a Sikhistan. ... Akali leaders were hoodwinked into believing that the merger was a step toward the establishment of a Punjabi Suba."[30] Akali leadership had fractured.

Negotiations had yielded no results,[31] and the government's 1957 decision deepened embitterment: Punjab was declared a bilingual state, Punjabi and Hindi both its official languages. Sikh protest mounted, communal tensions rose, and Sikhs began to perceive the downside of their Partition-time wager of staying with majority Hindu India.[32]

"At that time, after my schooling, I was back in Patiala," says Baljit Kaur, "What I wanted to study in college was political science. I didn't end up doing that. My desire was to join the Indian Administrative Services. Which I never got to. Just to kill time before I got married, I joined Mohindra College, took history classes. It was just a wish of mine to join the IAS. Had I spoken of it, maybe I would have gotten some guidance."

In 1958, Baljit Kaur married Jagjit Singh Gill. The couple soon left for the northeastern state of Assam, where his family owned tea estates. By 1959, their daughter Teerath was born, and the homesick and subdued bride found some joy. "I missed Punjab terribly. This was very enclosed," Baljit Kaur says. "There were servants, but it was lonely. And then there was the planters' club and men had drinks, not that ladies couldn't, but somehow, didn't. ... Our garden was fourteen miles away from others, so we didn't have immediate neighbors. No, I have no grouse. My daughter was born there."

Meanwhile, in her home state, her father's estate was abuzz with activity. The Congress–Akali animosity and competition for Punjab was in full view. Master Tara Singh had asked H.S. Jaijee to organize the All India Akali Conference of 1959 in Patiala. With internal disgruntlements, and several Akali defections, the conference was pivotal. H.S. Jaijee made a politically strategic speech about the shared cause of Punjabi Suba, despite any difference in political affiliations. The conference that rekindled the Akali spirit further raised H.S. Jaijee's public profile.

His youngest son, Inderjit Singh Jaijee, could hardly wait to have his own profile. The constant burden of never bringing unwelcome attention on his well-known family was often too much for his adventurous nature. After graduating from the Government College of Ludhiana, he went to pursue Law at Delhi University.

G.S. Grewal, his law school classmate, remembers how the young Jaijee made waves. "Oh, he was already a very important man for us. He spoke English phatt-phatt, fluently. A first-rate athlete. And then one with royal connections!"

In university, Jaijee actively pursued his own interests.

"Lots was happening in Delhi too, and I met many people I had only heard about. But you know what stands out? My good fortune of meeting Dr. Ambedkar."

"See, we would invite one VIP every month to a university dinner. Three of us boys went to invite Dr. Ambedkar to preside over our function. He had turned Buddhist by then and we had to wait for thirty minutes for him to complete chantings."

"He looked directly at me and asked, 'Sardar Sahib, where are you from?'"

"Patiala, I said."

"'Oh, the Jatt Land.' He said that and stared at me."

"I blurted out, No, the land of Baba Nanak!"

"Ambedkar thawed at the mention of Baba Nanak. Almost immediately. And I really took to that."

"'Why invite me, boys?' he asked."

"You, sir, are the father of the Indian Constitution!"

"'If I had a chance now, I would tear that Constitution,' he said.' Nehru made me write things I wasn't in favor of then and am against now.'"

"We just stared at him in disbelief."

"He said: 'I was never in favor of a reservation for the Dalits. I wouldn't have done it but for the insistence of Nehru.'"

The quota that reserves a small percentage of seats for the largest percentage of India's population, the so-called lower castes and Dalits. The alternative— separate electorates and proportional representation—was out of the question for Nehru and his cohort: India's Brahmin and high castes, less than 5 percent of the population, have always remained the ruling political elite.

"We were young and naïve. All we said was something like, But we really see you as the father of the Constitution! We were so taken aback. Truly, we were then probably mainly worried about securing our chief guest for the dinner!"

"Ambedkar did not attend."

Dr. B.R. Ambedkar, the erudite and visionary leader and Dalit champion, had even considered converting to Sikhism, along with his followers. Some Sikh leaders welcomed him, but many others, swayed by their own caste considerations, made this impossible. Jaijee expresses his deep regret at Sikhs not embracing their natural allies, the Ambedkarites. He reflects:

"I meant what I said to him then, retorting to his classifying Punjab as Jatt-land. But I also remember the reality well, from my boyhood. For example,

Master Tara Singh. Often I was made in charge of his care when he would come to visit. Some senility was setting in. And he felt embittered too. And tired. His weakness, looking back, was clearly in how he allowed the merger of PEPSU with Punjab. He was considering his own position and all that. Was a clear folly. Anyway, I remember him as an old man. He wanted to talk and I listened."

"What stands out most in my mind, the only wrong thing I ever heard him say, in fact, was around Ambedkar's conversion to Sikhi. He said, 'I opposed him … Inaa di gintni nahin taa aapne to ziadaa vaddh ho jaandi!' Confessing, blatantly, that he too had opposed Ambedkarites becoming Sikh, worrying the Dalits would then outnumber Sikhs like him! That really stuck with me as a flaw in his nature."

* * *

"HIS NATURE IS ONE AGAINST ANY CONFINEMENT, he feels suffocated even in an air-conditioned room!" laughs Rajvinder Bains. "Daddy always preferred the open outdoors. So he was feeling very uneasy in jail. He said, 'Get me out, I can't work here!' But my mother, she had declared no one was going to file for bail. That the government had to exonerate and release him. Till then, let him sit in jail, a thorn in their side. My mother's bravery really kept us all going."

Rachpal Bains's first petition to the High Court on April 6, 1992, was dismissed by the Court on April 8, 1992.[33] Even as the police failed to produce Justice Bains, the Court quickly closed its door on the issue of the secret and illegal arrest and detention of one of its retired justices. The Court quickly stated that the habeas corpus issue was resolved since the family had found the detained Justice was at Anandpur Sahib police station.

The Court did leave it to a lower Sessions Judge[34] to investigate the allegation that the Justice had also been illegally handcuffed by the police.

Justice Bains was then shifted to Burail Jail, just outside Chandigarh. "And Colonel Partap Singh was also there," remembers Justice Bains. Colonel Partap worked closely with Jaijee, Kaur, and Bains. He had been arrested from his Sector 18 residence the same day as the Justice. His arrest was somewhat less of a shock given the Khalistan freedom manifestos openly circulated by this once Indian Army Lieutenant Colonel.

"There was a superintendent, Mr. Sharma, who was very courteous," says Justice Bains. "He showed us all the rooms and said, You know, when Jayaprakash Narayan was arrested, for him, a room was made, and that room is the best." The Justice smiles at the mention of Narayan, the activist leader who had become the nemesis of Indira Gandhi during the 1970s and was thus shunted to jails far from his home state, Bihar. "That was a nice room … big, and attached bathroom. Colonel Partap stayed there too. They allowed some home food. Sharmaji was very nice."

Meanwhile, the imprisonment made the wiry justice a larger legend across Punjab, India, and the world. Amnesty International had launched an urgent action campaign days after Justice Bain's detention,[35] and followed the case closely thereafter.

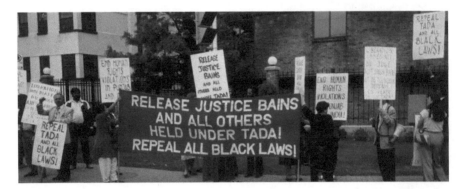

Photo 5.2 Rally for Justice Bains on Parliament Hill, Ottawa, Canada, June 5, 1992. (Photo courtesy Sandra Bains)

Media reports noted how the police's FIR did not even name Justice Bains.[36] And how the state's High Court had followed the bidding of Chief Minister Beant Singh, who released boastful statements that militant-sympathetic Bains would not be released anytime soon.[37]

International pressure mounted, particularly with the tireless work of the Committee for the Release of Justice Ajit Singh Bains, led by his younger brother Hardial Bains, founder of the Communist Party of Canada (Marxist-Leninist). "Hardial could arrange anything," says Jeffrey Goodman, who had worked alongside him since 1974 and was the spokesperson for the Committee for the Release of Justice Bains. At his favorite Portuguese café in Toronto in December 2015, Goodman remembers the shared outrage at the Indian State's impunity. "Justice Bains fought valiantly and vigorously and put his life on the line." He recounts how meetings and protests were organized in Ottawa, Toronto, New York City, Michigan, London, and Dublin (Photo 5.2).

In response to my question about the scope of their committee's outreach, he says, "When we had the meetings for Justice Bains, it wasn't about communism. The hundreds of people who came … I think they cared about the issue, as we did, not labels. Of course, the struggles were interconnected."

"We were activated as a family," explains Rajvinder of the weeks that followed the initial shock. "At the height of all the activity, we had a visitor, one of Daddy's erstwhile friends, in fact. He came on behalf of Chief Minister Beant Singh and said, 'We can get him released, if he just goes silent afterwards.' Then Mummy lashed out: 'If you are going to talk like this, go home!'"

Her steadfastness was noteworthy against the backdrop of continuing mysterious murders in Punjab. For example, in May 1992, Mohan Lal Manchanda, an engineer with All India Radio, was abducted.[38] Then followed a note from Babbar Khalsa militants demanding increased Punjabi-language radio programming. Jaijee remembers various human rights organizations trying to appeal to the Babbars and the government to negotiate Manchanda's release. According to Jaijee, the government showed a lack of urgency, while there

remained incredulity around the reported responsibility of the Babbar, Amrik Singh Kauli. On May 26, Manchanda's beheaded body was found near Ambala. "The final scene was the well-advertised 'manhunt' for Amrik Singh Kauli. A man who has committed a murder would normally try to flee, but Kauli met his end at a place quite near Ambala. The Provincial Civil Service Officers Association, in its memorandum to the governor dated August 26, 1993, had pointed out that Kauli had close links with the police."[39]

The legal battle for Justice Bains continued with sustained solidarity efforts. An April 18, 1992 report released by the Delhi-based Committee for Information and Initiative on Punjab highlighted clear evidence of foul play in the case against Bains.[40] The Punjab and Haryana High Court Bar had been on strike since April 6, joined by several other bar associations across Punjab. On May 8, 1992, the lawyers called off their strike, following Justice Bains's directive from jail that a working bar association was needed to support Punjab's battered rule of law (Photo 5.3).

"And then, Daddy really wanted to come out," says Rajvinder. "And we filed for bail. Otherwise, my mother and we all were not in its favor!" He laughs heartily. "But we then thought that we should not make him our sacrificial goat!"

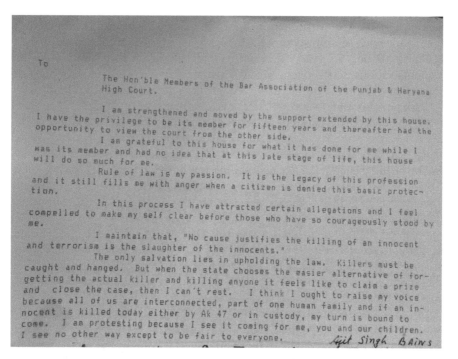

Photo 5.3 Justice Bains's letter to Punjab & Haryana High Court Bar Association. (From Justice Bains private archives)

Mrs. Rachpal Bains's little-known role fascinates me and I wonder about her background. Justice Bains only mentioned it fleetingly, remarking she is "a very brave lady."

Rajvinder explains that she is not his biological mother. "She is much younger than my father. She is my mother's sister, my maasi. My younger brother is from her, otherwise, we three older siblings are from her older sister, who died when I was about two. And at that time, it was a custom. A man left behind with three young children has a younger sister-in-law—get them married. She was very young when Daddy remarried. At eighteen or nineteen she managed us very well and for a long time we just didn't know the whole story. ... Though my older sister was eight years old and she understood everything, I'm sure."

"So anyway, it's a sensible custom for everyone except—as so many of our customs go—for the woman! For her, it was traumatic probably. You are taking care of three young children and you are yourself a child. So that did affect her personality. But she is very courageous, and when he was arrested, in that scenario it showed clearly."

I remind him that her role has never been acknowledged publicly.

"Yes, that's how it goes! For us kids, for the day-to-day, we had always looked to my mother's courage. Like even if there was a snake to be killed, she would do that! She was actually the anchor. Management abilities. Every practical thing. House construction. School admissions. ... I mean, Daddy didn't even know what school we were in. Actually!"

Rachpal Bains, 73 years old when we met, has not lost her spunk. As she recounts various details of the arrest, I remark that she was uniquely outspoken, given the times. She sniggers, "People have always loved that about me!"

I ask her about life before she became Mrs. Bains.

"I was the fourth daughter in our house, and the youngest ... I had to be feisty. I learnt early, if I even wanted a glass of milk, I had to cry and create chaos. I had to snatch everything that was my due."

She proudly channeled her rage during her husband's arrest. "Such games. I made it very clear: I will take down a hundred of them before going down myself, I am no giddar!" The jackal is often invoked as the cowardly contrast to the lionheartedness preached by the Sikh Gurus.

"See, on the one hand, he's still in jail. On the other they ask me, 'Should we get him a cooler, it's so hot?' I said, No, now treat him like you treat all your prisoners! And then he had a heart attack in jail and they called me saying 'The civil surgeon is calling you.' I said, Deal with him. You took him illegally, now you keep him alive or face our wrath!"

On May 22, 1992, the Sessions Judge at Ropar issued his report finding the police officers had handcuffed the elderly justice against set Supreme Court precedent on the issue.[41] The report noted several holes in the police version, including the claim that nothing had been found in the Justice's pockets when he was allegedly arrested from Anandpur Sahib. "It is beyond comprehension that Justice Bains could move at Anandpur Sahib without any amount with

him."[42] The judge concluded Justice Bains had been arrested at Chandigarh and not at Anandpur Sahib.[43]

The damning report did not result in the immediate release of Justice Bains. He had been accused under the notorious TADA, after all. Rachpal Bains approached the Supreme Court of India, which held it would only revisit the case after the Punjab Court decided on the Justice's bail.[44] On August 18, 1992, the Justice was released on bail. The terrorism charges against him were still pending.

"But Colonel Partap remained confined much longer," remembers Justice Bains. The once army man, Rotary Club president, well known for his Rolls-Royce and fondness for Chandigarh parties, Lieutenant Colonel Partap Singh had become a flag bearer for Khalistan. He especially attracted the government's radar in 1991 when, after resigning from the Working Committee of Akali Dal (Mann), he had launched the Khalsa Raj Party for an independent Sikh homeland. His book, *Khalistan: The Only Solution*, was released in 1991.[45]

"After I had gotten to know him through our work, we were also invited to some of the get-togethers at his house," says Baljit Kaur. "They seemed like a warm family …till bad times came upon them after he wrote his book and had to go abroad and the family had disputes."

G.S. Grewal, who witnessed neighbor Bains's home raid, would come to represent Lieutenant Colonel Partap in his sedition case. "It took six months of courtroom arguments. They would take it one hour at a time … then judge would say, 'Rest tomorrow,'" remembers Grewal. "However, they also wanted no appeal on this case concerning the right to ask for self-determination within the constitutional limits, because if it went to Supreme Court, it would make noise. So it was eventually just dismissed. After this, Colonel Partap went to the U.S. for a while."

Remembers Jaijee, "Partap was a good chap, a very good chap. He died early, you know, of unhappiness really. There was a familial breakdown. There were property disputes, lots of things happened as he began speaking out for Khalistan."

"When he was sick later, I remember visiting him and seeing him in shambles," says Baljit Kaur. "He had nothing to offer his guests. The same man who threw all those parties. His heart gave out."

Through his trial, lawyer Grewal remembers the Lieutenant Colonel's wife attending each of the numerous court dates. His friends only remember his lonely demise a few years later.

In its 1992 judgment, the High Court notes that while the police contended that Partap Singh's speech about his new Khalsa Raj Party was inciting communal ill will, fueling hatred, and was dangerous to the nation, the actual words of the speech clearly contradicted such intentions: "Grievance of the petitioner is against policies of the Indian Government and not against any religion, caste, or any particular community." Further, the High Court reiterates clear precedent about the ambit of freedom of speech protections under the Indian Constitution:

Mere demand for formation of separate State through non-violent and peaceful means would not in any manner incite or create violence or possibly could [not] have tendency to lead to the disruption of the State or public disorder or to undermine the sovereignty, territorial integrity of India.[46]

The case against Partap Singh was thus quashed. More broadly, the Court had clearly reiterated that the country's Constitution allows even demanding separation from the country, as long as such a demand is not accompanied by a call to arms and does not incite violence.

Despite this and other clear-cut judgments about "sedition," nothing has been clear-cut before or since. The police have filed more and more sedition charges in recent years, even in cases without any discernible threat to the integrity and unity of the nation-state. Sedition accusations, under Section 124A, immediately attach a scarlet letter to the subject, while causing due panic: the serious and nonbailable charges carry the potential of even life imprisonment. Whether against Lieutenant Colonel Partap Singh in 1992, or Simranjit Singh Mann in years before and after, or the celebrity author Arundhati Roy, or unwitting Kashmiri college students, or the unrepresented Kabirpanthi followers of Baba Rampal, or protesters against the Kudankulam nuclear project, "sedition" remains a convenient muzzle. It was used against Partap Singh in the early 1990s because while other elites censored themselves, he had published, in his own name, demands for the right to self-determination.

Lieutenant Colonel Partap's and Justice Bains's time behind bars had coincided with the most expedited elimination of Sikhs captured and jailed across Punjab. Militant leaders were killed in quick succession from July to September 1992 under the Beant Singh government.[47]

With escalated violence by the various deployed forces and the increased murkiness of the militant ranks,[48] the militancy rapidly lost civilian support.[49] "During 1992 police made people fed up with the militants, all the better to control them. Thus there was in the end no sanctuary for them," writes Joyce Pettigrew.[50]

The Indian media gleefully reported the turn of the tide. Baljit Kaur recorded a popular 1990s talk show hosted by the journalist Karan Thapar and actress Sharmila Tagore, who began the Punjab segment asking: "Are the militants really on the run?" The segment celebrates the changing situation in Punjab under K.P.S. Gill and Beant Singh.[51]

A photograph of the bloody dead body of Sukhdev Singh Babbar is shown. Then Thapar gives the example of Sukhdev Singh Babbar's "palatial Patiala house," which caused a "publicity blitz." The size and comfort of the house was emphasized, as against the religious values of the Babbars. Thapar concludes this was "gravely embarrassing that [he] lived in considerable style … that too with mistress and illegitimate son!"

Militant deaths are being confirmed. Varied as their records were—from the locally loved and protected Budhsinghwala[52] to the tarnished Sukhdev Singh Babbar[53]—the genteel anchors never stop to question the extra-legality as they employ the police term "eliminated." They focus on heightened police morale:

"Gill says that the militants had better watch out—now that the cops are doing the bhangra again!" Thapar concludes eerily, "Gill and Punjab police have opened a window of opportunity but the promised land is still a long way off, and if the government in Delhi does not step up, we might never get there." He then moves on to another communalized disaster: "If Punjab is getting better, Ayodhya could be getting worse."[54]

The historic Babri mosque in Ayodhya was violently destroyed in 1992, under resurgent calls to build a Hindu temple on the land. Thousands, mostly Muslims, were killed in the attendant riots. Congress Prime Minister Narasimha Rao was again the head of state during this communalized violence. Bharatiya Janata Party stalwarts were allowed to remain at the forefront of the right-wing violence in Ayodhya.[55]

To the powder keg that was Punjab, Jeffrey Goodman, with Hardial Bains's support, traveled from Canada. "After his release, I wanted to go meet Justice Bains. We had worked so hard on the campaign, now I went to see him."

Goodman then leafs through a photo album of the trip. "I was happy to see the energy and angered conversations about the atrocities against those demanding self-determination" (Photos 5.4 and 5.5).

Governance of Punjab remained democratic in form alone. As one district was to go to special local polls again in 1993 to fill a vacant parliamentary seat,

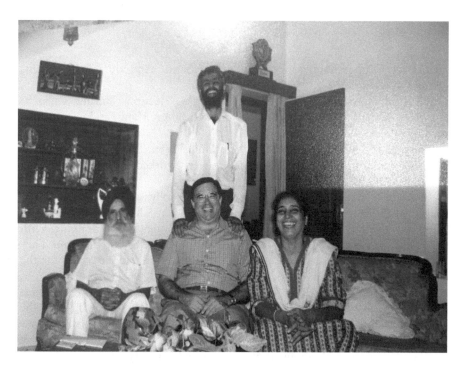

Photo 5.4 Jeffrey Goodman with Rajvinder Bains, Justice Bains, and Rachpal Bains. (Photo courtesy Jeffrey Goodman)

Photo 5.5 Justice Bains addressing a gathering soon after his release; also seen, Baljit Kaur (in white). (Photo courtesy Jeffrey Goodman)

villages were juggernauted by police deployments. And then Justice Bains sprang a surprise.

He suddenly declared he would contest this election. During a trip to Jalandhar, he had met with the leader Simranjit Singh Mann, and was encouraged to run.

"He did this without consulting the family," remembers Rachpal Bains. "Everyone told him this was a bad idea, every worker, everyone. But then Mann was Mann."

"Everyone tried to convince him this was a folly," says Rajvinder. "But Daddy would not listen. And then on election day, there were no booths. People were simply bribed on the way. They took money and went home. With no booths, not even a symbolic presence, who is going to vote for you? They were so well organized, because it was a vital election for the State, for the Beant Singh government."[56]

"Yet, I heard Mann telling Daddy, 'Prepare your speech, we are almost at victory!' And I was so amazed. ... Is he so out of touch with reality? So the bravery I knew him for, maybe it was something else? Jasbir Singh Rode was also egging Daddy on, but I think that was more for material reasons, to receive funding and all that. Mann just didn't acknowledge reality."

Justice Bains does not speak much about this detour from his human rights career. "Oh, yes, galti ho gaayi si." A mistake was made. But some colleagues like Dr. Sukhjeet Gill hardly saw this as an innocent mistake, given the stakes.

Rajvinder admits, "That decision threatened to take away the moral force of the human rights movement."

Jaijee was in the U.K. when Bains was canvassing at home. "I said we should support Justice Bains. And my London hosts, Chauhan and all, promptly agreed and said, 'You make the public appeal.' So I did. I explained Justice Bains is the biggest human rights activist and he has helped the Sikhs so much. And then in one and a half hours, I saw fifty-four lakh rupees collected. Money donated in the collection sheet right before me at gurdwara. Fifty-four lakhs in those days! And I called Justice Bains and told him, Don't worry about the monetary support, see what you can do on the ground."

"But, you know what? We didn't get a penny of that money donated at a gurdwara!" Jaijee stares intently, to bring home the gravity of the dishonesty.

"When I asked the London guys again, they hemmed and hawed and finally said, 'Oh, we had to use it in a protest here only!' Perhaps they did. But people had not donated for that." Jaijee and Bains habitually refuse to dwell on such uncomfortable wrinkles.

Justice Bains's own travel outside India remained severely curtailed, despite there being no travel restrictions in his bail conditions. On September 17, 1994, his luggage was off-loaded from his early morning plane at New Delhi airport and he was unceremoniously prevented from flying to a human rights conference in London. In November, the former Justice was stopped from boarding a plane to neighboring Nepal, where he was to serve as an international election monitor. Two days later, a special order of the Supreme Court allowed his travel. (During the only People's Commission hearing in Chandigarh (in 1995), various others, including Major General Narinder Singh—who was often harassed for his human rights work alongside Dr. Gill, Bains, Kaur, Jaijee—would testify to similar denial of travel over multiple years.) When December 1994 brought an invitation from the International Federation for Human Rights to attend a conference in Spain, Justice Bains realized his Indian passport was close to expiry. He applied for a new passport. This began another long wait and series of petitions.

"Look, Judge Saab's ordeals were in spite of his position, which landed each abuse somewhere in the English papers even. But he was also targeted precisely because of his position: his name had become the rallying cry for championing human rights in Punjab," remembers Baljit Kaur. "The government was so perplexed about how to put fear into such a man, and what he represented! They kept responding childishly."

On November 8, 1996, prompted by High Court orders, a letter from the Ministry of External Affairs explained that no passport would be forthcoming. It then listed the administrative procedures by which Justice Bains could attempt an appeal.

Through 1997 and 1998, legal filings continued for his right to travel.

The precedent set by the Justice's persecution threatened many in the legal profession. In 1994, Punjab lawyers wrote to the Chief Justice of India again, listing vulnerable lawyers and seeking investigation into the deaths of their colleagues and those still absent (disappeared), like Mr. Bhatti, who was abducted

on May 12, 1994, from a public bus—plainclothes armed men, who the bus driver insisted were policemen, climbed on just past a police checkpoint, ordered all Sikh passengers off, and took Bhatti.[57]

Meanwhile, Sikh judges largely remained muzzled, fearful of being labeled anti-State and facing repercussions, starting with being denied promotions and favored postings.[58]

In November 1996, Justice Bains was acquitted of all charges. The judge found the prosecution had not backed up its 1992 case. They had shown a photograph of people ostensibly meeting to make antinational plans, but no one was identifiable; they had referred to cassettes of Justice Bains's supposedly seditious speech, but no script was produced and no voices identified; and they had taken documents from the justice's home, but these only contained letterheads and general circulars, and were "not such which can be described as antinational, incriminating, or objectionable under any law." The police constables unraveled under cross-examination, while none of the other supposed witnesses were ever produced. The judge noted: "[Bains] at most made some speeches which are very much covered within the ambit of Art 19(1) of Constitution of India."[59]

The justice had filed for reparations for his false arrest, detention, and maltreatment. In 2001, a judge found the policemen in charge and the Punjab government jointly and severally liable and ordered that Rupees 50,000 be paid.[60] Says Rajvinder, "It was a matter of principle, why we had asked for a meager monetary award."

Rachpal Bains hasn't forgotten how few stood by their principles in 1992. She scoffs at the faintheartedness shown by the justice's judicial and social circles. "There were so many Sikh infiltrators too ... so many people who sell out for just nothing, no inducement even. They just stupidly give up on themselves, and their community." Mrs. Bains has attracted several detractors, she notes acerbically. "Sardar bewakoof ne," she is not shy to repeat: Sikhs are fools. Her husband, once out of jail, had resumed his work as a beacon of hope for Sikhs worldwide.

NOTES

1. Inderjit Singh Jaijee, *Politics of Genocide: Punjab, 1984–1998* (Delhi: Ajanta Publications, 2002), 163–64.
2. See, for example, Sanjoy Hazarika, "Sikh Militants in Punjab Impose Boycotts on Work and on Voting," *The New York Times*, February 19, 1992.
3. Article 356 of the Indian Constitution allows the federal government, in times of emergencies, to take over direct administration of a state, suspending the state's elected government. "It is of note that President's Rule has been imposed in Punjab between March 1953 and March 1954; June 1951 and April 1952; July 1966 and November 1966; August 1968 and February 1969; June 1971 and March 1972; April 1977 and June 1977; February 1980 and June 1980; October 1983 and September 1985; and June 1987 and February 1992." Angana P. Chatterji, Shashi Buluswar, Mallika Kaur, eds., *Conflicted Democracies*

and Gendered Violence: The Right to Heal (Berkeley: Haas School of Business/ University of California, 2015), 110.

4. Gurharpal Singh, *Ethnic conflict in India: A case-study of Punjab* (New York: St. Martin's Press, 2000), 152.
5. Gurharpal Singh, 149.
6. Gurharpal Singh, 152.
7. Ram Narayan Kumar, Amrik Singh, Ashok Aggarwal, and Jaskaran Kaur, *Reduced to Ashes: The Insurgency and Human Rights in Punjab* (Kathmandu, Nepal: South Asian Forum for Human Rights, 2003), 51, 152–53.
8. Gurharpal Singh, *Ethnic Conflict in India*, 153.
9. Jaijee, *Politics of Genocide*, 140.
10. Jaijee, 140.
11. Jaijee, 116–17.
12. Gurharpal Singh, *Ethnic Conflict in India*, 153–54.
13. Jaijee, *Politics of Genocide*, 139.
14. Gurharpal Singh, *Ethnic Conflict in India*, 154.
15. Which also saw the demolition of the Babri Masjid and subsequent violence as well as India's sharp turn toward a rabid capitalism.
16. Gurharpal Singh, *Ethnic Conflict in India*, 156–57.
17. Gurharpal Singh, 157.
18. See, for example, Jaijee, *Politics of Genocide*, 97, 213.
19. Gurharpal Singh, *Ethnic Conflict in India*, 165.
20. Gurharpal Singh, 166. See also, Ved Marwah, *Uncivil Wars: Pathology of Terrorism in India* (New Delhi: Harper Collins, 1995), 195–97.
21. Gurharpal Singh, 103.
22. Gurharpal Singh, 90.
23. See, Khushwant Singh, *A History of the Sikhs, Vol II; 1839–2004* (New Delhi: Oxford University Press, 1999), 280.
24. See, Ramachandra Guha, *India After Gandhi: The History of the World's Largest Democracy* (New York: Ecco, 2007), 100.
25. Khushwant Singh, *History of the Sikhs II*, 289.
26. See, Sangat Singh, *The Sikhs in History*, 2nd ed. (New Delhi: Uncommon Books, 1996), 268.
27. Khushwant Singh, *History of the Sikhs II*, 291.
28. Khushwant Singh, 288.
29. Paul R. Brass, *Language, Religion and Politics in North India*, reprint, (Lincoln, NE: iUniverse Inc., 2005), 293.
30. Khushwant Singh, *History of the Sikhs II*, 295.
31. Gurharpal Singh, *Ethnic Conflict in India*, 91.
32. See, for example, Khushwant Singh, *History of the Sikhs II*, 290, "The Muslims got Pakistan, the Hindus got Hindustan; what did we Sikhs get out of it?"
33. Order by J.B. Garg in response to Criminal Writ Petition No. 229 of 1992 *Mrs. Rachpal Kaur Bains* vs. *State of Punjab and ors.*
34. Judge for criminal matters in India's trial courts.
35. Amnesty International, 7 April 1992. "Urgent Action: India: Ajit Singh Bains, Human Rights Activist and Retired Judge." (AI Index: ASA 20/26/92), London.
36. See, for example, "No Mention of Bains in FIR," *The Tribune*, April 8, 1992.
37. See, for example, "Tilting at Windmills," *The Tribune*, April 8, 1992.
38. Jaijee, *Politics of Genocide*, 149.

39. Jaijee, 151.
40. See, Prabha Jagannathan, "Judge in the Dock for Speaking Out," *The Sunday Observer*, April 12, 1992.
41. Sessions Judge Ropar, Report per Criminal Writ Petition No. 229 of 1992. *Mrs. Rachpal Kaur Bains* Vs. *State of Punjab and ors.*, 22 May 1992, para 15.
42. Sessions Judge Ropar, Report, para 24.
43. Sessions Judge Ropar, Report, para 25.
44. Supreme Court of India, Order in response to Writ Petition No. 186/92 with SLP (Crl) No. 1526/92 *Mrs. Rachpal Kaur Bains* vs. *State of Punjab and Ors.*, August 14, 1992.
45. Lieutenant Colonel Partap Singh, *Khalistan: The Only Solution* (Chandigarh: Self-published, 1991).
46. *Lt. Col. Partap Singh v. U.T. Chandigarh*, Judgment in matter of Criminal Misc. No. 11926-M of 1991, High Court of Punjab and Haryana, December 18, 1992.
47. See, for example, Joyce Pettigrew, *The Sikhs of the Punjab: Unheard Voices of State and Guerilla Violence* (London: Zed Books, 1995), 123.
48. Pettigrew, 112.
49. Pettigrew, 187.
50. "During 1992 police made people fed up with the militants, all the better to control them. Thus there was in the end no sanctuary for them. Many were created by the police or by the chaos that the police had been happy to see flourish. So since they did not belong to the people, it was the people who informed on their whereabouts. When they were eventually killed, there was no protest from the people." Pettigrew, *The Sikhs of the Punjab*, 117.
51. Baljit Kaur video archive.
52. See, for example, Pettigrew, *The Sikhs of the Punjab*, 121.
53. See, for example, Pettigrew, *The Sikhs of the Punjab*, 73–74, which notes that if not by their own design, Babbar militants—complete with their stricter code of living—were especially manipulated and propped up to divide the ordinary people's support of the movement.
54. The public destruction of a Muslim mosque in 1992, resurgent calls to build a Hindu temple on the land, and attendant riots. The committee to "liberate" the land where the mosque stood was first convened in winter 1984.
55. See, Barbara Crossette, "India's Sikhs: Waiting for Justice," *World Policy Journal*, Summer 2004; Sangat Singh, 512–13.
56. See, also, Jugdep Chima, *The Sikh Separatist Insurgency in India* (New Delhi: Sage Publications, 2010), 238–39.
57. See also Ram Narayan Kumar, "The Matter of Mass Cremations in Punjab: A Window into the State of Impunity in India," in *Landscapes of Fear*, eds. Patrick Hoenig and Navsharan Singh (New Delhi: Zubaan, 2014), 239–47. Kumar details the Bhatti case, the eventual CBI investigation that only confirmed all the lies and cover-ups by senior police officials, and the CBI's astounding conclusion: that the case be closed.
58. See Justice Sodhi's example cited by Pettigrew, *The Sikhs of the Punjab*, 53.
59. *The State v. Kuldip Singh* et al., Session Case No. RT-10 of 2.7.1992, Rupnagar, November 27, 1996.
60. Judgment in the matter of Crl. W. P. No. 71 of 1997, High Court of Punjab and Haryana, December 11, 2001.

Holy of the Holy

Abstract This chapter presents the physical and sexualized violence the pro-
tagonists witnessed and processed without retreating; why they developed
unwavering compassion for a range of trauma responses by their people.

The chapter recounts vignettes captured through Baljit Kaur's video cam-
era, once bought to capture family functions and kids' birthdays. These display
the dehumanization of Sikh captives and captors in 1990 and 1991. Then the
chapter meets Mr. Darshan Singh Multani, whose struggle is notorious in
many Sikh homes for a confluence of reasons: his senior bureaucrat position;
his alacrity in responding to his son Balwant's abduction; the others abducted
with Balwant; the larger "Chandigarh bomb blast case" that preceded these
abductions; and the fate of the abductees that became morbid mythos, more so
after a perpetrator confession video surfaced in 2015.

The chapter also travels back to the 1960s, when Punjab was the chosen site
of the agrarian "Green Revolution." Meanwhile, Sikhs began widespread civil
disobedience to demand their rights, including the recognition of Punjabi as
their state language.

* * *

© Mallika Kaur 2019
M. Kaur, *Faith, Gender, and Activism in the Punjab Conflict*,
https://doi.org/10.1007/978-3-030-24674-7_6

My holy of holies is the human body...
:ANTON CHEKHOV:

THE PATRIOT

"We met about a year ago, when you were underground, and we had taken you to meet Governor Mukerji." The camera finds its focus on him in the tight room. "What's the date today?" she asks.

"April twenty-second."

"Nineteen ninety-one," Baljit Kaur's voice adds.

"Yes. After I met Governor Mukerji, I took the letter from him to the Deputy Commissioner. He was nice. Based on what I said, and what he knew before, he was convinced. He said, 'Look, the danger to you is from the police. Any security I arrange for you will be from the same police. And over them, there is no control, we have no faith in them either.' So then I said, At least help me get my license back. He tried to get my arms license back. But the Punjab police refused. There was back and forth, and the DC eventually said, 'Yes, to save your life, if you can run away, run.' I left with entire family for Ganganagar [Rajasthan]."

"These girls, sitting here, their education fell flat. A different school, different language."

"In March 1991, for five days, they took my sister in custody. She was sick then, even still ... District Jalandhar, Adampur police station. She was kept there and asked, 'Does [your nephew] come to you?' 'No, not since he left his father's home,' she said, 'he has never come to our house.' So she wrote me a letter, see."

"Why don't you read it out?" Baljit Kaur says from behind the camera.

"'If they don't find Pavitar Singh, they will kill the whole family, they have orders to kill his family.' And, she wrote, 'no family member should come to Punjab.'"

"The man I had left my land with, the police took him too, saying, 'Why are you tilling this land?' Panchayat got involved. They released him to them on the condition that he would not till my land ... and police came and told them, 'Make sure this land just dies. No one touches it.' That man wrote me a letter, I have that here."

"Then the person overseeing my village house, they told him that this house should remain empty, no water bill is to be paid, nothing. ... The man still tied some animal outside to keep some semblance of life there. And so, they took him in too. Then again, the panchayat got him released, and the police insisted, 'This house must remain absolutely vacant, whenever we want, we will set it on fire, as we want!'"

"And now, this telegram. No Punjab newspaper comes to Rajasthan. So now this telegram tells me that Pavitar Singh has been killed. Pavitar Singh was only about twelve when he ran away from home, last we saw him."

"Don't know how they did it, he was from Hoshiarpur, they reported his death in Malerkotla, put out news that bodies of unknown men were found in a car. Some policemen from our area were said to have identified him. There were bullets in his head."

The girls cough, sniffle. Zooming in, his face reveals no contortions.

"Well, our villagers organized his last prayers per Sikh rites. Lots of people poured in, Harijan,[1] Hindu, everyone ... *irrespective of caste and creed*," he emphasizes in English.

"We were very saddened to hear of your loss," Baljit Kaur says.

He looks down this once.

"Haanji, sadness is fine. But we've had so much torture inflicted against all of us. ... You know my career. Twenty, twenty-one years with Border Security Force—Nagaland, Manipur, Imphal, anti-dacoity area, Gujarat, Jammu Kashmir, Punjab, worked everywhere, and loyally."

"Now, my son is eliminated. My family on the run. My sisters—tell me, what have they done? And I'm still living in fear."

"People came from so far for my son's bhog, and police didn't let anyone go in. Seven or eight police jeeps parked outside instead, asking for me!"

"Like two thousand to two thousand five hundred people gathered. And the police were humiliating people who came, misbehaved with the women too. Some local lawyers—their clothes were torn, they were manhandled. Some people from out of town were kept in custody all night."

"There is no safety. There is so much money flowing in. Where is it coming from? Some foreign country? Or is our country itself funding this? There is so much money being poured in to create informers. In mandirs, in gurdwaras, people are bought. ... There is so much expenditure: intelligence network, cars whizzing everywhere, all the diesel, all the petrol, who is controlling these funds? Where are they coming from?"

"Yet this movement is not dying, it is being flamed, it will erupt more."

"And what we don't understand is why are other countries, why are other government heads still supporting this country?"

She says, "I'll be making sure this video goes to Amnesty International, which we talked about."

"Yes, but other government heads need to be sent this too. We read in newspapers that so many crores, so many millions, are being given [to India] by this government or that. And I believe all that money is being poured and spent on suppressing our, this movement."

"It seems that the population of our Punjab is outnumbered by State forces now—army, CRP, BSF, the intelligence network, State CID, CBI, IB, just can't tell. So much money goes toward this."

"When I had asked for that arms license back, it was because, if the police come in uniform, okay. In any court of law, I am willing to prove my innocence. But these days, police black cats are coming to kill us. In our own garb, in our identity."

"My patriotism, my service, what am I getting for it?"

"Now, the Governor, isn't he the leader? After my meeting with him, the police went to my village to tell people to testify against me. They would take one in and try to threaten him, then another. Finally, villagers said, Take our collective statement. … Don't know what was eventually written, these were unlettered folks."

"Amnesty International should come here and see how this law-and-order problem has been created by the police themselves. Administration and government and agencies and black cats themselves are fueling things—and yet, outside countries are giving aid! If that aid stops, this country that can't feed its own population, is hungry, is not going to be able to keep funding all this paramilitary, et cetera."

"Now it's like they want to finish our blood. Whoever stands up a little, stands with the truth, they ruin him, his support system, entirely. Now, if they pull me out and kill me, even the neighbor won't cause a noise. They have created such a situation."

"We understood first Congress was doing this with us, and so we all enthusiastically supported the Janata government, and put V.P. Singh in front. But now we think, whatever scheme they have made, it's like they have planned, the government may change, but Sikhs' elimination, our genocide, will just continue. How can you then trust anything about this administration?"

The Biased

The camera enters a press conference on February 1, 1990. A woman announces the new report on behalf of Delhi-based human rights group, the Committee for Information and Initiative on Punjab (CIIP).

"We believe that the alienation the people of Punjab feel today is largely because the institutions of the State have been distorted and instead of protecting the liberties and rights of the people, the State has become the main aggressor," she says, before turning to her colleague, Ram Narayan Kumar.

Much background chatter and cup-clanking compete with Kumar's explanation of the report's highlighted patterns of extrajudicial killings.

"And most importantly, please pay attention to this point, most important, most of the persons, cases cited in this report, mostly are of those persons who may still be *alive* in custody of the State."

Kumar explains that the report has been presented to the Governor. "We are not talking about past cases, we are not talking about what has happened in the past, we are saying, look, according to our information, investigations, here are the people still alive possibly, please find out. Release them if you can. If they have been killed, let the parents of people know, and punish those who you find responsible. This is the objective of this report."

The human rights defenders are soon in the dock.

"You have dealt only with police terror," says one newspaperman.

"Yes, we are dealing with those cases where we believe people are still alive, in illegal custody," he says.

Then, he is reminded that the last time the CIIP group held a press confer-
ence it was about Gobind Ram's excesses. Gobind Ram was murdered by mili-
tants in January 1990. "You are justifying the killing?" Kumar is asked.

Turbans on the panel, including Jaijee and Colonel Partap, turn to look at
him directly now. Only non-Sikhs will field the questions.

"Frankly you must understand, that I was spending, we were spending,
quite some time in that area," starts Kumar. "And I must say that I was horri-
fied at what the police were doing there. I feel, in the answer to the question,
he should not have been killed. His killing has subverted the possibility to pun-
ish such a person in a normal course."

"So ... you wanted him to be tortured!"

"Noooo ... Did I say that?" Kumar balks.

The questions persist. Even Gobind Ram's young son was killed. What does
he have to say about that?

Kumar repeats, "I don't know the motive, the psychology of the people who
did it, I can only give my personal view, that by eliminating somebody you
destroy the possibility of testing the character of the legal society."

"I don't want your personal opinion, but of the Committee. ... Do you
condemn this killing?"

His colleague answers, with her clear and measured tone: the one woman's
voice must not be dismissed.

"This press conference has been called by the CIIP. Ram Narayan Kumar
speaks on behalf of the Committee and I second it wholeheartedly. Our inves-
tigation in Punjab shows that the rule of law has completely broken down.
There is no remedy for crimes committed. ... Gobind Ram's crimes, were, you
know, the tapestry was full. Institutions did not even seem to be stretching
toward bringing him to punishment. And perhaps in that sense, in a historical
perspective, this could be seen as an inevitability. But nevertheless we feel that
such an act, inevitable though it might be, does negate the possibility of the
society itself, by its own organized structures, bringing justice."

No catchy soundbite.

Then again: "You are looking at only one side."

Kumar starts again. "We believe the root of the problems lies in the end of
the rule of law, the failure of the secular structure of the society, and inability
of Indian intelligentsia and institutions capable of understanding . . . human
rights and all that, to stand by [Sikhs]."

"The people of India as a whole, and institutions [need to] convince Sikhs
that they stand by rule of law, that no matter what their particular opinions are,
[Sikhs'] fundamental rights are respected, and we will fight on their behalf. By
that, we are seeking to resolve the psychological root."

"What about other cases? Those killed by terrorists, so-called terrorists?"

They answer that the culprits should be charged, the charges announced,
but there is no role of torture in legal process.

Now a question related to some language in the précis of the released report:
"If you read between the lines, it seems you have conceded the right to rebel?"

Again, the woman's measured voice adds, "The Committee has come to the conclusion that the rights of the people have been trampled on, in a completely *mindless* fashion. And we believe any government which says it believes in the Constitution, and calls upon the people to act towards the integrity of the nation, *must* itself adhere to some integrities. There are obligations, [the government] has to protect the rights of the people, which rights in our opinion have been denigrated by the State itself. So as a precondition to calling upon Sikhs specifically, people generally, to respect the constitutional framework, this government, which holds power, must use the power to respect the rights of the people."

Dismissed. Questions persist.

"Take the repressive machinery of Punjab today," says Kumar. "Does not this government have people it can trust? Cannot government change K.P.S. Gill?"

He who is not to be named. Kumar's attention is redirected. Questions about the killings by the militants persist.

THE GRANDMOTHER

Two giggling girls in floral dresses run through the house, identical white socks to different knee heights.

"Tara, I want to hear from you now. 'Little Raindrops' and other songs."

Following Tara, she captures a glimpse of the girls' mother, Tripat, in a blue caftan and fluffy slippers, packing.

"Now I want to hear 'A Female Deer.'"

Two parrots recite from "Doe" to "Do, Oh, Oh, Oh."

"Yay, finish!" busy Tripat says to her daughters.

"Why finish, Tripat?"

Kismat is older, she is more willing to oblige her grandmother gregariously. The children's Punjabi, Hindi, English prattle is constant.

"Okay, now sing a shabd."

Hands dutifully fold in prayer. "Rakhaa Ek Humaraa Suaami …," they sing to the One protector.

Then scurry to the garden.

"Oranges and lemons, sold for a penny …"

They stare at the camera for help, "All the school girls are so many …"

Yes, they remember. "The grass is green, and the roses red, remember me when I am dead, dead, dead."

They are tickled by their repetition. "Who is dead?" they giggle. Then they are distracted as Kismat complains Tara has put something in her mouth.

"Tara, you are very silly, take it out of your mouth!"

After the chiding, the camera follows them to their new dance floor, the sunny spot in the grass where all whites lie drying. Then their nanaji's deep voice feigns a scary growl from inside the house and the girls peel with laughter, gluing themselves to the large windows.

Baljit Kaur's voice behind the camera says quietly, "Quite sad you all are going to Delhi."

The video blackens.

Then flickers.

"Sat Sri Akaal. Sat Sri Akaal!" A group of men, dotted by women. Strategizing. Inderjit Singh Jaijee is greeting people.

The camera is back to its more familiar work these days: the family camcorder has become the main video recorder of human rights activities across Punjab.

A poster pasted on top of one of Chandigarh's ubiquitous flag-shaped road signs lists the demands put forth by those gathered today.

THE PISS

A large white chunni drapes her head, chest, merges with the white sheets of the hospital bed.

She had worked in an office right opposite Khalsa College, Amritsar. Plainclothesmen, with Sten guns, parked outside. Her colleague Gurdev's house had been raided earlier; the whole colony had been terrorized. So Gurmeet ran in to warn Gurdev of the men.

The men took her along with Gurdev.

There, Officer Gobind Ram caned Gurdev's stomach. Gurmeet couldn't bear to watch.

Then Gurmeet's hands were tied behind her back. As she was brutalized, she said, "Waheguru, Waheguru." He said, "You cannot say Waheguru!"

She remembers the stench of alcohol.

She was asked about her husband, whom she hadn't seen since 1984.

Then, "You took Guru Gobind's amrit, now drink mine!" Urine was poured on her face several times, a brutality for which Gobind Ram was notorious.

A rare expression of horror escapes the camerawoman, Baljit Kaur.

Her legs were crushed with a plank, as two men stood on either side. Rape was constantly threatened, she says. She passed out, came to, screamed in pain, passed out. Water was thrown on her face. She was made to walk on her broken legs.

Transfers between various torture centers, left her terrorized.

Policemen said, "If we leave you, then you may also give some statement to the press, and then we'll have to take you and your kids and kill you!"

"I put my hands together and said, I won't tell anyone, let me go."

Eventually, Gurmeet was made to sign several papers, which she couldn't read. And taken to court, where only the policemen went inside, while she was kept in the jeep. She was taken to a doctor, but then the policemen wrote the report.

"Then the policemen said, 'We'll drop you home.' I didn't want them to take me anywhere, I was so scared. They fortunately released me to a woman jail employee who was kind to me. Her name was also Gurmeet Kaur. She kept me in her house with love and care. I slept there one night … in the morning, went to Darbar Sahib." She was brought to this hospital two days later.

THE PROVIDERS

Saade haqq Ithe rakhh!
Our Rights Keep Them Right Here!

August 27 to September 11, 1990. Punjab Bhartiya Kisan Union protests in Chandigarh. Men stop to pose solemnly in between camping, chanting, gathering, walking. There are no other women.

Manngaa Mangg ke Vekh Liyaa Zor Lagaa ke Vekhan Ge
We've Seen Results of Requesting We'll See Results of Forceful Protesting

"If we ask for our rights," says the leader at the rally, "we get sticks. Our boys ask for rights, and they get bullets. Farmers work twenty-four hours a day. We shouldn't need to beg for our rights, and our lives."

Choothe Mukaable Bandd Karo Bandd Karo, Bandd Karo
Stop False Encounters Stop Them, Stop Them

To the sea of turbans, speaker after speaker reiterates the epidemic: on the one hand, rising agrarian debt, on the other, police encounters.

Sikh kirtan, workers' slogans, leftist chants, take respectful turns. There is a statement about Khalistan, and a loud response, "Sat Sri Akaaaaal!" follows.

"And why have we brought the farmers together in such large numbers? Well, on July twenty-third, a month ago, we gave Governor Verma a written memo."

"Our demand about loan forgiveness comes later. First of all, whatever it is, the peppers, the sugarcane, et cetera, our labor, our sweat, we want fair value. This is about simple economics. Or they can make electricity cheaper, make clothes cheaper, decrease the cost of living, and then we are willing to give them everything at half value!"

Bhartiya Kisan Union Zindabaad!
Bhartiya Kisan Union LiveLong!

"Veer, would you hold this a second?" We hear Baljit Kaur from behind the camera, the only female voice in an hour.

One speaker is narrating a recent extrajudicial killing and thwarted attempts at memorializing: "In Batala, a youth was killed, for example. The police rained sticks on people. Then people tried to erect a nishaan sahib, flag, in his memory, and the police pulled that out too!"

"Our Gurus have said that committing atrocities is sinful and so is accepting atrocities, and here, we have these bhootray, deranged officers. Our mothers and sisters are dishonored. When the law-and-order keepers themselves disturb things, then, we must fix things. We want the secret intelligence agents here to also know this!"

| Suno Kursi de Thekedaaro | Kharaa Kisaan hai, Goli Maaro! |
| Listen Up, You Who Lord over Us | Here Stand Farmers, Come Shoot Us! |

"The country in which, on a daily basis, there isn't roti to eat. That country can't be called free. The country in which youngsters trudge around with bags full of degrees, and then have to pay thousands in bribes to get a job. That country isn't called free!"

| Saadi Bijli, Sadaa Paani | Ehoo Mangg Kare Kisani! |
| Our Electricity, Our Water | This Is the Demand, By Our Farmer! |

A Hindu leader makes a speech, reads a poem, and closes with the Sikh greeting, "Waheguruji ki Fateh!"

Then, a woman in a bright yellow chunni climbs on the stage. She sings a poem.

Finally, it's time for the announcement. "The reason you all have gathered and sacrificed so much, the cause is fulfilled now!"

The leader, Lakhowal, announces that an agreement has been reached with the Governor's office on several issues: on prices, on some compensation for crop failure, on Punjab getting Punjab's water, on telling the Center to limit urban landholdings to the same 17-acre agrarian landholding limit, and on pensions for army men.

"On debts: If any government man comes to you now, feel free to lock them in your outhouses!" The crowd rocks with laughter. "Even one rupee of debt is not our responsibility right now!"

"On keeping our youth in interrogation centers. They have agreed, going forward, they will only take someone after informing and involving the village panchayat, and when the panchayat inquires, police will allow meetings and welfare checks. This has all been agreed to, in writing. Nothing oral. A written agreement!"

THE SURVIVOR

Even bandaged, his legs seem as thin as his spindly arms. They are propped as high as his chin, on two large pillows.

He stares vacantly. A collapsing small purple turban wraps his head and careless bandages crisscross his body.

The camera zooms in unceremoniously. "Kaka, show the marks on your legs," she says. Petrol had been poured inside him. Chili peppers inserted in his anus. His father explains he has not been able to defecate for eight days.

The mill worker had been taken on November 30, 1990. His father, also kept for a day of torture, was told to arrange 25,000 rupees for his release. "Your boy is a thief," he was told.

His eyes downcast, the boy begins to describe his torture.

Stripped. Legs torn apart. Electrocuted till his mouth foamed.

His kirpaan taken. "Why do you wear this?"

His kachera torn.[2] "Why waste this cloth?"

His hair used as ropes, pulled out in clusters. They would always lift him by the hair.

He was in and out of consciousness.

Once, he saw the policemen scuttling about. "Quick, quick." Three of them tied on fake beards, wore yellow underturbans, and left with rifles in their hands.

By December 21, 1990, his aged father was able to approach the High Court and file a habeas corpus petition. A court officer was appointed and the father managed to bring his son from the police station in a bus, then a three-wheel autorickshaw. They were followed menacingly by the police officers, the 100 kilometers from Ludhiana to the High Court in Chandigarh.

Lawyers Navkiran Singh and I.P. Singh stand by them in the hospital now. They got involved when the half-dead boy and his father fell out of the autorickshaw at the courthouse. On their intervention, the High Court grudgingly ordered a medical exam, "at applicant's expense."

"We went to S.S. Saini to convey the High Court order to him," explains Navkiran Singh. "S.S. Saini took it casually."

The boy stutters to Baljit Kaur, "Even with the court officer and my father securing my release, I was too scared to get my clothes. We sent a tea-stall boy back in to get the clothes so I was not stark naked, so my father could take me away."

THE UNTARNISHED

Large corrugated gold hoops hang from earlobes accustomed to strain. She stares ahead, tightening her square jaw.

"We were landowners, with a solid farmhouse, in the Amritsar area."

"The night the police and paramilitary raided, we first thought nothing of it. Just that they had come for murgaa."

"For *chicken?*" asks Baljit Kaur.

"You know, we were landowning jatts. A well-to-do house in the village. The Punjab Police would often stop by, for their usual alcohol and chicken. It would cost us close to five hundred each time. They would come and say, 'It's been a long day at work.' That meant, they expected to be entertained."

"But that night, the CRP also came. Why would they bring them? Just as I began to think aloud, they were ducking my husband into a jeep."

"Come on, brothers, I said. Just tell us what happened. Talk to us! You know us!"

"And then I asked to go with them, worried what they would do to him. And I was so embarrassed by how they were speaking to me."

"OK, please, I said. I am going to follow on a motorcycle."

"My son is ten. They cursed at us. You know ... 'Sisterfucker. Cunt.'"

"'Motherfucker. Dog ...'"

"Once we got to the station, they took us in. They beat my son in front of me. Then I heard them talking to each other. 'This woman is beautiful, we are going to take her tonight.'"

"The new commando police was there too."

Baljit Kaur and Sukhjeet Kaur nod. They know of this new special deployment across Punjab.

"I was in a room alone. The head of the police team came in."

"I finally said, I am also a jatt's daughter. This is just too much."

"He said, 'Don't you recognize me?'"

"He got really mad that I didn't know his name."

"'I'm Pashora. Pashora, I am.'"

"And then he began beating me. To his heart's fill. I urinated all over myself. Look, it wasn't like my body was used to violence."

She raises a broken finger closer to her face.

"A junior sepoy finally spoke up. 'Let her go, Sir, it's just a woman.' And he got yelled at. 'Fucker! Dog. Motherfucker.'"

"Through all of this I heard they had found some letter on some boy they killed earlier. The letter spoke about a plan to kill Phoola.[3] Who knows what plan, but"

Sukhjeet Kaur begins to finish her sentence. "Do not prompt," Baljit Kaur quickly intervenes.

She blinks into the camera, waiting for the English language exchange between the colleagues to end.

"So, haan, they asked me for fifty thousand rupees."

"They said, 'If you don't arrange this, we'll put a stick in you and make sure we don't remove it till it comes out of your mouth. You'll never forget the deputy who paid you a visit!'"

"The one standing to the side, Chaudhry, he moved forward to grab me after the deputy left the room. I didn't even feel like looking at him. His face, his face was so terribly ugly."

"He is the one who pulled me to his quarters. He was really ugly. Really terrible."

"'Today, we'll take your honor,' he said."

"I fell to his feet, my chunni outstretched, asking for mercy. I cried that we had nothing to do with anything, and they can even go ask that Nihang Baba Phoola, even he would clear our family's name! I had never stepped in a police station before."

"He asked, 'How much are you willing to pay then? To save your life? Because its thirty thousand for the officer, twenty thousand for the deputy, and ten thousand for me.'"

"However we do it, we'll adjust, I said. I think I was sobbing."

"Then he sat down to eat, satisfying himself. And he made me eat. He was so ugly. Half the bite would be in his fangs, half spilled out. You know, he was already saturated with alcohol."

"'Eat the yogurt!'" he shouted.

"No, I thought, no way. He is another caste, a Muslim, I am a Jatt. How can I now eat the daahi he has been eating from the same bowl?"

"No, I don't want to eat the yogurt. I can't eat yogurt!"

"He wanted to feed me. I refused."

"He now lay down beside me. I got up."

"'Come lie with me.'"

"Do what you want, but I am not going to spoil my honor, I said. He began pawing at my clothes. And I was already badly beaten."

"I said, No way. Your pistol is lying on the bed. I would shoot myself instead of lying with you. You are an older man; What are you doing?"

"He said, 'Why are you so resistant? I am in love with you, can't you see?'"

"I tried locking myself next door."

"Anyway, I fought off that ordeal. Later, the next day, they charged my husband and me. Some alcohol charge. Took a bribe of thirty thousand too. They had said they will put this lesser charge if we gave the money, or else would put a terrorism charge."

"Look, this is widespread. They pick up women. They ask families to bring money and claim the women."

"My ten-year-old is scared stiff after that night," she continues, "and I've been away from my home for a month and a half. The shame, the fear."

The gold hoops slowly shake. Then her jaw releases.

"How do I go back and live in my area again?" she gushes. "Police are doing so much. So much is happening all around."

* * *

So much is happening all around. H.S. Jaijee walked through his beloved Chural home, humming a favorite tune. The redbrick sanctuary, ventilated by many doors and windows in the many rooms, always seemed in need of upkeep. The patriarch enjoyed the din.

> *Itt kharakke, dukhhar wajje*
> *Tatta hove chulha.*
> *Aaun fakir tey kha kha jaawan*
> *Razi hovay Bullah.*

> Bricks clang in construction, tambourine plays—
> Stove is heated.
> Traveling ascetics come and go after feasting—
> Bullah is elated.

Bullah Shah, whose birth date is as uncertain as its place, lives on as a leading voice of Punjabi mysticism since his death in 1758. Transmitted through rich oral tradition, unchronicled till the nineteenth century, his couplets are often heard stylized and personalized: the cost of being nestled in the conscience of a people.

Bullah Shah's verse about a lively scene of musical and culinary sustenance resonated with H.S. Jaijee as he oversaw the running of his Chural estate. These particular lines, many Sikhs believe, were inspired by the scene Bullah Shah witnessed at a Sikh gurdwara. The unconfirmed inspiration further inspires pride and intimacy with Bullah's Sufi—a mystical order of Islam—writing (mostly done during the peak of persecution of Sikhs by the Mughal government, in the name of Islam). The verses of Sikh Gurus (1469–1708)—whose revolutionary practices brought on the wrath of the Mughal emperors—are to this day sung with reverence to instrumental accompaniment. The beat of the

Chural house was no less musical to the Jaijee patriarch, who prided openness and vivacity, within Sikh mores.

"Pitaji didn't believe in pure and impure," explains Inderjit Singh Jaijee. "The so-called low castes were the Sikhs to whom he gave charge of the Chural langar. People otherwise cast aside by society as impure or unlucky or whatever nonsense. So that was a much-loved change."

"Well, it was not appreciated by everyone immediately, of course," Jaijee adds. "As is the story of every reform."

Langar, the hallmark free kitchen, had been introduced by the first Sikh Guru, Nanak (1469–1539), and institutionalized during the time of the third Sikh Guru, Amar Das (1552–1574) and his wife, Mata Khivi. The sixteenth century saw the nascent Sikh community develop a distinct script and distinct death and marriage ceremonies, establish a series of rest houses for the weary, and langar for the hungry. But langar was also directed at those free from hunger. The "high castes" and royals had never, in segregated South Asia, been known to sit on the floor and eat together, with all other castes and classes. The Sikh Gurus insisted on langar, the equalizing force, prepared by anyone, for anyone. While most women in the subcontinent were relegated to the private domestic sphere behind the purdah, Mata Khivi ran the administration of langars, popularizing radical food politics for change.

"Pitaji always said Langar Guru daa, Dihaari Chaar Aaane di—Guru's langar for all, and four anaas for a day's labor, that was the fair rate."

The Jaijee estate employed scores and close to 150 men during harvests. But by 1960, the traditional methods of agriculture were increasingly complemented with machines and pesticides. The pestering peacocks that were once lovingly protected, and the deer that would frolic freely, began declining in population. Punjab had become the Indian government's chosen site for the Green Revolution. With droughts threatening food security, the government implemented a series of agricultural changes. The U.S. government's aid had been tied to the acceptance of the Green Revolution blueprint, which required the import of high-yield seed varieties that depended on increased water and fertilizers. Punjab was the test site and its villages began to change forever.[4]

Meanwhile, the Punjabi Suba Movement raged through Punjab. The central government's official bilingual designation for Punjab had fueled anger. Khushwant Singh notes the overwhelming unity of purpose displayed by electoral trends that "prov[ed] that the majority of Sikhs supported the Punjabi Suba."[5]

"The earlier British toadies, they gained a lot post-Independence," says Justice Bains. "And Nehru didn't support Sikhs before he became PM, and wasn't about to after!" His pronunciation always conveys his negative association: Nay-roo.

"So yesterday's Gadris stayed in same position vis-à-vis the State. Revolutionaries stayed in the same position. The Communist Party was banned. Lots of the mess all around was the doing of these new toadies. Even the Partition was Gandhi and Nehru's doing. It was the worst for Punjab and then for Bengal. And now Nehru even opposed Sikhs having their language."

Punjabi had already officially lost millions of its speakers in the Partition of 1947. It is the mother tongue of over 60 million Punjabi Pakistanis, but Urdu was declared (and enforced) as the national language: less than 8 percent of the Pakistani population speaks Urdu. Media, bureaucracy, education all are conducted in Urdu. There isn't a single Punjabi-language newspaper or school in Pakistan. Being anti-Urdu is derided as anti-Islam.[6] Similar denial of language, in the interest of "nation," was threatened with India's introduction of Hindi as an official language of east Punjab.

Language was religionized, Justice Bains explains. "In the 1961 census, Punjabi Hindus wrote, in Punjabi script and idiom, that their mother tongue was Hindi! That was the extent of collusion against Punjabi."

"I always say, don't forget your maa boli. If you forget your mother tongue, you forget your culture. And that boli in which your mother raised you, sang lullabies, that is your real boli. English is the language of our enslavement."

"Do you speak Punjabi?" he asks. But before I can answer, he smiles, realizing that's what we've been speaking.

"I had to do all my court work in English. But we made sure to speak no English at home. My father had insisted on as much education as possible, but we all had gone to local schools. No convent schools, which was good. Mother tongue is essential for your brain, your spirit, your identity."

"I remember I said this once in England, that Punjabi is so much richer. I gave them one example. Aunty and uncle. Do we have to ask, which aunty? Which uncle? And which grandpa? We have unique words for each relationship," he says with satisfaction.

"What a loss that our kids from outside, or even who study in Chandigarh today, don't speak Punjabi. Speak half-English. Don't speak English well either. And then, during those days, one section of Punjab had refused to recognize their own language! What a loss. Otherwise Punjabi Suba Movement would not have been needed. But Sikhs have always been made to sacrifice."

Close to 57,000 Sikhs were arrested in the related civil disobedience movements. Leader Fateh Singh—left to spearhead the resistance when Tara Singh was jailed again—declared a fast unto death, which he called off on government assurance. When the government did not budge, Tara Singh began a fast. But after 43 days, and no success, he broke fast. This won him the scorn of Sikhs and loss of political capital.[7]

Meanwhile, war clouds had darkened at the India-Pakistan border in 1965. Pakistan broadcast its support for Sikhs and their Suba Movement. But Sikhs suspended their agitation and in the border areas valiantly supported the Indian Army during the Indo-Pakistan War that September. After the war, a parliamentary committee was set up to reassess Punjabi Suba. The committee's resolution of March 10, 1966, declared that a state with Punjabi as the official language would be carved out from the existing Punjab.[8]

After a decade of protest, east Punjab headed now toward a sour deal. The Sikh linguistic demand provided New Delhi the rationale to further divide Punjab.[9]

The new commission assigned for Punjab in 1966 made its boundary recommendations based on the results of the 1961 census, widely deemed unreliable

due to false reporting by nervous Punjabi Hindus.[10] The resultant Reorganization Act was vehemently criticized by Sikhs as a betrayal. In his address to the Indian Parliament on September 6, 1966,[11] writer and leader Sardar Kapur Singh represented the Sikh community and passionately rejected the act that would now relegate Sikhs to a severely shrunk, limited, capital-less Punjab.

On November 1, 1966, the bifurcated (in 1947) Punjab was further trifurcated: Punjab, Haryana, Himachal Pradesh. In the newer Punjab, Sikhs were a majority: nearly 80 percent of the Sikh population was in one state.[12]

Now would begin the battle for capital city Chandigarh, which had been demarcated a Union Territory, to be shared by the new Punjab and Haryana. East Punjab had been left without a capital in 1947; Lahore had gone to Pakistan. By 1950, American architect Albert Mayer had been hired to design a new capital city, to be unlike any other. French architect Le Corbusier joined the design team and the resultant Chandigarh was developed with edgy style and practical beauty.

Justice Bains had moved to Chandigarh in 1961. He had been practicing law in Hoshiarpur for about five years. But after his wife's death in a Hoshiarpur hospital, he neither wanted to live in the same house nor wanted to continue his previous routine. Without a plan, he took a bus to Chandigarh, with its then brand-new High Court. On this bus, he met a Communist Party Member of Legislative Assembly who had been his father's colleague. This MLA asked where he planned to stay in Chandigarh. Bains had made no arrangements. The MLA handed him a key and said he wasn't using the assigned MLA flat—the Bainses could live there.

"So for a few years, in fact for as long as that man was MLA, we were in the MLA flats in Sector 3, Chandigarh," explains Justice Bains.

"In those days, plots were cheap, so we got one and built a house. My work in the High Court was going well. I became an elected member of the Bar Council, later won the election and became chairman of Bar Council."

Rajvinder was five years old when they moved to Chandigarh, and remembers no other home. "Daddy was always working, that's what I remember. Home was really about food. We just came home for that, before running out to the grounds again. And the Chandigarh Secretariat was our playing ground. When we found the lift, that was gold! That became our game, go up, go down."

Meanwhile, desperate demands continued to be made for the return of the capital city and Punjabi-speaking areas to the newly diminished Punjab. Fractured Akalis competed for attention. Fateh Singh declared another protest unto death, and called it off citing another assurance by the government.

On April 13, 1967, marking the high holiday of Vaisakhi, a Telegu-speaking Sikh from South India quietly took matters into his own hands. After early morning prayers before the Guru Granth Sahib, he created a pyre with large logs. He doused himself in petrol. He lit a match.

Nand Singh left letters that explained this self-immolation was for the cause and against the insult to the Sikh Panth by leaders who had reneged on their assurances. Fateh Singh, whom he once admired, had broken his martyrdom promise sworn at the Akal Takht. In a letter to his village headman, Nand

Singh requested his body not be given to the police, but be cremated in the village, and by Sikh rites: "Let the expenses of the ceremony be realised from the sale of my bicycle."[13]

Master Tara Singh also breathed his last in 1967, at the new PGI hospital in Chandigarh, still not returned to Punjab. Gurtej Singh writes of his final visits with the once influential leader: he died surrounded by only close family, without many means or even access to a vehicle, which "speaks volumes for his honesty in public life."[14]

Then came a death that captured media and political attention. On October 27, 1969, Darshan Singh Pheruman died in the Central Jail in Amritsar: he had been on hunger strike for 74 days. Pheruman had written a letter to Fateh Singh, calling the Sant's abandoned pledges a betrayal of the Sikhs, promising his own fast till death. Pheruman had been jailed. His day-by-day withering brought attention from across India, including a letter from Indira Gandhi promising again to resolve the Chandigarh issue. Pheruman expected hollow words. He had been jailed for 15 years during the anti-British struggles and had remained politically involved since. Like Nand Singh, he fulfilled his promise. Pheruman's death resurrected some of the lost Sikh pride; he became a beacon for thousands.

In 1970, Indira Gandhi eventually announced a five-year plan by which Chandigarh would revert to Punjab, while simultaneously confirming the transfer of additional regions away from Punjab to Haryana.

In the chaos and dismay—including its bittersweet victory—of the Punjabi Suba Movement, various Sikh politicians shifted and reshifted allegiances amidst allegations and counter-allegations. Caste-based rifts had played out[15] (including the sidelining of Tara Singh for not being a Jatt), while the immediate dividends of the Green Revolution began to solidify class fractures.[16]

*　*　*

Baljit Kaur remained consumed with domestic life, even as she moved back into this Punjab reeling with broadening gaps, unachieved goals, and uncelebrated sacrifice.

"I was very happy to come back, at first—though life with my in-laws was quite, quite overpowering, I must say. We were in Ludhiana for eight years, where Jagjit started his business, which didn't do so well somehow."

"And it was a small house and a huge family, who thought I needed to learn cooking and washing." She laughs.

"I wasn't up to their standards, I could sense it," she says quietly.

"My mother-in-law would bring Jagjit's shirt and say, 'Look at this collar, Mutto has washed this!' And then, the next day a bucket of water would come and I was seated, to show me how to clean a collar!"

Mutto to her family, she smiles again.

"It was, that was, not a nice period. A lot of people were living there: my mother-in-law, my sisters-in-law were unmarried, my mother-in-law's sister, her

sons … they were perfectly nice people, but only different. Like, I would want to do up the drawing room my way, and then next I would hear my mother-in-law tell the servant, 'Go put this canister of ghee there, in the drawing room!'"

She glances around her immaculate living room now.

"So I didn't know what to do, where to start; their systems were different. I was young. After some time, my daughter Teerath also went away to boarding school, to Sanawar."

Her brother, Inderjit Singh Jaijee, was also now far away from Punjab, by design, exercising the choice and freedom available to a male child.

"I completed law, LLB. I worked for a lawyer soon after my degree. I didn't like the way he asked me to do things, to collect money from someone. It really wasn't my cup of tea."

"And then I got admission to University in Wisconsin and at the same time got hired by a British company. I did the calculations. The salary packet would not get any better if I went to Wisconsin and came back to work in India. So I didn't go. You know, the British companies and the American companies did business in very different ways. The British companies wanted to provide a career for life. And there was a loyalty to the employees."

"On my own request, I was posted in Calcutta." In the state of West Bengal, seventeen hundred kilometers from Patiala. "See, my father was known. So wherever I went, his name came up."

"I now remember one bad experience. My salary was, well, how do I put it? Your moustaches were bigger than your salary! Your perks were bigger than your salary. For instance, I was given the perk of traveling anywhere, air-conditioned. And anywhere, we were allowed to stay in a five-star hotel. But your salary was like only five hundred. So somewhere, a transporter I met asked me, 'Sir, you have come from Patiala and your name is Jaijee?' I said, Yes. He said, 'Well then, what are you doing working for Dunlop? What is your salary?' So I signaled to my senior who was with me, and I told the transporter a number double my actual salary! And still this transporter said, 'Well, just for that you joined Dunlop? Join me, I'll give you much more.' He had the idea of my name carrying weight and being useful for his business."

"I enjoyed Dunlop a lot. The first trip I went on was to Assam. I was doing market research for them. My boss said, 'Remember to take your golf set. Your job is also public relations. Go to the golf course, that also helps.' So after that, I did a lot of PR!" He chuckles gleefully about his extended bachelor days.

"I traveled extensively in the eastern Himalayas from 1960 to '62. My interest was in meeting the various people of the mountains, learning about their culture."

Back home in Punjab, the common people were ever more discontent and disillusioned. Soon, another movement, this time leftist, and via Bengal, would channel the villagers' angst.

* * *

THE VILLAGERS' ANGST TODAY MINGLES WITH SOME EXCITEMENT. They present their overnight catch: a blue Matador van. A rope. A tin of oil. Leather boots. Slippers. A rod. Army print seat covers. The camera pauses as they point out contents strewn in the van.

Then a Sikh with an uncovered topknot, no turban, lying on a bed with blanketed legs, explains how he was caned. A man holds up a medical card from a hospital in Chandigarh where the critically wounded were taken. Then another man, his hair closely cropped, explains where his legs were hurt. Another man holds up a broken finger to the camera. At least 20–25 people were injured.

Justice Bains is interviewing people to piece together what transpired in Pind Chhat in 1991.

Someone mentions the adjoining Chhatbir zoo—the zoo in the once-jungle outskirts of Chandigarh, which my brother Manpreet and I visited, enthralled, as kids. Unlike the villages that became Chandigarh, the natives around the zoo had not all been displaced. But these days, they faced another kind of danger.

Looters frequented Chhat and neighboring villages.

"No one sleeps at night here. We are all giving watch now, by turn. Someone always stays awake."

"The police don't do anything, don't stop anything, that is why we believe these are police people."

Villagers speak about the Kaale-Kachhe Vaale, Black-Underwear Men, prominent in the news. The moniker had made us giggle as children. But amusing lore for the cities was nightly fright for these villages. These gangs, who oiled their bodies and wore black briefs, were dismissed as militancy-related outlaws by the state. But victims maintained that the violent gangs were under the direct and clear command of the Punjab Police.

"Everything was murky those days," Baljit Kaur remembers. "I brought the camera, once used to record just my family, whenever I could, hoping to capture the victims' voices directly. It was all amateur camerawork, of course." But no one else could or would do it.

In Chhat village, on the night of December 14–15, villagers were able to score a victory over the marauders. Someone had seen a suspicious-looking van near the village bus station. The villagers quietly pushed it into their sarpanch's house. They created a barricade, ready to resist any attempts to take away their evidence. Gurdwaras made announcements on their loudspeakers, alerting nearby villages to gather.

"No one called the police."

A chorus of voices confirms. Various villagers come speak on camera.

"The SHO came close to nine a.m., right to the sarpanch's house," says one man. "When we do call the police, no one comes for four-four hours. Now, when we haven't called them, they come running!"

People from two dozen nearby villages began gathering, and police blockades intensified. BSF soldiers were assisting the police with crowd control. There was a jam of bodies.

"Then, they tried to be sneaky and had some boy present himself as the driver of the van, who had come to claim it! People were incensed. As the noise grew, the boy withdrew his statement and said, 'No, no, it's not my Matador!'"

"And then the SDM[17] Patiala, Gill saab, who had arrived there, orders laathi charge, caning of the crowd. People hit back. And they fired. Not in the air, but were ordered to shoot into the crowd. The BSF men intervened, in fact. They said, 'Don't shoot these unarmed people, or we'll shoot at you!'"

"Things had gotten out of hand with Gill saab." Due deference, in a system ever servile to bureaucracy, is given to this Gill, still the *saab*.

"Then, SDM Rajpura, Ravneet Kaur, began to talk to people. Her demeanor was very nice. She spoke evenly ... things calmed down. The injured were taken to the hospital."

When people demanded that the injured be compensated, a total amount of Rupees 6000 was offered.

"They just made a mockery of it!" says one man.

An older man quietly says, "But still, for us it was something. It was them accepting their deed."

A group of Sikh, Hindu, and Muslim men has gathered to elaborate on the villages' experience.

"We all were going there, because of what the police is doing. They come, and say, 'We've come for your protection.' In fact, it is to scope out the villagers' watch system. Then they go on ahead and wireless these so-called dacoits and say, 'OK, all clear, you can go in!'"

"Everything that is happening, the government is doing—otherwise, at least someone would have gotten caught by now?"

"We would have gotten them ourselves!" another villager says. "We could get these looters if the police didn't help them."

"They are commando trained, black cats, they jump up high, know how to scale walls, they are trained."

"That is true ... with everything that has happened in other villages, even after what happened in D.,[18] the rapes even. There has never been accountability. Police laugh at the people instead."

Uncomfortable silence follows the mention of rape.[19] Kaur and Bains now head to D.

An old man lies on a bed, his mouth wired shut. His son explains the events of December 10–11, 1991. The old man heard the neighbors raise an alarm and ran out. He was badly beaten. "They shouted, 'We are Singhs.' But really, they didn't look like sardaars, they were in khaki clothes. They were saying they were militants. When we ran after them, they threatened to shower us with bullets."

The old man was taken to hospital in Chandigarh. They stitched his head, set his cracked jaw.

Another man sits with his arm in a sling. A fly refuses to stop picking at the wounds on his face. His family explains, "The dacoits came in khaki pants and

jackets. They went through everything in the house: the wheat storage, the clothes, they took what they wanted. Took a silver jewelry set. They tied up the younger brother's hands. Then they moved to the other room, with the older brother and his wife. Started throwing everything about."

"They took gold. Took one lady's watch. Took ten thousand in cash. And then they turned to our sister-in-law and wanted her necklace. They were pawing at her neck and so older brother said, 'I'll take it off and give it to you, don't touch her!' At that, they broke his arm. They didn't look like the militants they told us they were. Two of them were sardaars. Rest were not. And they didn't talk like kharkoos. We believe they were policemen."

"When we told the police that evening, they stood there laughing. They mocked: 'Really, you had all those valuables? What, you had quintals of gold?!'"

The camerawoman tries collecting more details about D.

"In D., you mentioned, besides the robbing and stealing, they did something else too"

"No ..."

"You had mentioned before ...?"

"What, ji?"

"With women?"

"Yes," a whisper. "Dishonored them."

Back in Chhat, the women are incensed.

"The police are fully involved in violating women," says one livid woman. "Given what happened in D., we are fully chaukannae, alert! We, the women of Chhat, will fight these men. We are not scared."

"Bravo!" Baljit Kaur exclaims.

They turn to one woman shying from the camera. "What are you scared of? Come up front, sister!"

"We sit on the rooftops too, with our household weapons. We are going to launch full combat too, with our children." A cohort of wide-eyed children surrounds them.

"We will give full support to the men." She stares fire into the lens. She is not amused when another woman giggles shyly at the camera.

"In D., even a pregnant woman was raped, okay? We are on our roofs now, we have our gandaase, axes. When our kids raise alarm, we get ready to fight. And we are not going to let police enter during the day, nor during the night. This should be known!"

"Yes," says another, "Chhat village is not one of the scared ones. The women of this village have no fear, let it be known!"

* * *

Anti-Sikh state violence spread beyond Punjab's borders: Pilibhit's murders were a case in point.

On July 12, 1991, a bus carrying pilgrims touring Sikh sites in central India was stopped by police vans. From the bus of 25 people—several women and

children—13 men were pulled out, their hands tied behind their backs with their turbans. Two elderly men were allowed back onto the bus. Two days later, "ten of the eleven men who had been taken into custody were reported as having been killed in three separate 'encounters' with the police in forest areas near the Nepal border."[20] The men were claimed to be militants in then Superintendent Tripathi's proud announcements to the media; bloody photographs of their corpses were flashed to "prove" the encounter. Families were not otherwise informed and last rites were not allowed. There has never been any further information on the fate of the 11th person abducted: 17-year-old "Billu."

One tenacious journalist, the local Hindi daily's Vishwamitra Tandon, reported these deaths were certain custodial killings. Some families of the victims remained dogged in their pursuit, despite being hounded, jailed under TADA, even having more family murdered.[21] Some local Sikh leaders continued to persevere.[22] And the Pilibhit case investigation snailed through the system.

Three years later, the horror was multiplied: 28 Sikh detainees in Pilibhit jail were brutally tortured by jail guards and police. It was reported as an attempted jailbreak. Broken legs, ripped-out nails, mutilated bodies told their own stories. Survivors also reported the guards had first burned the Sikhs' turbans and prayer books in a bonfire.

In the U.S. House of Representatives, Philip M. Crane recounted on November 29, 1994,

> According to Agence France Presse, Indian prison guards at the Pilibhut [sic] prison in Uttar Predesh [sic] murdered six Sikh prisoners and may have tortured as many as 30 others. All six were scheduled to be released, and four of the six were witnesses to another cold-blooded incident where 12 other Sikhs were pulled off a bus and shot in the head at point blank range by Indian police. ... The Pilibhit prison murders are only the tip of the iceberg.[23]

Being far from polarized Punjab, and with the perseverance of some families and courageous advocates, the Pilibhit false encounter case led to a sentence 24 years later. Judge Lallu Singh held 47 policemen guilty (ten of whom were now deceased) in 2016.[24] The reporter, Tandon, who had first highlighted the Pilibhit false encounters commented, "I am happy for the victims' families. But I regret the manner in which high officials have gone scot free. ... Neither the then DGP Parkash Singh or the SP, who so joyously claimed to have eliminated terrorists, or the Additional SP have been even reprimanded."[25]

The jail massacre inquiry had eventually been truncated by the state government.[26]

* * *

The growing impunity has lessened the ability of Sikhs from all stations of life to protect themselves. In another satellite city of Chandigarh, the camera runs in a dingy living room, recording women whose uncombed hair do not

correspond to their tidy, upholstered living room. Baljit Kaur's colleagues speak to this terrified business family, whose daughter-in-law has been taken by the police after the family failed to meet extortion demands. "You are an army man, I am an army man, we have to be tough. Don't give in now!" retired Army General Narinder Singh counsels the worried father, who has been scrambling to arrange the ransom money. "Fight this legally now, we are with you." The father looks grateful, but unconvinced.

Emboldened police criminality was believed by many the result of a possible final push for extracting money and revenge in nonmilitant-controlled regions. Through 1990–1991 militants had solidified strongholds, running a parallel government in many areas, where villagers reported policemen were scared to even enter. And now a formal change in guard was expected.

There was a high likelihood of a militant-sympathetic government after the scheduled 1991 elections. "This was widely believed possible, even probable," says Jaijee, who archived an *Economic Times* news report of May 12, 1991: "Punjab Police officials are making preparations to meet the eventuality of Assembly elections and a militant-minded government coming to power in the state. Sources said certain sensitive records with the police are being systematically destroyed. Most of these pertain to cases of encounters. ... The police fear that a new government may try to initiate criminal proceedings."[27]

But after the June 1991 elections were postponed and the central government reinforced countermilitancy operations across Punjab, killings gained further momentum.[28]

Family members of both police officers as well as militants were now being targeted. Growing up, we had heard from wizened Sikhs, "Once they started killing police officers' family members, the militants' demise was certain." But, Jaijee writes:

> Up to 1991, the Punjab Police had disappointed the Central government strategists: when it came to terrorizing unarmed villagers they were ready enough, but they tended to hang back when their adversaries were actual militants. A way had to be found to motivate the police. Killing the families of policemen was considered the best way to accomplish this.[29]

Whether staged or genuine militant actions, the mysterious killings of policemen's kin redoubled the wrath of the police force.

In August 1991, a bomb blast rocked Sector 17, city center and shopping square of Chandigarh, and SSP Sumedh Singh Saini, narrowly escaped with his life. A rampage ensued. This included the murder of the entire family of Babbar Khalsa militant Balwinder Singh Jatana, including his 95-year-old grandmother and infant cousin.[30]

Another roundup of suspects in the Chandigarh blast case brought Mr. Darshan Singh Multani to Jaijee's home in December 1991. Mr. Multani was a retired Indian Administrative Services officer. His son Balwant, 28 years old, worked for CITCO (Chandigarh Industrial and Tourism Development Corporation) and lived in Mohali. He had been abducted on December 11 (Photo 6.1).

R-2/2

Annexure **A-1**

TELEGRAM

1. Governor Punjab, Chandigarh.

2. Chief Secretary to Govt. Punjab.
 CHANDIGARH

3. HOME SECRETARY TO GOVT. PUNJAB, CHANDIGARH

CHANDIGARH POLICE RAIDED MY HOUSE AT MOHALI ON 11.12.1991 AT 4 A.M. AND TOOK AWAY MY SON BALWANT SINGH FORCIBLY AND KEEPING HIM IN ILLEGAL CUSTODY() ON 13.12.1991 AT 5.30 PM CHANDIGARH POLICE TRESPASSED MY HOUSE WHILE IT WAS LOCKED() PLANTING OF ARMS OR OTHER ILLEGAL MATERIAL TO IMPLICATE MY SON IN A FALSE CASE IS APPREHENDED() KINDLY INTERVENE()

SD/-
(D.S. MULTANI) IAS
JOINT DEVELOPMENT COMMISSIONER (IRD)
PUNJAB, CHANDIGARH

True Copy

Advocate

Photo 6.1 Telegram sent by D.S. Multani immediately after the abduction of his son, Balwant Singh Multani[31]

Mr. Multani had filed for bail by December 17, 1991.

"But really," explains Jaijee, "he knew he had to quickly find some connection to the senior police ranks, so as to get Sumedh Saini to spare his son's life."

Mr. Multani's senior bureaucratic position and alacrity were bringing little result—a fact that had a further chilling effect on Sikh middle-class families.

"I called Mr. Sarao from Delhi," says Jaijee. "He was a senior I.A.S., and due to his Assam connection, I called him. He had known K.P.S. Gill from Assam and they were friends. And when I had been at Dunlop, I had also known Sarao, who was then posted in Shillong. So we were friends. On my request, he came here. And he tried his best to meet with K.P.S."

"On the third day of trying, Sarao got the meeting. And he told K.P.S., 'If you don't intervene, the boy will be killed.' And K.P.S. set up a meeting with Saini. But Saini just looked down and said, 'How can I bring him back now?' They had clearly killed the boy already. On paper, they showed the boy's encounter somewhere near Amritsar."

The police reported that they had taken Balwant Singh Multani to Qadian on police remand, where he had escaped from custody, and there was thus no body to produce, as required by the habeas corpus petition filed by Mr. Multani.

Balwant Multani had been friends with Devinder Pal Singh Bhullar, the mechanical engineering lecturer from Ludhiana's Guru Nanak Dev Engineering College, declared wanted by S.S. Saini in 1991. Bhullar had fled while his father, uncle, mother, other family members, and friend Balwant were abducted in the wake of the bomb blast. Bhullar's father and uncle were never seen again. Bhullar was implicated in another case in 1993, a blast at the All India Youth Congress office in Delhi.

Bhullar was arrested in 1995 at the Delhi airport after Germany denied his political asylum application and had deported him (two years later, a German court would find this denial erroneous).[32] After being held without trial for five years, and without access to an attorney, he would be sentenced to death in the Delhi blast case.[33] His conviction was based on a confession, affirmed with only a thumbprint, which Bhullar later said had been obtained during torture in police custody. None of the prosecution's witnesses had identified Bhullar. His death sentence was confirmed two-to-one by the Supreme Court in 2002: one justice found him decidedly not guilty.[34] Appeals for clemency continued to be filed with the President of India, while national and international groups like Amnesty International sustained advocacy on the case, pointing to its various excesses and irregularities.

In December 2006, all three accused in the 1991 bomb blast case, including Bhullar, were acquitted. In 2007, the acquittal was upheld by High Court Justice M. S. Gill. Justice Gill then *suo motu* (on the Court's own initiative) asked for a report regarding the others related to the same 1991 blast case who, like Balwant Multani, had been long declared "proclaimed offenders, POs," supposedly on the run, evading arrest.[35]

The High Court directed that a special investigative team be constituted to enquire into these POs, missing for over 16 years. On September 16, 2007, Mr. Multani petitioned to implead himself into this case. He explained his certainty that his son, declared a PO since 1993, had in fact been killed by the police.

The High Court asked for an investigation by the CBI, which in October 2007 claimed it was overburdened. But the Court insisted that the person

under investigation was in too high a position for the CBI not to be involved in this long-pending case. Sumedh Singh Saini, who was the SSP during the events in question, now held the all-powerful position of Head of Vigilance, Punjab.

On October 30, 2007, Devinder Pal Singh Bhullar—still on death row for the Delhi blast case—also filed in the Punjab and Haryana High Court, alleging that his father and uncle had been killed by Saini in 1991. The State of Punjab balked at the Court considering this petition, filed by a "terrorist."

The CBI's investigation was confirming what had already become morbid mythos in Punjab about the fates of the young Multani and the older Bhullars. In July 2008, a CBI status report, drawing on 70 witnesses, concluded:

> The police party picked up Balwant Singh Bhullar and brought him, as well as Balwant Singh Multani, to Sector 17 police station, Chandigarh, on December 13, 1991.
>
> They were tortured in the presence of and on the orders of Saini, the then SSP, by DSP Baldev Singh Saini and his men inter-alia to know the whereabouts of Devinder Singh Bhullar. Balwant Singh Bhullar was again brought to Dialpura Bhaike on February 2, 1992, by the Chandigarh Police for investigation. His face was found swollen. He was brought back to Sector 17 police station, Chandigarh, and tortured on the orders of and in the presence of Saini. Due to torture, Bhullar lost his mental balance and was unable to walk properly and eat anything. On the seventh day, he was segregated and taken away.[36]

A F.I.R. was filed against S.S. Saini and junior officers.

Now the State of Punjab challenged its own High Court through a Special Leave Petition in the Supreme Court of India, noting "the observation of the Hon'ble High Court is hugely demoralizing for the state administration as it has not done anything to attract such suspicion."[37] It alleged that S.S. Saini was in fact conducting an enquiry against the High Court judge, who therefore was prejudiced.

S.S. Saini's battle with High Court judges was a matter of judicial record, as noted in the concerned judge's order, also produced before the Supreme Court. The order referred to the Kumar case, a triple murder case against S.S. Saini that was pending in Delhi CBI Court. In 1994, while Saini was SSP Ludhiana, a dispute with a local family escalated and their son Vinod Kumar petitioned the High Court for protection against Saini. Saini was issued orders, which he ignored, prompting the Court to initiate contempt charges. Soon after, the petitioner, Vinod Kumar, his brother-in-law Ashok Kumar and brother-in-law's driver Mukhtiar Singh were taken away in a police vehicle, never to be seen again. Thirteen years later, in January 2007, with the persistence of Vinod Kumar's then 90-year-old mother, Amar Kaur, S.S. Saini was charged, alongside three other senior officers, with criminal conspiracy, abduction, and wrongful confinement.[38]

In 2008, the Multani case however screeched to a halt, with a Supreme Court stay order. Then, in 2011, the Supreme Court decided in favor of Saini and the state of Punjab, finding "a biased approach" by the High Court judge

who had insisted on a CBI inquiry into the fate of the reportedly missing men. "It was a misplaced sympathy for a cause that can be termed as being inconsistent to the legal framework," the Supreme Court concluded.[39]

Lawyers close to the case confided: "The state must have found something on the judge and shown in secret, et cetera. Still. This was an astonishing move by the Supreme Court. Absolutely against the central fundamentals of law." And "Even this supposed bias of a judge doesn't make the entire investigation false. Especially when there is no allegation against the CBI and the numerous witnesses!" Mr. D.S. Multani kept calling his attorneys regularly, trying to ascertain if there were any avenues for an appeal.

The Kumar case remains pending in Delhi. Amar Kaur died on December 12, 2017, at age 102.

Meanwhile, in Bhullar's case, Devinder Pal remained on death row, in no position to advocate for his father and uncle or his one-time friend Multani. Review petitions were rejected. This, despite an astonishing statement by the special public prosecutor who had led the government's case against Bhullar in the Supreme Court in 2002:

> Surprising as it may sound, I believe that Shah [the dissenting justice who had found Bhullar not guilty] was right in not accepting my submissions in support of the trial court's decision to convict Bhullar in a terror case, entirely on the basis of his confessional statement to the police. Shah refused to acquiesce to the Delhi police's presumption that they had a lot of margin for shoddy investigation because of the involvement of terror.[40]

After 18 years behind bars, many of them in solitary confinement, Bhullar was being treated for mental illness in 2013. His doctor declared him mentally unfit for hanging.[41] Several protests and machinations later, the Supreme Court commuted Bhullar's sentence to life imprisonment in 2014, on the basis of inordinate delay and his mental condition. Against the backdrop of increased pressure due to a campaign for Sikh political prisoners by an 82-year-old activist, Surat Singh Khalsa, Bhullar has been released on parole intermittently since 2016.

S.S. Saini continued to rise in police ranks. In 2012, he became Director General of Police, Chandigarh. He served in this position until October 2015.[42]

A former police hitman for S.S. Saini, Gurmeet Singh, aka Pinky, provided a sensational video confession in 2015.[43] Among many other cases, Pinky confirms nonchalantly on camera how, after the blast, Balwant Multani was taken to a police center in Chandigarh and his condition deteriorated especially after "the rod was given." He was sodomized.

About a year before this account circulated on Sikh social media, D.S. Multani had passed, as his lawyer learned while calling to arrange my meeting with the dedicated father. The former hit man's confession opened the possibility of further legal action. Whether the one surviving Multani son will now reenter the same legal system as a petitioner remains to be seen.

Notes

1. An erstwhile term for Dalits (supposed "low" castes), which was popularized in the 1930s by M.K. Gandhi as loving and embracing, even as it has been protested ever since as condescending and patronizing.
2. The Sikh Gurus created a unique identity (consolidated by the tenth Guru, Gobind Singh), often quickly explained as the Five Ks: Kesh (uncut hair); Kara (steel bracelet); Kachera (underpants); Kirpaan (small sword); and Kanga (small comb).
3. Ajit Singh Phoola dressed in the traditional garb of a Nihang. Nihangs are a Sikh community order that began by emulating the spartan lifestyle of the Guru's seventeenth-century irregular army; they are distinguished by their blue garb, steel armaments, and towering turbans. Phoola became notorious during the conflict years as Punjab Police-sponsored, and operated with a heavily armed guard. See, for example, Ram Narayan Kumar, Amrik Singh, Ashok Aggarwal, and Jaskaran Kaur, *Reduced to Ashes: The Insurgency and Human Rights in Punjab* (Kathmandu, Nepal: South Asian Forum for Human Rights, 2003), 191 for an example of how Phoola served as a conduit when families sought the release of women taken by the Punjab Police.
4. See, for example, Bryan Newman, "A Bitter Harvest: Farmer Suicide and the Unforeseen Social, Environmental and Economic Impacts of the Green Revolution in Punjab, India," Developmental Report No. 15, Food First, Institute for Food and Development Policy, Oakland, Ca.; Vandana Shiva, *Violence of the Green Revolution* (London: Zed Books, 1991); Aman Sidhu and Inderjit Singh Jaijee, *Death and Debt in Rural India: The Punjab Story* (New Delhi: Sage Publications, 2011).
5. Khushwant Singh, *History of the Sikhs, Volume II; 1839–2004* (New Delhi: Oxford University Press, 1999), 296.
6. In 1947-created East Pakistan, the rejection of the imposed Urdu over mother tongue Bengali caused serious tensions. Eventually, the war of 1971 would lead to a cessation of East Pakistan and the creation of Bangladesh. See, for example, Abbas Zaidi, "Linguistic cleansing: The sad fate of Punjabi in Pakistan," in Thomas J. Hubschman (Ed.), *Best of GOWANUS: New writing from Africa, Asia and the Caribbean* (New York: Gowanus Books, 2001).
7. Khushwant Singh, *History of the Sikhs, Volume II*, 296–97.
8. Khushwant Singh, *History of the Sikhs, Volume II*, 302.
9. Gurharpal Singh, *Ethnic Conflict in India: A Case-Study of Punjab* (New York: St. Martin's Press, 2000), 91.
10. Khushwant Singh, 303.
11. See, Kapur Singh, *Sachi Sakhi* (Jalandhar: Bright Printers, 1972), Appendix E.
12. Khushwant Singh, *History of the Sikhs, Volume II*, 304.
13. Gurtej Singh, *Chakravyuh: Web of Indian Secularism* (Chandigarh: Institute of Sikh Studies, 2000), 88.
14. Gurtej Singh, *Chakravyuh*, 74.
15. See, for example, Khushwant Singh, *History of the Sikhs, Volume II*, 317; Gurtej Singh, *Chakravyuh*, 92 (on Fateh Singh's inflaming Jatt versus Bhapaa tension to oust Tara Singh, a non-Jatt leader).
16. See Chap. 7, note 28.
17. Sub-Divisional Magistrate.

18. The village is not named here to protect the victims' privacy.

19. "I have personally heard first-hand descriptions of sexual abuse at the hands of police from women who did not report it to their own fathers, husbands, and sons. In one case, a woman had been viciously raped no less than six times while in custody and had chili peppers forced into her vagina and anus, and the male members of her family did not know about it. (Indeed, one said, 'Luckily, my sister escaped insult when she was in jail.')" Cynthia Keppley Mahmood, *Fighting for Faith and Nation: Dialogues with Sikh Militants* (Philadelphia: University of Pennsylvania Press, 1996), 224.

20. Asia Watch, "ENCOUNTER IN PILIBHIT: Summary Executions of Sikhs in Uttar Pradesh, India," *News for Asia Watch*, September 29, 1991.

21. "Nishan Singh, rushed to Pilibhit with his wife, Surinder Kaur, to locate his 'missing' siblings. However, the cops picked up Nishan Singh, a lineman with the erstwhile Punjab State Electricity Board (PSEB), and murdered him. Charges under TADA (Terrorist and Disruptive Activities (Prevention) Act) were slapped against Surinder and she was sent to an Uttar Pradesh jail, from where she was released on bail after three years." "Pilibhit Verdict Offers No Solace to Gurdaspur Victims' Families," *The Tribune*, April 6, 2016.

22. Often at high personal costs. See, for example, Keshav Agrawal, "Sikh Leader, Aide Arrested by Jt Team of UP ATS, Punjab Police," *Times of India*, September 17, 2017.

23. "Six Sikh Prisoners Killed by Prison Guards," Philip M. Crane, Remarks, Tuesday, November 29, 1994, Congressional Record Volume 140, Number 147.

24. Manish Sahu, "1991 Pilibhit Fake Encounter: 25 Years On, 47 Cops Held Guilty of Killing 10 Sikh Men," *The Indian Express*, April 2, 2016.

25. "Scribe Who Brought Pilibhit Story to Light," *The Tribune*, April 7, 2016.

26. "Pilibhit We've Forgotten: 7 'Murders,' Brutality That Were Buried In UP," *The Tribune*, May 9, 2016, ("Then a senior Samajwadi Party functionary and social worker Haroon Ahmad, who was instrumental in getting the FIR lodged, is horrified to learn that all the accused in the case have been spared").

27. Inderjit Singh Jaijee, *Politics of Genocide: Punjab, 1984–1998* (Delhi: Ajanta Publications, 2002), 136–37.

28. See, for example, Gurharpal Singh, *Ethnic Conflict in India*, 153–54.

29. Jaijee, *Politics of Genocide*, 148.

30. Jaijee, 148.

31. From Multani High Court case file. On file with author.

32. IANS, "EU opposes death to Bhullar, writes to Chidambaram," *The Deccan Herald*, June 17, 2011.

33. "Devender Pal Bhullar at Risk of Imminent Execution," *Amnesty International India*, ASA 20/059/2013, April 12, 2013.

34. Darshan Desai and V. Venkatesan, "There Is a Case for Commuting Bhullar Sentence: M.B. Shah," *The Hindu*, April 21, 2013.

35. Order in Crl. No. 152-MA of 2007, High Court of Punjab & Haryana, August 22, 2007.

36. Tribune News Service, "Multani, Bhullar were abducted, tortured on Saini's order: CBI," *The Tribune*, July 4, 2008.

37. "Petition under Article 136 of the Constitution of India seeking special appeal against the final orders dated 05.10.2006, 06.11.2007 and 04.07.2008." On file with author.

38. Abhishek Angad, "Abduction case: 102-yr-old key witness dies after 23-year fight for justice," *The Indian Express*, December 13, 2017.
39. *State of Punjab v. Davinder Pal Singh Bhullar & Others Etc.*, Judgment in matter of Criminal Appeal Nos. 753–755 of 2009, December 7, 2011.
40. Manoj Mitta, "Public Prosecutor Turns Surprise Ally for Bhullar," *Times of India*, April 18, 2013.
41. Bindu Perappadan, "Sending My Patient to Gallows Is Disturbing, Says Bhullar's Doctor," *The Hindu*, April 17, 2013.
42. S.S. Saini retired in 2018.
43. See, Kanwar Sandhu, "Confessions of a Punjab Police Cop—FMI Exclusive," https://www.youtube.com/watch?v=1J4gidBIaw8, December 4, 2015.

Two Urns

Abstract This chapter illustrates how Kaur, Jaijee, and Bains were prepared to use their bodies as resistance; believed in showing up during times of dire need; and remained in touch with people they had met in the worst of circumstances, without pretending to share those situations or experiences.

In July 1989 the three protagonists were joined by others in surrounding a police station to demand the release of young "Kid." The chapter thus enters a time not so long ago where Members of Parliament running on the platform of Sikh self-determination, indeed separatism—Khalistan—won landslide electoral victories, due to a groundswell of support for candidates running against the status quo.

The chapter's parallel timeline explores the turn into the 1970s, and how the demands for greater Punjab autonomy were neither secessionist nor new. The growing disparities in the country—promised by its Constitution to be a "socialist" republic—also drew many to a more strident leftism, the Naxal movement. The State response to Naxals first introduced "police encounters" to the countryside. At the same time, a document collating the demands to decrease centralization and increase autonomy for all states was prepared by Sikh leaders in 1973.

* * *

ਬਾਬਾਣੀਆ ਕਹਾਣੀਆ ਪੁਤ ਸਪੁਤ ਕਰੇਨਿ ॥
:Guru Amar Das:
Guru Granth Sahib, 951
The stories of ancestors nurture virtues in children

"I CANNOT REMEMBER EXACTLY HOW I FIRST MET JUSTICE BAINS, but I do remember how we all surrounded a police station together." A gossamer white chunni gracefully pulsates on Baljit Kaur's shoulders against the beat of the ceiling fan. "They had picked up a boy. Kid, his family called him. He was only about twenty."

When asked if there were any other women protesting, she gently shrugs. "I think ... no!" A dimple momentarily appears on her bronzed face.

"My brother was also there. They had guns drawn out. We said, 'We will walk in unless we get what we came for.' And I told the men, Justice Bains and my brother, Please stay behind, they won't shoot a lady." The lady, now 75, shifts a little, adjusting herself on an emerald green cushion, the seat of a large, sparklingly revarnished cane chair, reminiscent of a different era. "Well, at least it was less likely for them to shoot me."

She pauses to swirl a silver spoon in floral china. A photograph of a bearded man with a sun visor over a small turban, golf club in mid-swing, looks over her right shoulder. Jagjit Singh Gill had passed away three years earlier, of natural causes.

"Jagjit didn't know we had gone to surround the police station of course!" She stares down at the receding vortex in her teacup. Silence around complicated relationships with the beloved dead is deemed best.

"Ultimately it worked in the sense that this was the first time that the police met human rights resistance on their turf."

It was July 1989, when about 20 people surrounded the police station in the sleepy town of Kharar. Kulwinder Singh, "Kid," had been taken by policemen on July 22 in broad daylight, in front of witnesses. By July 24, Kid's father, Principal Tarlochan Singh Sidhu, learnt that the same police party had staged an encounter with two Sikh boys. He quickly approached the High Court for an order to prevent their secret cremations.[1] The resourceful father then made appeals to all quarters, including the most high-profile human rights figures of the day.

Their protest outside the police station took place amidst the heightened volatility of that year. January 1989 witnessed the hanging till death of Satwant Singh and Kehar Singh in the 1984 Indira Gandhi assassination case. Kehar Singh was accused of conspiring with Gandhi's bodyguards Beant Singh (his nephew, killed on the day of the assassination) and Satwant Singh. Meanwhile, a judicial commission was investigating the alleged larger conspiracy around the assassination: various circles believed there was a deeper story, and the Sikh bodyguards were at best pawns. The government, now run by Gandhi's son Rajiv, refused to release the commission's report and the two men were hanged. When shown to Parliament two months after the execution, the report confirmed that Kehar Singh had no involvement with the assassination.[2]

Civilian communal vitriol and violence were escalating quickly. Guru Gobind Singh's gurpurab that January witnessed mob attacks on the Sikh population in

Punjab's neighboring Jammu, where Sikhs had always been a strong minority. But this year, when 10,000 gathered for the celebration of Guru Gobind's birthday, violence was unleashed by an organized Hindu mob. Hundreds were injured, at least 13 killed, and Sikhs were terrorized as their shops were looted and bodies pulverized, while the police refused to act. The magazine *India Today* reported, "Not a lathi was raised, not a tear gas shell fired. It almost seemed as if the police were encouraging the show." In the days that followed, the 200 Hindus arrested were freed after the BJP Party led a weeklong protest. The Congress government at the Center issued no statement.[3]

Militants in Punjab began experiencing an intensified onslaught, corresponding to critical political shifts in the subcontinent: "Pakistan intelligence reduced support for Khalistan and increased it for Kashmir."[4] It is widely believed that Sikh militant hideouts were divulged to the Indian establishment by none other than its sparring sibling, Pakistan. Sangat Singh writes, "[Benazir Bhutto] in 1989 had helped Rajiv Gandhi [vis-à-]vis Sikh militants as quid pro quo for his helping her against Zia."[5]

Rural Punjabis had been bearing the program of mass punishment and humiliation. February 1989 saw the simultaneous resignation of over 40 sarphanches, village panchayat-government heads, and over 100 panchayat members, in Batala region.[6]

Village after village tells the human rights team from Chandigarh a similar story.[7] Police would cordon off the entire village; boys and men herded together, were whipped and beaten, while the rest of the village was made to watch; and the entire village was ordered to chant curses against local Sikh militants. Panchayat members were belittled for being useless in capturing these militants. They were then often rounded up and taken away. One sarpanch who had been taken by the police explains, "There's the Beiko torture center. They have machines there, and a heater for electrocution. They disgraced us there." This dreaded center had been set up in an abandoned factory belonging to Beiko Industries. Another man who had been made to lie prostrate for floggings, said, "The beatings are still tolerable, but the dishonor of our daughters and mothers is unbearable."

When asked about their rationale for the collective resignation, one leader says, "Well, we were already demoted when we were treated this way! But even injustice has to have some limit. We'll do the job, if there is some system, some limits."

Sarpanch after sarpanch relays how the police directed them to catch militants. "They even told us, 'When you feed them, just there, in their milk even, why can't you put in some poison and kill them?' And when our families came looking for us at the police stations, when they came to give us food, they were told, 'First go deposit the money!' Extortion at every point is perfected. Meanwhile they want us to do their assignments of catching and eliminating the boys!"

Villagers explain how police refuse to directly face off with the armed militants. "The boys themselves gave a date … told them, BSF and police, 'Come face us!' No one, not a single one of the forces showed up. The boys put Khalistan flags, cursed the forces out loud, no one came. No firing. Nothing."

The human rights team would repeatedly hear that people were told, "Your village's number, turn, has come. Come now, get your share!" The police teams moved from one village to the next.

In one village, an interfaith group explained the cordon-and-beat experience of their village. Men told Baljit Kaur how the police were accompanied by the Border Security Forces (BSF), and were especially enraged when some villagers identified themselves as retired army men and tried to intervene. A Christian resident of the village says, "All Sikhs, non-Sikhs, about a hundred men and boys, got it very bad that day ... senior police officers even turned to BSF men and said, 'Can't you do it properly? I'll show you how to beat them!'"

Baljit Kaur remembers, "It was so brazen, and the police had no fear, of God or man. Traumatized children ran helter-skelter at the slightest sound!" Many women from these villages left for weeks on end. One witness recounted to Baljit Kaur, "After four hours of beating, they said to villagers. Next time we come, we'll take the women, beat them and show them too. So the women went to stay with other relatives." These operations were creating more and more runaways.

After over 40 sarpanch resignations, Governor S.S. Ray called a meeting. In 1986, Ray had become the sixth Governor of Punjab since 1984.

Most sarpanches mocked the Governor's call, with heaviness. "He came and stayed at Circuit House and asked us to come. Most of us didn't go. We expect no fair hearing," they told the human rights team. Then the Governor organized a public function. Various policemen, including the notorious Gobind Ram, sat with the civil officers who asked villagers to come forward and share any concerns. The next day, the police returned to many villages, to terrify villagers again. "We again went to Delhi, to the Governor, complaining about this. ... And again, Gobind Ram gets a clean chit. So we think it's in the central government's own policy to do all this."

Says Justice Bains, "Gangs of criminal officers were uncontrollable, and that's why the panchayat members wanted to make a public declaration about the death of democracy."

Repression flamed militant resistance, which was met with further oppressive punishment, overwhelmingly borne by noncombatants.

"This was the same time when Professor Rajinder Pal Singh's case happened in Ludhiana," Justice Bains remembers. "S.S. Saini had taken him. He was killed. He was a beloved professor. His wife pursued the case legally for some years."

Campuses had again become sites of resistance, despite the government's clampdown on student organizing. During Baljit Kaur's interviews at Guru Nanak Dev University in 1989, one teacher explains that the students were on strike, and uncontrollable. He remarks how students' behavior reflected popular trends. "In the 1970s it was very difficult to find in our university any student who was an Amritdhari ... not fashionable. But now, after 1984 Operation Bluestar, it suddenly became the opposite, it became very unusual to find persons who would not have a flowing beard and saffron turban."

The government dreaded the groundswell. "By now, anyone could be labeled Khalistani and antistate, and beyond the protections of the law," says Inderjit Singh Jaijee. "We worked on getting external observers. Had been trying for long to bring Western parliamentarians into Punjab to witness for themselves. In April 1989, UK parliamentarians finally visited. They were followed everywhere."

"We had a convoy going together to Gurdaspur to show them a case where a mother and daughter were raped and killed. When we reached Phagwara, we stopped for tea. Now we decided to split up. I was able to get them into a smaller car. The bigger group went ahead and the police followed the bigger group, with Baljit and Justice Bains. I had the MPs with me and an open road to Gurdaspur, to meet the family of the women. And then from there we were able to go to Mal Mandi too."

Jaijee took the parliamentarians to the notorious torture center: Mal Mandi, Amritsar. Surprising the low-level police officers there, they gained entry into a room with an iron beam running across the middle of the ceiling. "The room was otherwise empty. They thought they had hidden everything. There were power switches all over this room. Also a locked almirah. But the beam was imposing. When we kept asking the policemen about it, one cop finally said, 'Oh, sir, it's nothing, sometimes we like to hang curtains!'" After a breath Jaijee explains, "It was used to hang people upside down for torture." A sudden fierce focus replaces his chuckles about the curtains.

Jaijee's ability to live between the grotesque and the jocular is probably the secret to his young heart at the age of 88.

"And around this time, it all began being mixed up. Murkiness of militant representatives abounded. Don't forget police too were roaming in gangs, dressed as militants. Would go into homes saying, 'We are being chased by the police.' And the people would sympathize and open the doors and help, and then these chaps would do what they wanted and as soon as they left, the police came for the so-called harborers."

By now, police targeting of women in these vulnerable villages had become unbearably rampant. Under mounting pressure, including letters from the U.S. Congress, Governor Ray issued new instructions to his police: women were not to be taken to police stations. But the overall system was staunchly defended.[8]

"I think a turning point of the conflict violence was in 1989 when K.P.S. Gill, Ray, and all decided that they were playing a role in a bigger game," says Baljit Kaur. "They were playing not just for Punjab. Delhi was playing for rest of India. Showing their prowess in controlling a troublesome minority. To win political points for the elections, they were playing the Sikh card."

"I remember a bloodbath at the engineering college, where a number of students were killed. And militants were immediately blamed. But a junior policeman who carried out the gunning had an inside story. This I heard by chance from a retired general whom I knew, who lived in Sector 8. He was ancestrally from the same area as that policeman, Samrala area. The general told me these details."

"He said that this policeman and others were called by Ray and told that the militants were holding an important meeting in the engineering college, and no one must be spared because they won't be gathering like this again. And ask no questions, but you will be rendering a great service to the nation. And don't go by their looks, because they have even cut off their hair and beards. So, gathered students, no Sikh militants, were killed. I think about seventeen. It was all done by Ray's orders."

The students had come from Kanpur, Uttar Pradesh, to Thapar Engineering College, Patiala, for a youth festival.[9]

"And this junior police officer collected his reward. He was given a Maruti car and then told that he could go on leave to his village for a few days. And this man went home very happily that he had done his job, interrupting a major meeting by the militants. And then on the way, he stopped at a tea stall. Here he picked up some newspapers. He read how students had been killed!"

"The policeman was apparently quite shaken," says Baljit Kaur. "He started blabbering when he was drunk about how he was made to kill students. Now, all these people who were given such tasks by the State, were watched. So when he started saying, 'Sorry,' 'What have I done,' 'These were only students,' et cetera, he got on the police radar. Soon after, he was shot while walking along the canal bank one day. And they reported quickly that this Special Police Officer was shot by unknown militants."

"The nice old general said enough people in area had heard this, I should investigate. He was sympathetic but he didn't want to be involved." Baljit Kaur laughs quietly. "Interesting, yes, most Sikhs here in Chandigarh would at most quietly tell me I was doing the right thing and point me to other cases of abuses and then change the topic," she remembers. "But I couldn't go because every day people were being killed; you couldn't go everywhere."

"This case came handy in the next elections in Kanpur. The Sikh card was played, about how students had been shot by Sikh militants. People couldn't understand any other reason for such brutality except that the Sikhs must be so anti-Hindu. Meanwhile, Ray kept warming his chair."

Baljit Kaur waves a hand and indicates we have talked enough today. It's the first time she acknowledges her ongoing medical treatments leave her very tired. Should we just drink some cold Pepsi now? She feels parched.

The killings at Thapar College left indelible marks on many lives. Students in the college were traumatized first by witnessing these murders and then by what transpired after. Every so often, a friend living in Washington state still recounts this college experience that changed his life. How the sudden thakk-thakk-thakk-thakk-thakk-thakk had jolted him out of his Thapar hostel bed. How he opened the door to a very angry police party, holding a young Sikh boy. Saw the injuries across his body, knots in his open hair, half-open eyes. Heard the shackles clank and "So, how about this one? You know this one?" Was pushed forward toward the captive. Stood scared stiff of being "identified" by someone he had never met before. Almost fainted in relief at the painfully slow shaking of the boy's head. "He was yanked on to the next hostel room. Ever since, I have thought he saved my life at the cost of more pain to himself. If he had quickly identified some more Sikh boys, he would have been spared some of the torture, perhaps?" Our friend had fled back home to New Delhi soon after, and then migrated as soon as U.S. embassy paperwork allowed.

* * *

Human rights defenders had been demanding attention. Justice Bains remembers of a September 1989 demonstration, "despite strict government ban,

Oct. 4/1988

Dear Mr. Ray,

Please refer to your Secretary's D.O. No.PRB-GS-89/736

We are unable to meet you now because of its futility. There is
nothing to discuss but much to feel. On the 30th September, when we
wanted to meet you and present the memorandum, you not only failed to
meet us but on the other hand arrested us. Your response was massive
deployment of police and para-military forces, barricading of routes
leading to and within Chandigarh and large scale pre-emptive arrests.
Your security forces prevented even the devotees from paying obeisance
in the Gurdwara, and threatened people in the country side with dire
consequences if they tried to participate in the peaceful agitation.

You have the memorandum in which we have outlined steps we consider
important to restore the rule of law. You only have to implement it
if you mean business. Talking and meeting will serve no purpose. We
trust and hope that you will change the state policy and no longer
use state apparatus in the service of state terrorism.

Alas ! the dream of our great patriot, poet and philospher, Rabindera
Nath Tagore, "where the mind is without fear and the head is held high -
----------- Into that heaven of freedom,my Father, let my country
awake." remains unfulfilled even after 42 years.

Yours sincerely,

Ajit Singh Bains

for PHRO and Movement Against State Repression.

Mr. S.S. Ray,
Governor of Punjab,
Raj Bhawan,
Chandigarh.

Photo 7.1 Justice Bains's letter to Governor S.S. Ray, October 4, 1989. (Ajit Singh Bains personal archives)

thousands came." A petition was submitted to Governor Ray regarding human rights violations and demanding the release of innocent civilians in jail. "We were arrested … the Governor did not take any action on our demand." (Photo 7.1)

Justice Bains remembers running into Governor Ray at a dinner party hosted by a High Court Justice in late 1989. "Ray taunted me like, 'Why haven't you human rights people said anything about Gobind Ram's murder?' And I told him, He was a killer. If the government had worked to bring Ram to justice, nonstate actors would not have murdered him. He didn't say much to me after that!" Bains shrugs, as if Ray was often spoken to this way. "It was true. *They* were trying to question us!"[10]

Justice Bains recalls another incident in 1989 when, along with Baljit Kaur and local activists, he was detained at a police station in Dehlon for a whole day. Young men were beaten in front of them, as intimidation. The Justice then smiles as he remembers how Baljit Kaur raged against the police officers, despite dark warnings.

Baljit Kaur dismisses discussing her own pluck. "This just had to be done." She falls into a studied silence, which her life's work has taught her to hold with grace. "The Kid case was only the first of several incidents where we surrounded a police post. Tarlochan Singh was the principal of Senior Secondary School in Kharar, District Ropar. He wouldn't give up. He brought the case to us. When we physically confronted the police, they too were taken unawares. They must have been on their phone asking whether to shoot at us or not. Must have said, 'These human rights folks are here, what to do, sahib?'"Kaur stops for a shy chuckle, always discreetly provocative."But there were too many of us, and we were not far from Chandigarh. If one of us had been killed, the press would have caught it," she says. "Of course later we went out more like this too, like the station in Dehlon. But that was an easier time. Mann had come back with many MP seats, so it wasn't so difficult for Sikhs protesting."

In the November 1989 elections, candidates running on the platform of Sikh self-determination—Khalistan—won landslides victories. Simranjit Singh Mann's wing of the Akali Dal party won six seats to the Indian Parliament, and was allied with four other candidates. In this sweep, with over 89 percent of the votes cast, Mann had won while lodged in a jail cell 900 miles from Punjab.[11]

This now long-standing, always newsworthy politician had been an Indian Police Services officer in 1984.[12] Mann resigned in protest after the June 1984 attacks on Punjab. From a prominent landed and political family, the English boarding-school educated elite's resignation was neither quiet nor inconsequential to the government. He proceeded into hiding in the months that followed. Captured on the international border, trying to escape to Nepal, Mann was jailed under the National Security Act and taken to Bharatpur Jail, Rajasthan, where he was tortured. His charges included coconspiring to kill Indira Gandhi.

In one prison letter to his daughter, he writes, "I believe the French orchestra played Chopin in Chandigarh. In the new charge sheet you will hear that, besides writing to Amnesty International, I used to attend music classes. How that makes me seditious in character, God only knows. I think the Gandhis are going loony."[13]

Despite having the highest-profile legal eagles on his case, including Ram Jethmalani from Delhi, Mann's jail term stretched languidly. But his harsh treatment and distance from Punjab and its sordid conspiracies, conflicted loyalties, and challenged sincerities, elevated Mann as a flagbearer for Sikhs.

Calls for Mann's release gained momentum. The voting masses of 1989 now linked Mann's freedom with their own.

In November 1989, Rajiv Gandhi's Congress faced a humiliating defeat. A coalition of parties, the "National Front" came into power. Before leaving office, Rajiv Gandhi ordered the newly elected MP's release. Mann came home to a hero's welcome.

The new Prime Minister of India, V.P. Singh, was quick to flow with the changed current in Punjab. Two days into office, he traveled to Darbar Sahib, Amritsar, and drove through the streets without much security. His speech suggested a changed policy, acknowledging Punjab's pain and the need for healing.[14] This was a clear departure from the Congress, and people began to hope for some resolution.

Punjab Governor S.S. Ray resigned. He left a trail of allegations: his careless strong handling of Punjab was now questioned.[15] Governor Nirmal Kumar Mukherjee took office, promising a new approach.

Mann's political party began working with the National Front government, defining Sikh demands within the Union of India, without the secessionist threat that had become an excuse for abuses in Punjab. But Mann himself never took the oath for his parliamentary seat: he had been stopped at the entrance to the Indian Parliament for carrying his large kirpaan. While most Sikhs carry this article of faith in its smaller size of a few inches, strapped along their body, Mann's kirpaan was three feet long and he refused to submit it at the door, as a matter of constitutional right. Thus began the legal battle for his kirpaan rights, which ended his parliamentary career before it began.

New Delhi had meanwhile launched another offensive. The years 1989–1990 marked the beginning of Kashmir's popular uprising, and its forceful quashing. Mann made swift statements of solidarity with Kashmir: "On Saturday, the leader of the strongest Sikh political organization in the state said that if India went to war with Pakistan again, Sikhs—a religious minority that has been a mainstay of the Indian Army—would refuse to fight. 'We have learned that if they suppress the Kashmiris through the bullet and the tank, they will do the same thing on the rolling fields of the Punjab, which has no forests, no place to even hide our heads.'"[16]

After five years in prison and no political experience, Mann struggled. His detractors included seasoned politicians and erstwhile supporters. Rumors spread rapidly about him having "turned" during imprisonment. The obvious difficulties of working a Punjab solution soon soured his relationships with the National Front government, facing its own political challenges in Parliament. Akali Dal Mann's proposed "autonomous Sikh region" in North India—harking back to Nehru's original pre-1947 assurances—was sharply contested in New Delhi, and not only by the Congress.[17]

Then, MP Jagdev Singh Khudian's "disappearance" cast a dark cloud, right when Mann was expected to attend all-Party negotiations. Elected on the Akali Dal (Mann's) ticket in November 1989, Jagdev Singh disappeared from his Khudian village on December 28.

"Khudian was a very sincere man," Jaijee remembers fondly. "We had become friends when we were both elected MLAs in 1985.[18] I got to know Khudian well, up close." He remembers Khudian's sense of duty: "See, twenty-seven or twenty-eight of us former Akalis used to meet in Darbar Sahib and talk about mass killings in the countryside. The age group between fifteen and fifty was facing an onslaught. Once, Khudian brought up Guru Tegh Bahadur's ultimate sacrifice for freedom of religion, even someone else's religion. The Guru had died protesting against Hindu Pandits not being allowed their freedom by Mughals! So now, Khudian said, 'Why not one leader give sacrifice each month?' And then he said, 'Since I made the suggestion, I will be the first one to go on hunger strike.' At this, our leader got very worried!" Jaijee chuckles, "Staying hungry is very hard! Khudian was sincerely ready. But others didn't let the discussion continue."

"Later, in 1989, when Khudian went missing, villagers searched everywhere. People even held hands and walked through the nearby river for six miles, seeing if a body would turn up. Found nothing. But a couple of days later, a rumor was spread: 'There's a body!' His dead body was never medically examined."

"It was rotten, how he died. The judge investigating MP Khudian's death said that the needle of suspicion pointed toward a planned murder. On that basis, there should be an investigation!"

Jagdev Singh's body was recovered on January 3, 1990. Justice H.S. Rai's inquiry report released in May 1990 strongly repudiated the police version and noted "If the police are so indifferent in probing the death of an MP, what about an ordinary citizen?" (Photo 7.2)[19]

With political solutions increasingly unlikely, conflict violence in Punjab continued unabated, raising a dust storm of uncertainty.

"The police force had been entirely criminalized," says Jaijee. He explains how local criminals were recruited by junior officers to execute policies created by higher-ups: often these henchmen were heavily armed, informed, and allowed to wreak vengeance for as long as considered expedient. Working off official books, reinforcing lack of accountability, these operatives came to be feared by villagers as nefarious police cats.[20]

Even the city of Chandigarh, power center of Punjab's elites, was becoming precarious for some of this class.

"I felt sorry for my brother—this was a very dangerous time for him and he was facing it mostly alone," says Baljit Kaur about the threats to the Jaijee household. "Did he tell you about how they warned him? The very serious midnight visit he got once? His house was in Sector Forty-four then. The police came and said, 'We have to search.' He said, 'Okay, look, there is nothing inside.' And then as they were leaving and he walked out behind them, he

Movement Against State Repression

Convener :	Chandigarh :
Justice Ajit Singh Bains (Retd.) Chairman, Punjab Human Rights Organisation 22. Sector 2, Chandigarh Tel. : 28162	Dated...30...4...90

Khudian Murder- Probe Gills role-
MASR.

Justice Ajit Singh Bains, S. Inderjit Singh Jaijee,
Col. Partap Singh, Mrs. Baljit Kaur, Dr. Sukhjit Kaur Gill,
leaders of the Movement against State Repression have
demanded that the recommendations of Justice H.S. Rai
Commission's Report on Khudian murder should be accepted
in toto ie. 'death of Mr. Khudian alongwith the conduct
of the Investigating Agency should be gone into by some
independent body.

Punjab Governor they said has merely recommended
Khudian murder case for CBI investigation. MASR on the
other hand has also demanded a time bound investigation
by a sitting judge of High Court against the Police
investigation agency as well as the role of Mr. K.P.S.
Gill, DGP, Punjab.

According to MASR leaders, Justice Rai has held
Mr. K.P.S. Gill responsible for misdirecting the
investigating agency towards suicide theory; faked
canal search, suggesting 'an attempt at evaporation of
material clues', and direct attempt at interference and
intimidation of post mortem proceedings through
unwarranted procedural changes and his personal presence
during all the stages of the post mortem examination.

Col. Partap Singh Justice A.S. Bains, Inderjit Singh
Co-convener. Convener. Jaijee,
 Co-convener.

Photo 7.2 MASR's statement seeking probe into MP Khudian's death, April 1990. (From I.S. Jaijee personal archives)

saw they had boys with saffron turbans in their jeeps. So it was a warning. That they could have easily said they found militant boys in his house!"

Jaijee had been recently elected President of the Minority and Dalit Front organization. He explains this tenure brought him heightened personal threats.

"The Front was a Naxalite and Akali group. I believed in its mission to create coalitions. In general, the leftists over time had deserted the Akalis. In fact, out of seven communist groups in Punjab then, only two supported the movement. Then they too felt the pressures and deserted."

"Now this Minority and Dalit Front, the government really didn't like."

Jaijee explains that it had been a steadfast government policy to keep distance between Dalits and Sikhs (whose earliest numbers through history had in fact been built through conversions by the no castes and low castes). "This policy was forwarded through force and inducements . . . like how laws around reservations [affirmative action] were strategically made available to Hindu Dalits, but not Dalits of any other faith. This was a way to bring Dalits back into identifying, and politically counting as Hindu, and to prevent their conversion out of the Hindu caste system," Jaijee says in 2017, as anti-conversion laws and related violence continue to sweep India.[21]

The coalition between Sikhs and Dalits in 1989's burning Punjab inconveniently portended a larger rural uprising. "I remember, at a party, the then chief secretary of Punjab came and said to me, 'How many groups do you plan to start, Mr. Jaijee?' And then he said he had urgent advice for me: 'Don't go in for this Front, protect yourself. You are on dangerous ground.'"

"You see, K.P.S. Gill's move was to create the divide between the Jatts and non-Jatts. Fact of the movement is that there was significant non-Jatt contribution to the militancy. They wanted to change the reality. So this coalition building was probably the most dangerous thing I did."

Jaijee would later write in his book:

Analysis of the militant movement indicates that the Dalits lent considerable support to militancy in Punjab. At the initial stages the police tried to downplay this; at a later stage they tried to attribute killing of Dalit militants by police to the militants themselves, perhaps to foster a rift between the two....

Another reason for high Dalit casualties was that petty criminals belonging to the lower economic and social groups (Dalits and small farmers) were safe prey for the police and therefore an easy source of awards. They were not represented in the power structure of the state so little would be said against the police if they went after the Dalits.[22]

After Jaijee's presidency, the Front split into two: the Sekhwan faction (under former President Sekhwan's son) and the Bhatti faction. Buta Singh Bhatti was abducted from his house on September 24, 1991, and by September 28, police had declared he had been killed by militants disguised as police. "Sekhwan's faction went under Badal Akali Dal's control and effectively became toothless," says Jaijee. "The Front was a body they were afraid of and were looking to neutralize. They succeeded."

"Every time, K.P.S. would say, 'Jatt saade naal hai.' How the Jatts are with him, how the Jatt police is winning against the dwindling troublesome Jatt militants. The narrative was about Jatts fixing Jatts. Playing it out to be a story

of Jatt pride and infighting rather than anything bigger. Of course, if you look at the movement, it was mainly Jatts. But also all backgrounds of Sikhs, including Dalits, and some non-Sikhs too. They wanted to break them apart."

The impression that the conflict resulted from a "Jatt Sikh militancy"—a categorization accepted by commentators and scholars since[23]—was strategically created and controlled.

* * *

STRATEGICALLY CREATED AND CONTROLLED, THE NEW PUNJAB accumulated pressure, sans an escape valve. What had been simmering since the Partition of 1947 came to a boil in the 1970s.

Walking home to home, she would first display, then debate, pout a little till the residents smiled, and finally readjust her bundles and walk to the next home. The bhaande-vaali, the "woman of dishes," collected old usable clothes in exchange for new dishes. "O your Naani's pride in getting a new skillet, for a few old shirts!" I have only heard my mother remember her mother's exchanges with the bhaande-vaali. It was much before my time that my Naani's wrinkleless face lit up as she begot goods for old goods, rather than cash—a time when houses across Punjab, and India, were part of an ecosystem of reused and recycled goods, unbroken by capitalism.

India never saw reforms to fulfill the 1950 Constitution's promise of a "socialist" republic. The growing disparities in the struggling country drew many to a more strident leftism. In the Naxalbari village in the eastern state of Bengal, a new leftist movement—channeling disillusionment with the Communist Party's inefficacy—sprouted in 1967. The call to guerrilla warfare spread through the fields and villages, and caught the fancy of cities by way of college campuses.

The turn into the 1970s saw enthusiastic Naxalites in Punjab, particularly the southern area of Malwa. The landless and the lesser landed had found common cause with their Bengali comrades.

> Remember that day
> when your waters caressed
> my shoulders,
> and
> I felt a gun had been placed there.[24]

Poet Lal Singh Dil wrote about the wildfire-like spread of Naxalism through the divided lands he knew best. In Punjab's homes, fields, places of worship, he had experienced the caste discriminations and subhuman categorization of people like him. "The lambardar's brother pushed me out because the women were sitting there without purdah. I was happy because, for the first time, I had been treated like a man," he recalled, to biographer Nirupama Dutt.[25] Lower-caste men were otherwise considered less than men, and thus a lesser threat to

higher-caste women's chastity. Born into a Dalit family, Dil had converted from Hinduism to find caste liberation in Sikhi, in Islam, in communism, and then eschewed them all for being biased in practice.

> How sweet are those words
> Dedicated to God.
> I wish my last words
> Would be:
> "I have complete faith in you!"
> I want to steal this line
> And dedicate it to the Revolution.[26]

Naxalism sought relevance across caste. Another popular poet of the revolution, Avtar Sandhu, was born into a Jatt family in Doaba area. Adopting the name Paash, he wrote rousing poetry, publishing his first book under the title *Loh-Katha* (*Iron Tale*), in 1970. Paash's revolutionary poems would result in almost two years of imprisonment, under what would be proven as false charges. Paash would later move to North America, gain diaspora renown, and publish challenges to Sikh militancy and religiosity.[27]

Communist organizing was hardly new to Punjab and the Bains family was testament. Harmohinder Singh Bains explains how his brother Ajit Singh Bains's judicial career had been far from certain growing up. "In our house in Hoshiarpur, I remember the high chabaarae, and the communist meetings that my father would hold there. They had small typing and copying machines there too. One day, again, the police attacked. And they threw everything helter-skelter. They took my dad, who was sitting there in a vest and undershorts, and barefoot. Didn't let him dress properly even. I vividly remember this, because I literally shook with anger. What was wrong with people? Why weren't they intervening? Our own people, serving the British, had become loyal to the rulers only?"

"But there were exceptions. There was a letter my father had given to Bhaaji [Justice Bains]. And when the police officers tried to take Bhaaji too, for helping smuggle messages, the inspector intervened. He said, 'Let's let the boy go, this is about his father.'"

"And then, many years later, when Bhaaji had become a judge, he ran into this inspector." Justice Bains was elevated to the bench in 1974. "He came up to Bhaaji and said, 'Remember, I saved you then. I thought, maybe you'll do something important, something good one day!' We all remembered. That was the nature of honest officers then—versus now."

This is the longest narration by the otherwise shy Harmohinder Bains, whose wife garrulously fills his pauses and refreshes his recollection.

"We grew up with communist ideals," says Rajvinder Bains. "We children just saw Daddy very absorbed in work. He read a lot, read a lot of newspapers, and a lot of political people came in and out of our house. Read all the Russian literature. That's what used to be in our house. And all talk was about revolution this, and revolution that."

"Daddy's office-sitting life as a communist idealist was not attractive to me, but my grandfather was always headed from one protest to another and my uncle in Canada had founded the Communist Party there. So first I wanted to join the Communist Party full time. Uncle got me admission to an Irish college somewhere. But my grandfather stopped the move and said, 'Why put a young man in violent atmosphere?' He persuaded me to complete my education and then do something. And that turned out to be good, I suppose," smiles the now seasoned attorney of the Punjab and Haryana High Court.

The violent and armed Naxalite rebellion of the 1970s that attracted young people in India threatened a united uprising of the wretched of the earth. The harvests of the Green Revolution in Punjab were yet to turn bitter for the larger landowners, but smaller farmers and landless laborers had become even more displaced by the increased mechanization and expense of the new agrarian experiment.[28] Their despair had found natural synergy with the larger movement across India, demanding increased rights for the poor, redistribution of wealth, general decentralization, and increased autonomy for states.

The movement met swift blows. Naxalites became early target practice for Punjab Police's extralegal methods. Nonviolent students, thinkers, and writers were systematically targeted, making allyship with the rural poor increasingly difficult. Naxalites began to be commonly referred to as criminals, areligious, and antisocial elements.[29]

Economist Pritam Singh, who was taken into police custody from Punjab University, Chandigarh, in 1971 and spent 20 tortured days in jail for his ideological support of the left, notes:

> There is a general lack of trust in the police in India but when the police are involved in cases relating to national security, the national mainstream tends to ignore the malfunctioning of the police setup and tends to entrust the police with substantial if not full sanction to execute their powers. If a person, who is tortured by police or even killed in a fake encounter, is portrayed by the police as anti-national or terrorist, such torture or encounter deaths are normally justified by the mainstream media and intelligentsia as necessary in the interest of either national unity and integrity or law and order.[30]

With a stellar university record, political and police connections, and the financial ability of his family, Pritam Singh was spared. His friend, Harmit Purewal, a mathematics student who joined the Maoist Naxalites in 1970, was tortured to death by the police in 1971. In his book dedicated to Purewal, Singh notes that Punjab's Naxal movement in total claimed 82 lives (60 of these between 1971 and 1972), at least 20 from torture.[31]

For a while, the Naxalites had remained a dire challenge to the authorities. "The authorities then didn't have what they had later: complete impunity," says Jaijee. "Still, the bloody quashing of the movement was soon achieved. Even the larger movement, in Bengal, had simmered down." As Calcutta college students began aspiring for armed rebellion, anti-Naxalite operations

became swifter and deadlier. S.S. Ray, then Bengal's Chief Minister, sanctioned a severe clampdown. Internal fractures to the movement deepened, and in 1972 its popular face, Charu Majumdar, was arrested and killed in jail.

Meanwhile, Punjab's relationship with New Delhi was worsening. After Punjab's 1966 trifurcation, the Congress had faced defeat in the 1967 Punjab election. "At the centre, however, the Congress party was still in power," writes Pritam Singh. "It had not adjusted to the idea that it could lose power anywhere. It soon started various manoeuvres against the non-Congress governments in several states."[32]

Their tactics enabled the fall of the Akali government in 1967 and the imposition of President's Rule in 1968. Yet, the Akali-led coalition won the 1969 election. The Akalis continued to be seen by Punjabis as fighting for Punjab's rights against a nonreceptive and even deceptive Delhi. Sikh demands, since 1947, had been met with apathy or derision. Internally, the Akali Party suffered further challenges, accelerated by the death of Fateh Singh in 1970, and reported infiltrations by Congressites and communists.[33]

The Akalis had formed political coalitions with the more Hindu right-wing supported Jana Sangh (today's BJP). Any alienation of the majority Hindu community would hurt this alliance. Thus, when in 1971, J.S. Chauhan (a U.K. resident, and former Punjabi politician) began propagating "Khalistan"— through tours across North America, which were reported actively by the Indian media—it was believed by many to have been orchestrated by the Congress. "His idea of Khalistan was treated as a hoax but it could embarrass the Akalis and tickle their opponents in politics," writes historian J.S. Grewal.[34] Chauhan's statements about Pakistan's support of Sikhs worsened the image of Sikhs in India.

Further unrest brewed after Congress government's May 1971 reported takeover of the historically significant Sis Ganj gurdwara in New Delhi. Thousands of Akali protestors were arrested in the following months. President's Rule was imposed again by the Center on June 15, 1971, and the Akalis were prevented from forming a government in Punjab.

In December 1971, India and Pakistan were at war again. Again, the Akalis suspended their agitation against New Delhi. India's victory resulted in the formation of Bangladesh (from what the British had left as East Pakistan). And it gave a new boost to Indira Gandhi's national image and popularity.[35] She called for Punjab assembly elections immediately after, in March 1972. Support for her victory came from the Communists as well as the Punjabi Hindus "determined not to let Akalis come into power themselves or in alignment with other political parties."[36]

With the Congress win in 1972, Zail Singh was ushered in as the Chief Minister of Punjab. Known by his Sikh seminary degree title, Giani, Zail Singh was a new face and strategy of the Congress in Punjab, and would become a formidable challenge to the Akalis.[37] Indira Gandhi's government continued to promote the perception of the Akalis as a parochial religious party, given to infighting and protestations against the Center.

By 1973, the Akalis had prepared a document collating demands to decrease centralization and increase autonomy for all states. This Anandpur Sahib Resolution (ASR) would be the nucleus of Sikh demands and protests for years to come.

The ASR highlighted the disparities created by central control over decisions essential to peoples' lives—in Punjab, for example: language, water for farming, prices of crops—and demanded fulfillment of the Constitution's promise of a confederation of states. Drafted by Kapur Singh, the resolution was adopted on October 16, 1973, at the historic Anandpur Sahib—site of the birth of the Khalsa, where Guru Gobind Singh bequeathed Sikhs' unique identity. Written with Kapur Singh's flourish of Sikh idiom, it reflected hopes for Sikh self-governance within India.

Notes political scientist Gurharpal Singh,

> The ASR calls for restricting the union government's powers to defence, foreign affairs, currency and communications. A political framework based on these lines, the resolution states, would provide the appropriate environment 'where the voice of the Khalsa Sikhs will be pre-eminent.' The ASR also demands the integration of excluded Punjabi-speaking areas into Punjab, economic reform in favor of the agrarian sector, and central assistance in the construction of power generation projects.[38]

While agriculture was already faltering after the Green Revolution experiment, Punjab was now closer to losing its second most popular avenue of employment since British times: the Indian Army. A quota was proposed (finalized in 1974) limiting the number of Sikhs in the army, proportional to the Sikh population of the country (about 2 percent).[39]

The 1973 ASR would gain prominence later when it was endorsed at the 1978 All India Akali Conference.

"The furor it attracted was entirely unwarranted," says Jaijee. "The Resolution was not something outlandish. The federal structure demanded had been promised in India's own Constitution."

Jaijee continues to openly write and advocate for more federalism in India today. But when the stirrings were beginning in Punjab, he was still very far from this politics. The happy bachelor had married in 1971. "I had thought I was not the marrying sort." Then he met Daljit Kaur, a serving Indian Administrative Services officer. "I married at the age of forty-one. Once we were engaged, I got transferred to Lucknow. My older daughter Aman was later born there. And then, they posted me to Delhi. Harman was born in Delhi."

Baljit Kaur's problematic years were also coming to a close. "Jagjit bought this house when he sold the Ludhiana house. We began to renovate." In 1975, she moved to Chandigarh for good.

* * *

FOR GOOD MEASURE, I HAD BEGUN TO SPEED READ the May 2012 news article: "Court Acquits Moga SSP, 6 Other Cops."[40] Stories of police acquittals for the

crimes of the 1980s and 1990s feel as predictable as the Bollywood movies we grew up watching. I scanned the piece. Then I realized this was the "Kid case" I had heard about from Baljit Kaur. It had been first filed by Principal Tarlochan Singh Sidhu in 1989.[41]

After Kaur and her comrades surrounded the police station, they had received word that Kid's body was in Ropar, a city in southeastern Punjab.

The Ropar hospital was skittish when the human rights team arrived in July 1989. Doctors said they must obtain orders from higher-ups before showing the body to the family. So Jaijee and Bains went to meet the concerned officer.

"The Deputy Commissioner pretended he was busy working. Justice Bains and I sat at the back," Jaijee remembers. "He had us waiting for an hour and half or two hours. Then he said, 'Okay, I give you permission to go to the hospital to see the body.' When we went to the hospital we were told the body has already been taken away. The bloody chaps were buying time, they were all working in tandem! The DC was very much in on it. He had waited to get the message that further pursuit had been made impossible; they could now wave us along."

The body had been cremated as "unclaimed" a little earlier. Tarlochan Singh's petition asking for a High Court order to prevent such a cremation had gone unadmitted and unheard.

"Then a police post was said to have his son's ashes," says Baljit Kaur. "They told the Principal, 'Here are two urns; pick out whichever is your son.' What does one do? You pick one up, put it in the water, and consider last rites completed?" Sikhs cremate their dead and release the ashes in flowing water.

Kulwinder Singh, lovingly called "Kid" was born on September 18, 1969, in Chajju Majra, in Kharar. For secondary school, he was brought to DAV School in Sector 8, Chandigarh, where his father had hoped for a superior education compared to Punjab's interior schools. In the wake of 1984, Kid had been exposed to the ideology of the ascendant All India Sikh Student Federation (AISSF). In September 1986, while still a school student, Kid was arrested for being a militant sympathizer. He spent the final years of his teens in a maximum-security prison. In October 1988, he was released on bail. He lived in constant fear of the police. His father later explained to the CBI Court that "when bailed out, [Kid] remained at a secret place away from police to avoid harassment." Kid married Ravinder Kaur and largely stayed away from his extended family. The family nevertheless faced police harassment. Principal Tarlochan Singh met with SSP Ropar to complain against police harassment of Kid and his family.[42] The SSP had apparently assured Tarlochan Singh that there would be no trouble, since Kid was not wanted in any pending criminal case. On February 22, 1989, when Kid was being hounded by local police again, Tarlochan Singh produced him before the SSP Ropar.[43]

Parents walking their children into police stations was becoming more common. The ardent hope was that themselves taking the person of interest to the police would preempt the narrative of an "absconding" militant suspect, and prevent police capture, extortion, and potential murder of their child. Families often found themselves begging the police to "show the arrest"—to appear in

official police files, with whatever charges. Police acknowledgment that some-one had been taken somewhat lessened the danger of the person being quietly murdered by "encounter," unnamed pyre, or canal.

After the February 1989 meeting and related interrogation, the fearful Kid fled again.

Tarlochan Singh next heard about his son when the phone rang on July 22, 1989. A house in Phase V of Mohali had been cordoned off with heavy police deployment since the morning; Tarlochan Singh better come there quickly. By 3:00 p.m., accompanied by locals and colleagues, he arrived in the residential area, which was abuzz.

When two young boys walked into the courtyard of House No. 1752, plain-clothes men rushed from inside the house. One of the boys, Kid, was blind-folded and his hand and feet bound. A black blanket was thrown on his head as he was seen being pushed into a jeep. The other boy had gotten further. Witnesses saw a group of 20–25 armed policemen chase the fleeing boy. He jumped a wall. Shots were heard, and he was seen falling into empty plot No. 1765.

Tarlochan Singh rushed to Mohali police station to register a report, but was denied entry. He then left for Chandigarh and met with a Member of the Legislative Assembly. He sent urgent telegrams to the Governor and the head of police. He contacted local media. By July 24, he had heard from a human rights attorney regarding additional "encounters" in the area.[44] He sent urgent telegrams to the High Court.

Then, after the hasty cremations despite the appeals, protests, and best efforts of the Jaijee, Bains, and Kaur team, Tarlochan Singh filed an application for photographs and the return of the personal effects of the deceased, indistin-guishable by their ashes. In response to Tarlochan Singh's petition, the police filed an affidavit describing how "on 22 July police had raided the house of Kulwinder Singh, that the 'terrorists' Kulwinder Singh and Palwinder Singh had opened fire on them, that police had returned fire, killing Palwinder Singh, and that Kulwinder Singh had 'managed to escape.'"[45]

With the benefit of education and a fortuitous personal connection to Jaijee's and Kaur's family, Principal Tarlochan Singh was in a position of rela-tive power compared to many parents in the Punjab of 1989. He had approached the courts almost immediately, even if unsuccessfully. He continued his cam-paign after receiving the unconfirmed ashes and appealed all sitting heads in Delhi and Chandigarh to institute an inquiry. With no response, he eventually filed a Writ Petition on September 22, 1989, in the Punjab and Haryana High Court. In June 1990, the High Court directed Chief Judicial Magistrate Ropar to hold an enquiry.

Tarlochan Singh continued championing his son's cause. A police case was filed against Tarlochan Singh, alleging he was knowingly pursuing a false mur-der case against the police in order to receive monetary compensation, even as his militant son was in hiding. Tarlochan Singh reported to human rights advo-cates: "I used to receive threatening phone calls. The caller would say that they

had killed thousands of boys and thrown them into canals, and they would also do that to Kulwinder Singh's wife, [son], or me and my wife. I would tell the callers that they knew where I lived and they could come and get me."[46]

The accused policemen had continued in their employment, and enjoyed promotions.

At one point, Tarlochan Singh was detained in the same secret center as Ms. Kulbir Kaur Dhami and her young son. Besides withstanding all pressure, Kulbir remembers he also became one of the unsung smugglers of her explosive letters from prison. "Principal Saab was really solid on the inside," Kulbir taps a finger on her heart. "His spirit remained undefeated."

Baljit Kaur and Inderjit Jaijee remember the lanky Principal attending various rallies and protests for other cases of excesses, always composed, grounded, and tireless. "Though Kid was not as noble a soul as some of those boys were. He was like a spoilt, rowdy child," Jaijee recalls. Baljit Kaur remembers little of what was said about the boy's past, but remembers the Principal explaining what he had hoped for the future.

It took six years for an enquiry report to confirm that a police party, in plain-clothes, had raided the house in Mohali and gunned down Pulwinder Singh, alias Pola, and taken away Kulwinder Singh, alias Kid.[47] On July 5, 1996, the High Court ordered a criminal case be registered against the defendant police officers[48] and a CBI inquiry was launched.

The CBI's investigation took another three years. After interviewing a variety of eyewitnesses, it concluded that the police party had laid in wait for the two men in 1989, killed one on the spot, and the other, Kid, a day later.

The trial crawled ahead. The same defenses flew in, about Kid absconding and not having been abducted, about his father viciously pursuing a false case. A bulk of the defense's energy was spent pointing out minor inconsistencies in Principal Tarlochan Singh's petitions (starting with his July 1989 telegram in immediate shock of the abduction), as well as in his oral testimony to the CBI (e.g., whether he had indeed described his son was wearing pants of "Coca-Cola" color).[49]

While some eyewitnesses from 1989 testified over two decades later, others withdrew. Kid's landlady—who had directly dealt with the police who came to her house and sat in waiting for the boys—recanted her original testimony and had to be declared a hostile witness by the prosecution.

On May 10, 2012, the CBI trial court announced its order: all officers were acquitted.

In the news article I had at first only scanned, victorious defense counsel Rajan Malhotra told journalists Kid's body had never been found and he was "still a proclaimed offender of the Ropar court. ... There was no material evidence in the case to prove the murder charge."[50]

On July 30, 2012, now a 73-year-old Tarlochan Singh again approached the Court: he filed an appeal against the acquittal.[51] Four months later, in September 2012, Kid was still ostensibly "absconding," when Jaijee, Kaur, and Bains attended Principal Tarlochan Singh's own funeral. He had died of cardiac arrest.

"The old man had determination. Kid's wife ... she was just a child herself," says Jaijee. "And Kid's son was born after the father died anyway. What can this generation do?" Jaijee retains a characteristic lack of moral judgment about survivors he has worked with, and all the accelerated familial breakdowns he has witnessed since 1984.[52] With Kid's death, Tarlochan Singh lost connection with Kid's wife—who parted ways with her in-laws—and son Mandeep Singh. Through an anguished will and power of attorney, Tarlochan Singh left a nephew the inheritance: a small home as well as the pursuit of the Kid case.[53]

Kid's wife had in fact been Tarlochan Singh's original personal connection to the human rights group. "Principal's daughter-in-law was from Patiala," explains Jaijee. "She was the daughter of one of my father's ... well, Pitaji had taken this boy under his wing. She was his daughter. That is how we knew Tarlochan Singh." Ram Singh, the son of one of H.S. Jaijee's loyal workers, grew up in the Jaijee household through the family's exile. Ram Singh was later given a house by the Jaijees. His daughter today continues to live in this house. My visiting her to talk about Kid, her husband of all of one year, was determined to be unwise.

Asked if Kid was indeed active with a militant outfit when he was married and then abducted in 1989, Baljit Kaur pauses thoughtfully and states, "He wasn't. I don't think so. His father was politically outspoken, and that was all."

"I am quite sure he was," remembers Jaijee, when asked the same.

"The point is that the law prohibits eliminating people after kidnapping and hiding and torturing them," says Justice Bains, who at 93 does not remember the case details as much as surrounding the station with his fearless comrades.

NOTES

1. Human Rights Watch and Ensaaf, "Protecting the Killers: a Policy of Impunity in Punjab, India," Volume 19, No. 14(C), October 2007.
2. See, Sangat Singh, *The Sikhs in History*, 2nd ed. (New Delhi: Uncommon Books, 1996), 478 "It was extraordinary, firstly, that the conspiracy trial by Additional Sessions Judge and enquiry into Indira's assassination by Justice M.P. Thakkar, a sitting judge of the Supreme Court, went hand in hand. And then, Thakkar's two reports throwing valuable light were suppressed. These were not shown even to the President, Giani Zail Singh, much less to the Judges of either the High or the Supreme Court."
3. Inderjit Singh Jaijee, *Politics of Genocide: Punjab, 1984–1998* (Delhi: Ajanta Publications, 2002), 334.
4. Robin Jeffrey, "Punjab: Federalism, Elections, Suppression" in *Diminishing Conflicts in Asia and the Pacific*, Edward Aspinall et al., eds. (London and New York: Routledge, 2012), 92–93. "Pakistan support for the Khalisan movement had been equivocal from the start. Sikhs and Muslims have angry antagonistic memories of the killings at the time of Partition. And for Pakistan, the outstanding issue with India remains the status of Kashmir. Thus when the Soviet Union withdrew from Afghanistan in 1989, arms and zealous Muslim fighters, no longer needed for the war in Afghanistan, could be deployed in Kashmir."

5. Sangat Singh, *The Sikhs in History*, 516. President Muhammad Zia-ul-Haq had died in a mysterious plane crash in 1988.

6. On other mass resignations by panchayats in districts across Punjab, see Jaijee, *Politics of Genocide*, 230–31.

7. Narratives from Baljit Kaur video archives.

8. See, Jaijee, *Politics of Genocide*, 176.

9. See, for example, "Sikh Separatists Kill 19 Students at India College," *The Los Angeles Times*, November 11, 1989.

10. "His only son, who was a student of DAV College, Jalandhar was killed and he himself was also killed in his office by bomb blast. It was the Governor Ray who was responsible for the murder of his only son and Gobind Ram. Had the Governor Ray taken action on our report and arrested Gobind Ram on a charge of murder, both he and his son could have been saved." Ajit Singh Bains personal archives.

11. Another Sikh candidate, Atinder Pal Singh, running as an Independent from Patiala constituency, also won while still lodged in Tihar Jail, New Delhi. His campaign was run by his wife Kamaljit Kaur, then a new mother to their older daughter. Singh would be escorted to Parliament from prison for just long enough to take his oath, and was released only the next year.

12. See, for example, Mark Juergensmeyer, *Terror in the Mind of God* (Berkeley: University of California Press, 2000), 86–92.

13. Pavit Kaur, *Stolen Years: A Memoir of Simranjit Singh Mann's Imprisonment* (Gurgaon: Random House, 2014), 169.

14. Khushwant Singh, *Captain Amarinder Singh: The People's Maharaja* (New Delhi: Hay House, 2017), 188.

15. Kanwar Sandhu, "S.S. Ray: Acrimonious Departure," *India Today*, December 31, 1989. "What legacy does Ray leave behind? Ray himself is immodest: 'What I achieved in three years, people will find difficult to do in three times that time.' Few would agree. His policies alienated vast sections of the Sikhs. His reign saw the eclipse of the civil authority with serious complaints about police excesses."

16. Barbara Crossette, "Amritsar Journal; Sikh Bears a Sword, Prison Scars and a Grudge," *The New York Times*, May 31, 1990.

17. Sangat Singh, *The Sikhs in History*, 486.

18. See, Chap. 9.

19. Kanwar Sandhu, "Jagdev Singh Khudian killed, proves probe," *India Today*, May 15, 1990.

20. See, for example, Jaijee, *Politics of Genocide*, 135, for a description of one of these underground police squads, complete with AK47 guns.

21. See, for example, The Law Library of Congress, "State Anti-conversion Laws in India," updated, October 18, 2018, https://www.loc.gov/law/help/anti-conversion-laws/india-anti-conversion-laws.pdf.

22. Jaijee, *Politics of Genocide*, 154.

23. See, for example, Virginia Van Dyke, "The Khalistan Movement in Punjab-India and the Post-Militancy Era: Structural Change and New Political Compulsions," in *Ethnic Subnationalist Insurgencies in South Asia*, Jugdep Chima, ed. (Oxon and New York, Routledge, 2015), 73.

24. Nirupama Dutt, *Poet of the Revolution: The Memoirs and Poems of Lal Singh Dil* (New Delhi: Penguin, 2012), 53. Lal Singh Dil is a nom de plume.

25. Dutt, *Poet of the Revolution*, 108.

26. Dutt, *Poet of the Revolution*, 105.

27. See, for example, Tejwant Singh Gill, "Pash: Man and Poet," *Manushi*, available at: http://www.manushi.in/docs/613-pash-man-and-poet.pdf.
28. Vandana Shiva, *Violence of the Green Revolution* (London: Zed Books, 1991).
29. See Pritam Singh, *Federalism, Nationalism and Development* (Abingdon, UK: Routledge, 2008), 193.
30. Pritam Singh, *Federalism, Nationalism and Development*, 22.
31. Pritam Singh, 180.
32. Pritam Singh, 103.
33. Indira Gandhi's Congress was at the time working in consort with the Communist Party. See Sangat Singh, *The Sikhs in History*, 350.
34. See, J.S. Grewal, "Sikh Identity, the Akalis and Khalistan," in *Punjab in Prosperity & Violence: Administration, Politics and Social Change 1947–1997*, J. S. Grewal and Indu Banga, eds. (New Delhi: K.K. Publishers, 1998), 71.
35. Sangat Singh, *The Sikhs in History*, 353. "Indira's prestige reached new heights following India's victory over Pakistan leading to the creation of sovereign, independent, Bangladesh, and with over 93,000 Pakistani Prisoners-of-War."
36. Sangat Singh, 354.
37. See, Khushwant Singh, *History of the Sikhs, Volume II; 1839–2004* (New Delhi: Oxford University Press, 1999), 313–14.
38. Gurharpal Singh, *Ethnic Conflict in India: A Case-Study of Punjab* (New York: St. Martin's Press, 2000), 96. The importance of the ASR grew with growing Akali agitation.
39. Stephen Cohen, "The Military and Indian Democracy," in Atul Kohli, ed., *India's Democracy: An Analysis of Changing State-Society Relations* (New Jersey: Princeton University Press, 1988), 133.
40. Aneesha Sareen, "Court Acquits Moga SSP, 6 Other Cops," *The Tribune*, May 11, 2012.
41. Criminal writ petition No. 3342/89, Punjab and Haryana High Court.
42. Amnesty International, International Secretariat, "India: Human Rights Violations in the Punjab: Use and Abuse of the Law," May 9, 1991, 28.
43. Statement of PW-5, Tarlochan Singh Sidhu, cited in Judgment, *CBI v. S.S. Grewal & others*, CBI Court, Chandigarh, May 10, 2012.
44. See, Human Rights Watch and Ensaaf, "Protecting the Killers."
45. Amnesty International, 1991, 29.
46. Human Rights Watch and Ensaaf, "Protecting the Killers."
47. See Judgment, *CBI v. S.S. Grewal & others*, CBI Court, Chandigarh, May 10, 2012, 3.
48. FIR was registered in August 1996, per High Court judgment in CWP No. 3342 of 1989.
49. Judgment, CBI Court, 2012, 74.
50. Aneesha Sareen, *The Tribune*, 2012.
51. Application for special leave to file appeal, *Tarlochan Singh Sidhu v. Central Bureau of Investigation & others*, Crm-A-649-MA of 2012, Punjab and Haryana High Court, July 30, 2013.
52. Indeed, across the world, "wars have their endings inside families." Cynthia Enloe, *The Curious Feminist: Searching for Women in a New Age of Empire* (Berkeley and Los Angeles: University of California Press, 2004), 204.
53. Annexure 2 to Application dated 22 November 2012, in *Tarlochan Singh Sidhu v. Central Bureau of Investigation & others*, Crm-A-649-MA of 2012, Punjab and Haryana High Court.

CHAPTER 8

Guavas and Gaslighting

Abstract This chapter highlights how, despite their necessary focus on the immediate visible actors and perpetrators (largely Punjabi and Sikh), the protagonists kept an eye on the bigger context: the politics of communalization, command responsibility, and invisible puppeteers.

The chapter recounts the unique roles played by Sikhs and Punjab during the 1975–1977 Emergency—the suspension of democracy by Prime Minister Indira Gandhi. After her furious return to power, Punjab was at a boil. In the notorious Nirankari-Sikh clash in 1978, the police were ordered to side with a sect leader who had provoked the sentiments of religious Sikhs; the killings of unarmed Sikhs then provoked even areligious Sikhs. As the decade turned, Center-state relationships soured further, Sikh diaspora activism grew, and civil and noncivil disobedience intensified. Thus began the reporting of rising orthodoxy in a media hullaballoo that was peaking when the chapter closes in 1981.

The chapter then travels outside Punjab. The reader listens to Kuldip Kaur relay why she encouraged her only son to move from their South Delhi home to South India. But the Sikh engineering school that became his home for three years was soon swept by violence in 1988. Meanwhile, back in Punjab, counterinsurgency special laws and extrajudicial killings had become ubiquitous. But "What is wrong with these Sikhs?" became a louder refrain in many circles, as the media selectively reported blasts and bullets that killed innocents.

* * *

© Mallika Kaur 2019
M. Kaur, *Faith, Gender, and Activism in the Punjab Conflict*,
https://doi.org/10.1007/978-3-030-24674-7_8

> *Those are the same stars, and that is the same moon,*
> *that look down upon your brothers and sisters,*
> *and which they see as they look up to them,*
> *though they are ever so far away from us,*
> *and each other.*
> :SOJOURNER TRUTH:

"BUT I WAS NEVER SO INTERESTED IN THE MOUNTAINS, AS IN the people and how they lived," says Inderjit Singh Jaijee, recalling his world-record-setting trip across the Himalayas in 1976. "I had been trekking around in the Himalayas before, Leh, Ladakh, Spiti, central Himalayas. And then I began thinking. ... Why not do it all in one trip?"

So at age 45, Jaijee decided it was time to traverse the ranges from west to east. "I had first begun exploring the little-known tribal belts in the northeast on Dunlop dime, during business trips. I remember that area before the Chinese-Indian Border War in 1962. It has been militarized and changed ever since."

The far northeastern states are connected to the Indian mainland by the tenuous Siliguri corridor: the "chicken neck" pass is at points merely 20 kilometers wide. The incorporation of the region—bounded by Burma, China, Bhutan, and Bangladesh—into India in 1947 was unceremonious and remains unresolved. These old areas, and relatively newborn states, are home to multifarious cultures and traditions, practicing a range of spiritual beliefs. Phenotypically more East Asian than South Asian—the easternmost state, Arunachal Pradesh, has been claimed as South Tibet by the Chinese—peoples from the northeast face discrimination in mainland India, and a dearth of government resources at home. After British decolonization, the fraught relationship had soon exploded into intractable armed conflict. Jaijee explored these valleys and mountains at a relatively quieter time (though the Naga Hills were first declared "disturbed" and subjected to special law in 1958).

"One of my interesting experiences there was with a DC I knew, whose Punjabi wife was appalled by all the nakedness in this belt. They were invited as chief guests for some annual function and she decided to take saaris. The first woman she awarded a saari to looked confused. The woman didn't know what to do with it. So she began tying it on her head, round and round, all that cloth!" Jaijee laughs. "That was the last modesty gift that officer's wife gave, hopefully. You can't go in and change people like this. Nor should you."

North Indian saaris would come to symbolize religio-cultural hegemony for many groups, including post-1984 Sikhs.

Through the 1960s and 1970s, Jaijee remained deeply intrigued by the differences of those counted as citizens for disputed borders and censuses, but who were seldom represented in mainstream Indian media, movies, books, and policies.

"I went to the Indian Mountaineering Foundation to ask them to support my trip. The chairman reviewed my plans of starting from the Karakorams in the west and going up to Burma. He said he was impressed with the scope of

the plan, but said, 'Sorry, ours is a mountaineering club, we support those climbing peaks like Everest, Kangchenjunga, Nanda Devi.' So I said, In that case, there should be two clubs, one called the Peak-climbing Club and the other the Mountaineering Club. I told him that with peaks, you go via helicopter, close in on the peak, and then, with the help of a sherpa, you climb. And so let there be a club for that. But let's also start another club. He started laughing and said, 'Okay, I'll sponsor your trip.'"

On September 13, 1976, Jaijee began his 49-day expedition from Jammu, timing it right after the monsoon rains. "I kept progressing towards the retreating monsoons. Only once did I get completely stuck for about half a day." He barely mentions that this entire trip was on a newly donated motorcycle he had learnt to ride after it was delivered for the trip. He first paid a mechanic from Patiala to ride pillion with him; within days, the man developed altitude sickness and a deep annoyance at being recruited on this adventure, and took a bus home. Jaijee and his bare minimum rations continued eastward.[1]

"You know, when you travel, you learn. Otherwise, if you live within one group, you don't see it, because you are lost in yourselves."

His adventures captured the diversity of the Indian tapestry, as he visited temples and monasteries, enjoyed local hospitality, and attracted curiosity. These experiences would later in life inform his argument about the crux of communalized politics in India: with so much uncommonality, creating an "enemy within" is the most expedient way to forge nationalism.

When he was finally able to call home, he spoke with his wife. "Daljit said the trip had made it to newspapers, now I best complete it in one piece!" Jaijee often commends his wife's buoyant spirit. (Photo 8.1)

By the end, he had covered over 5300 miles during his solo expedition from Ladakh to eastern Arunachal Pradesh, creating a world record. "I had my own goal of doing this in one go. And I didn't realize that I was the first one to do it!"

But the ecstasy of setting new records was hardly new for Jaijee, a celebrated school and college athlete. So, unsurprisingly, he soon yearned for a new challenge. This time his eyes were on the Andes. "I decided to travel the length of South America. I began learning Spanish. And I was in touch with UNESCO to help offset costs."

Jaijee flew to Buenos Aires in 1979. "I was supposed to pick up a motorcycle there. But I had gone wrong in my budgeting. It was going to be very expensive. The government of India had granted letters to all the embassies on the way, that they should take care of me, I was on an expedition. But I gave up the motorcycle after a while in Argentina and used whatever conveyance I could. Again, my interest was not covering distances, but meeting the mountain people." He made his way up to the Sierra Nevada ranges in North America. "Eventually, I went back home to my wife and girls, wanderlust quite satisfied for a while! And then, other priorities took over."

The extended Jaijee family was already embroiled in extreme misadventures underway in India since 1975. "I got involved at the time of Emergency. My elder sister was most involved, and we were very close," explains Baljit Kaur.

Photo 8.1 Inderjit Singh and Daljit Kaur Jaijee. (From I.S. Jaijee personal archives)

On the night of June 25–26, 1975, Prime Minister Indira Gandhi declared a state of national "Emergency."[2] On June 24, 1975, the Supreme Court of India had upheld a verdict of the Allahabad High Court that confirmed election fraud charges against Indira Gandhi and disqualified her for six years. The Supreme Court had granted a conditional stay to allow Gandhi to continue her term as Prime Minister. Still, the conviction posed serious obstacles for her future career. Gandhi declared a state of Emergency, suspending democracy across the country and imposing President's Rule: direct central rule over all states.

Opposition leaders who were able to flee, scurried underground, while the press was immediately curtailed—major media houses lost electricity the very night Emergency was declared—and were only allowed to print government verbiage. The main opposition figure, Jayaprakash Narayan, was arrested just as Emergency was declared. From Bihar, popular as "J.P.," he had been a respected leader since colonial times, who had steadfastly rejected political parties or office, and especially attracted youth activists. Indira's image (gained by the 1971 Bangladesh War) was threatened by the antiestablishment movements that exposed her government's corruption. J.P. was transferred far away from his home, to Chandigarh (where two decades later, Justice Bains would be offered the "J.P. Jail Cell"). His maltreatment during detention resulted in kidney failure, and J.P. was released in November 1975.

Indira Gandhi maintained there were conspiratorial threats to the nation's internal security that necessitated the Emergency. Then, she introduced a series of constitutional amendments to prevent her unseating as well as to immunize herself from judicial review. "With the sweep of her hand, Mrs. Gandhi had snuffed out democracy,"[3] writes Granville Austin.

On November 7, 1975, as Emergency peaked, the Supreme Court of India overturned Indira Gandhi's conviction.[4] The Indian judiciary, hailed internationally mere months before, became farcical. *The New York Times* reported:

> In August, Parliament, which is dominated by her Congress Party, retroactively amended the election law in such a way as to clear her.
> In language specifically tailored to the circumstances of her case, the amendment provided, in effect, that the things the Prime Minister was found to have done during the election campaign of 1971 were no longer illegal.[5]

Working for the spurned judiciary felt severely dispiriting. "During Emergency, Daddy had gone abroad," remembers Rajvinder about Justice Ajit Singh Bains's hiatus in the late 1970s. "Begrudgingly traveled there, as always. Five of his six siblings were in North America then, but Daddy never liked the idea of 'abroad.' He had been the oldest son, and my grandmother had always been very pained about sending her children far. You know, in those days, it just meant losing your children."

"Now, Daddy had gone to see his siblings, and to get away from the pressures at home. And my Uncle Hardial, he had an acute sense of politics. He said, 'You resign in protest to Emergency. You will become a hero, and this can't last.' Ultimately he turned out to be right of course. And Mummy supported it too. She said, 'Resign and you can lead the campaign for civil liberties in India.' But Daddy was looking out for the children too. We were here in India. He didn't stay in Canada. He was not as moved to action yet."

Alienation grew in citizens. Younger people with education and means joined the "brain drain" to Western countries, as repressive measures swept India. Student unions were quashed, journalists were hounded, and political opponents who were not yet jailed remained on the run. Sycophants prospered: "Indira is India, and India is Indira," declared the president of the Indian National Congress.[6]

Indira Gandhi's younger son, Sanjay Gandhi, led the charge of overseeing several nefarious campaigns.[7] Forced sterilization took place across northern India—disproportionately targeting the poor for "family planning"—and slums were destroyed in significant areas like old Delhi.

Rohinton Mistry's novel *A Fine Balance*, set in the Emergency era, reflects the perceived pernicious corruption:

> You see, government employees have to produce two or three cases for sterilization. If they don't fill their quota, their salary is held back for that month by the government. So the Thakur invites all the schoolteachers, block development officers, tax collectors, food inspectors to the clinic. Anyone who wants to can bid on the villagers. Whoever offers the most gets the cases registered in his quota.[8]

Baljit Kaur remembers, "My elder sister [Maharani of Patiala] had taken a stance to protest against Indira and her office was in Jantar Mantar, New Delhi. They used to print anti-Emergency literature—for students, universities, and all. And I often carried it to Punjab for them. Those days, one's baggage was regularly opened and checked while traveling. But fortunately I didn't get caught ever."

Punjab was at the center of anti-Emergency activism. Akali agitation had taken the form of "Save Democracy" marches, launched from Darbar Sahib just about a fortnight after Gandhi's declaration of Emergency. Punjab also continued to serve as a haven for anti-Emergency protesters. Several dissidents from other states, and Gandhi's political opponents, were housed in the Darbar Sahib Complex; up until 1984, the complex was well accepted as a hub for social justice organizing and politicking against persecution.[9]

Punjab's leadership—with arrests of over 40,000 Akalis[10]—did not go unnoticed, and Sikhs earned Indira Gandhi's ire. Many cite the Emergency as the catalyst for the devastation of the 1980s. "Indira got into her head that it [was] only the Sikhs who constituted a threat to her imperious and dynastic rule, and decided to inflict blows from which they would take long, if at all, to recover."[11]

By January 1977, the negative world press, the overturned conviction, the renewed passion among her hardline supporters, all together signaled to Indira Gandhi that it was time for a new approach and was propitious to call for national elections. The Congress Party was defeated by an opposition alliance, officially ending the Emergency on March 23, 1977.

Akali-Janata candidates unsurprisingly won in Punjab. "The apparent Hindu-Sikh modus vivendi, to Indira seemed failure of Congress strategy of creating controlled distrust between the two communities."[12]

Morarji Desai became Prime Minister and led the Janata government's amalgamation of opposition factions. The right-wing Hindu organizations, Rashtriya Swayamsevak Sangh, the Akhil Bharatiya Vidyarthi Parishad, and their official political party, Jana Sangh (soon to be rechristened as today's Bharatiya Janata Party, BJP), had ironically been legitimized and elevated in mainstream politics.[13] By J.P.'s death in 1979, the Janata Party's brief hoorah was already over. Indira Gandhi had regained strength and returned to her power-consolidation agenda through the office that she had only temporarily left.

* * *

SHE HAD ONLY TEMPORARILY LEFT HER HEART IN BIDAR, KARNATAKA. Kuldip Kaur had encouraged her youngest child and only son, Ginnu, to move to South India, far from their comfortable South Delhi home. As he had graduated from the elite Modern School, Delhi, Kuldip Kaur wanted to spare her shy, young turbaned boy the violence against Sikhs in North India. A Sikh engineering school in Bidar, Karnataka, sounded like the perfect reprieve while things settled at home.

"They had managed to eject Sikhs from the mainstream. Sikh men were seen with suspicion everywhere around us, after 1984." During the November

1984 pogroms, Kuldip Kaur's family had eventually been forced to take refuge in a Hindu neighbors' home.

"To get reelected, they had unleashed violence on Sikhs. And we began feeling unsafe right at home. My son, he had obtained admission in colleges in Delhi. But we travelled to Bidar Sahib. We paid respects at Nanak Jheera."

There is believed to be something special in the soil of Bidar. Masons taste test it before using it to create the black oxidized metal handicrafts, with intricate inlay work, that have brought Bidar repute since the fourteenth century. Bidar was the first independent Muslim kingdom in medieval South India. In the early 1500s, during his travels southward toward Ceylon, Guru Nanak stopped there. The jheera, spring near the gurdwara in Bidar, remained sweet-tasting and brought fame and followers to the Nanak Jheera. Then, three centuries later, in 1699, when Guru Gobind gathered Sikhs and initiated the order of the Khalsa through five beloved ones, one of them, Sahib Singh, was from Bidar. Six miles from Bidar's jheera, the legendary Sikh woman warrior-leader, Mai Bhago, is believed to have visited to spread the Sikh ethos, as instructed by Guru Gobind himself.

"During our visit," says Kuldip Kaur, "we decided we will enroll our son in the Sikh-run engineering college there. I told myself that he'll be safe in Guru ki nagri," Guru's own townlette.

So Gurinder Singh, Ginnu, moved to Guru Nanak Dev Engineering College, Bidar. In September 1988, just short of 22, he was in his fourth year, when things changed forever.

"Shiv Sena[14] had caused disturbances there even in 1987." Kuldip Kaur recounts the buildup as she understands it in retrospect. "Joga Singh was the owner and he had expanded to build a medical college, pharmaceutical college, nursing college, besides the engineering college. The Shiv Sena felt Sikhs were gaining too much influence, it is said. We didn't know what was going on at the time. Later we learnt about these dynamics. And what did the local government do? They removed from duty any influential Sikh officers. There was a Sikh left in charge at the airport, but others had been transferred by 1988."

Kuldip Kaur traveled south in mid-September 1988.

"I had gone to Hyderabad. And I had bought tickets for September 17, for both of us to return to Delhi. On the thirteenth, Ginnu called me from Bidar to confirm. And then he said, 'I'll call you day after.' I kept waiting on the fifteenth, but no phone call came. I began wondering. And then I tried contacting people in Bidar. And I found someone who knew that Sikh in charge at the airport. They got back to me and said there were some riots. That was the first we heard of anything happening, nothing had come in the news or anything. Nothing had come from the school. I got frantic, I pleaded, Please find out about a Gurinder Singh."

The media silence on Bidar would run into weeks.

"And then my source got word and said the children are all in the gurdwara, they are safe."

"See, Nanak Jheera was high up on a hill. They were supposed to be all gathered there."

"I called again, asking Ginnu be put on the line. They said, 'He's okay, but not around.' Those days, there were no mobiles and all. And he was not living in the hostel. As a senior, he was in a rented house with some other boys."

"I stayed up that night, consumed by dread."

"Next morning, I heard a handful of students had been killed. That's when we left for Bidar."

"In their rented home, I saw everything had been ransacked. Books strewn all around. And no boys. When we asked around, we learnt that a mob had come, had chased them. There was now no sign of these four boys."

"These boys hadn't known, but people said the houses where Sikhs were living had been marked before. ... We slowly learnt six boys were definitely dead. My son, it was clear now, was one of those. We knew two of the others were brothers, one was Ginnu's classmate, the other was in first year, he had just been admitted in July. Bodies had been thrown down a well. The well was seven or eight kilometers from where they were murdered. The rampaging mob wouldn't have carried them. We heard the police picked up the bodies, put them in a jeep, and threw them."

"We went the next morning, to retrieve their bodies. All swollen. All. Just from his clothes. Recognized." She pieces her gasps together. The body had severely decomposed between September 15 and 18 in a well just about a 100 meters from the Superintendent of Police's residence.

"By then, my husband had arrived. We conducted the cremation, and then left. We returned to Delhi, but nothing ever returned to the same. Our house, many houses, were plunged into darkness."

As the Sikh students' families—many educated, all of relative economic privilege, all devastated—slowly began returning home, media reports finally started emerging.

"The general silence was so egregious, we decided a PHRO team must go down there to investigate," says Justice Bains. "I went along with Gurtej Singh, who had served in the South during his IAS tenure and was familiar with the region."

The team arrived in Bidar exactly a fortnight after the violence. Their vehicle, driver, luggage, persons were diligently searched by policemen who stopped them at the city limits. "Now, all this police had kicked into action, while then, for three days, as butchery took place, policemen either looked away or cooperated," says Bains.

The worst of the violence had taken place on the 15th, the team learnt,[15] the date of the Ganesh Chaturthi festival. Hindu-Muslim tensions had often spiked during the annual festival, which provided opportunity for Hindu political groups to demand "donations" and enforce compliance. Now, the small but growing Sikh population had entered the mix. "Students recall that of late tiffs between them and local toughs had become a usual feature. Central Intelligence officials told our team that [their] office [anticipated] anti-Sikh trouble as early as May 1988."[16]

On the eve of the festival, a group of Sikh students were returning home after dinner when they were stopped for donations. They refused—besides not celebrating the Hindu festival, they said they had already donated in the weeks prior. They were asked to produce donation receipts, which they did not have. The students were physically assaulted. The first Sikh-occupied homes were attacked and burnt soon after.

Anticipating worse, groups of Sikh students began collecting at the gurdwara the night of September 14. Some students informed teachers and administrators. Swarms of students continued to be welcomed by the gurdwara. An armed mob began closing in on the gurdwara's boundary wall.

The local head of police refused to act, while the students often heard the mob's slogans include cheers for the police. Eyewitnesses would tell PHRO the mob was armed with "bamboo sticks (of uniform size and colour), iron pikes, daggers and incendiary material."

Through the 15th and into the 16th, the violence continued. Mai Bhago gurdwara was looted. The college buildings were damaged. The PHRO team documented how all Sikh-owned businesses were destroyed and Sikh-occupied homes were attacked; where the landlords were Hindu, the students' property was taken outside and burnt; where the landlords were Muslims, the entire houses were burnt. Scores were brutalized, and the six boys died horrific deaths. All reported perpetrators were Hindus, led by those belonging to the chauvinist political groups, the Rashtriya Swayamsevak Sangh (RSS)[17] and Shiv Sena.

One causal factor of the Bidar violence was what Kuldip Kaur remembers hearing: disgruntlement of local business interests against the growing Sikh power. Indeed, this aspect made all the news when the media did break its silence.[18]

However, the PHRO report notes that the claims about Sikh business consolidation were conveniently inflated: the 11 Sikh business families owned small shops such as a homeopathic dispensary and cold drink store, whereas the college, with a 43 percent Sikh student body, was one of many in the area, and "last year as well as this year no local student who approached the college authorities for admission was refused." The PHRO team concluded that the violence was in fact instigated in this non-Congress-ruled state by the Congress (I), which had become accustomed to consolidating votes by propagating rumors of a Sikh threat.

Meanwhile, Ginnu's father sought to channel his household's mourning and rage. Dr. Mohinder Singh, an engineer with a doctorate from The Netherlands, had job offers in the United States, but then decided to move back home to Delhi and start his flourishing business. He was now in search of a fact-finding team that would be above allegations of communal bias. He funded the travel of a three-member non-Sikh team from Delhi to Bidar in October 1988.

This team's published report concludes that the violence was aimed at scaring away Sikhs for good. It rejects the notion of a deep-rooted Congress conspiracy trickling in from New Delhi, while accepting that the Congress is "the

main fascist force in the country today ... responsible for creating a divisive atmosphere in which Bidar-type incidents can be both organised as well as justified."[19] The report also names individual ministers of the Congress Party and Janata Party (then ruling the state) as culprits, but concludes that the events were neither party's policy. Instead, it highlights turf tensions between the two right-wing Hindu groups, RSS and Shiv Sena, both seeking to bolster their base through a spectacle of strength: a local chapter of the Sena had been launched just three months before the violence, and Sena's demagogue, Bal Thackeray, had reportedly visited Bidar days before to bless the final violent preparations.

Divergent root causes aside, both human rights reports illustrate the prevailing political culture: Sikhs were understood as India's new expendables. "Bidar was just one example of the consequences of the national plan to demonize one minority community to distract attention from the country's real problems," says Bains.

The Chief Minister of Karnataka, Mr. S.R. Bommai, recalcitrantly made statements regarding the violence only after much outside attention, and even then only bolstered rumors besmirching the character of Sikh victims in Bidar.[20]

Bidar has not been written about since these early reports. Sikhs, especially outside Punjab, largely learnt to remain silent: bringing attention to their second-class status was fraught with danger; the persecuted community was the easily identifiable "national enemy."

The post-1984 fear had quickly morphed Sikhs' sense of their own reality: first outside Punjab, later inside as well, the Sikh community was effectively "gaslighted." Like an abuser often succeeds in making a victim of domestic violence question her own sanity, memories, values, and truths, this community lost confidence in its own beliefs and experience. Sikhs increasingly found alternative explanations that did not implicate the abusers. For example, the Bidar carnage was rationalized by some as a result of Sikh boys teasing local girls and provoking the local boys—even as the PHRO determined that all available evidence pointed to no actual incident or complaint of such transgression: "In any case, even if some incidents of gross misbehavior of the Sikh students is shown, that would neither explain the organised and determined character of the incidents nor would it justify in any way whatsoever the orgy of loot, arson, and killings."[21]

For Kuldip Kaur, who had retrieved her last born's unrecognizable body with her own hands, the reality of the depravity remained crystal clear. "Wasn't very much we could do. Kept living as best we could, recalling, Teraa bhaana meetha laage." Your will is our sweet command, said the Ninth Guru.

Ginnu's sister says, "He was such a calm and quiet child, the baby of the family." She lovingly shows me his yearbook and reports from Modern School, Delhi. A history buff, theater society enthusiast, avid equestrian.

Flipping through Ginnu's files soon reveals media clippings from 1988 about building political violence and obfuscations. Just as Bidar's mayhem had made it to the papers, another touted release of the "Jodhpur Detainees" was

unfolding on the front pages.[22] Sikhs detained since 1984, including in Jodhpur, Rajasthan, had become political pawns during Chief Minister Barnala's tenure (1985–1987). Then Rajiv Gandhi had dismissed Barnala's government in June 1987, imposing President's Rule (Punjab would remain under this state of emergency central rule till 1992).[23]

A swift series of counterinsurgency special laws had swept Punjab. The National Security Act (NSA) of 1987 made an exception of Punjab, allowing detention without trial for up to two years. The infamous TADA, Terrorist and Disruptive Activities (Prevention) Act, was formalized (and would survive through renewals till 1993). "The Act defines 'terrorist' so vaguely that an individual need not necessarily indulge in violence to attract the penalizing eye of the legislation," Bains would write in the book he began drafting during his reprieve in Canada.[24] He had left Punjab temporarily and sought advocates abroad—the faraway lands he had always avoided—convinced the internal situation in his heartland was becoming dire.

<p style="text-align:center">* * *</p>

Sikhs were regularly feeling the brunt of police and militants alike. And so, on January 12, 1987, he didn't look twice at the headline posted on the billboard of the landmark Tribune newspaper building as he drove out of Chandigarh to Kharar on business. "I remember reading it said four women killed, including schoolteacher and two children," says Jasbir Bhullar, now a famous Punjabi author. His wife, Gud, would travel behind him to Kharar hours later: the schoolteacher killed the night before was Bhullar's sister.

"He clutched my arm so hard," says the otherwise elegantly composed Gud Bhullar, as she trembles a little telling the story 31 years later. She was also the one who would travel to Tarn Taran, to the site of the killings.

"See, as soon as people started coming to pay condolences, they started telling me, 'You can't go to Tarn Taran,'" says Jasbir Bhullar. "Because the terrorists had also given a threat that 'Anyone who comes for last rites, we will take care of them too.' And Gud decided she would be the one to go. And there wasn't much left to go to." The murdered women had been blown up in a powerful explosion.

Gud remembers, "It was all black, all soot, nothing left. Except a faraway room, a servant's quarter. And that was the only reason we even heard what had happened." In this room lay a man with a disability, married to the family's maid. He lived to tell the story.

"'There was a midnight knock,' he said. The maid answered, 'Who is it?' And they responded with, 'Your in-laws, who else!' They came in, they showered bullets. My sister, her girls, the maid." Jasbir Bhullar stops. His nieces were then in fourth and fifth grade. "They then pulled the bodies into a room, used we don't know what sort of explosives, but everything burnt to smithereens. The whole house. Gud saw it. And my mother, my Biji went to pick out ashes there, whose ashes, whose not, who knows. That's how a mother bade

farewell to her daughter and granddaugthers." He stops again. "You see, I've never written about this, because to write, you need to develop some distance. I can't write about it still."

The Bhullars explain that the murderer was openly known: "Ranjit Singh Ranaa. Which particular group, we don't know. Didn't care." Their sister had three older daughters, one of whom was married to a Surjit Singh. "He had been classmates with Ranaa and others," says Jasbir Bhullar. "They played hockey together. Got into fights together. Grew up together. And then some of the boys joined the militants. Surjit didn't realize how serious it was. Thought it was just another shenanigan!"

Gud Bhullar says, "Once, Surjit Singh's relative's house had been rented to some bank. Some terrorists wanted to loot that. And Surjit, he was tall and broad built, he was walking by when the man came running out. He grabbed the man, and took him down. The police arrested the man. And then, the terrorists were angry at Surjit. And you know, police would also use people. Gave Surjit a revolver. And he wasn't afraid of the terrorists."

Jasbir Bhullar elaborates: "And it was easy for him to provide the police what information they wanted, he had grown up with the local boys." Villagers couldn't really say no to either side those days, we all agree.

Surjit was soon killed by the boys. "They found one slipper in one field. One in the next. Body in a third. He was tortured. Lost nails. Eyes gushing." His wife, Jasbir Bhullar's niece, would give birth to their child soon after the murder.

"And that Ranaa was killed too by the police, not long after our sister," says Gud Bhullar. "We felt no happiness when we got news he had been killed. No happiness at all. What happiness lies in this situation? In fact, seven men of his family were killed. All like this."

After some silence, Jasbir Bhullar helps her break into a smile. "Gud, let me tell you, developed the habit those days of never letting me answer our door. She would run if the bell would ring, if there would be a knock. She would stiffen her shoulders and say, 'I will see to it!' She didn't have a weapon, nothing. But see to it, she would! As if she were protected."

Gud Bhullar remained undeterred by their family's tragic proof of the fallacy of Sikh women's safety relative to men's. She now smiles, "Well, also tell Mallika that till date, you conveniently never get up when a bell rings!" Replenished with some laughter, Jasbir Bhullar now returns to general observations about the times he wishes to forget. "All around, it was a loss. All these boys, Surjit, Ranaa, were what, twenty-one, twenty-two?"

It was a collective tragedy; each murder reprehensible. However, reparations varied by affiliations. The Bhullars explain how Surjit's surviving family received help from the "terrorist-affected families" funds and his younger brother was officially inducted into the police force on compassionate grounds. They know no more details about Ranaa's surviving family. The conflict was consuming Punjab's countryside.

* * *

The sensational and sensationalized merged to justify extraordinary measures in Punjab. In February 1987, news of India's biggest bank robbery rocked the nation. The Khalistan Commando Force (KCF), led by their General Labh Singh, had robbed 58 million rupees from Punjab National Bank in Ludhiana.[25] Dressed as policemen, they were in and out in broad daylight, without any violence or injury. Notably, the KCF took immediate ownership of this robbery—unlike other robberies reportedly carried out by Sikh militants.

Under Labh Singh, who enjoyed a respected personal reputation, the KCF had been recently reorganized and disciplined. Codes of conduct were now frequently issued by militants. Some aspects were widely applauded: for example, limiting marriage parties to 11 people in order to lessen burden on brides' families, and prohibiting the practice of dowry. Other diktats included prohibition on all intoxicants, including alcohol; dress codes for schoolchildren; and grave warnings against infiltrators.

Many militants' reputations grew and were even romanticized in the local mythos, for devotedly pursuing Khalistan as a religiopolitical mission. The government openly added negotiation to its counterinsurgency strategy. Interlocutor Sushil Muni, a Jain monk, was sent by the government to meet with militants in May 1987. These meetings in Punjab represented the militants' convening power, bringing New Delhi to the table. But they also created fissures in the militant ranks—encouraging divides between those favoring "talks" and those opposing. Meanwhile, infiltrations grew.

Anthropologist Joyce Pettigrew reports her interview with Darshan Singh, the appointed Jathedar of the Akal Takht in 1987, who enjoyed the respect of militant and nonmilitant Sikhs for a brief but pivotal period before his ouster and subsequent relocation to Canada.

I must say that from early 1987 the movement was taking a direction away from all the basic tenets of Sikhism and we didn't know from where this thinking was coming. The planning was most certainly that of the government but it was executed through many of these militant groups. For example, the Babbars were by no means an effective force in 1987. Yet SSP Suresh Arora was commenting favourably on them saying that when they are arrested they don't speak, or the police are convinced that when they do speak, they are telling the truth. In other words they were being praised by their enemy. Their enemy was building them up. Many times as I was talking to people I thought to myself the traitors are sitting within. ...

Many Sikhs came to me from the city and elsewhere, saying they had received letters asking for money. No one knew who was giving these directions. Sikhs were being killed and Sikhs were taking responsibility for the killings. So something was wrong. Then in May 1987 Sushil Muni came. He said to me that 'I've come from the government, can you get your people together in two days for a dialogue with our people.' I replied, 'Look, I can't. Your people are in houses and ours are underground.' Then he said: 'Leave arrangements for contacting the kharkhus [militants] to us. We'll send two people who can contact all of them.'[26]

"As human rights people, we knew that despite reported talks, and secret talks, the ordinary civilian was going to get further repressed," says Inderjit Singh Jaijee, who had formalized the organization MASR in 1988. Baljit Kaur and Lieutenant Colonel Partap Singh were MASR's coconveners, and Justice Bains the honorary president. Justice Bains had renamed his human rights group Punjab Human Rights Organization (PHRO) in July 1987.

Baljit Kaur remembers, "It was the same core group of people, but we thought it best to spread out. We kept groups smaller, to decrease likelihood of infiltration."

Jaijee adds, "Our methodology was very different. Judge Saab could hold large crowds and so he would attend large gatherings and make speeches. I believed in documenting cases that could get us into international fora."

Asked about any criticism they attracted for only highlighting the State's oppression, Jaijee says, "Yes, there was a lot of noise that 'You are only focusing on the government.' But it was Movement Against State Repression. State repression is only by the government. There were also incidents of atrocities by the militants. And with those, we said, 'Arrest him, put him behind bars, and produce him in court.' But nothing justifies just abducting and shooting him."

"Partap in fact came up with our name, MASR. And I'm glad it prevails till today. He was so earnest. I feel bad now, because he often suggested he could take the leadership of MASR. But I didn't give MASR over to him mainly because he remained a pucca, committed Khalistani. And to run a human rights movement you should be nonpartisan. He would write and come out with papers, statements. He would bring them over and say, 'This is for human rights, just needs your signature.' But it would have a statement for Khalistan within it," Jaijee laughs.

Calls for Khalistan by the diaspora, in relative safety, had gained traction. Dr. Gurmit Singh Aulakh, once a bioengineer, became a full-time lobbyist and founded the Council of Khalistan in Washington, D.C. in 1987. The advocacy groups in Punjab did not or could not adopt similar strident tactics. But the noise abroad helped Sikhs at home immensely, explains Jaijee. "See, whatever reports we were writing, we began sending to Aulakh and he was lobbying the U.S. Congress. That pressure helped a lot, it saved lives."[27]

Western governments' interest and attention to Punjab was focused on the instability, but exaggerated by the Indian government to Indians as an affront to national pride.[28] Meanwhile, in its diaspora populations post-1984, the Indian government continued misinformation campaigns.[29] Sikhs clamored for verified updates from Punjab.

"Western academics would go meet prominent scholars and, having not met the people directly affected by the oppression against Sikhs, come back with limited information." Dr. Ranbir Sandhu remembers urging the U.S. academics traveling to Punjab in the 1980s to meet men like Justice Ajit Singh Bains and not limit their contacts to Patwant Singh and Khushwant Singh. Both of these authors remained the most prominent Delhi-based Sikh voices; the for-

mer developed his identity as a politically active Sikh after 1984; the latter recoiled from the violence he witnessed in 1984, but would subsequently go to great lengths to distance himself from the Punjab "problem," belittle so-called Sikh orthodoxy, and become the infamous creator of the Santa-Banta jokes (blackface-like satire of Sikhs).

Dr. Sandhu was himself prompted to activism at the nudging of his young daughter—then a sophomore at the Ohio State University—who insisted that he find out what exactly had happened at Darbar Sahib and "do something" about it. Dr. Sandhu began actively seeking information from Punjab and became part of nascent efforts to inform the Congress, the White House, and academicians interested in India and South Asia, about the unfolding events affecting Sikhs. In July 1984, Dr. Sandhu purchased copies of four cassette tapes of Bhindranwale's speeches, smuggled from Punjab. Driving from New York to Ohio, the Sandhu family listened to the speeches of the purported terrorist leader. Dr. Sandhu tried to learn more about the leader and collected recordings of his speeches and conversations from various sources. He remembers finding that "contrary to the Indian governments propaganda, the Sant was neither a separatist nor a terrorist. He was solely a Sikh preacher teaching Sikhs to be good Sikhs, Hindus to be good Hindus, and Muslims to be good Muslims." Eventually, Dr. Sandhu would write the book *Struggle for Justice: Speeches and Conversations of Sant Jarnail Singh Khalsa Bhindranwale*.

Dr. Sandhu remembers how he finally managed to invite Justice Bains to an academic conference to report on the brutally murky ground reality in Punjab. "In February 1987, at a conference in Berkeley, California, all speakers, including myself, were discussing Sikh history, Sikh faith … but no one was talking about the bloody happenings in Punjab. Professor Surjit Singh of State University of New York at Buffalo stood up and asked why what's happening today is not being discussed. Professor Stanley Wolpert of University of California at Los Angeles, who was chairing that particular session, allowed Dr. Surjit Singh to speak. Professor Jain objected on the grounds that the Indian government was not present to provide a rebuttal. This prompted Professor Wolpert to announce that he would host a conference dedicated totally to the current problems in Punjab in October that year. I recommended that Justice Ajit Singh Bains, Chairman of a human rights organization, be invited."

"At the conference," Dr. Sandhu remembers, "Justice Bains spoke for about fifteen minutes. When his time was up, numerous audience members started saying, 'Go on, Judge Saab, go on …'" Dr. Sandhu describes the desperation for authentic voices from Punjab.

In Punjab, the extraordinary had been folded into ordinary life. In March 1988, the Indian Parliament passed the 59th Amendment of the Constitution, allowing the extension of President's Rule beyond the standard maximum of one year: adding exceptional clauses to the state of exception. Article 21 of the Constitution, guaranteeing the rights to life and liberty, was officially suspended in the "disturbed" state.

Ram Narayan Kumar writes,

> On 21 March 1988, the Indian media sensationally reported the first militant attack against a paramilitary camp in Punjab in which rocket launchers had been used. ... The press coverage helped the government rush through a constitutional amendment in the Parliament. ... Dhiren Bhagat's story suggested that the rockets had been fired by the government-sponsored *agents provocateurs* with the intention to whip up anti-Sikh hysteria in the country.[30]

Journalist Dhiren Bhagat had traced how India's intelligence unit, the Research and Analysis Wing (RAW), was smuggling arms from Afghanistan into Punjab, and reporting them as the arsenals of Sikh terrorists.[31]

The militancy was unfolding like the haphazard seeds we would try to decipher for patterns in my Naani's prized guavas, during our regular summer trips to Punjab after my brother's birth in 1986. Naani had three trees in her cramped backyard, from which she would deferentially pluck unripe fruit while chiding the taste-testing parrots. With almost no schooling, my Naani was well educated about things that mattered most. Naana, a retired District and Sessions judge, who had always left his official position at the gate—which he always opened himself for the car he drove himself, having refused any perks allocated to government officials—would quietly enjoy the fruits of the garden Naani tended with much love. But the hard green balls she would wrap and keep, smelling each occasionally till ripe and ready to travel to her daughter and granddaughter. The fits and spurts of the seeds in the fleshy pulp would never form the flower-like symmetry I had seen in other guavas. But no other guavas ever tasted quite as luscious.

Infiltrations into the militant circles multiplied, criminal gangs spurted, and murders for profit were easily folded into the militancy narrative. Justice Bains wrote, "Newspaper reports reveal that these criminal gangs have received the blessings of the Prime Minister [Rajiv Gandhi] and Adviser to the Punjab Governor."[32]

Says Justice Bains, "First civil authorities complained about police violence. But then they too became very fearful as officers like Izhar Alam and Sumedh Saini rose in stature." He refers to a May 1987 letter from the Deputy Commissioner of Ludhiana to the Chief Secretary of Punjab that recounts police abuses even against young children and reports "it is quite common for the police to rob passengers who embark or disembark at Ludhiana Railway Station."[33]

Not all violence by the police or paramilitary was as transparent. Ram Narayan Kumar writes, "As the strength of the guerrilla groups grew during 1987 and 1988, the government put into operation plans to sabotage both their strength and co-ordination. Initially it did so politically."[34] Writes anthropologist Joyce Pettigrew,

> The government projected its own groups. These groups disabled the politically minded and the intelligentsia and created disunity and diversion by stressing the need for personal reform and purity rather than sovereign status to protect one's

rights. The policies of the leadership of the Babbar Khalsa International were such as to create a wedge between the guerrilla movement as a whole and the professional classes as well as the political movement. They antagonised journalists, doctors, professors, broadcasters, engineers and the liberal-minded.[35]

External and internal sabotage dangerously swirled through the underground guerrilla movement. The year 1988 witnessed several splinters of the Khalistan Commando Force, and much militant and nonmilitant bloodshed. Government-run groups specifically targeted villagers, the militants' rural base. At the same time, "a massive influx of arms was coming into the province after 1988 through BSF-protected routes."[36]

"When the Center had dismissed the Barnala government, they had used the pretext that the government was not able to curtail innocents' killings," says Justice Bains. "But then, between 1987, when President's Rule was declared, and 1988, killings just escalated."[37]

Sushil Muni, the once interlocutor, stated in April 1988 that militant leaders had agreed to sign a peace accord, but the government had backed out at the very last moment. He alleged that peace efforts were sabotaged by those within the establishment. He also suggested the media was given access to purported terrorist killings—often disowned by all militant factions—to bolster the government's claims of ongoing terrorism.[38]

The title of Justice Bains's book, *Siege of the Sikhs*, had become lived reality for thousands of villagers across Punjab. The book was published in 1988 by his relatives in Canada and distributed widely, while he traveled back to India on the heels of Operation "Black Thunder II": Darbar Sahib, Amritsar, had been swarmed by the Indian Army once again in May 1988 in a reported effort to "flush out" militants. Sikh militant circles strongly challenged the authenticity of the supposed holed-up Sikh fighters. There were several points of evidence of police infiltrators posing as militants, instigating violence, and then being allowed to surrender outside for photo ops (after killing many militants inside). "It was totally a New Delhi job," wrote Jaijee, noting the radio links set up between Tactical Headquarter in the Golden Temple Hotel just outside the complex, and the National Security Guard Control Room in New Delhi.[39]

Meanwhile, there was little pause at the "Wanted: Dead or Alive" posters, circulated by the police, that encouraged extralegal killings. Jaijee notes that in August 1988, DGP K.P.S. Gill announced rewards for "apprehension/liquidation of wanted terrorists/extremists," identifying over 50 individuals by name and address.[40]

The Akali Dal approached the Supreme Court about the licenses to kill. Jaijee remembers, "The matter came up for hearing, was continued, the government dithered, and suddenly KPS quietly issued a new circular omitting the word 'liquidation.' And without some names. Because already, a dozen of the men in the first list had disappeared. There was never any inquiry about those. And the Akalis were asked to withdraw their petition in the national interest," says Jaijee.

Suspicious deaths of famed militant leaders came in quick succession during the summer of 1988. Charismatic General Labh Singh was killed on July 12, 1988. The rumors of his betrayal by his own ranks gained momentum. Ten days later, Avtar Singh Brahma, who had gained a significant local following, was dead. Rural Sikhs felt outrage at the eliminations of the original militant leadership, as well as fear of what was to come. Despite the unknown, their support for separatism continued, and was even bolstered—soon to be expressed in the 1989 elections.

Yet, outside rural Punjab especially, "What is wrong with Punjab's Sikhs?" was becoming a louder refrain as the media reported blasts killing innocent civilians on buses or bullets piercing poor non-Sikh laborers. "The confusion of militant and criminal was one of the successes of the police and intelligence forces," noted Joyce Pettigrew of her fieldwork in Punjab.[41] Militants, embroiled in external and internal fighting, carried out executions for revenge, particularly against alleged informers, while criminals within the militant ranks began increasing extortions and gratuitous violence. Jaijee notes how several prominent leftists were mysteriously killed.[42] Notably popular poet Paash was gunned down during a visit home from Canada. He had been running a magazine against what he described as the communally-minded militancy.

* * *

Sikh turbans on Punjab's murderers, both state and nonstate, created intended chaos. In this milieu, Sikhs were increasingly shamed for feeling anger and fear.

"There was a very clear message that we shouldn't talk about the murders," says Kuldip Kaur. The Bidar school had quickly been reopened and continued business as usual. One month after the violence, the Principal had sent a stiff form letter commiserating over the family's loss, with no comment on the injustice of the killing.[43] Incensed, Ginnu's father, Mohinder Singh, wrote a letter noting how this Principal and Joga Singh, the owner of the educational conglomerate, neither met with any of the bereft parents nor attended the painful last rites. Despite being clearly warned of the impending doom—Joga Singh had even fled with his family for safety—the school administration took no preventive or corrective measures and now shirked their duty again. "All those killed were my sons and all those suffering are also my sons. If you really want your soul not to torment you, you should yourself resign the post and work for the welfare of the remaining students and serve the future youth of the nation for the rest of your life."

Ginnu's mother, Kuldip Kaur, remembers, "After his bhog, we thought, Okay, let's ensure remembrance, and then put out a notice in the newspapers that six children were shaheed in the riots. Didn't let us use the words 'riots' or 'shaheed.' So finally we put out the announcement that 'We lost six precious lives in the madness of this world.'"

The family continues its frustrated attempts at counter-memory and, on every anniversary of the Bidar massacre, they continue to print the newspaper remem-

brance notices. Ginnu's father started a trust in his name and wanted to open an eye hospital in his memory: he always remembered cremating decomposing Ginnu's body without his eyes, which had always blinked behind studious glasses.

Eventually, Bidar's unacknowledged trauma resulted in another execution. Ginnu's sister says, "A Sikh student, still reeling from what he had seen, killed owner Joga Singh, holding him responsible for not protecting the boys against the mobs. The student surrendered and received capital punishment."

"Our lives of course were ruined," says Kuldip Kaur. "But the entire environment in India also only spiraled down."

Kuldip Kaur's surviving children voted in 2014 for Narendra Modi and the BJP government, itself accused of electorally expedient pogroms against Muslims in 2002. "But, for us, for Sikhs, clearly the Congress is never an option." Obvious parallels between the pogroms of 1984 and 2002 are ignored. "Look what the Congress government did to us! This is the obvious choice," they explain their chosen survival strategy.

Kuldip Kaur purses her lips, rotates her wrists slowly till all fingers point to the sky, and finally mumbles, "My understanding is that it's all the same game."

* * *

THE SAME GAME WAS NOW FEROCIOUSLY REPEATED BY INDIRA GANDHI, back from her post-Emergency hiatus. This time, she planned to retain power, and redoubled efforts to regain her reputation as India's formidable protector from threats (real and imagined).

"Sikhs were already raw," says Jaijee. "First took their water. Then, didn't develop industry, saying Punjab is a vulnerable border area. Then took away their land. And finally didn't allow the historic rate of participation in the armed services. The government had begun to usurp people's economic rights. Today, we see people dying due to the repercussions. And not just in Punjab. That belt they call the Maoist belt today. It's a belt of iron ore and coal, for which the native people are displaced. Then where do they go? Either die or become rebels. Same thing was happening in Punjab then."[44]

The government of India's 1976 redistribution of Punjab's river waters diverted 75 percent to neighboring states, against riparian laws, and without compensation to Punjab.[45] The diversions signified an unjust blow to the agrarian land. The Green Revolution's early promise had been replaced by disillusionment.[46] Post-Green Revolution's agricultural demands on Punjab—which had become the grain basket of India, by the central government's program—required farmers to use multiple times more, rather than less, irrigation.[47] Simultaneously, under the new quotas, army jobs were now limited. Punjabi impatience and fears about the future escalated.

At the same time, early returns of the Green Revolution had introduced bewitching consumerism into village life.[48] Large farmers squandered profits on luxury goods such as televisions and jeeps. Women were often relegated back into the domestic sphere due to decreased labor jobs and an increased

perception of family status corresponding with female protection. There was also an increase in intoxicants (more potent than the homemade alcohol ubiquitous to village life), gambling, and pornography.[49]

Religious teachers, some more genuine than others, worked on entering the spiritual void of this new milieu. The following of the charismatic new leader Jarnail Singh Bhindranwale grew. Himself hailing from a struggling farming family, he had grown up in the Sikh seminary Damdami Taksal and become a favorite of the then head Kartar Singh. In 1975, when Kartar Singh suddenly died in a car accident, Jarnail Singh was unanimously chosen as the successor. "Though many organisations and individuals played a crucial role in the Sikh revivalist movement, it was Sant Jarnail Singh Bhindranwale who ... came to occupy the central role," writes Pritam Singh.[50]

The spiritual "revivalism" often had political ends. Under Zail Singh, the Chief Minister of Punjab (1972–1977), roads, cities, and hospitals were renamed distinctively Sikh; large kirtan programs were organized; Sikh holidays were celebrated extravagantly. Congress's Zail Singh was challenging the Akalis's strong suit: their Sikh appeal. Akalis had largely retained their legitimacy as Punjab's political party. The masses, often feeling discriminated against by the Congress, easily sided with the Akalis, the original Sikh vanguard. Trained in a Sikh seminary, Zail Singh advised Congress leaders in Delhi on how they might be able to better penetrate his state. Most significant was Zail Singh's reported patronage—approved by Indira Gandhi's son, Sanjay Gandhi—of Jarnail Singh Bhindranwale.[51]

Bhindranwale's following, particularly among women, soared, especially since he focused on having men renounce alcohol consumption and other social ills that affected women and children. Through oratory skills, complete with an imposing and alluring physicality, he sermonized for a better, simple life.[52] He drew more followers, and soon was trusted as a righteous mediator, a spiritual guide, and torchbearer of renewal.[53] His adherence to the Gurus' message of egalitarianism is noted even by his disparagers: "What won him the greatest acclaim was that, unlike other preachers who paid lip service to the Sikh ideal of a casteless society, Bhindranwale made no distinction between higher and lower castes and treated the lowest castes of Sikh untouchables as members of his fraternity," writes Khushwant Singh.[54]

Unsurprisingly, Bhindranwale had detractors. Of all hues. Many urban Sikhs—like my family, who saw little in common with a man who had not completed secondary school, donned clothing of a style even my great-grandfather had outgrown, and spoke only in rustic idiom—were at best indifferent, or then embarrassed and dismissive. Urban Hindus were swifter in deriding him and his reportedly illiterate and gullible Sikh followers. Politicians competing for mass following were threatened by him. Bhindranwale maintained a broad message, within the umbrella of mainstream Sikhism. Tensions grew with a significant religious sect, the Nirankaris, who often attracted his derision and, increasingly, ire.

Nirankaris had historically been a part of the Sikh mainstream. Their original leader had developed the Anand Karaj ceremony, by which every Sikh is married

till date. Over the decades, one branch of Nirankaris began regarding their successive leaders as Gurus. By the 1970s, Nirankari Baba Gurbachan Singh held himself out as being at par with the Guru Granth Sahib. Tensions rose between Nirankaris and other adherents: particularly followers of the Taksaal and the Akhand Kirtani Jatha group. The skirmishes are now attributed in significant part to political machinations. The government provided support to the Nirankaris.[55] "Sanjay Gandhi and Zail Singh [] needed a religio-political issue to cause a confrontation between Sant Jarnail Singh Bhindranwale and the Akali Party and the Government," writes Sangat Singh. "This, they found in [the] obliging Sant Nirankaris. ... Already, Bhindranwale was being provoked by senior Sant Nirankari officials in the Punjab administration who were harassing him."[56]

The breaking point came with the notorious Nirankari-Sikh clashes on Vaisakhi 1978.

Traditionally celebrated on April 13, Vaisakhi is historically the most significant day for Sikhs: marking the birth of the Khalsa by Guru Gobind Singh in 1699 when he honored five ordinary Sikhs as his beloveds, who then collectively were asked to bestow the Guru with Amrit, initiating a community of equals.[57]

On Vaisakhi 1978, Nirankari Gurbachan Singh declared "Seven Stars" among his own followers in order to ridicule the traditional "Five Beloveds," and planned to carry out a large procession through Amritsar. "This was a bait guaranteed to enrage orthodox Sikhs and sure enough, they responded to the provocation," writes Jaijee.[58] Thirteen Sikhs, two Nirankaris, and two bystanders were killed in the violence that ensued.

Survivors describe the events with heavy emotion. Clear as day, they remember feeling dutiful as they left the Darbar Sahib after an earnest ardaas.[59] They had committed to nonviolence, when faced with violence. Bhindranwale walked them—predominantly men, joined by women who refused the advice to stay back—to the gates, where he was requested to not join; should things go sideways, he would be needed to lead. The local police deputed near the Nirankari meeting met the protesters and asked them to wait, the police would go speak with the Nirankaris about their offending program. But the police returned with armed Nirankaris on their heels. In the melee, police fired selectively at the Sikh protesters, killing several unarmed men. In particular, the well-respected Fauja Singh, of the Akhand Kirtani Jatha, who was leading the protests, was killed. He breathed his last as other Sikhs carried him to a hospital. Fauja Singh and 12 other Sikhs were cremated in a large ceremony attended by tens of thousands of people. The photograph of Fauja Singh's maimed body, garlanded in death, with a bullet wound through his left eye, became emblematic of the community's experience.

News of the deaths spread like wildfire. The government's laxity in apprehending the attackers redoubled the outrage. The ruling Akalis were accused of shielding the perpetrators. Meanwhile, the media painted the events as intersect wars, proof of rising Sikh "orthodoxy."[60]

The deaths of unarmed protesters left an indelible mark even on Sikhs away from Amritsar's brewing politics—those who had been disinterested in Punjab;

those uncomfortable with such spotlight on Sikhs; those more distanced from the religiospiritual matters; or those convinced that the freedom of divergent practice would have been respected or even encouraged by their Gurus. Identity-based organizing grew organically, and spread quickly. In Berkeley, California, young Sikh students obtained their first permit to stage a protest: Prime Minister Morarji Desai, who had provided little salve for Sikhs, was to visit campus. This organizing resulted in the creation of the Sikh Student Association, still active on the campus where I teach today.[61]

"By mid-1978, various components were in their places, and Indira's plan was fully operative," writes Sangat Singh of the growing confusion, infighting, and the Indian public's image of rising Sikh intolerance.[62] After the Nirankari-Sikh clash, several Hindu fundamentalists began open praise of the Nirankaris, while Sikhs continued protesting against the emboldened Nirankari activity, increasingly believed to be State-supported. In June, the Akal Takht officially declared the Nirankaris "apostates": Sikhs were no longer to maintain relationships with them. Meanwhile Sikh nonviolent protests were again met with harsh violence. In September 1978, in Kanpur, Uttar Pradesh, a dozen Sikhs were killed and scores injured, provoking more agitation.

Others in Punjab took to noncivil disobedience. Bhindranwale never directly claimed the violence. He did ask Sikhs to be prepared: more violence was to come, and self-defense was a Sikh's right and duty.[63] It became increasingly unclear which violent acts by Sikhs were in spite of him, and which may have been carried out to spite him. The media's incongruous attention on Bhindranwale only grew. Writes Sangat Singh: "Bhindranwale could not be the sole spokesman of the various strands operating in Punjab. But it suited the government to project him otherwise."[64]

Amarjit Kaur, Fauja Singh's widow, was increasingly revered by the Akhand Kirtani Jatha group, but became a vocal opponent of Bhindranwale, who had been excused from the 1978 protest that had claimed her husband's life. The militant group that organized under Amarjit Kaur's watch became the Babbar Khalsa. The schisms between the Jatha's Babbars and Bhindranwale's Taksaal would become history-defining through 1984, and after.

Center-state relations further deteriorated, quickly. Punjab interrupted canal construction diverting its waters to Haryana, and Haryana Chief Minister Bhajan Lal moved against Punjab in the Supreme Court of India.

In October 1978, the All India Akali Conference was held in Ludhiana. It was time to revive the draft of Punjab's demands, the Anandpur Sahib Resolution of 1973. The Resolution was endorsed after some wordsmithing, ensuring it clearly focused on demanding greater federalism within the ambit of the Indian Constitution.[65] "Chandra Shekhar, leader of the Janata Party, who was present at the Conference, had nothing to say about it. Congress leaders also did not react, to it. The Communist Party (Marxist), which ruled West Bengal and had been clamouring for greater autonomy, saw nothing against Akalis making similar demands for the Punjab. Apart from the BJP, only the Communist Party of India (CPI) expressed disapproval," writes Khushwant Singh.[66]

Despite having been drafted in consort with various non-Sikh leaders, and the unsurprising nature of its demands for federalism, the resolution would soon be declared "secessionist" by the Center.[67] Thus began the labeling of Sikhs as dangerous subversives.

Says Jaijee, "This federalism agenda was in fact drafted by Jyoti Basu of Bengal. And also asked for by Orissa's Biju Patnaik. And Assam's Chaliha. But why hit Punjab? Because Sikhs were two percent and it suited them for electoral reasons."

"As for Khalistan, Zail Singh admitted that he created the Dal Khalsa. And Khalistan demand came from their Dal Khalsa, not from the Akalis or Bhindranwale."

"Look who demanded state's rights: Patnaik. Chaliha. They were the Khalistanis! But the Sikh minority was a convenient scapegoat. Bhindranwale was not demanding Khalistan. In fact, all those who spoke very loudly about Khalistan in the 1970s, instead of about the legitimate federalism demands, all were suspected of being part of the government brigade."

Of course, at the time, happily busy with career and his young family in Delhi, Jaijee was unaware of these dynamics or players; he had hardly registered Bhindranwale's name yet.

"Even here in Chandigarh, I would just glance at what they reported about Bhindranwale on TV," admits Baljit Kaur.

One group that provided convenient media sound bites was the newborn Dal Khalsa. The origin of the firebrand group is disputed, strongly rumored to have been created in April 1978, during a meeting in Hotel Aroma in Chandigarh, under the direction and patronage of Zail Singh.[68] It involved diaspora leader J.S. Chauhan, who circulated the call for Khalistan through the media and the UN, and had issued passports and currency of the new desired nation. In Punjab, the Dal Khalsa often worked with the growing All India Sikh Student Federation (AISSF), led by Bhindranwale's close ally Amrik Singh. The Dal Khalsa also became involved with the hit squads graced by the Jatha's Amarjit Kaur, looking for retribution for the 1978 killings, after the courts had meted no punishment. The Dal Khalsa regularly provided fiery resolutions, speeches, and slogans.[69]

The year 1980 opened with the Congress under Indira Gandhi sweeping the polls. April 1980 witnessed a prominent assassination: Nirankari Chief Gurbachan Singh was killed in New Delhi. The narrative about the violent Sikhs only grew, while some believed the killing was "with Congress (I) or Union Government's complicity."[70] In June, the Congress Party was victorious in Punjab as well, and Darbara Singh became Chief Minister."

Punjab's water—far more pressing for the majority of Sikhs than the apostasy of sects—fueled more fire. Resumption of canal construction and reallocation of water was declared by the Congress government: 4.22 MAF to Punjab, 3.5 MAF to Haryana, 8.6 MAF to Rajasthan, 0.65 MAF to J&K, and 0.2 MAF to Delhi.[71] Over two-thirds of Punjab's water was to be diverted to non-riparian states.

Akalis continued organizing around the Anandpur Sahib Resolution. Indira Gandhi remained unfazed.

The Nirankari-Sikh clashes continued to be connected with bloodshed. Lala Jagat Narain, a Hindu newspaper baron who had taken provocative stances against the agitating Sikhs, and also sided with the Nirankaris, was murdered in September 1981, providing credence to his claims about Sikh aggressiveness.[72] Angry anti-Sikh slogans during his funeral procession exemplified how the religious divide was being cemented.

Bhindranwale was immediately named a suspect in Narain's murder. The plans for his arrest were then strangely announced on the radio, but not carried out for another week. As police tried to arrest Bhindranwale—in Haryana at that time, touring the country with his followers—they were thwarted by politicians, notably Haryana Chief Minister Bhajan Lal. Journalists reported that the Haryana Chief Minister was acting on the orders of Home Minister Zail Singh, and that Bhindranwale was sent an official car to drive him out.[73] (When the police arrived after his departure, his followers were beaten and several scriptures were desecrated.) On September 20, Bhindranwale gave himself up to the police, surrounded by many followers. He was released a few weeks later. "This could not have been done without the intercession of the Home Minister Zail Singh, after he got the sanction of Prime Minister Indira Gandhi," writes Khushwant Singh.[74]

Bhindranwale has often come to be described as Congress's Frankenstein,[75] much to the chagrin of the multitudes who viewed him as a Sant, a saint. Referencing his research, Dr. Ranbir Singh Sandhu says, "As far as I have been able to understand, the Sant was not a politician, had no interest in political matters, and in fact was promoted, then vilified, and eventually hunted and killed by politicians—both Congress and Akali—for their own perceived political gain. The traditional Sikh leadership was worried that even though Sant Bhindranwale insisted that he had no personal political ambition, he could emerge as a kingmaker and jeopardize their hegemony over the Sikh community."

Those removed from the interior of Punjab absorbed what was being reported in mainstream Indian media: a religious strongman in Punjab had the government cowering, while he bolstered a rise of the ferocious Sikhs, threatening the rest.

Indira Gandhi's "talks" with the Akalis were routinely reported. The stalling points were never clearly identified. In October 1981, she was presented with another list of Akali demands, and another clarification that the Anandpur Sahib Resolution was not secessionist. "All that was required was a certain amount of give and take between the Akalis, the [s]tates concerned and the centre to arrive at an amicable settlement," writes Khushwant Singh, who had remained an Indira Gandhi supporter even through the Emergency. "But it did not suit Mrs. Gandhi to agree to any settlement which might be construed as a concession made to Sikhs at the expense of Hindus. She had her eyes firmly fixed on her party's electoral prospects."[76]

NOTES

1. See also, Inderjit Singh Jaijee, "Mobiking along high mountains," *The Tribune*, December 20, 1988.
2. See, Ramachandra Guha, *India After Gandhi: The History of the World's Largest Democracy* (New York: Ecco, 2007), 492–504.
3. Granville Austin, *Working a Democratic Constitution: A History of the Indian Experience* (New Delhi: Oxford University Press, 1999), 309.
4. *Indira Nehru Gandhi v. Raj Narain*, 1975 Suppl. SCC 1, November 7, 1975.
5. William Borders, "Mrs. Gandhi Wins Court Reversal of Her Conviction," November 8, 1975, http://www.nytimes.com/1975/11/08/archives/mrs-gandhi-wins-court-reversal-of-her-conviction-unanimous-decision.html. The Supreme Court did, however, strike down Gandhi's proposed 39th Amendment that would circumvent judicial review of elections. In *Courage, Craft, and Contention* (Bombay: N.M. Tripathi, 185), Upendra Baxi argued "that the Court was on the defensive" and that judgment "worked out a masterly strategy of accommodation, so that neither the regime nor the opposition could say that the Court failed them," because the Court struck down the constitutional amendment while dismissing the charges against Gandhi.
6. See, for example, Vikas Pandey, "A Short History of India's Political Slogans," BBC News, October 9, 2012, https://www.bbc.com/news/world-asia-india-19802394.
7. See, for example, Ramachandra Guha, *India After Gandhi*, 508–10.
8. Rohinton Mistry, *A Fine Balance* (Waterville, Me.: Thorndike Press, 2002), 806–07.
9. See, for example, Harji Malik, "The Politics of Alienation," in *Punjab: the Fatal Miscalculation*, Patwant Singh and Harji Malik, eds. (New Delhi: Patwant Singh, 1985), 38.
10. Paul Wallace, "Religious and Secular Politics in Punjab: The Sikh Dilemma in Competing Political Systems," in *Political Dynamics and Crisis in Punjab*, Paul Wallace and Surendra Chopra, eds. (Amritsar: Guru Nanak Dev University, 1988), 22.
11. Sangat Singh, *The Sikhs in History*, 2nd ed. (New Delhi: Uncommon Books, 1996), 362.
12. Sangat Singh, *The Sikhs in History*, 363. He further writes, "The new Prime Minister Morarji Desai, an ultra Gandhiite had opposed the formation of Punjabi Suba till the very last, and was fully imbued with anti-Sikh spirit. For instance, when the Minorities Commission was set up in 1978, Morarji Desai, as also Chaudhary Charan Singh, wanted to exclude the Sikhs from within its purview as, they contended, the Sikhs were not any different from the Hindus."
13. "How the Emergency Provided the Template for the Mobilisation of Hindutva Forces," *The Hindustan Times*, March 29, 2017. ("The RSS's participation in the JP movement as well as the civil disobedience against the government during the Emergency gave it. . .a legitimacy that it had hitherto lacked. The mobilisation of RSS cadres during this period also provided the template for the populist Hindutva mobilisations of the late 1980s and the early 1990s. ... What's more, when Mrs. Gandhi returned to power three years later, she began appropriating elements of Hindu majoritarian politics."

14. A right-wing regional political group, espousing Hindutva ideology, founded in the 1960s in Bombay, Maharashtra.
15. Punjab Human Rights Organization, "BIDAR: The Signal from Bidar."
16. Punjab Human Rights Organization, "BIDAR."
17. An organization that swears allegiance to a right-wing agenda, toward a Hindu nation.
18. For example, Amarnath K. Menon, "Mob Mayhem," *India Today*, October 15, 1988.
19. Dvijender Nath Kalia et al., *Bidar Carnage: Facts, Factors, Fallacies* (Delhi: Peoples' Rights Organisation, 1988), 11.
20. Kalia et al., *Bidar Carnage*, 18.
21. Kalia et al., 16.
22. PTI, "137 Jodhpur détenus freed, to be flown to Chandigarh today," *The Statesman*, Septembter 22, 1988.
23. See also, Virginia Van Dyke, "The Khalistan Movement in Punjab-India and the Post-Militancy Era: Structural Change and New Political Compulsions," in *Ethnic Subnationalist Insurgencies in South Asia*, Jugdep S. Chima, ed. (Oxon: Routledge, 2015), 63. "From 1966 to 1997, no Akali-led government lasted its full term, falling victim to factional fights within the Akali Dal that were manipulated by the Congress Party at the center."
24. Justice Ajit Singh Bains, *Siege of the Sikhs* (Toronto: New Magazine Publishing Co., 1988), 16.
25. See, for example, "Sikh Separatists Masquerade as Police to Stage India's Biggest Bank Robbery," *The Los Angeles Times*, February 13, 1987.
26. Joyce J. M. Pettigrew, *The Sikhs of the Punjab: Unheard Voices of State and Guerilla Violence* (London: Zed Books, 1995), 46–47.
27. See, International Sikh Organization, *U.S. Congress on the Sikh Struggle for Khalistan*, Vols. I and II (Washington, DC: International Sikh Organization, 2013).
28. See, for example, Brian Keith Axel, *The Nation's Tortured Body: Violence, Representation and the Formation of a Sikh "Diaspora"* (Chapel Hill, NC: Duke University Press, 2001), 81.
29. See, for example, Zuhair Kashmeri and Brian McAndrew, *Soft Target* (Toronto, Canada: Lorimer, 2005).
30. Ram Narayan Kumar, Amrik Singh, Ashok Aggarwal, and Jaskaran Kaur, *Reduced to Ashes: The Insurgency and Human Rights in Punjab* (Kathmandu, Nepal: South Asian Forum for Human Rights, 2003), 103–04.
31. See, Dhiren Bhagat, "Stray Bullets Open Pandora's Box," *India Post*, April 23, 1988.
32. Bains, *Siege of the Sikhs*, 33.
33. Bains, *Siege of the Sikhs*, 33.
34. Kumar et al., *Reduced to Ashes*.
35. Pettigrew, *The Sikhs of the Punjab*, 78.
36. Pettigrew, *The Sikhs of the Punjab*, 78.
37. In Bains, *Siege of the Sikhs*, 63, he notes: "But the facts show that killings have skyrocketed ever since the declaration of presidential rule in the state. Close to 1300 people have been killed in the first six months of 1988, whereas 909 people were reported killed in 1987."
38. Kumar et al., *Reduced to Ashes*, 104.

39. Jaijee, *Politics of Genocide: Punjab, 1984–1998* (Delhi: Ajanta Publications, 2002), 80.
40. Jaijee, *Politics of Genocide*, 109.
41. Pettigrew, *The Sikhs of the Punjab*; on the orchestrated sudden cessation of the militant movement see also, Van Dyke, "The Khalistan Movement in Punjab-India," 72.
42. See Jaijee, *Politics of Genocide*, 283, 285.
43. October 14 letter from Sukhija, appended to report by Kalia et al, 1988.
44. See, also, J.S. Grewal, *The Sikhs of Punjab* (Cambridge; Cambridge University Press, 1998), 214. "They were unhappy with the Congress over the delay in starting work on the Thein Dam, discrimination in the allocation of heavy industry, and unremunerative prices for farm produce. The Morcha continued throughout the period of the Emergency, and nearly 40,000 Akalis courted arrest."
45. "The loss in agricultural produce to Punjab and gain to non-riparian states was estimated at Rs. 2500 crores (Rs. 25 billion)," Sangat Singh, *The Sikhs in History*, 362.
46. For example, in 1971–1972, the returns on wheat cultivation were 27 percent; but by 1977–1978, were reportedly less than 2 percent of the cultivators' investment, Vandana Shiva, *Violence of the Green Revolution* (London: Zed Books, 1991), 174.
47. See Bryan Newman, "A Bitter Harvest: Farmer Suicide and the Unforeseen Social, Environmental and Economic Impacts of the Green Revolution in Punjab, India," *Food First, Institute for Food and Development Policy*, Developmental Report No. 15, 2007; Mallika Kaur, "The Paradox of India's Bread Basket—Farmer Suicides," *PRAXIS, Fletcher Journal of Human Security*, Vol. XXV, 2010.
48. G.S. Bhalla, *Green Revolution and the Small Peasant* (New Delhi: Concept Publishing Co., 1983), 162.
49. See, Pritam Singh, *Federalism, Nationalism and Development* (Abingdon, UK: Routledge, 2008), 152.
50. Pritam Singh, *Federalism, Nationalism and Development*, 108.
51. See Mark Tully and Sushil Jacob, *Amritsar: Mrs. Gandhi's Last Battle* (New Delhi: Rupa Publications, 1985), 52–62.
52. His core message included: Nashe Chaddo; Amrit Chakko; Singh Sajjo. Renounce intoxicants; don the Guru's amrit initiation; embrace the Guru's identity markers.
53. "Ethnic masses who mobilize behind leaders do not do so automatically. After all, ethnic leaders are not puppet masters who can manipulate the ethnic masses at will with their symbolic appeals. Instead … political and socio-economic conditions must also be favorable (or must be made more favorable by deliberative consciousness-raising) to enhance the salience of the symbolic appeals." Jugdep S. Chima, ed., *Ethnic Subnationalist Insurgencies in South Asia* (Oxon and New York: Routledge, 2015), 4.
54. Khushwant Singh, *History of the Sikhs, Volume II; 1839–2004* (New Delhi: Oxford University Press, 1999), 325.
55. Who had also become a powerful contingent in Punjab's bureaucratic services. Iqbal Singh, *Punjab Under Siege: A Critical Analysis* (New York: Allen, McMillan, and Enderson, 1986), 108.
56. Sangat Singh, *The Sikhs in History*, 365.

57. "Almost two centuries later, Guru Gobind Singh's amrit initiation dramatically staged the antistructures introduced by Nanak. ... Guru Gobind Singh's new rite of passage shattered traditional social and religious structures by which people were divided and stratified, and brought forth the family of the Khalsa in which all of them were to have the same last name, the same parents, the same birthplace, and even the same physical format—kesha, kangha, kirpan, kara, and kacha." Nikky Guninder Kaur-Singh, *Birth of the Khalsa: A Feminist Re-Memory of Sikh Identity* (Albany, NY: State University of New York Press, 2005), 93.

58. Jaijee, *Politics of Genocide*, 19.

59. See, for example, 1984 Living History Project, Dr. Onkar Singh interview, http://www.1984livinghistory.org/2014/10/16/dr-oankar-singh/.

60. See, for example, Tully and Jacob, *Amritsar*.

61. See, 1984 Living History Project, J.P. Singh interview, http://www.1984livinghistory.org/2014/08/22/jp-singh/.

62. Sangat Singh, *The Sikhs in History*, 368.

63. Harminder Kaur, *Blue Star over Amritsar: The Real Story of June 1984* (New Delhi: Corporate Vision, 2006), 81.

64. Sangat Singh, *The Sikhs in History*, 393.

65. However, on the unitary structure provided for by the Indian Constitution and resultant legislative and executive "hegemony of the central government," see, for example, Hurst Hannum, *Autonomy, Sovereignty, and Self-Determination: The Accommodation of Conflicting Rights* (Philadelphia: University of Pennsylvania Press, 1996), 153–54.

66. Khushwant Singh, *History of the Sikhs, Volume II*, 339–40.

67. Dipankar Gupta, "The Communalising of Punjab, 1980–1985," in *Punjab: the Fatal Miscalculation*, Patwant Singh and Harji Malik, eds. (New Delhi: Patwant Singh, 1985), 220–21.

68. See, J.S. Grewal, "Sikh Identity, the Akalis and Khalistan," in *Punjab in Prosperity & Violence: Administration, Politics and Social Change 1947–1997*, J. S. Grewal and Indu Banga, eds. (New Delhi: K.K. Publishers, 1998), 72.

69. See, Harminder Kaur, *Blue Star over Amritsar*, 68.

70. Sangat Singh, *The Sikhs in History*, 371.

71. Vandana Shiva and Kunwar Jalees (eds.), "Water and Women," a report by the Research Foundation for Science, Technology and Ecology, Delhi, India, 2005, 71–72.

72. See, Harnik Deol, *Religion and Nationalism in India* (London and New York: Routledge, 2011), 165–68.

73. See, for example, Tully and Jacob, *Amritsar*, 70–71; Jaijee, *Politics of Genocide*, 34.

74. Khushwant Singh, *History of the Sikhs, Volume II*, 330.

75. See, for example, Harji Malik, "The Politics of Alienation," 42.

76. Khushwant Singh, *History of the Sikhs, Volume II*, 346.

Glasnost

Abstract This chapter captures how the shock of the events around the protagonists led to their politicization and activism rather than resignation.

The chapter provides glimpses into the events immediately before and after 1984. Sikh demands cohered in 1985; the central government was at the negotiating table facing the nontrivial threat of Punjab's secession; many Dalits, Sikhs, and communists in Punjab were working together; there was a promise of change in the aftermath of the carnage. There was worldwide sympathy and outrage following the events of 1984, before a devastating event eviscerated much of this compassion. Then, in April 1986, at a large spirited gathering of Sikhs in Amritsar, a collective community declaration for a separate homeland, Khalistan, was announced.

The year 1982 was marked by protests launched by the farmers who felt they were getting an only worsening deal even while providing food security to the nation. Their desperation was comingled with fear and alienation, especially after the targeting of Sikhs preceding the 1983 Asian Games. Punjab came under the impervious Armed Forces Special Powers Act (AFSPA), giving the armed forces widespread powers and immunity from prosecution. Punjab would soon be declared a "disturbed area" and brought under President's Rule. The popular leader Bhindranwale became a larger legend, living now in the golden Darbar Sahib complex.

* * *

© Mallika Kaur 2019
M. Kaur, *Faith, Gender, and Activism in the Punjab Conflict*,
https://doi.org/10.1007/978-3-030-24674-7_9

ਭੈ ਕਾਹੂ ਕਉ ਦੇਤ ਨਹਿ ਨਹਿ ਭੈ ਮਾਨਤ ਆਨ ॥
:GURU TEGH BAHADUR:
Guru Granth Sahib, 1427
Frighten None. Fear None.

"'THE MOVEMENT IS OVER NOW, SON,' HE SAID IN 1986. 'We don't need you running towards this.' And then he, himself, took me all the way home, where my parents welcomed the little runaway with a tight slap and many hugs." A 40-year-old man and political asylee in midwestern United States narrates his 1986 childhood memory of an unexpected interaction with a prominent member of the All India Sikh Student Federation, the organization he had run away from home to join.

Philosophically driven Sikh militant leaders had waged and waned in the months after 1984. Now, violent chaos mounted. Mr. Singh describes a clear distinction: the few early years, when men who became militant leaders out of philosophical commitments were joined by boys who ran from home to support them, and the subsequent years, when males of all ages who were forced "underground" due to police excesses and eventually took to arms were joined by opportunists of all colors.

"One keeps quiet, knowing so much truth about the people who came later, how muddy they were," he says. "But, in a battle that was like slingshots against nuclear arms, how can one start yelling at the powerless party, especially after what we faced in 1984?"

The floodgates had been opened and Punjab was well on a path of no return: rumors, misinformation, broken promises, and blood now ran through its defining rivers.

* * *

ITS DEFINING RIVERS WOULD BE STOPPED BEFORE DIVERTED: NEHAR ROKO! After the obdurate Indira Gandhi laid the foundation stone of the Sutlej Yamuna Link canal on April 8, 1982, Akali leaders in partnership with the Communist Party of India (Marxist) launched a new protest movement against the decision to divert Punjab's waters to Haryana and Rajasthan. The Communists soon parted ways after the Akalis decided the agitation would gain more momentum if organized out of the spiritual center, Darbar Sahib. The Akalis then declared the Dharam Yudh Morcha, the Campaign for Righteousness, under the leadership of preacher Harchand Singh Longowal.[1] They courted arrests in the thousands; "in a period of 2.5 months, 30,000 Sikhs had been arrested."[2]

"It was no surprise that the socioeconomic demands resonated so greatly with rural Punjab. Issues of livelihood were being entirely disregarded by the Center," says Inderjit Singh Jaijee, who has been recording the agrarian debt crisis in Punjab since the 1980s.[3] "Today, this agrarian desperation is reflected in the fact that Punjab has, per capita, the highest rate of farmer suicides in India."

Farmers who provided food security to the nation were facing insecurity in their homes. Experts began echoing the concerns of the protesting farmers. Studies from the 1980s documented how small and marginal farmers were unable to meet basic consumption needs on their agrarian incomes.[4]

In 1982, government action against the protests mounted and several Sikh organizations were outlawed. Reports of custodial killings began haunting the countryside. Akali leader Kulwant Singh Nagoke's obvious death under torture—his body was found handcuffed and bullet-ridden in June 1982—and the lack of government response fueled more fire.[5] Dozens of Sikhs began marching and courting arrest. Chief Minister Darbara Singh promised stern action and ordered the arrest of Bhindranwale's main men.

The mainstream media reported Sikhs resorting to indiscriminate violence, seeking attention for their demands. The media continued to accuse Bhindranwale of "Hindu-baiting," while reports of cow heads being thrown outside Hindu temples began appearing with more frequency (and more prominence than concurrent reports of desecration of gurdwaras). The acts of desecration were in fact increasingly linked to agents provocateurs. "Thirty Congress MLAs submitted a letter to the President naming the culprits, men who were close to the leader of Punjab's Congress government, Chief Minister Darbara Singh. Vehicles carrying cow heads had been stopped and ownership of the cars was traced to these men."[6]

"But really, where did we see eruptions of communal riots? Nowhere," says Jaijee. "There were tensions and rising wariness of each other, but people in the countryside are not fools. Neighbors did not suddenly turn to each others' throats."

Through early 1982, Bhindranwale and his men freely toured Punjab and India for their religious services. But by mid-1982, if the Congress had truly once patronized or controlled Bhindranwale, it began showing signs of realizing he had become a larger force unto himself. Bhindranwale's close associates were soon imprisoned, while negative media attention mounted. Bhindranwale began working with the protesting Akalis. He met with the Akali leader Harchand Singh Longowal and decided to merge with the Akali's Dharam Yudh Morcha, injecting it with new energy. Bhindranwale and his men would soon move their residence to the Darbar Sahib complex. The Akhand Kirtani Jatha's Babbar group also resided in the complex and tensions between the two groups were reported.

When July 1982 saw an assassination attempt on Chief Minister Darbara Singh, Bhindranwale's men were immediately named. In August, two attempts to hijack planes to Pakistan—both times the Pakistanis refused to allow the crafts to land—were made by Sikh men.[7] The media buildup of Sikhs' dangerous tendencies was at a climax.

Meanwhile, Akali leadership continued meeting with New Delhi, seeking a resolution of their demands. Indira Gandhi continued stalling. Nonviolent protesters continued to fill jails. While the government reported the unreasonableness of the Akalis, "non-governmental sources maintain[ed] that on five occasions the terms of a settlement were almost finalized and it was not the Akalis but Mrs. Gandhi who resiled from her commitments."[8] In March 1983, in a new move, Indira Gandhi announced a commission to evaluate Center-state

relations—Akali demands for greater federalism had been echoed by other states and leaders since the Anandpur Sahib Resolution in the 1970s. The commission would be chaired by retired Supreme Court Justice R.S. Sarkaria, my Dadaji's older brother. The government forwarded the commission as evidence of positive movement. (Its report would not be released for another five years; it concluded lack of need for any drastic changes to the status quo.)

On April 25, 1983, a well-respected police officer succumbed to bullets on the steps of Darbar Sahib complex. DIG Atwal was shot at point-blank range before the assassins turned him over to ensure death; even as security guards stood just about 100 feet away.[9] Atwal's suspicious death cemented the general public's distrust and disgust for the Sikhs inside the complex. Bhindranwale condemned the murder and was not alone in suspecting it was the work of the government.[10]

In the summer of 1983, even as meetings between Congress and Akali politicians continued, Punjab saw intensifying violence. According to Chand Joshi, "On an average, the police detained 50 Sikh youths every week and shot in cold blood at least half-a-dozen of them."[11] Further, new right-wing Hindu groups had mobilized in various states, including Uttar Pradesh, Haryana, Kashmir, and unleashed violence on identifiable Sikhs. This bolstered the anxiety in Punjab and intensified the Dharam Yudh Morcha. "Dharam Yudh volunteers suffered little inconvenience, apart from being kept in jail for a few months or days (often a few hours)," wrote Khushwant Singh.[12] While such elites joined the New Delhi government in underplaying the groundswell, rural Sikhs thronged to Darbar Sahib to participate in the civil disobedience. In April, protesters blocked main thoroughfares: Rasta Roko! In June, railway tracks were blocked: Rail Roko! In August, Akalis calendared a day to stall all work across Punjab: Kaam Roko!

Bhindranwale had given a call to Sikh youth to prepare themselves to forsake luxury consumerism and spend money on self-defense, by investing in a motorcycle and a revolver. At the same time, he stated, "Being armed, there is no greater sin for a Sikh than attacking an unarmed person, killing an innocent person, looting a shop, harming the innocent, or wishing to insult anyone's daughter or sister. Also, being armed, there is no sin greater than not seeking justice."[13] But, for the media, simply reporting a call to arms made for sexier national and international headlines.

"News came that weapons were being transferred into Darbar Sahib," says Jaijee about the fortification that would continue to be cited even decades later as evidence of the impenetrable menace of Bhindranwale. "The person who objected to that in fact was I.G. Bhinder. And he was a personal friend of the Gandhi family. He informed the Center. And the Center's advice was, Let them go in. Bhinder told me this. And he had made it public also. So it was happening with the government's knowledge."[14] And by the government's design, many others also believe. Former IPS and IAS officer Gurtej Singh writes:

So the arms were smuggled across from Pakistan by the government's own secret 'Third Agency' and dumped into the complex. I personally know the facts. In the summer of 1983, I was first chosen as one possible smuggler of weapons into the

complex. The approach was crude and direct. A serving Brigadier, posted at Jalandhar, came along with my acquaintance in the official army Jonga driven by an army-man and attended by an orderly. Posing as a good Sikh, he pretended to be worried that though the attack on the complex was coming soon, the Sant had no weapons. He offered a truckload, which I could take into the complex in a kar-sewa truck. I had taken my National Cadet Corps service and my army attachment seriously and it was easy for me to smell many rats in the proposition. So declining the singular honour came almost spontaneously to me. I later learnt that the deed was done by the acquaintance who had accompanied the Brigadier.[15]

The surprise at the sudden fortification of the complex was shared by the family members of the young men who had quietly left home to join the protesters and preachers in Darbar Sahib. Devinder Kaur, whose husband was once an alcohol-happy Punjab Police officer and would later become the legendary militant General Labh Singh of the Khalistan Commando Force, has recounted her visit to Darbar Sahib in summer 1983.

Darbar Sahib was an open complex, and in all of her previous visits, she had walked wherever she pleased. Being stopped in this way felt, at the very least, different. Nevertheless, Devinder composed herself and pleaded with the guards that she was searching for her husband—he was a policeman who might have been living here in the company of a Sant.

A man, who the guards referred to as Baba Ram Singh, overheard Devinder and took the family inside. He asked her what she wanted to drink. Still dazed by these guards and their weapons, she responded softly, "chaa." "This isn't an environment for chaa," replied Baba Ram Singh and sent for warm milk instead. He then left, asking Devinder and her family to wait in the room.

By now, Devinder was growing wary. There were so many weapons in this complex. Then came the terrifying realization that her husband was still a fugitive from the police and potentially in the midst of a group of men who conducted themselves without a care for any outside authority.[16]

On October 5, a bus was stopped in Dhilwan village, and Hindu passengers were ordered to disembark. Then all six were summarily executed. Bhindranwale condemned the Dhilwan killings and denied Sikh involvement, but the media apparatus ran amuck, declaring Bhindranwale's Sikhs had opened hostilities against all Hindus.[17]Allowing no time for investigation into the unclaimed terrorist action, Indira Gandhi swiftly suspended state government in Punjab and President's Rule was declared. The government promulgated additional laws, placing Punjab in a further unusual governance category.[18]

"Punjab then came under the unjust law of AFSPA, later applied in Kashmir, and till date causing so much havoc there," says Justice Ajit Singh Bains. The impervious AFSPA, Armed Forces (Punjab and Chandigarh) Special Powers Act, of 1983 gave the armed forces widespread powers, including the power to shoot on suspicion, with immunity from prosecution.[19]

Further, the government forces were suspected of several undeclared actions, provoking further violence in the state. The many bomb blasts in the state since mid-1983 and massacres like the Dhilwan bus attack were suspected to be false

flags. In 1984, *Surya* magazine, patronized by the BJP party, would substanti-
ate many suspicions, providing detailed reports about the role of the "Third
Agency," a special secret agency under the direct orders of Indira Gandhi.
Tracing the careers of various agency officers, their respective promotions and
honors, and agency plans to replicate their Punjab model to other conflict are-
nas, including the rising imbroglio in Sri Lanka, *Surya* noted:

> [S]election of men for the Punjab operation was masterly: men who looked like
> incompetent fools, but were masters of the intelligence game; men, who would
> maintain a totally low profile even when the Government, the ruling party and
> the national opposition made hysterical attacks on the failure of intelligence in
> Punjab. Only P.S. Bhinder, former Director General of Police in Punjab, had
> given the game away when he said that intelligence and the police had not failed
> Punjab. And indeed it had not.[20]

Publicly, through 1983, Indira Gandhi continued meetings with Akalis. But
the impasse continued. The Akalis now declared their intention to bring their
campaign to Indira Gandhi's doorstep: New Delhi, while under international
eyes, during the Asian Games. "In sheer disgust the Akalis decided to embar-
rass the central government by letting the world know how they were being
treated. They organized bands of volunteers to raise anti-government slogans
at the Asian Games," writes Khushwant Singh. The government's response was
executed through the Chief Minister of Haryana, Bhajan Lal, who "issued
instructions to his police that every Sikh going towards Delhi by rail or road be
stopped, searched and questioned. Amongst those who were humiliated were
army officers in uniform and Congress party Members of Parliament."[21]
Police stopped all identifiable Sikhs.[22] Armed gangs waylaid travelers.
Remembers Baljit Kaur. "That time, my daughter had come here to Chandigarh
to deliver her first baby. Our granddaughter was about six weeks, when they
allowed travel, and my son-in-law had come to take them back to Delhi. And they
got caught in that violence, led by Bhajan Lal and all throughout Haryana."
"They were driving and saw a barricade being created ahead. Fortunately,
my son-in-law had a jeep. So he quickly put it in four-wheel drive and bypassed
the barricade. But all their windows were smashed. There was glass every-
where. The girls were okay, fortunately. The child was not hurt."
"And she named that child Kismat, fate. Because they had survived just
by kismat."
Jaijee's children were still enjoying their Delhi childhood, says Harman.
"Papa was as enthusiastic as us kids. One Sunday, we would be going to the zoo.
Another, going somewhere else. We lived in Golf Links, New Delhi. My mother
worked for the Planning Commission. Life was routine, life was good ... though
really, I must say our life has always been good," she adds, channeling her father's
eternal optimism. "It was just that our Delhi life came to an end abruptly."
Jaijee had now begun following the trends in his home state more closely.
"The situation was deteriorating. Something was about to happen. There was
conflict, and the government was proceeding with it. ... I could see it on the
horizon. Was figuring out how to be useful. And you know, interestingly, I got

a good sense of things when I was in Kashmir in 1983. When I traveled there, and talked to locals, they would greet me with, 'Sardar hum aapke saath hain!' We are with you Sikhs, they said. But no one knew the extent of what was coming.'"

In many other states, Sikhs were being singled out. Hindu groups in Rajasthan issued an ultimatum for Sikh residents to evacuate. This evoked a thunderous threat from Bhindranwale against the Hindus residing in Punjab.[23]

Akali politicians reportedly began expressing concerns about Bhindranwale, who was now beyond political maneuverings and convinced of the need for a fight for Sikh rights. There are accounts of secret meetings with the then Punjab Governor B.D. Pande, in which Akalis agreed to Bhindranwale's arrest, so long as the forces did not enter Darbar Sahib.[24]

Dalbir Singh was a senior journalist for the English *Tribune* newspaper. A former Marxist, he had developed a close friendship with Jarnail Singh Bhindranwale in the early 1980s. In 2015, the octogenarian remembers, "In one of our first meetings, after spending about two-three hours with him, he asked for my impressions. I made three predictions: You will get more support than anyone else. You will get more donations than you'll know what to do with. And with the support, you will get many women looking up to you too, if you slip up in any way, even once, there will be a lot of trouble. Jarnail Singh laughed heartily. Then, his tall frame embraced me warmly. I just told him what I thought. He was a unique man! There was so much treachery on his vision and the mission, after him."

The internal violence and intrigue was undeniable.[25] "But the government designed the master plan," says Jaijee. "With men like Tohra conniving with them, it just became easier. But even these men had no exact idea what was planned. It was Tohra who told Jarnail Singh to move into the Akal Takht with his armed men. That suited the government."

A move held against Jarnail Singh Bhindranwale even by many Sikhs, till date, not the least because it provided the most convenient excuse for the government's storming of the Akal Takht.

When the Akal Takht had been established by the sixth Guru, Hargobind, in the seventeenth century, two flags were planted by its front entrance, to serve as a constant reminder of its dual function: spiritual (piri) and temporal (miri). Under this doctrine of miri-piri, weapons were a regular part of the tradition of the Akal Takht, the temporal seat of the Sikh nation, a few feet away from the spiritual heart, the gold-domed Darbar Sahib. Historian Iqbal Singh writes, "The British and the Government of independent India did not interfere with this tradition," till 1983.[26] This legacy could not have been lost on Bhindranwale, who perhaps only needed a nudge to move into the Akal Takht. Khushwant Singh notes,

> For some months the three factions [Akalis, Babbars, Bhindranwale's men] lived in close proximity in the *serais* adjoining the offices of the SGPC on the eastern end of the Temple complex. There was frequent exchange of abuse and fusticuffs. … Tohra as president of the SGPC was responsible for the maintenance of peace in the Temple. He pressurised a very reluctant Gyani Kirpal Singh to let Bhindranwale and his followers occupy the upper story of the Akal Takht, of which the Gyani was then Head Priest.[27]

Jaijee remembers, "So much anxiety was created about Bhindranwale and his men. They were called antinational even though Bhindranwale had always maintained he was not asking for Khalistan, but if the government wanted to push that as the only solution, he would take it. ... The government meticulously set the stage. It was not him."

* * *

"IT WAS NOT HIM. I DECIDED THIS WAS NOT RIGHT," says Baljit Kaur. And so she quit her Air France job in 1985. "I had been keeping very busy with activities across Punjab in the immediate aftermath. No one stopped me after June 1984. Maybe thought I was headstrong, and foolhardy, but in all my undertakings, I was never actively stopped by relatives," says Kaur. She always makes a hard distinction between societal custom, expectations, gossip, even ostracism, and active curtailment.

"Mostly, in every Sikh heart, there was a desire for some resistance. Our family was in fact very activated," she remembers of her parental Chural household. Soon after 1984, the farmhouse that had nurtured several previous social movements began hosting spiritual amrit sanchaar ceremonies, to which villagers thronged in large numbers. "I was one of the first people to take amrit there," says Kaur. "We began holding monthly sanchaars. It was in defiance: we didn't want amritdhaaris, Sikhs, to feel afraid, or think they were alone. It was all in response to the headhunting that was going on. But I must say, that was an amrit I never kept, didn't keep all the rules for long, but it was part of my joining a larger collective defiance. ... These young boys were being targeted just for being visible Sikhs."

Including a young student from their village Chural. He had been a member of the Taksaal seminary and was arrested with his closest friends in the months following 1984. He recounts sitting together in the dark jail cell, wondering if they would see the outside world ever again. The boys made a pact of continuing fellowship. They slipped karaas off their wrists, exchanged them, pledging continued friendship through whatever came next. The student from Chural had an exam and the police fortuitously agreed to release him to his college officials. He never saw his friends again. When their death by "encounter" was reported, he ran for his life, wearing his friend's karaa. The Jaijees had the boy live in their house for a few months before assisting in his relocation from Punjab, where he hasn't returned for 34 years.

Official circulars declaring "all *Amritdharis*" as dangerous and "potential terrorists" had been circulated by the Indian Army since June 1984.[28]

Jaijee explains this flamed the family's sudden interest in the Amrit initiations. "We were so worked up. ... The idea was simple: however many they kill, we will create. We would hold the ceremonies in memory of my father. Many common people were unhappy and angry at the bloodbaths and constant fear. A lot of Hindus from nearby even took amrit, and converted. Muslims didn't convert, but they were with us. But this was mainly meant to raise the spirits of rural Sikhs, feeling extremely vulnerable, helpless, angry all at once."

Inderjit Jaijee had returned to Punjab under the dark clouds of 1984. "I stayed at the farm, and traveled to wherever the killings happened."

His younger daughter, Harman, remembers the weeks after June 1984 turning into months, then years, in a rushed blur. "Honestly, I have little memory of how I got from second to fifth grade. ... Though I have plenty of childhood memories before that. We had been pulled out of our Delhi school suddenly, where everything had been in English. Hello, teacher. Good morning, teacher. I remember suddenly thinking how different these kids in Punjab were, referring to a 'Ma'am.' This I remember!" Her eyes twinkle with her father's mischief. "Mama had tried putting us in boarding school for a bit, but that failed too. And look, in our house, our view of Sikhi had always been very limited. No paath or prayers in house. No going to gurdwara. Only on gurpurabs. Till date, there is no paath in the house. The focus, my mother's focus, was on good karma. She thus supported everything my father had started and I remember no tension between them, though the times were tense."

The floodgates had opened in 1984. Popular slogans across Punjab now resounded with "Khalistan," which had largely been foreign nomenclature earlier. There was a surge of community unity in the face of State impunity.

The Congress Party had made no bones about the "lesson" taught to Sikhs. Rajiv's December 1984 election rallies resounded with slogans celebrating the violence—Jeeten gay to looten gay, haaren gay to maaren gay—If we win we will loot you, if we lose we will beat you.[29] Delhi Sikhs remember the shock of posters with barely veiled threats and castigations of Sikhs as treacherous separatists: "Will the country's border finally be moved to your doorsteps?" and "Should you be afraid of your cabdriver?"[30] Sikh cabdrivers, auto drivers, truck drivers, and others working far from their homes and possible hiding places had been particularly vulnerable targets during the November 1984 pogroms. Survivors seethed at the mockery and shaming to which they were subjected in the aftermath.

"Have I told you how Jagjit, after barely making it home in November 1984, applied for an arms license?" Baljit Kaur remembers her husband. "And then, a few months later, we went to London. And he wanted to go to a gun shop. Jagjit. Never before. We went to a gun shop. And he said to the man, I want a short barrel, lots of rounds. The shopkeeper was a short, stocky Englishman, and he said, 'What are you going to shoot, sir?' And, without blinking, he said, 'Hindus who come for me.'"

Baljit Kaur's eye widen again recounting this story.

"And the fellow there didn't blink either and said, 'Yes, I hear that's all the rage in Punjab this season, sir!' Imagine. It was shocking. But something terrible had been unleashed. Jagjit kept the gun for a year. Then sold it. I didn't want a weapon in the house."

Sikhs shared a sense of alienation and insecurity in their own homes. My father—who had in response to 1984's carnage just developed the habit of knotting one end of long cloth to a doorknob, walking across the chocolate carpet of our small apartment, working the other end, folding and refolding toward the door, conducting the metamorphosis of the starched cloth into a turban for wrapping each morning—traveled back to Punjab in 1985. He remembers

hearing accounts about the violence even from the most unlikely sources. Some of these were barefaced (often described with the value-laden term "clean-shaven"), alcohol-drinking, cigarette-smoking (a historic anathema for Sikhs) men. Those considered 'lapsed Sikhs' sometimes got a clearer picture of the complicity and even felicity of their Hindu colleagues and friends. Many people from Sikh families who had only felt cultural affiliation to their faith tradition were now being asked to prove their antireligiosity. This often backfired, at least in the immediate aftermath of 1984. "Another small mercy was that the Jatt-Bhapaa[31] talk had entirely ceased in Sikh living rooms at this time," says Papa. "There was, if anything, a kind of consensus that Jatts overwhelmingly died in Punjab in June, and Bhapaas, across Indian cities in November. And thankfully, people started talking about Sikhs as Sikhs, while also fearing more violence."

Once in office, Prime Minister Rajiv Gandhi attempted to downplay the bloodsoakedness of his victory, and declared interest in negotiating with Punjab. Other regional elections however soon took priority and there was little movement toward accounting or accountability. Still under President's Rule in March 1985, Punjab was sent a new Governor, Arjun Singh (who had been swiftly relocated from his chief ministership in Madhya Pradesh, when it had witnessed one of the world's worst industrial disasters in Bhopal in December 1984).[32]

Against clear apathy and disinterest in ameliorating Punjab's situation, demands for justice, enquiries, punishments, and redressals grew louder. "We saw seas of kesri now," remembers Baljit Kaur of her trips into the burning countryside. Saffron is considered the color of sacrifice in Sikh ethos.

Many were making thumping calls for freedom, and some for retribution. Babbar Khalsa militants warned of grave consequences if Sikh demands were not met by Vaisakhi, April 1985. For the Indian mainstream, the excited reportage of such warnings reinforced the impression of the unwieldy security situation in Punjab. For the Congress government, it provided an opportunity to selectively release Sikh leaders after creating prisoners' dilemmas and inserting splinters into the tenuously unified collective.

The palpable Sikh anger and the rise of multiple militant groups provided clear scapegoats for political maneuvering, even murder. Deaths crudely ascribed to Sikh militants often led to local Hindu backlash, and in turn, further communalization.[33]

In June 1985, to mark the anniversary of horror that had unfolded the year before, Sikhs thronged to Amritsar. Women's voices would provide the most captivating pathos. To minstrel beats, Surjit Kaur and Jaspal Kaur, sisters from Nabha, sang of the battle between Indira's troops and Bhindranwale's. In familiar folk Punjabi, Indira's authoritarian demands and the rebel Bhindranwale's response to one of the world's largest armies was eulogized, glamorized, and it revitalized spirits. Sikh history was not one of victimhood, but of unifying and responding to injustice, they sang fearlessly.[34]

Meanwhile, Sikhs' demands were being validated in halls of power in North America. MP Lorne Greenaway told the Canadian House of Commons on June 13, 1985, "For a year the Punjab state has been under martial law, and communication has been difficult. ... Such organizations as the International

Red Cross and Amnesty International have been denied entrance to this state."[35] On June 12, 1985, Jesse Helms placed in the U.S. Senate record: "Profound religious conflict in the subcontinent resulted in the formation of the state of Pakistan and the state of Bangladesh, both Moslem countries. If a just solution to the situation in the Punjab, the homeland of the Sikhs, is not found a similar process will inevitably occur."[36]

Under such attention, Prime Minister Rajiv Gandhi began negotiating with the Akali leaders whose release from jails he had recently ordered. Harchand Singh Longowal was now the default Akali head. The demands of the Sikhs were more unified and externally validated than ever before; the shock of 1984's collective punishment had paused the internecine vitriol and violence.

Then, the West's compassion and concern for Punjab eviscerated in the flames of a blast off the coast of Ireland. Air India Flight 182, from Montreal to Delhi, became the first ever 747 to crash. The June 23, 1985, plane bombing resulted in the death of 329 people, the majority Canadian citizens, most of Indian descent. The Sikhs suspected for the bombing immediately captured worldwide attention. Their trial would become the most expensive in Canada's history. After over two decades, it resulted in the exoneration of all but one of the men originally accused. Canadian public opinion remained less forgiving, despite several revelations over the years about the motives and motivators of the heinous crime.[37]

"This was all very murky and there was massive coverup involved, none of the actual victims got justice," says Justice Bains. In 2007, his organization, Punjab Human Rights Organization (PHRO), wrote a report on the crash and how the death of its supposed prime accused in Punjab Police custody had strangely elicited no outrage from the Canadian government.

Says Justice Bains's son, attorney Rajvinder Bains, "The Sikh men were just likely pawns in this operation. When PHRO publicized the information we had about the accused Parmar's death by Punjab Police, and his disclosures before his murder, the Canadian government sent us air tickets to come and testify in Canada. But that too was really eyewash. They weren't interested in getting to the bottom of anything."

In their revealing 1989 book, *Soft Target*, veteran journalists Zuhair Kashmeri and Brian McAndrew note that the Canadian Security Intelligence Services had by November 1985 created a flowchart of the assumed "Sikh" violence in Canada. "At the very top they placed the GOI (government of India), Third Agency. Below GOI were the names of Indian agents of influence and agents provocateurs. Below these were the supporters of the Babbar Khalsa, many of them suspects in the two bombings. CSIS agents believed RCMP task force was setting its sights too low in the investigation."[38]

Canadian intelligence had been contending with the meddling of Indian intelligence operatives since the 1970s.

How did India get away with it? Part of the answer is that the keepers of our security, the Canadian Security Intelligence Services (CSIS) and its predecessor, the Security Service of the Royal Canadian Mounted Police (RCMP), were so

preoccupied with the Soviet threat that nothing else seemed to matter. ... To its credit, CSIS eventually woke up just before the tragic Air-India bombing. ... It chased the culprits right to the Indian embassy and consulates. But what it then faced was political interference. ... CSIS found External to be an obstacle in its pursuit of the Indian spy network. Officials in that department were not anxious to embarrass a country that was Canada's gateway to Third World trade.[39]

The continuous reports of potential Sikh terror threats had sent the Canadians down frustrating rabbit holes in the past,[40] and now the fierce noise from the Indian government would affect the blast investigations. The journalists explain how Canada's External Affairs department then pressurized the conclusion of this messy mass murder case. They report that the harried RCMP charged two Sikhs in Canada, Parmar and Reyat—and while Canadian television viewers "were left with the impression that the Air-India case has been solved," those arrests were in fact for charges unrelated to the blast.[41]

While these had little impact on public discourse or prosecutorial decisions, several startling facts were uncovered by Canadian intelligence: How, within 16 hours of the crash, the Indian consul-general in Toronto, Surinder Malik, was leaking details to the press that were not publicly known.[42] How Malik and his family and other Indian bureaucrats had canceled their own reserved seats on the same plane days before.[43] How the bombing had many uncanny similarities with an earlier Madras, India, bombing, which CSIS learnt was also the work of India's Third Agency.[44]

The diaspora was by now rife with activity: government and nongovernment often blurred together. *India Today* in 1985 reported, "Indian Government intelligence on external groups has increased dramatically in the last two years, mainly because of the additional intelligence operatives from RAW and the IB [Intelligence Bureau] that had been posted under diplomatic cover in key embassies like Toronto, Vancouver, London, Washington, New York, Bonn and Paris."[45] Of the diaspora Sikh organizations created in the post-1984 frenzy, the World Sikh Organization was most prominent. It gained attention with high-profile events such as the unprecedented large gathering of North American Sikhs in New York's Madison Square Garden.[46] A newcomer from Punjab, who had known Bhindranwale and his men, gained popularity as an organizer: Major General (Retired) Jaswant Singh Bhullar. Bhullar had a considerable and committed following, though is now believed to be an agent provocateur. Sangat Singh writes that Bhullar's rhetoric and method injected "sectarian, unproductive, terms" that weakened the human rights basis of Sikh demands.[47]

"Sikhs are so foolish and blindly start following anyone," says Dr. Sukhjeet Kaur Gill, then a member of Justice Bains's PHRO. "Bhullar had served under my husband in the Army. Post-retirement, had suddenly gotten close to Sant Jarnail Singh ji. And also to Longowal. And he kept talking about it. Every other day, this man who had no religious background was off to Amritsar. Then, he gets a passport and is helped out of the country. And he went around saying he has been sent by the Sant. He was working for the government of India!"

"Some doctors from the U.S. who were active in human rights work by then came visiting Punjab in late 1984. They asked us our opinion on Bhullar. I remember telling them categorically that he should not be trusted. But he was very good at what he did. In minutes, tears would flood his eyes and he would give passionate speeches."

* * *

Meanwhile, in Punjab, political solutions rested on Akali leader Longowal's parleys with New Delhi. Longowal signed an Accord with Rajiv Gandhi on July 1985. Among other things, the Rajiv-Longowal Accord provided for transfer of the capital city, Chandigarh, to Punjab by Republic Day, January 26, 1986; adjudication of the river waters dispute; withdrawal of the draconian Armed Forces Special Powers Act; and an inquiry into the November 1984 killings of innocent civilians.[48]

The Accord was unacceptable to various sides. Gandhi's own party, having reaped electoral benefits from alienating the mainstream from the Sikh minority, saw concessions as unnecessary. Sikhs worried, at the minimum, about the authenticity of Rajiv Gandhi's promises, and many distrusted Longowal. Much of the Accord had been deliberated, and hurriedly signed, in secret.

"A clear clause-by-clause reading of this Accord exposed the smokescreen," says Justice Bains. "They mentioned innocent victims but without mentioning the perpetrators. There were no details about how they would calculate the supposed compensation. And then there was the matter of river waters, clearly the purview of riparian laws, but it had been sneakily snatched away from the judiciary by Indira Gandhi and was now by default set as a matter for a commission. And the November 1984 killings were being handed off to another commission. The same Prime Minister who won on ordering and condoning these killings was going to provide justice now?"

But the Accord also signaled a possible de-escalation: after all, it was unacceptable to both the most vocal segments in New Delhi and in Punjab.[49] In their decidedly weaker bargaining position, Sikhs were eventually sold on the Accord by Longowal, who termed it a "victory" and obtained approval at a large gathering in Anandpur, on July 26, 1985. Longowal temporarily gained momentum.

"Sant Longowal had a lot of respect for my father and had seen me do work," says Jaijee. "Now he proposed I run for elections, and offered support. But he was killed before that election."

Longowal was shot dead less than a month after signing the Accord. While the death was ascribed to two Sikh militant gunmen, there were several lacunae in the assassination story. K.S. Dhillon was Punjab's Director General of Police—an Indira Gandhi loyalist who had been handpicked in July 1984. He notes being kept out of the inquiries around the mysterious murder, despite being the state's highest-ranking policeman.

Eyewitnesses to the foul deed, had narrated shocking details of the sequence of events during interrogation by the local police right after the incident. It seems that two young Sikhs sitting behind the Sant whipped out their revolvers and shot the Sant as

he bowed in prayer after the ardas. Predictably, the firing led to much commotion among the worshippers, though some of them had the presence of mind to lie on top of the Sant, thus shielding his body from further attack. A police officer then apparently appeared and asked those protecting the Sant to let him get up as the alleged assailants had been caught. It was then that the Sant was fatally shot again. True to form, these details could hardly have formed part of the recorded evidence.[50]

Jaijee remembers, "Longowal had been heard telling his critics, 'If you find out the real inner conversations I had with New Delhi, you will be surprised! There is a secret clause.' But before he could tell anything, he was shot. We don't know what he tried to settle with Rajiv. It's still unresolved, nothing came of the inquiry around his murder. What we know is that Haryana and the Hindi belt were upset that Rajiv Gandhi negotiated with Longowal. Later, even the nonsecret terms of the Accord were altered, which won votes in Haryana."

Two months after Longowal's assassination, Punjab did go to legislative assembly polls. These resulted in overwhelming victory for the Sikh political party. Some, including D.G.P. Dhillon, believed that the Akali victory was part of the central government's plan for Punjab: "To transfer power to an Akali government and let them battle the militant forces, while the Centre watched the Sikh premier party fail miserably to contain the rising tide of militancy, as intelligence agencies discreetly stoked up extremist violence."[51]

Many saw the Akali victory as promise of real change in the aftermath of the carnage. "This was the one time that Dalits, communists, and others went in toto with the Sikh party," remembers Baljit Kaur of the voters. The Akali candidates too had included Hindus, a Muslim, and a Christian. Akalis received a record number of Hindu votes and successfully projected themselves "as a regional than a religious party."[52]

One of the victorious Akali candidates of 1985 was Inderjit Singh Jaijee. "Oh, we were all Akalis then, just like the general wave," Jaijee says remembering his extended family entirely supported his decision to run as an Akali. "My nephew Amarinder had quit Congress too, in protest," says Jaijee of the now Maharaja of Patiala, the current sitting Congress Chief Minister of Punjab as of 2017.

"I remember the time of the elections of 1985," says Jaijee's daughter Harman. "I remember because for twenty days my sister and I went from relative to relative's house. And we sensed a fear in people housing us too. I remember there were calls to our house in the middle of the night. And I remember a lot of times being sent to live in Ludhiana, with my naniji. It was boring for us since there were no other kids. But Papa would drop us. Mama would be at office."

"My mother was an I.A.S.[53] officer. She had given up her government-allotted house. She told my dad, I am working for the government, you are working against its policies, and that too with a loudspeaker! So it's not fair to live in government housing. There was little other talk about his work, though he was very busy."

Killings were accelerating in the countryside. Police excesses met few checks, while those whisked away during 1984 were still in jails. With the Akali sweep, Sikh demands for justice were stronger, and the new government's response was

impatiently expected by its voter base. The newly elected Chief Minister of Punjab, S.S. Barnala, decided to quickly appoint a judicial committee on the volatile issue of political prisoners. The communist-leaning retired Justice Bains had never been known as a Sikh judge. He was at that time the safe choice for committee chair.

Rajvinder remembers, "Daddy told us one day that Barnala came to him and said 'Let's appoint a committee to look into these detainees.' And Daddy said something like 'Why do you want to appoint a committee—go free them!'"

The already anxious and uninspired Barnala could hardly throw open jail doors. "Barnala told Daddy, 'No, we are going to have to appoint a committee and you can recommend whatever, we'll keep you for the term.' And what they were hoping was that it will take time, like all committees, three to four years and then the storm will pass. And they would coolly, slowly move along, releasing a few prisoners at a time, strategically. This way, Barnala wanted to get the goodwill of the Sikhs, without the anger of the central government," says Rajvinder. "But what Barnala had not bargained for, was the breakneck speed at which Daddy proceeded."

Much more had changed in Justice Bains beyond the longer strands in the beard he had always trimmed short before 1984. His impatience and impertinence were heightened by the time the four-member Bains Committee convened in the first week of October 1985 to "review the cases of convicts, persons facing trial and all persons under investigation in connection with the political agitation from 1981 to September 1985."[54]

"The other members were Mr. Sabharwal, a senior advocate of Jalandhar, Mr. Gurdarshan Singh Grewal, advocate general, and Mr. Midha, joint director of prosecution," says Justice Bains. "There was, however, little expectation that the committee would be doing anything anytime soon. So there was no steno, no office, no staff, no timeline. So, I did it all here."

Rajvinder elaborates. "The committee went into action on day one. We had this house. And Daddy just found his own steno. It was someone who had a government job otherwise, but volunteered to do this for free on the side. So everything was set."

Writing in 1987, Justice Bains noted:

> [The committee] started from Amritsar district, since most of the detainees and persons affected were from there. It called on the police officials, along with the District Attorney, to produce the materials implicating those who were under trial or under investigation. Likewise it reviewed the cases of all the detainees belonging to the other districts and completed the bulk of the review in about a month's time. It recommended the release of about 6000 detainees against whom there was no credible evidence, ruling that they were falsely implicated. ...
>
> The police officials who appeared before the committee admitted that most cases were trumped up—especially the alleged encounters. Even in serious cases of murder, like the murder of Harbans Lal Khanna in Amritsar the month before Operation Blue Star, the officials admitted that the persons arrested were innocent.[55]

The committee traveled to Punjab's jails. "Once, I also went inside," says Rajvinder who was often the committee's volunteer driver. "To a Hoshiarpur jail. And Daddy told the jail superintendent to bring out all persons lodged under TADA-shadaa, he said. And so they brought them all out and collected

them in a big hall and Daddy talked to all of them individually too. He had no business going to the jail, but all complied with his orders and no one stopped him. He was behaving as he had been used to, like a judge, because he had only recently retired. This way, he got direct input from the inmates. I don't remember the stories, though most of these were from Bluestar and Woodrose."

Former Bains Committee member and Punjab Advocate General Grewal notes, "We visited at least seven or eight jails and saw the miserable situation. I remember Pathankot, Gurdaspur, Patiala, Amritsar, Jalandhar. We also told the boys, 'You behave, and we'll work on getting you released from this false imprisonment.'"

The committee then submitted its final report on January 15, 1986. "In just two and a half hours. I mean, months!" Rajvinder laughs. "Though really, in the Indian system that is like two and a half hours in fact!"

The Bains Committee's recommendations were unanimous. "In not a single case was there a difference of opinion," wrote Justice Bains. "The committee came to the conclusion that the origin of the violence was State oppression, that the police force itself started killing innocent youth in fake encounters, giving rise to retaliation by some of the youth who took to arms."[56]

Says Rajvinder, "And now various officials started protesting so Mr. Barnala had to set another committee of police officers, and they went through the recommendations, adding delay. And then Daddy went public, saying 'the Chief Minister had promised no one would lord over my committee and yet they are.'"

While the Bains Committee report was never made public, the Barnala government had to release 3000 detainees due to the publicized debate.

"Justice Bains became a household name by the end of 1985, when I probably first met him" says Baljit Kaur. He was now the "People's Judge," and letters and visitors from across Punjab arrived at the Bains home, hoping for relief. Justice Bains convened a human rights group. He says, "There was no State Human Rights Commission at that time or no human rights body even at the central level. Jaijee saab was an MLA then, but Bibi Baljit became our secretary, and General Narinder Singh our vice president, and Bibi Sukhjeet Kaur, and many, many other people were part of that first human rights organization in Punjab." Names he cannot now recall. Altogether, they constituted a miniscule percentage of similarly situated, relatively elite Sikhs.

"You know, from before Bluestar, I had many friends, some in the police also," remarks Baljit Kaur. "As I started traveling and doing this work, they would say, 'What are you doing? You will get killed!' And soon they began saying, 'What was your recent trip like?' And I would say, 'Very successful.' And just smile." She breaks into a soft laugh, gracefully recrosses her legs. "I think some people felt their own guilt at not doing anything, others hoped they were safe and didn't want attention. From our social circle, people naturally backed away. And later, my social life, really, became my colleagues in this work."

As January 1986 drew to a close, any promise of the Rajiv-Longowal Accord had been eroded. Writes Ram Kumar, "The Central government repudiated its part of the accord in its entirety. Chandigarh was not transferred to Punjab as promised. The commissions on the river waters and territorial disputes were scuttled. Those guilty for the November 1984 massacre of the Sikhs remained unpunished."[57]

Unrest and distrust grew. State responses remained hastily harsh at best and instigatory at worst. Sikh protests and gatherings became volatile when police opened fire. In February 1986, policemen under Mohammad Izhar Alam— who would later head the notorious hit squad "Alam Sena"—killed protesters in Nakodar, and then forced quick cremations.[58] Communalized violence broke out in many towns between Sikhs and Hindus, with the support of out-siders. Various interested parties, including the Shiv Sena, had found a ready playing field in Punjab.

Civilian Sikhs increased the pressure on the lame-duck Chief Minister Barnala, while armed militants again swore retribution. These militant groups were neither organized nor disciplined in their responses. Media reporting painted a picture of systematic militant control of Punjab, even as Punjabi Sikhs and Hindus were often left questioning the true architects of the violence. Meanwhile, militant daring, such as the April attack outside a Jalandhar court-house, killing six policemen, and achieving the escape of three Sikh prisoners amidst a volley of bullets,[59] solidified the narratives of Punjab's "Sikh takeover."

The central government now sent S.S. Ray as the new Governor of Punjab. Ribeiro was appointed DGP. Chief Minister Barnala was sidelined.

On April 29, 1986, at a large, spirited gathering of close to 50,000 Sikhs in Amritsar, a declaration for Khalistan was announced. A new five-member com-mittee was officialized as the council of elders for the Khalistan movement. The Khalistan Commando Force became this movement's official militant arm.

Blasphemous to many Khalistani Sikh ears are accounts describing the cen-tral government's role in itself hastening this declaration, expedient to their narrative about Sikhs to the media, the Indian mainstream, and the world.[60] Says journalist Dalbir Singh, who remains proud of his emotional friendship with Bhindranwale, "He stayed true to his word. And, his last words to me ever? 'Bhaiyaa, yaari nibhaayin.' Brother, uphold our friendship. I tried. But what you were seeing in 1986 was all treachery and double-speak." Dalbir Singh was at the center of planning the April gathering, to present a declaration of increased states' rights. But soon, those seeking a declaration of Khalistan drowned other voices and Dalbir Singh walked away.[61]

The declaration and the large gathering provided the backdrop for another army action. April 30 saw "Operation Black Thunder I," a heavy deployment on Darbar Sahib. The five-member council and other militants had long left. There was no resistance. The army conducted heavy-handed searches and arrested whoever they could, including women and children. "Ribeiro [DGP] conceded 'No one of note was caught.'"[62] While relatively few lives were lost, the Sikh community was further scarred and incensed.

"The next day, twenty-seven of us Akali MLAs broke away from the party in protest," says Jaijee of his half-term political career. The breakaway MLAs were dismissed from the Akali Party and unseated from the Punjab Assembly. "The real work now began. Reports of indiscriminate killings had increased, while media would report only the threats to Hindu businessmen or the excesses by Sikh militants. Those happened too, but the State repression was at the core."

"In our area, the killings were low, because we were chasing each and every case, so they kept distance from us. But it became standard quite early on for

them to pick up the boys in one place and kill them in another area. So in our area, we heard shots being fired in middle of night. ... These would later be claimed as encounters. One case we were able to follow up, where a young man was killed by our railway crossing. ... Local people had seen policemen come, two chaps on a motorcycle followed by a police jeep, with a boy inside. They saw that. An hour later, they heard a lot of firing at the crossing. We got there to investigate. How could it be an encounter when this boy was seen inside the jeep just an hour before? They had taken the body away quickly. But I saw fire marks on the tree. It seems they had tied him to a tree and shot him. They then claimed this chap was fleeing on the motorcycle and they had to fire."

"And these were the cases in which they were claiming encounters, and showing bodies. In others, they let them go down the canals. Absolute impunity."

Despite Ribeiro's famed "bullet for bullet" warning against the militants,[63] the hit lists of militants, and the high reward for militant killings,[64] the militancy and its support soared. The Khalistan Commando Force had entered a new phase of its life cycle. From the early groups in Amritsar and Gurdaspur since 1984, the organization now had committed generals: "Under its first two leaders, Manbir Singh Chaheru and Labh Singh, it became very popular and the number of operating groups mushroomed. ... The KCF, consisting then of 400 young guerrillas, was well-armed."[65]

Wanton violence by gun-toting boys had also become commonplace. "Once, I was in Darbar Sahib," recounts Jaijee. "We breakaway Akali MLAs would go discuss our next course of action. I was in the parikarma, along with two MLAs, one from Ropar, another from Ludhiana. We were walking the reverse parikaram, I remember." Counterclockwise. He takes a twig to the dirt floor outside his Chural house and traces from memory, the scene, how they were walking bungaa to bungaa, tower to tower. "And just about a hundred yards ahead, we saw a scuffle. There were two armed boys and Bimal Kaur Khalsa was clearly in charge of them. And they said that the police were hiding in the bungas. Next, in a flash, they pulled one chap out of the bungaa and they killed him. We ran, to see if we could save him. He bled out there. And one man stopped us, saying, 'He is dead, you back off.' One of the other MLAs did run ahead to see if he could help. The government then registered a case against *him*, for murder! Just imagine. Right there in Darbar Sahib's walkway, they murdered a man. Against all Sikh tenets."[66]

Of his own safety measures, Jaijee says, "Well, wherever we went, we went in our own car. And we never carried weapons. Like once these two militants came when we were traveling, stopped us and said, 'We have information that there will be an ambush. We want to protect you, we'll come with you!' We said, 'No, thank you.' Maybe they were genuine militants, but we didn't know. Our getting involved with armed boys would have been the end of our unbiased human rights reporting."

Did Jaijee's own family worry for his safety, in the environment of intrigues, murders, and cover-ups?

"No," Jaijee's daughter Harman says definitely. "We had internalized as kids that it was happening to everyone. When we were with my Naniji in Ludhiana, we heard about things in the countryside. And my Naniji, she was so brave.

Anytime any armed militants came to the house, she would go alone to talk to them. I always remember her using the same tone she used with children, 'Yes, Betaa,' she would start. And then explain, 'I am a widow. And my daughter-in-law is a widow.' She would say, 'There are only women here, think about how it looks if you come in. Rest, is up to you.' And they never came in. What often brought them there was seeing a government car. Mama's car! Naniji explained patiently that that was her daughter's official car, but there were no other government people here. So nothing happened. But we sensed a lot was happening."

Harman takes a break to answer a canvasser's call for a competitive Chandigarh Golf Club election now. She has inherited her grandmother's patient but effective tone. Without promising anything, she hangs up and smiles. "A very different election this!"

"Though, should I tell you, as a kid, when it was that I first realized our family was different? It wasn't midnight adventures or other things. It was when I went to a school friend's house. And we were asking her mother permission to do something, and she responded with something basically like, 'Whatever your father says.' I found it so off. None of the women in our house delegated decision making like that! I realized our family was different, more egalitarian than others. To me that mattered the most."

"Coincidently, soon after this incident, this very classmate's father called our house. He was in trouble, he said. He had been getting extortion calls. Called Papa for help. Papa said, 'Those are not real terrorists, if they are harassing you for money like this.'"

Harman employs the now prevalent descriptor for yesterday's militants, even while distinguishing between the real and sponsored.

Two men would soon rise to become the best-remembered Sikh militants. On August 10, 1986, General Arun Vaidya, chief architect of the 1984 army attack on Punjab, was shot dead by Khalistan Commando Force's Harjinder Singh "Jinda" and Sukhdev Singh "Sukha." They escaped, remained on the run for some months, and once caught, admitted to the murder and maintained they were not guilty since they had brought to justice a mass murderer.

Photographs of Sukha and Jinda can today be found in many Sikh homes, especially in the diaspora. Their steadfast high spirits in the face of the gallows became legendary as their death-row letter to the President of India was widely circulated:

> The dark storm of oppression that is blowing over the Khalsa and the fire of tyranny that is burning it, must have touched at least a little, the soul of Lincoln, Emerson, Rousseau, Voltaire and Shakespeare because the people fighting for their freedom and sovereignty have the same blood flowing in their veins....
>
> The rope of gallows is dear to us like the embrace of our Lover but if we are condemned to be the prisoners of war, we will wish bullets to kiss the truth lurking in our breasts so that the sacred ground of Khalistan becomes more fertile with our warm blood.[67]

Hoping to see no more bloodshed in her homeland, while knowing the conflict was now at a new boil, Baljit Kaur redoubled her work.

"I had started with the Air France job when my daughter had gone away to college. The boss was from Patiala, and with that connection they gave me the job. Not that I was trained for airline work or anything. But I was their person in Chandigarh. Post-1984, they were perfectly okay with me. They knew, from reading in the papers, that I was part of human rights groups."

"But I resigned, as I felt it was not fair on them. I was working on human rights. I was perceived as a Sikh advocate. And the nice man who had hired me at the airlines, he was a Hindu Punjabi. I didn't want him to feel awkward, so we parted ways." She shrugs.

"I was still entitled to one more free ticket. So I took it. And with that ticket I went to meet Amnesty International in U.K. and Asia Watch in the U.S. I told their people what I had seen. I took two cassettes I had made. Because I knew I had to directly show them something. They sat and watched for two hours. It was in Punjabi, and they did ask some other people to translate."

"And I told them, We don't even know how to record a case and ask for quick action and everything. They told me what sort of information they needed from us, etcetera."

Asked if she was the first person from Punjab visiting them, Baljit Kaur hesitates, "Uh, I-I wouldn't know that ... I'm sure they must have other information too. But this is when we essentially learnt how to interact with Amnesty. They gave their telephone number and all. I thought we'd now be able to better intervene and end this mayhem."

NOTES

1. See, for example, J.S. Grewal, "Sikh Identity, the Akalis and Khalistan," in *Punjab in Prosperity & Violence: Administration, Politics and Social Change 1947–1997*, J. S. Grewal and Indu Banga, eds. (New Delhi: K.K. Publishers, 1998), 80–81.
2. Harnik Deol, *Religion and Nationalism in India* (London and New York: Routledge, 2011), 105.
3. See, Aman Sidhu with Inderjit Singh Jaijee, *Death and Debt in Rural India: The Punjab Story* (New Delhi: Sage Publications, 2011).
4. G.S. Bhalla, *Green Revolution and the Small Peasant* (New Delhi: Concept Publishing Co., 1983), v.
5. See, Gurdarshan Singh Dhillon, Truth About Punjab: SGPC White Paper (Amritsar: SGPC, 1996), 199–200.
6. Jaijee, *Politics of Genocide: Punjab, 1984–1998* (Delhi: Ajanta Publications, 2002), 20.
7. Khushwant Singh, *History of the Sikhs, Volume II; 1839–2004* (New Delhi: Oxford University Press, 1999), 332.
8. Khushwant Singh, *History of the Sikhs II*, 347.
9. See, Satish Jacob and Mark Tully, *Amritsar: Mrs Gandhi's Last Battle* (New Delhi: Rupa, 1985), 96–97.
10. See, Ranbir Singh Sandhu, *Struggle for Justice: Speeches and Conversations of Sant Jarnail Singh Khalsa Bhindranwale* (Ohio: Sikh Educational and Religious Foundation, 1999), li.
11. Chand Joshi, *Bhindranwale: Myth and Reality* (New Delhi: Vikas Publishing House, 1984), 139.

12. Khushwant Singh, *History of the Sikhs, Volume II*, 332.
13. See, for example, Sandhu, *Struggle for Justice*, vi.
14. See, also, Lieutenant Colonel Partap's notes: "[Bhinder] revealed that arms and ammunition were carried inside the Temple Complex in Kar Seva (voluntary service) trucks meant to carry food and construction material. They were not intercepted because there were oral instructions 'from the top' until two months ago not to check any of the Kar Seva trucks." 33
15. Gurtej Singh, *Chakravyuh* (Chandigarh: Institute of Sikh Studies, 2000), 49–50.
16. Rattanamol Singh, "Labh," Lighthouse Collective, republished on Naujawani. com, July 13, 2015, https://naujawani.com/blog/labh-by-rattanamol-singh/.
17. See, Sandhu, *Struggle for Justice*, xxxvi–vii.
18. See, "Black Laws in Punjab: Report of an Enquiry," *Economic and Political Weekly*, Vol. 20, No. 19 (May 11, 1985), 826–830.
19. See, for example, Human Rights Watch, "Getting Away with Murder 50 Years of the Armed Forces (Special Powers) Act," August 2008.
20. Rajeev K. Bajaj, "Dead Men Tell No Tales," *Surya* (September 1984), 10.
21. Khushwant Singh, 348–49.
22. See, for example, UPI, "700 Sikhs Seized as Asian Games Are Due," *The New York Times*, November 16, 1982.
23. See Sandhu, *Struggle for Justice*, 332.
24. Chand Joshi, *Bhindranwale: Myth and Reality*, 149.
25. See, for example, Tavleen Singh, "*Terrorists in the Temple*," in *The Punjab Story* (New Delhi: Roli Books, 1985), 42–43, describing a "civil war" between the "extremists" (Bhindranwale and his men) and the "moderates" (Longowal, assisted by the Sten-gun-strapped Babbar Khalsas).
26. Iqbal Singh, *Punjab Under Siege: A Critical Analysis* (New York: Allen, McMillan, and Enderson, 1985), 18.
27. Khushwant Singh, *History of the Sikhs II*, 334.
28. "The Punjab Situation," *Baat Cheet*, Serial No. 153, July 1984.
29. Sangat Singh, *The Sikhs in History*, 2nd ed. (New Delhi: Uncommon Books, 1996), 428.
30. Harji Malik, "The Politics of Alienation," in *Punjab: the Fatal Miscalculation*, Patwant Singh and Harji Malik, eds. (New Delhi: Patwant Singh, 1985), 56.
31. Bhapaas—a term often used pejoratively—are nonfarmers (non-Jatts), often business families, most of whom had migrated from west Punjab during the Partition.
32. Arjun Singh had quickly fled. His government's mismanagement and complicity before and after the disaster was well documented. Following thousands of deaths and little succor to the stricken city, years later, Rajiv Gandhi's role in facilitating the escape of Union Carbide's executive would become clearer.
33. See, Sangat Singh, *The Sikhs in History*, 432–33, on the coordinated series of bomb blasts across North India in May 1985, pointing back to the government. In another example, he notes the attack on a political leader who survived and reported to Rajiv Gandhi that a senior Congress leader had ordered the hit.
34. See, for example, Sangat Singh, *The Sikhs in History*, 434–35.
35. Zuhair Kashmeri and Brian McAndrew, *Soft Target* (Toronto: Lorimer, 1989), 52.
36. Kashmeri and McAndrew, *Soft Target*, 52–53.
37. See also, David Kilgour, *Betrayal: The Spy Canada Abandoned* (Ontario: Prentice Hall, 1994), Chap. 9 on Air India bombing.
38. Kashmeri and McAndrew, *Soft Target*, 85.
39. Kashmeri and McAndrew, v–vi.

40. See, for example, 1984 Living History Project, T. Sher Singh interview, http://
 www.1984livinghistory.org/2014/10/29/t-sher-singh/.
41. Kashmeri and McAndrew, 84.
42. Kashmeri and McAndrew, 86.
43. Kashmeri and McAndrew, 87.
44. Kashmeri and McAndrew, 92.
45. See, Kashmeri and McAndrew, 45.
46. Marvine Howe, "Sikh Parley: 'We are United, We are Angry,'" *The New York
 Times*, July 29, 1984.
47. Sangat Singh, *The Sikhs in History*, 434.
48. See, Ram Narayan Kumar, Amrik Singh, Ashok Aggarwal, and Jaskaran Kaur,
 Reduced to Ashes: The Insurgency and Human Rights in Punjab (Kathmandu,
 Nepal: South Asian Forum for Human Rights, 2003), 45–46.
49. Jaijee, *Politics of Genocide*, 142.
50. Kirpal Dhillon, *Time Present and Time Past: Memoirs of a Top Cop* (New Delhi,
 Penguin: 2013), 278–79. Dhillon had been transferred from Punjab soon after
 Longowal's death.
51. Dhillon, *Time Present and Time Past*, 272.
52. Sangat Singh, *The Sikhs in History*, 439–40.
53. Indian Administrative Services.
54. Justice Ajit Singh Bains, *Siege of the Sikhs* (Toronto: New Magazine Publishing
 Co., 1988), 34.
55. Bains, *Siege of the Sikhs*, 35.
56. Bains, 34.
57. Kumar et al., *Reduced to Ashes*, 46.
58. PHRO determined that these killings of several young Sikh students in Nakodar
 were "unjustified." Bains, *Siege of the Sikhs*, 37.
59. "Chaheru organised the attack on the police escort party at the Jalandhar courts
 on 25 April 1986 in which Labh Singh was freed from custody." Joyce
 J.M. Pettigrew, *The Sikhs of the Punjab: Unheard Voices of State and Guerilla
 Violence* (London: Zed Books, 1995), 82.
60. See, for example, Sangat Singh, *The Sikhs in History*, 452–53.
61. See Pettigrew, *The Sikhs of the Punjab*.
62. Sangat Singh, 453.
63. See Julio Ribeiro, *Bullet for Bullet: My Life as a Police Officer* (New Delhi:
 Penguin India, 1998). Ribeiro maintains that the popular slogan attributed to
 him was not coined by him, but was helpful for police morale nonetheless.
64. Jaijee, *Politics of Genocide*, 131–32.
65. Pettigrew, *The Sikhs of the Punjab*, 82.
66. See, for example, "3 Sikhs Sought in Slaying," *The Los Angeles Times*, June 6,
 1986.
 Jaijee would later go with Justice Bains to investigate Bimal Kaur Khalsa's own
 death. The widow of one of Indira Gandhi's alleged assassins, Beant Singh (shot
 dead before he could be tried and convicted), Bimal Kaur had been elected MP
 during the jubilant sweep by Simranjit Singh Mann's Akalis in 1989. Her suspi-
 cious death inside her home, protected by security, remained contested. Jaijee
 wrote, "The only thing certain about her death is the date: September 2, 1990."
 Politics of Genocide, 119.
67. Excerpts of letter from Khalsa Press, "Text of Bhai Sukha and Bhai Jinda's Letter
 to the President of India," Panthic.org, http://panthic.org/articles/5155. See
 also, on reactions to their executions, Pettigrew, *The Sikhs of the Punjab*, 41.

Ten Thousand Pairs of Shoes

Abstract This chapter traverses the watershed events of 1984 that presented Kaur, Jaijee, and Bains the choice to recognize their privilege and no longer accept that which they couldn't immediately change.

While most accounts of Punjab's conflict begin with 1984, this book closes with that year. To relay the events that jolted the Sikh sense of self, the three main protagonists are joined by various voices as the two timelines running through the earlier chapters converge in the cauldron of this terrible year.

Though June 1984's fierce firefight between the militants and the Indian Army was in Amritsar, 1984 was indelibly experienced across Punjab. Sikhs, particularly in traumatized rural Punjab, were overcome with sentiments of betrayal and alienation.

The chapter then travels outside Punjab, from where Punjab's history is most often written: in November 1984, Indira Gandhi was shot dead, reportedly by her Sikh bodyguards. Anti-Sikh pogroms, radiating out from the capital city of New Delhi, claimed thousands of lives. The political currency of the November 1984 carnage then won Gandhi's son and the Congress Party a landslide election victory, unmatched since.

The immediate effect on the Sikh psyche was unmistakable: the year 1984 was an end and a beginning.

* * *

© Mallika Kaur 2019
M. Kaur, *Faith, Gender, and Activism in the Punjab Conflict*,
https://doi.org/10.1007/978-3-030-24674-7_10

> *Life can only be understood backwards;*
> *but it must be lived forwards.*
> :SØREN KIERKEGAARD:

WHEN THE EARTH TURNED AS RED AS HIS HOUSE, H.S. JAIJEE WENT SILENT. "My father had been an activist throughout his life," says Inderjit Singh Jaijee. "But at ninety-two, ninety-three years, you cannot do very much. After the Army attack, he stopped talking. Not just him, a lot of old people just succumbed to the shock."

Inderjit Jaijee had moved back to Punjab two months before the attack. "The situation was deteriorating. Something was about to happen. My mind was not in company work. But none of our forebodings could have prepared us for this." He quietens, remembering the seminal year.

The preceding months had not provided sufficient indication. It was 1980s business as unusual in Punjab: violent eruptions, protests, reported Akali-Congress talks, stalls, media warnings, and more violent incidents. Indira Gandhi held seven talks with Akalis in early 1984.[1] When February talks came very close to a settlement, a strike called by a Hindu group erupted in violence against Sikhs across the state of Haryana, "forcing the Akalis to abandon negotiations."[2] Violence was also reported in Punjab's other erstwhile portion, the state of Himachal Pradesh, as well as within Punjab.

"A senior police officer posted in Amritsar in February 1984 told us about how things were deliberately handled and mishandled, and were far from spontaneous," remembers Justice Ajit Singh Bains. This officer was soon unceremoniously dismissed from duty, for doing his job, he had told Baljit Kaur's camera a few years later:

"It was a zabardasst, mighty, strike. The Hindu group marched into Amritsar's railway station and created a ruckus. They took the model of the Darbar Sahib there and smashed it into pieces. Guru Ram Das's portrait was removed, rubbed with mud too."

"We arrested forty people for this. And then Congress leaders started calling, saying, 'Let them go, let them go.' I said, No, this was deliberate violence and vandalism by these men. And news of what has happened has traveled inside Darbar Sahib to Bhindranwale and his men. Our role is to diffuse the situation."

"Then I was summoned to the Circuit House. ... I told the Congress workers, Look, these men committing the violence had also been provided alcohol. Police intelligence confirms it was organized. This would be a good time for Congressites to clean house too! But they said, 'No, this will create bad press for us.'"

"The following day there were [retribution] killings that would not have happened if we had been able to make all the proper arrests. ... Later I heard that in Bhindranwale's speeches, which used to be recorded for Intelligence, he had said, 'Look, such a good officer, they transferred him too, because he is also a Sikh.' But any accusations about my communicating with him were false. It was just that when I got a call about something brewing, I responded. I did my job!"

Meanwhile, the tale of the two "Sants" had grown: Longowal was reported as the nonviolent resister, Bhindranwale as the firebrand instigator.[3] The latter was reported to mock the former's "Gandhian" stance in the face of increasing State violence. But even Longowal was losing patience and threatening the central government with intensified civil disobedience. "On one side was an icy cool, calculating and evasive Mrs. Gandhi—on the other Bhindranwale breathing fire and brimstone down [Longowal's] neck."[4]

Longowal and the Akalis threatened to burn section 2(B) of Article 25 of the Indian Constitution. This Article providing Freedom of Conscience and Religion in the Indian Constitution also states that Sikhs, as well as Buddhists and Jains, are encompassed under the umbrella term "Hindu." This overt denial of distinct identities in the Constitution has for long represented legalized marginalization of religious minorities.

"Clearly, the government would paint any call to burn an Article of the Constitution as antinational, and so this wasn't the best course of action," remembers former Punjab Advocate General G.S. Grewal, then a young lawyer in close contact with the Akalis. "I believed the Sikhs' separate identity must be recognized, but that it wasn't the time to make this an issue. I told Longowal and Bhindranwale this. And a group of us also went to some seven-eight leaders in Chandigarh and made them agree to not join in the burning."

"Longowal announced he must follow through. Now, there was a house divided, but also the others were scared. If only Longowal went through and was arrested, who would run the morchaas? So Badal and Barnala and others joined him. And they were jailed for the first time. They were humiliated, called militants, sent to run-down cells, not at all what they had expected. Longowal was happy they too went to jail for once! He would often comment on how he was sick of Badal and Tohra and others who would publically support the protests and civil disobedience, but not provide any financial backing. And then there was Bhindranwale. Well, when he spoke, people flocked, and they piled monetary donations in front of him. I have seen that myself."

As Akalis continued to fill jails, all Sikhs faced increased surveillance. Violent clashes erupted in parts of North India. Akali-New Delhi talks continued to yield no results, while media reportage about the menace of Bhindranwale, and by insinuation of all Sikhs, only spiraled. But even Indira Gandhi's personally selected Inspector General of Punjab P.S. Bhinder issued a statement that there were no criminals hiding in Amritsar's Darbar Sahib complex.[5] Bhindranwale's crew of about 400 men lived publicly in the complex—ever open with its four entrances; granted media interviews[6]; and attended sermons on the complex's rooftops. In a March 1984 trip to Chandigarh, Indira Gandhi's son Rajiv Gandhi declared that Bhindranwale was simply a spiritual leader, worthy of praise. There was no arrest warrant or legal case against Bhindranwale.[7]

March 1984 also saw the banning of the All India Sikh Student Federation (AISSF), the organization that Principal Tarlochan Singh's son Kid[8] would be accused of joining by the end of the year. Its young members, and those suspected of supporting them, began to be rounded up across Punjab. Then, April opened with the killing of ex-MLA Harbans Lal Khanna, who had led the

February anti-Sikh ruckus at Amritsar Railway station. His funeral sparked Hindu-Sikh clashes that resulted in eight deaths.[9] Then a Congress MP was shot dead in Chandigarh. The next day, one of Bhindranwale's right-hand men was killed mysteriously by a woman, after which this woman's body was found outside Darbar Sahib. Meanwhile, incidents of suspiciously synchronized violence—including simultaneous attacks on three dozen railway stations on April 15—escalated the anti-Sikh frenzy. The Akalis continued noncooperation movement—Longowal announced Sikhs would soon refuse paying government bills and would prevent grains from being transported from Punjab—was increasingly viewed as antinational.

Quiet reconnaissance operations intensified across Punjab. As later revealed by various sources, Bhindranwale and his men had for long been constantly monitored through the government's secret Third Agency, which was ordered not to take any direct action against their targets.[10] Since January 1984, Indira Gandhi had ordered the army to be on the ready, and secret exercises were being carried out on replica models of the Darbar Sahib at several sites.[11] But army presence in the fields of Punjab was still unthreatening. Once the largest recruiting pool of the Indian Army, Punjabis held on to their admiring affiliation with the forces. Folk songs and stories had forever popularized the image of a "fauji chacha," an "army uncle," in each family, who was bold, youthful, daring, and always ready for self-sacrifice. Army wives and widows were ubiquitous in Punjab; it was a noble calling. So, in early summer 1984, farmers from around Jaijees's Chural village reported army men in their fields—well over 125 miles from Darbar Sahib and Amritsar—without too much concern other than the damage caused by the soldiers' hasty tenting and trotting.

"But it had also felt somewhat different this time, because none of them were Punjabi," remembers one of these farmers 30 years later. "I remember so many outsiders, none of our Army boys. They spoke haughtily and didn't understand what we said. But they left after ten or twelve days that May." This farmer's own imprisonment was reported to the Jaijee home in early June 1984. Longowal had called on farmers to support the noncooperation movement by depositing a portion of their produce at Darbar Sahib. This farmer joined others from his area, taking trucks of grains and vegetables to feed the protesters.

With a high holiday approaching, people—worshippers and protesters alike—thronged to the golden domes. "Sikhs coming from outside could not at all anticipate what we had started feeling locally," explains Mrs. Paramjit Kaur Khalra. Amritsar residents began noticing ominous fortifications and armed takeovers of residential rooftops, schools, public buildings. "Still, even we were not so worried, given all the tensions that came and went in Amritsar. Even the more cautious people were not scared, yet." The Khalras continued their routines with their usual optimistic abandon.

Chaman Lal remembers witnessing the never-ending caterpillar of army trucks toward Amritsar, eventually to be sieged by at least 70,000 troops. "Look, honestly beti, we went out and offered those soldiers water." It is not

difficult imagining Lal being hospitable to any traveler, especially in the peak of summer. "We didn't know why they were there! To cut off Amritsar, the holy city, from every exit route! We didn't know then, the inhumanity that was being committed in our name." He expresses his embarrassment at being a Punjabi Hindu that year. "The whole plan was to make sure no one knew. This secrecy, this curtain over the truth in Punjab, is what has been the cruelest, ever since those Army caravans creeped into our Punjab."

On May 30, Indira Gandhi met with the President of India, turbaned Sikh Zail Singh, and had him sign off on imposing military rule across Punjab. He reportedly remained unaware of the plans for Darbar Sahib.[12]

Through secret parleys with New Delhi, some of the Akali leaders reportedly also knew about the impending attack. Says G.S. Grewal, "Tohra told us privately, I've come from meeting the Governor, I've told him it's not within our capacity to control Jarnail Singh now, if you want to do it, do it." Even if there was a clear (or co-opted or coerced) Akali nod, the attack's nature and ferocity was unlikely to have been comprehended by any of these leaders: Tohra and others were holed up in the complex for days, hiding to save their own lives.

On June 1, Kulbir Kaur Dhami and family arrived at Darbar Sahib to pay gratitude for the Guru's blessings, including the family's new tractor. They were inside the complex just minutes before the first firing by the army, and the commencement of the so-called operation. "This preliminary firing was just to assess the firepower of Bhindranwale and his men inside Darbar Sahib. Sant Bhindranwale was prepared too. He had told his men not to waste their limited rounds," says Kulbir.

"Despite eight hours of probing, the besieged did not oblige them by returning fire," writes Khushwant Singh.[13] Eleven people were killed, many injured, and several bullets lodged in the golden domes. A curfew was declared.

"So, understand this," says Kulbir, leaning forward. "The government had time to test the capacity inside Darbar Sahib, but they didn't take the time to warn pilgrims or evacuate Darbar Sahib. In fact, the government waited till people entered in large numbers the next day. The real deathly assault was timed and launched *after* the maximum number of people were inside for the shaheedi Gurpurab."

Guru-purab, Guru's-day, marks a day of death, birth, or martyrdom, shaheedi, of any of the ten Sikh Gurus. June 3 was the martyrdom day of the fifth Guru, Arjan Dev.

In his lifetime, Guru Arjan Dev had completed the task commenced by the fourth Guru and established the city of Amritsar; designed Darbar Sahib (Photo 10.1); attracted a considerable following; and had written voluminous scripture. Then, to protect against the distortions of oral transmission, Guru Arjun compiled the Adi Granth: the revelatory words of the first five Gurus and those they deemed inspired by the Divine (making the Sikh scripture unique in its demonstrated respect for all others equally faithful to a universal force, even if walking different paths). A century later, the tenth Guru would add the ninth Guru's writings to this Adi Granth and declare the final collection the Guru Granth Sahib, a living embodiment of all Gurus.

Photo 10.1 Darbar Sahib, Amritsar. (Photo by author, 2016)

In his death in 1606, Guru Arjan had defined the course of Sikh resistance against tyrannical rulers. Accused as an infidel for refusing to convert to Islam, Guru Arjan met his torturers, ordered by Mughal Emperor Jahangir, with resolute poise. He had groomed the sixth Guru, preteen Hargobind, to prepare defenses for the growing Sikh community. Guru Hargobind now began bestowing Sikhs with arms training to create sant-sipaahis, saint-soldiers. He built the Akal Takht, Timeless Throne, next to the Darbar Sahib, propagating the necessary tandem of the temporal and the spiritual. Thus ensued further clashes with the Mughals, tempered with the Guru's righteousness. Guru Hargobind later befriended the repentant Emperor Jahangir, who had ordered the death of his father Guru Arjan: exemplifying for Sikhs a hatred for tyranny rather than the tyrant. Tyranny was to be resisted at all costs, as demonstrated by Guru Arjan. His profound martyrdom day remains a high holiday for all Sikh progeny.

"We did not leave Darbar Sahib when the curfew was relaxed for a short time on Gurpurab," says Kulbir. "I was full of rage at the tense situation around. To be clear: I hadn't imagined the kind of monstrosity that I was about to see in the coming days."

"Even at this late hour," said Indira Gandhi, "I appeal to the Akali Dal leaders to call off their threatened agitation and accept the framework of peaceful settlement which we have offered. Don't shed blood, shed hatred." In her televised

address to the nation, Gandhi claimed the Sikh leaders remained incorrigible despite her government's best efforts. "The leadership of the [Akali] agitation appears to have been seized by a group of fanatics and terrorists whose instruments for achieving whatever they may have in view are murder, arson and loot."[14] The speech included no warning to civilians, no plan for their evacuation in order to limit casualties. Curfewed Punjab—where media, electricity, and water connections would soon be disconnected—was not Gandhi's audience.

Shoot-on-sight orders had quarantined the entire population. Months of drills had overcome any reluctance by army men to be deployed among citizens: the Sikh population was now the enemy within the nation's hallowed borders. "Not even a leaf moved without their permission," Chaman Lal remembers of the army clampdown on all movement in Punjab: rail, road, even foot. Under strict curfew, Punjab was cut off from the world, and most journalists were cut off from Punjab.[15]

Then, between June 4 and June 7, a fierce battle raged in the complex.

"We were in Nanak Niwas," says Kulbir Dhami. "The way the complex is built, you don't have full visibility from any one building. But the screams, we heard the screams from the sarais, as people in those rest houses were set on fire. ... And I saw plenty bullets fly, and bullets do not discriminate. Men, women, elderly, children. All fell. And the Army, they did all sort of things inside Darbar Sahib."

The majority of civilian deaths took place inside the rest houses. These pilgrim rest houses showed no signs of major shelling, corroborating eyewitness accounts of close-range massacres by the army. Sikh men's own turbans were often used to tie their hands, as they were beaten and left for dead, or shot. One of Jaijee's neighbors would return to Chural to narrate the carnage. Three decades later, in winter 2014, he sits across from me in the redbrick courtyard. "But first, please listen to this Babaji, who literally rose up from among the sea of dead." He turns to the older man who has come with him, tentatively riding pillion on his Enfield motorcycle.

Bushy white eyebrows rise and fall in sync with the large yellowing mustache over a sunbaked nose that exhales the stench of June 1984. "It was four AM on June fourth," he starts in his raspy voice, repeating the exact line of the now legendary ballad that was sung post-attack by a women's troupe, village to village, telling the tale of the firefight inside Darbar Sahib. But unlike the Nabha sisters, his recitation is not only about valor.

"We were stuck. I used to do voluntary service there. I would stay there off and on ever since I had been arrested for protesting Indira Gandhi's Emergency in 1978. I had remained in touch with Longowal's movement. Now I was holed in. But at dawn on June 4, it began in earnest. There had been no warning, no announcement or opportunity to come out. No one could go out from inside, no one from outside could come in, except for the forces. By June 6, there was an announcement asking us to line up. People from the rest houses. They ordered us to sit. In the courtyard of the Ram Das Sarai. All noncombatants, young and old. Then, a whistle pierced the air."

He circles a finger above his small turban.

"Just following this whistle by their officer, military men appeared all over the verandah above. Some grenades were thrown, but mostly I heard the tarrrr-tarrrrr-tarrrr of guns. People fell. I fell under some dead bodies."

"I lay there, still, for many, many hours. Khoon chatt chatt ke zindaa rahe. We survived licking blood on the ground. Blood on the ground, bibaji," he raises his sun-flaked palm with deep lines to ensure I understand.

"I was alive by sheer luck. Later, I heard another officer announce that any survivors capable of still moving should come towards him for safety. I finally decided to crawl out."

Of the survivors he saw, the terrified and dehydrated children were most striking. "We looked around to create some quick sieves. Put some cloth over an empty can. So we could just get some water to wet their lips, to keep them alive. Water from the mixture of blood, urine, feces all around. It was an unforgiving summer. And then, some soldiers saw what we were doing and started yelling. We said we were just trying to keep these kids alive. And they barked, 'These bastards still ask for water! They are scorpions, they too will grow up to sting us, they are better dead!' And then they struck my face with a rifle butt. Four upper teeth sunk in and I lay there bleeding."

The injured received little assistance for days. Red Cross workers were stopped a couple of miles away from Darbar Sahib, ironically at the historic Jallianwala Bagh, the site of the massacres of Punjabis protesting British colonials just 65 years before facing Indian guns in Amritsar.

Till June 6, the heavy artillery, reinforced troops, and chemical weapons had still not entirely dominated Jarnail Singh Bhindranwale's remaining men. Small groups of fighters—men armed largely with World War II guns[16]—continued to emerge from the basement of the Akal Takht, and fought till they met their end. "'Operation Blue Star' will go down in history as one of the biggest massacre[s] of unarmed civilians by the organised military force of a nation. The word unarmed is used deliberately as the disparity in arms on the two sides was so great that those resisting army invasion of the Temple could hardly be termed as armed."[17] It is also remembered in Sikh history as a courageous battle by a few against one of the world's largest armies.

Tanks rolled into the complex for the final assault. The battle ended around 1 a.m. on June 7. The bodies of Bhindranwale and his closest associates were taken away by the army. The edifice of the Akal Takht, the immortal throne, had crumbled under heavy shelling.

"There was no vestige of humanity." The lonely survivor among the corpses shakes his hand toward the sky. "Thousands died inside the complex. And not just Sikhs, and hardly just the militants. Even three hundred bhaiyae[18] died." Poor people, who sought langar and free shelter in the complex. "Phook diye," he raises both hands toward me. Blown up. He drops his hands. There is nothing else to say.

From Darbar Sahib alone, an estimated 10,000 never returned to claim their shoes, deposited with reverence at the entrance of the gurdwara. "The Operation

Bluestar was not only envisioned and rehearsed in advance, meticulously and in total secrecy, it also aimed at obtaining maximum number of Sikh victims, largely devout pilgrims unconnected with the political agitation," writes Ram Narayan Kumar.[19] The exact number killed remains ominously unknown.

The younger man at Jaijees' house now speaks. "Yes, so many, like Babaji, rounded up in that courtyard. But I was eighteen-nineteen. I ran to stay back in Samundri Hall and sought any weapons for when they came for me. We heard so much going on all around, but were safe in there. Then, the various leaders surrendered to the Army in the middle of the night." Announcements had been made on June 5 calling for the surrender of the people in the offices and rest houses. A few hundred came out with trepidation while others continued to hide inside, delaying their fate. The soldiers' outrage at any Sikhs found in the complex was by now redoubled due to the reports of a groundswell Sikh uprising across Punjab and India.

Thousands of miles from Punjab, spontaneous mutinies by some incensed Sikh Army men—estimated at 4000 from eight army cantonments[20]—caused furor. The government and the army command worried about far-reaching implications. But the mutineers, while ready to stake careers and lives for their community, were generally younger, lower-ranked men without a plan.[21] Through main thoroughfares, they attempted to reach Amritsar, which seemed to be their only aim. Well trained in arms, they hardly used them on the way. Their rebellion was easily quashed en route; those not intercepted and killed on the spot were arrested. And so this mutiny of sorts that first caused some panic in Delhi soon became a bonus victory. Details of the courts martial of those arrested are still largely shrouded in secrecy, but the extent of the disaffection can be gauged from two (disjoint) lists later compiled through civil society efforts, giving the names, army numbers, and sentences of 309 men and 942 men.[22]

Sikh villagers had also begun marching toward Darbar Sahib to help defend their most venerated site from the Indian forces. "A dandaa, a sickle, whatever people had, they grabbed, and rushed out, to protect against the desecration," says Paramjit Kaur Khalra. "Young and old, and many old women too, were brutally quashed along the way."

The Associated Press's Brahma Chellaney reported on what could be heard from the city's periphery: "The slogans—'Long live the Sikh religion' and 'Bhindranwale is our leader'—were heard briefly on each occasion and were followed by rapid army machine gun fire and screams."[23] Khushwant Singh reports that

[h]uge mobs numbering upwards of 20,000 each were stopped by helicopters. Tanks and armoured cars were sent out against them. Army commanders realized that time was running out and, unless they liquidated the resistance in the Temple, they might have to face a general uprising of the Sikhs. They decided to finish the task during the night of 5–6 June, no matter what it cost. ... An hour after midnight Longowal, Tohra, Ramoowalia, Amarjeet Kaur, and scores of others surrendered to the Army.[24]

The younger man at Jaijee's house 30 years later remembers what followed these leaders' surrender. "They had Ramoowalia make the announcement for the military. They knew announcements from them would not yield our surrender. And so on Ramoowalia's word, trusting him, we came out. They made us all line up. There were old women. There were children. They took down their names. The old women's, the children's, even the old men's. Not ours. ... Roadways buses came from the side of the water tank. They ushered in the old people, the children, and then, into every bus about ten of us unrecorded people. They locked the buses from the outside. We reached the Army camps. About twenty-five hundred people were there I think. I was sick, there was little food, and they interrogated us. But at least I was able to return home after five or six months, not like this Babaji. He was sent to Jodhpur jail."

The older companion looks up again.

"Yes, so after Longowal, Tohra, etcetera, left, they rounded us up and handed us over to Punjab Police. Those injured, like me, were taken to the hospital. After a week there, I was taken to a military camp with five or six hundred people. It was horrible. One little can to defecate, to urinate. If we tried to step beyond their orders, they had huge dogs there. Children and women were sent to jails, or even released. Not us."

Reports of one group of children, between the ages of two and twelve, lodged in Ludhiana jails, would surface in coming months.[25] "These children had been divided into three categories: dangerous terrorists, very dangerous terrorists, potentially dangerous terrorists," says Justice Bains. "They would be given some relief only after the dogged efforts of a social worker, a Hindu lady from Delhi, Kamladevi Chattopadhyay, who petitioned the Supreme Court in September 1984."

Captives were distributed all across Punjab's jails, remembers the old man. "And forget allowing any family or any lawyers. Then, about forty or fifty of us from this area were sent to Sangrur Jail. Any court dates they took us to, the judges asked why we were still in jail. But then these judges also issued another extension. And then, some orders came for five to ten of us to be transferred to Jodhpur. We knew little of what was happening. Over three hundred fifty of us were moved, including two women."

Justice Bains comments, "It is hardly atypical that people didn't even know what the court was being told by the government. And of course the courts themselves did not do their job or demand evidence." His Bains Committee would evaluate hundreds of such cases in 1985–1986 and order expedited releases of those who should never have been apprehended. Bains Committee's recommendation on the Jodhpur detainees was ignored despite the clearly recorded violations of all due process. And so, for six years, the old man from Jaijee's area remained over 600 kilometers away from his family, making it quite impossible to receive visitors who would deliver the basic personal supplies that are required in squalid Indian prisons.

Says the octogenarian, "Till today, a legal case about compensation languishes. No ruling government has done anything. I go for the court dates still, every month or two. Two of my young boys died during my imprison-

ment in Jodhpur. And my ordeal continues. But I did survive with my life. I survived under all those dead bodies. Later, like carcasses, they took the bodies away in trucks."

Darbar Sahib's dead were too many to be reduced to ashes quickly on the premises, though eyewitnesses noted hours of thick black clouds from near Guru Nanak Niwas on June 7.[26] More bodies were carted away, often in municipal council garbage vans. The government threatened and bribed local sweepers of the Dalit caste, which is often relegated the task of handling dead bodies, considered dirty or inauspicious in Hindu culture. They were promised possession of anything found on the dead of Darbar Sahib.[27] Unceremonious clandestine cremations followed.

After the firefight, plumes also rose again from within the complex. The Sikh Research Library, containing the valued archives and artifacts of the Sikh nation, including hundreds of original handwritten manuscripts, was set on fire. When Devinder Singh Duggal, the director of the Sikh Reference Library, had left the night of June 6, it was intact.[28] When Duggal refused to sign a receipt for handover of the burnt building from the army a week later, he was arrested.

The finally victorious tanks and soldiers were garlanded and cheered by many Hindu Punjabis right outside the desecrated complex. The communalized narrative of the "dangerous Sikhs" had its intended effect on the Hindu Punjabi community. Outside Punjab, this narrative prevailed. "The victory of the armed forces over the Golden Temple, Amritsar, caused wild jubilation amongst the Hindus all over northern India. It gave fulfilment to atavistic feelings of Hinduism's victory over Sikhism."[29]

Families around Punjab assumed the worst fate of the many missing. Kulbir Kaur Dhami's family back home in Hoshiarpur had performed their missing daughter's final prayers. Media censorship continued for days. Newspapers often printed black boxes. Punjabi media remained meticulously muzzled. "We weren't from Amritsar," says Kulbir Dhami, "so after the attack, we just walked out into the famous maze of narrow streets around Darbar Sahib. I don't remember exactly from where, but a Sikh named Gurcharan came for us. He told us that staying there was suicide. He led the way out." Sikhs living in homes around the complex had fared poorly: houses were confiscated, looted, and several people killed after bondage with their own turbans. "Our land was now clearly enemy territory," Kulbir says. She stretches her arms along the length of the small room that is now her orphanage's office. "It was just about eight feet by like twenty feet. The room we landed in after that stranger led us outside. Fifty of us from Darbar Sahib ended up in there. So forget sitting, it was standing room only. And remember how hot it was. And the electricity was cut. There we stood, with our lives held on our tippy toes. For seventeen days, no traffic moved, no real news moved. The Army had a free hand."

Worshippers and visitors were trapped not only in Darbar Sahib, but also in other gurdwaras hundreds of kilometers away. There are varying estimates of the number of other gurdwaras attacked: 38, 42, 74.[30] The quick cover-ups made it impossible to estimate the total number killed.[31]

Jaijee was in Chural during the attack. "Punjab was all pinned down. We heard the attack had started in Amritsar. But we heard more about the attack in nearby Dukh Nivaran Sahib." Patiala's historic Gurdwara Dukh Nivaran, literally the "Eradicator of Suffering," had become another carnage site.

Our relative's home in Patiala had been at some distance from Dukh Nivaran gurdwara. He lived to tell the story of witnessing, from his rooftop, the army move into the city. I remember hearing him recount how he had heard first some loud explosions then continuous firing for many hours; seen parts of the gurdwara light up; and then heard a persistent howl, he said, like that of a large, wounded animal before it dies. Perhaps thankfully, my child's mind did not comprehend the bullet-ridden bodies of trapped pilgrims who had slept the night before on the cooler marble floor of Dukh Nivaran Sahib. Our relative had later made his way, through back roads, to the home of friends who lived right across the gurdwara and who had a young child forced to go without food or milk for days. As he handed a small drum of milk to the petrified family, he heard about the lorries they had been counting. Lorries laden with dead and half-dead bodies wobbling their way out of the city limits.

When Jaijee was finally able to drive around Patiala town again after the attack, he too heard about the transport of bodies en masse. "Army trucks were seen heading to Bahadurgarh Fort, outside of Patiala," he says. "And there were cremations at two other locations in Patiala. In one, a crematoria attendant reported eighty bodies from the gurdwara were brought. At the Civil Hospital, doctors confirmed sixty-five bodies were brought. The Army later admitted to having killed twenty people at Dukh Nivaran. Residents described the stench of death and then the sky darkening ominously by the smoke of many fires."

Growing up, Rajindra Hospital, Patiala, was often mentioned in our house. It had been my Dadaji's final posting with the Punjab Civil and Medical Services and had taken him back to his ancestral Patiala. A senior doctor serving there in 1984 would tell my family that before the attack, an army officer had come to ask the doctor to hold some beds, because casualties were expected. When asked how many, the officer replied: 21. After the bloodbath in Dukh Nivaran, exactly 21 "wounded terrorists" were brought by the army to Rajindra Hospital.

The soil of Dukh Nivaran turned an indicting scarlet, eyewitnesses still remember. A man who was a young boy that June tells me: "You know how when a turban is washed, and then you wring it out, and water splatters out, just think about that ... but with blood. So much blood. All these bloody turbans. Blood everywhere ... we could not even estimate how many bodies this had come from. Because there were no bodies there, just the blood ... and the loosened soil below had porously retained so much blood."[32]

"Even just from the road outside, one could make out," remembers Jaijee. "That boundary wall, going towards Patiala, was riddled with bullets. Later, very cleverly, they had Sikh politicians order the construction of shops along that way, to cover things up. But at that time, even the Nishaan sahib flag was riddled with bullets."

Smaller gurdwaras nearer to his father's Chural home were also occupied by the army. The ghastly stories traveled quickly. "My father just withdrew," says Jaijee. "A chap so active, now lying in bed, feeling he can't do anything."

My Dadaji had been proud of his success within the Indian Army as a skilled surgeon—I had best known him for his steely precision in gutting grapefruit, cutting chicken for curry, and grafting cacti on luscious succulents—and fiercely held to his reputation as a feared disciplinarian. Through the Emergency years, he had even resonated with Indira Gandhi's rationales about national security. Then, in 1984, Dadaji stoically internalized the shock of being castigated as part of an enemy population. Later in life, he reflected that his first heart attack resulted from the effects of 1984.

"Many old people just died of heartbreak. My father stopped speaking and took to bed that June," Jaijee says, of the year that changed the world he inhabited.

* * *

THE WORLD HE INHABITED WAS REPLETE WITH INEQUALITY, CRUELTY, AND violence, but Guru Gobind Singh found time to master multiple languages, write poetry, patronize arts, and encourage sports, including his beloved falconry. A white baaz, falcon, became the constant companion of the tenth and last Sikh Guru, whose life would be marked with the sacrifice of all four of his sons—the older two died in battles with the Mughals, the younger two were bricked alive because they refused to compromise and convert to Islam—and whose death came early through treachery.

And so, in 1984, when the earth became unbearable, Sikhs took flight with the mighty Guru's baaz. "There were many spottings, a baaz here, a baaz there." Jaijee's eyes laugh. "Everyone saw them ... or needed to see them." The ever-pragmatic Baljit Kaur reports with earnest surprise, "I myself saw the baaz twice after the attack. The baaz story is not cooked up. At pivotal times, people saw it and felt the Guru's presence despite the disaster."

The Indian government continued controlling the narrative. Journalists were provided a closely supervised tour of Darbar Sahib after a hurried cleanup. But Brahma Chellaney, who had stayed in Amritsar during the attack, had already filed: at least 1200 deaths—twice the government's number—in the complex alone; killings by close-range shots at Sikhs with their hands tied behind their backs; dumping of half and fully dead Sikh men, women, and children into garbage trucks for mass cremations. The government issued arrest warrants for Chellaney, and *The New York Times* led vociferous protests, opining that his only crime was "doing his job too well."[33]

Soldiers given a free reign had trampled through with shoes, smokes, and scorn at the lives trapped inside. Journalists Mark Tully and Satish Jacob note, "The army certainly had plenty of drink available. A notification of the Government of Punjab's Department of Excise and Taxation allowed for the provision of 700,000 quart bottles of rum, 30,000 quart bottles of whisky, 60,000 quart bottles of brandy and 160,000 bottles of beer, all free of excise duty ... 'for consumption by the Armed Forces Personnel deployed in

Operation Blue Star.'"[34] The premises had also reportedly been stripped of all possible valuables, from donation boxes to utensils from the langar kitchen.

When the public was allowed inside again, petrified masses thronged to search for their missing loved ones. They were left to guess what transpired from any belongings—stray shirts, turbans, shoes, karaas—that still remained on the premises three weeks later.

"Even the general public rushed to our Darbar Sahib as soon as possible," says Mrs. Khalra. "People swarmed to see for themselves. In this area especially, the bond is deep and the wound was deeper. From the many telltale signs of the attack that remained, people felt an assault on their own bodies."

K.S. Dhillon, posted DGP Punjab in the immediate aftermath, writes,

> I personally saw the agony of Sikh men and women, ignorant of any extremist ideology, when they saw the bullet marks on the walls and doors of the Harimandir. They reverently ran their hands over what were, to them, real wounds inflicted on what they regarded as the incarnation of their gurus, and silently wept and sobbed.[35]

Indian newspapers fanned rumors,[36] including of prostitutes being found in Darbar Sahib; of pregnant women being rescued from the premises; of large quantities of drugs as well as condoms being retrieved.[37] These stories made the front pages, while corrections issued subsequently received scant highlight. The stories continued to be peddled as fact long after.[38] That the Darbar Sahib had been fortified and stockpiled with large amounts of sophisticated weaponry was quickly debunked by Indian Army experts like Lieutenant General J.S. Aurora, a former commanding officer of two of Operation Bluestar's commanding officers, who also admitted "the extremists had taken every advantage of their defensive positions and fought valiantly and skillfully."[39]

The wounded Darbar Sahib had let out a collective call. Particularly in the traumatized countryside, Sikhs were overcome with feelings of betrayal and alienation. "To the Sikh masses," notes Khushwant Singh, "neither Mrs. Gandhi nor Bhindranwale, neither the Akali Dal nor the Congress party, nor any individual politician, mattered very much; the sanctity of the Golden Temple and the Akal Takht did."[40] Jaijee remembers the group of bereft Sikhs that headed out to Amritsar from his area, on the other end of Punjab: "And my brother led another jathaa from Chural. He was arrested for protesting. He used to be in the police, was the SSP Amritsar, was arrested by his own troops. But he was not mistreated."

The outrage was shared among Sikhs of all ranks, though strongest at the base of the economic pyramid: the anglicized, city Sikh had still been able to "pass" throughout the buildup of the 1970s and 1980s. "Have I told you about Jagjit in 1984?" says Baljit Kaur. "He used to work in Delhi. That June, he was meeting with some Hindu businessmen who had the nerve to send out their peon and get mithaii, sweets, celebrating that Bhindranwale had been killed and Akal Takht had been dominated and whatever else. And when Jagjit came and told me this had happened during his trip, I said, What did you do? And he quietly said, 'Well, I couldn't do anything, I took a piece of mithaii too!' I was incensed, I stared at him and shouted, I would never have! He looked stung."

There were some prominent protests by Sikh elites. "My brother Gursharan returned a Firearms Medal he had received," Baljit Kaur says. "So many people, like historian Ganda Singh, returned their medals," she says almost dismissively; this was the least that could be done. But she agrees it was only done by a relative handful. Amarinder Singh, the Maharaja of Patiala (Inderjit Jaijee and Baljit Kaur's nephew), resigned from the Parliament and the Congress Party. Indian ambassador to Norway Harinder Singh resigned. Simranjit Singh Mann resigned from the Indian Police Services. And various Sikhs, including the noted humanitarian Bhagat Puran Singh, returned their government-granted honors.[41] Even the longtime Gandhi family friend Khushwant Singh returned his national literary honor: despite his many flip-flops later, the prolific writer's decision then was significant and prominently captured by newspapers that could not bother with the ordinary village Sikhs.

Meanwhile, Punjab had already become the site of another operation, code-named Woodrose. The state was crawling with soldiers, ordered to approach identifiable Sikhs as enemies.[42] Cordon operations, mass arrests, torture, sexual harassment and assaults, disappearances, were employed to discipline the countryside.[43] Tens of thousands were traumatized and antagonized.[44]

In a June 25 address, Indira Gandhi spoke of her "healing touch" for Punjab and asked Sikhs to stop harboring ill will. Gandhi also summoned some high-profile Sikhs to assess reactions to June 1984. Remembers renowned author Ajeet Cour, "She called small groups of Sikh intellectuals. I told her the next step is very simple. She should wear a salwar kameez, wear a chunni on her head, and go ask for forgiveness."[45] But Gandhi's concern was only assessing possible retaliation, electoral and personal.

And then, on July 10, 1984, the government unfurled its White Paper: the official account about June 1984 that pushed the government's version to a farcical extent. Blaming the Akalis for singlehandedly failing Punjab, insinuating intrigues and foreign hands, and grossly underreporting the casualties,[46] it was dubbed "Operation Whitewash."

The government had also primed itself to spin yarns across continents. The Sikh diaspora by now had the ear of foreign press, ministers, and donors. Angry rallies across England and North America had soon morphed into effective lobbying and human rights advocacy. The diaspora movement was gaining traction.

Soon, a video cassette began appearing in the mailboxes of Sikh households across North America. It contained footage of what the government claimed to be the authentic story about 1984 and the rationale for the attack. "Unfortunately for India, however, the quality of the tapes was poor. Careless editing revealed several phony segments," note Canadian journalists Kashmeri and McAndrew. "Accompanying the approximately fifty thousand cassettes was a glossy magazine entitled The Sikhs in Their Homeland—India, which praised Sikhs' contributions to India and denounced the evil separatists, especially those outside India."[47]

* * *

New Delhi was in a tearing hurry to clean up the telling destruction in Amritsar. The government arranged the rebuilding of the Akal Takht; donating gold and commissioning willing Sikh contractors. "You know, after eighty-four, even those who had no sympathy, even those who hardly looked like Sikhs, and in fact even some non-Sikhs, if they saw that building, they were enraged," says Kulbir Dhami. "Indira Gandhi knew she had to build over our memories, and quickly."

To give their effort an air of legitimacy, the Congress government organized the calling of the traditional Sikh Sarbat Khalsa—communal meeting—on August 11. The event ended with a whimper: government inducements were a clear insult to most Sikhs, and only a few government-paid busloads attended.

"It all really began for me with the Sarbat Khalsa of 1984." Baljit Kaur remembers her own awakening as a Sikh activist. But she means the larger Sarbat Khalsa meeting that was called after the government's attempt. "On September 1–2, 1984, the jathedaars called a gathering, a World Sikh Convention. The government quickly began blocking all roads, trying to prevent people from attending. I immediately took time off from my job and went from Chandigarh to Chural and readied a group of about ten villagers to go with me to Amritsar. My husband warned that I was taking a big risk, that I would get caught by police and be killed. I told him to completely disown me if I got caught and just say, Sundi hi naahin hai, I don't have control over this woman!"

"Anyway, so we went. And four days ahead of the meeting date. We had worried about how much they'll stop us on the way. They had not blocked the Hari-ke Pattan crossing when we went—heard it was all closed the very next day. Over one hundred fifty thousand people had been turned away from Hari-ke pattan."

"And then in Amritsar, people of Amritsar, of the walled city, were breaking their walls and homes to create passages. They would beckon us over, 'Come from here! No, here!' They were opening ways into Darbar Sahib. It was really wonderful."

She stops to smile at the resilient love.

"The first day we got there it was about a lakh [a hundred thousand] people, I was told. By the time we left, three lakh. Singh Saabs had said Khaane, Rehne da sehraa, Amritsar shehar de sir te, that Amritsar locals would take charge of hosting and feeding everyone. And did Amritsar respond! And I remember a free flow of milk supply from all over the Majha region. The big barrels, not the matki-pot kinds, but big long barrels, full of milk, kept being donated. And food was freely available. They in fact had to announce, 'The army surrounding us has also been fed now, we need the influx of food to stop.' Imagine that!"

"And with the lakhs of people inside, there were only three toilets, I remember. And let me tell you, they were spotlessly clean. Amritsar locals had really taken it upon themselves. ... As soon as one person would leave, the women would rush in with phenol and a broom. Kept things spotlessly clean."

In the caste-segregated society, bathroom cleaning remains an almost political act in India, even today. Baljit Kaur continues to describe her pride at seeing the casteless teaching of Sikhi in actual practice in 1984. "They didn't let things get out of hand for a minute. Everything was done enthusiastically. Take our sleeping arrangements too. It was raining those days. And we were sleeping in the verandas. And the people were using jute sacks to soak up water, to keep things dry, to make sure we got rest. ... It was an overwhelming feeling of community."

"Of course, the Army was surrounding us at all times. And yet, I remember on top of a gurdwara, Shaheedan da gurdwara, I think, a Khalistan flag flew! At the same time, all the high points in the city were manned by Army machine guns. They thought they would scare people. The backdrop of the Army, ready to pounce, remained pervasive. I remember people alerting, 'Helicopter aa gaaya! The Army has called in helicopters now!' This and that."

"And all sorts of stories spilled out. People shared about the various cruelties. Those who had survived the attack came swarming in too. And there were lots and lots of youngsters. And speeches about the Sikh history of sacrifice. How with Guru Arjan's shaheedi, Sikhs got Akal Takht Sahib. With the tenth Guru sahib's, we got the Khalsa. Today, with Akal Takht's shaheedi ... think of what's next. The crowd would become a sea of voices. Khalistan Zindabaad! Khalistan Zindabaad! All around me, everywhere, everyone."

She stops to blink; the energy remains overwhelming in her mind's eye.

"Also, I had noted that one section of Sikhs was very, very quiet. I was also just learning all these dynamics. This quiet section was the Babbars. They felt they were seen as suspect given their whole Bhindranwale dynamic. So they were quiet, till, one girl, must be about sixteen, got up and said she wanted to address the crowd. She said, 'Main Babbaran di dhii haan, I am the daughter of Babbars, and I was next to Amrik Singh inside. He said to make sure to carry one message for us, that the Babbars gave full support in the end!'"

"I remember I saw small, sad smiles erupting on faces around. The girl broke down and cried later, but she thawed that ice."

"Lots of people told of lots of horrors that hadn't come out yet."

"And I have other stray memories. Like during the evening divans. I heard, 'Do rupae babaji de naam te ...! Two rupees in the name of Babaji.' Bhindranwale was the Babaji. His absence was very present."

"What I myself was very aware of though was that it was mainly the people from the villages of Punjab who came out—came in droves, came with their Panchayats, came in full force. Not the city Sikhs."

Later, Jaijee talks about Baljit Kaur's boiling spirit: "You know, the Army had clamped down hard. And Baljit, you won't believe me, she took a taxi herself and she went to Darbar Sahib, right after Bluestar. It was a single-person venture. She went to put up huge posters. You know, every sensible person told her not to do that, because it was very dangerous, because she could have been shot anywhere. But she did it."

"And, not only in Amritsar. She did this on her way back too, in Jalandhar, in Ludhiana."

Baljit Kaur explains these large posters. "What I took for Sarbat Khalsa, was an English magazine's photo that captured the Army outside and the Sikhs inside. It was a compelling photo. Bhindranwale's boys standing on the Akal Takht. And the Army you could see on the other side. One of the boys is wounded. It was a very moving picture. I decided to take it with me, this snapshot of the battle. It was just a magazine photo. Yet, the total blackout in Punjab was so complete that this was a big deal, to have a photo."

"I had gotten it blown up. From a studio in Sector 17, Chandigarh. The Sikh owner didn't know me, I didn't know him. I just took the photograph and said I want color blowups of this picture. We settled the money. And he did it. He didn't ask why, and I wasn't going to tell him. But he sympathized. Otherwise he wouldn't have done it!"

"And I had taken lehvi to stick the posters," kneaded wheat flour separated into small balls of putty. "In Darbar Sahib, I had barely stuck up two of these, and many youngsters came running with questions. 'Auntyji, what does it say? Where is it from? Where are you from ... from outside? Babaji jiyonde haan? Is Babaji alive?' I realized their concern and excitement was around whether Bhindranwale might still be alive. They were not sure about anything. Such blackout had been enforced."

The rumors of Bhindranwale being alive served various constituencies. Some began taking solace in the fact that he may still return to extract revenge. Others attributed him with supernatural powers—one Sikh sect still refers to him as a living saint. The government was able to avoid a cremation that would once again have prompted Sikh villagers to throng Amritsar. Writes Sangat Singh, "According to some reports, Sant Bhindranwale, critically injured, was alive when captured. ... It took Army Headquarters six hours to obtain orders from Indira. ... He was tortured and died defiantly."[48] Photographs smuggled out of Amritsar in 1984 include one of Shabeg Singh, Bhindranwale's right-hand man and the chief architect of the armed response of the Sikhs from within Darbar Sahib: eye gouged, body battered, it shows marks of torture likely post-capture.

"And then, as the excitement around the posters grew, I got called up by the jathedaars," says Baljit Kaur. "They were watching everything, standing guard upstairs. They sent a messenger and summoned me. ... It was clear they thought I may be a government spy. They asked me who I am and why I am pasting these? I said, I'm doing this because we have no photos of what happened."

"Then the Damdama Sahib Jathedaar finally placed me. See, the Jathedaar knew my older brother from when he had been posted at Bathinda, much before eighty-four. He said to the others, 'She is Jaijee's sister.'"

"They then told me they were concerned the Army can just use anything as an excuse to enter. So, I went down and started taking the posters off, and people asked more questions. 'Why, why Aunty, why are you taking it off?' I explained we didn't want to give the Army any pretexts. We talked calmly as I removed posters."

"There had been other announcements too. That the Army might cut the loudspeaker, might cut the electricity, that those who had the relevant skills be on standby. Nothing at all broke down for those two days. People were working together. It was fascinating. And then, as we all started leaving, I remember youth flooding the stage. They had not really been allowed the stage as older folks had been talking. We warned them to leave. That the army will shoot at you, will take you. You think they listened? I am sure many were shot at that day."

"As we walked to the train, I remember the white paint. In big letters it said, Khalistan Express. So, I took Khalistan Express, back to our village! And every time Khalistan Express stopped anywhere, people would rush toward it and yell Zindabaad! Long live Khalistan!"

"Finally, I got back to Chural. My father was so proud I had gone and represented. I had just known I had to go! I felt Sikhs had been slapped in the face. My daughter wouldn't stop me. She would say, 'Go Mama, but be careful, Mama.' She was little."

Baljit Kaur stops. The memories of her daughter often mesh together: she was no longer a little girl in 1984. Confusion contorts Kaur's face briefly and then she laughs it off, remembering her tragically deceased only child. "I was just saying to you that Justice Bains has started forgetting things, and now look at me!"

"So anyway, no one else went, but it was okay. And my husband, despite our conversation that he would just have to disown me, if he had made it really difficult, I don't think I would have gone. And my in-laws didn't stop me either. They thought she is off the deep end! But then, really, even if people didn't actively do anything, there was a shared feeling in the hearts of all Sikhs."

The Sikh spirit and growing angst was not lost on New Delhi. Indira Gandhi ordered the Army to vacate Darbar Sahib. By October 1 the forces were withdrawn, the posthaste edifice repairs completed.

The prevalent Indian mainstream narrative in the following months reflected a surge in Prime Minister Indira Gandhi's popularity as India's "savior" who had resisted the Sikh threat head-on. Narasimha Rao, then the External Affairs minister, gave statements about the "foreign hand" that had threatened the country and held that "if the government had not initiated the Army action against the terrorists in Punjab, the security of the country would have been in peril."[49] Even weeks later, the government provided nothing more specific about the supposed imminent threat.

British documents, declassified under the 30-year rule, have now revealed letters between Margaret Thatcher and Indira Gandhi deliberating British Special Air Service (SAS) support for an attack on Amritsar. These communications are dated February 1984, four months before the reportedly exigent and unavoidable Army action.[50]

The attack's political benefit to Gandhi's next election was openly discussed. "Elections in October?" ran a headline in *The Tribune* on June 27, 1984.

At the same time, it was widely observed that Indira Gandhi began living in fear.[51] Sikh history through the centuries stood testament to the fact that no one who ever ordered an attack on the nerve center, the beautiful Darbar Sahib, had been forgiven.[52] Stories of how tyrannical rulers of the past had been punished by Sikhs were now retold, and even more loudly in the diaspora— Gandhi's government and Congress foot soldiers would for weeks protest the BBC for its reporting of protest rallies where such a fate for Indira Gandhi was wishfully predicted.[53] New Delhi strengthened all security protocols. And yet, Gandhi was said to be consumed with the question not of if, but when, they would come.

<p style="text-align:center">* * *</p>

THEY WOULD COME FOR THE CRATES EACH MONTH. Take away the dozen empty glass bottles for a full set of black, orange, and yellow colas. By November 1, 1984, scrambling to find weapons in their homes, some Sikh households collected these bottles from their kitchens and pantries to use against the marauders—these more fortunate, more wealthy Sikhs had some time to prepare for their defense. Crude Molotov cocktails against mass, armed mobs.

"They had first televised her bloodied body for a whole day, and then the next day, systematic killing began in earnest," explains Kuldip Kaur of the events that would convince her to send her only son, Ginnu, as far away from Delhi as possible. Indira Gandhi had been assassinated on October 31, 1984. "Now no Sikh was safe," Kuldip Kaur remembers, sitting in her home in the affluent south Delhi neighborhood.

After operations code-named Bluestar and Woodrose had seared through its countryside, Punjab would become eerily uneventful in November 1984, while an anti-Sikh pogrom unfolded everywhere outside the Sikh heartland, starting with New Delhi. "On three successive occasions in 1984 Sikhs as a people were attacked. On each of those three occasions, their social class, their family background, their service to and positions in the structures of the state signified nothing. The fact that they were Sikh removed their status and their rights from them," writes Joyce Pettigrew.[54]

"First the assassination news that shocked everyone, and then the rumbles that some mob is marching," recounts Kuldip Kaur. "People started advising each other: call everyone back home, from schools, from offices, from work sites. Because on television they reported she was killed by Sikhs." In contravention of the usual practice of not revealing information that might incite communal violence, All India Radio had quickly noted that the Prime Minister had been gunned down by her Sikh bodyguards. "But nothing happened that day or night really," remembers Kuldip Kaur.

Indira Gandhi's dead body lay at the elite All India Institute of Medical Sciences. Her son Rajiv Gandhi had landed back in New Delhi hours after her death. The market near AIIMS had seen attacks and the first bonfire of Sikh turbans soon after Rajiv's arrival. About half a dozen deaths were rumored. The chief executives of the ravenous violence that would follow now thronged

around Rajiv Gandhi: "Significantly, about 1730 hours, when Rajiv Gandhi came out of AIIMS after seeing the dead body of his mother, he was greeted with the slogan *Khoon ka badla khoon se*, blood for blood. H.K.L. Bhagat, the doyen of Delhi's underworld urged the crowd, 'What is the point of assembling here.' Their field of operations lay elsewhere."[55]

Soon, the turbaned President, Giani Zail Singh, arrived at AIIMS hospital, rushing back from a foreign state visit. He was greeted by a growling crowd. His cavalcade was stoned, and he barely scurried away unharmed.[56] He hurriedly expressed support for the plan to elevate the grieving Rajiv Gandhi to Prime Minister. That evening, Rajiv Gandhi took the oath. Two high-level meetings were held at the new Prime Minister's residence on the eve of the pogrom.

"We were unaware at that point that the ruling Congress Party was using all the organs of the Indian state to conduct a pogrom," writes author and child survivor of the pogrom, Jaspreet Singh. "The state-controlled All India Radio announced that, barring a few little incidents, the 'situation was under control.' The state-controlled television, Doordarshan broadcast live the national mourning as Mrs. Gandhi's body lay in state (with Bergmanesque closeups of her face). But the soundtrack was the soundtrack of the 'mob' created by the cabinet ministers and members of parliament."[57] Bollywood's superstar Amitabh Bachchan, Rajiv Gandhi's close friend, was reported by many as lending star power to this instigative soundtrack on television.[58]

"And then, on November first, the mob started marching," remembers Kuldip Kaur. "In our market, a posh market, a very famous market, the stores were largely Sikh-owned. They started with looting these shops. Woodlands. Bata. Taking away bagfulls of shoes. And electronics shops, television shops. Just pulled away whatever they wanted. And the Sardar men by now knew not to come out. So some of the women from these families in fact went out to see if they could save their businesses from the arson. And they went to the policemen, who just laughed at them, said, 'Bachaa lo jo bachaana hai! Try saving what you can!' They barely got back home safe."

But homes were not safe either.

"The warnings would crescendo many times throughout the day: The mob is coming, the mob is coming! They hadn't come on our road yet. But we had neighbors, very good friends, who said, 'Please don't stay at home. Come over to our house.' First, my husband just wouldn't even hear of the idea. 'We are not going to hide,' he said."

"Then, in the adjoining locality, the mob entered a Sardar house. A big business family. And they desecrated everything, looted everything, rolled the carpets out, stole the silver, and then set fire to the house. And then they got into gurdwaras, and in one gurdwara we knew well, they rolled the local bhai saab in the floor rug and set him on fire. He was half burnt, half alive!"

The June attacks had removed forever any barrier in the Indian psyche to attacking faith centers. "Nothing was sacred anymore, everything was permitted," wrote Ivan Fera in 1984, tracing the coordinated carnage and ritualistic killings. "It was the first time that such invasions into the psyche of a particular

community were carried out for purely political ends. Officially violated to this extent, the Sikhs were now common fodder for everyone."[59]

"Not in our wildest dreams did we ever think anything like this could happen," says Kuldip Kaur. "That we would have to scurry to our neighbor's house. You know, we had a little doggy at that time. My neighbors were the ones who told me, 'Bring him along too, otherwise when the goons break in, he will come looking for you and give you up!' I realized they were picturing our possible fate. We stayed, curtains drawn, for a day and a half, holed in. Couldn't get any supplies. Nothing."

"And we were the fortunate ones. Across Yamuna, in poor colonies, they brutalized people. Sikhs were tortured to death, slowly, deliberately. Their bodies desecrated."

From Kuldip Kaur's house, I travel to meet with a woman who was a young girl in one of these colonies in November 1984. Balvinder tightly purses her lips between short, clear sentences. Her eyes masterfully repel moisture.

"We lived in front of the train tracks. On the morning of November first, a train stopped, and a large herd of people jumped off. Jaats.[60] We later heard these men were from Jind, Narwana, Rohtak. And there was just lots of haa-haakaar. Lots of screams kept rising. They beat a whole colony down with stones and crude weapons."

"We just had to wait for it to befall us. My father sat praying, meditating through the night. I was in the room with my parents and two younger brothers. They were three and five. My older brother was standing guard outside. My father stood up at four AM and said to me, 'Betaa, this day, you'll remember this forever!'"

"He had not even for a second entertained the neighbors' suggestions of cutting his hair. He knew what was about to come. My father was proud and he was committed. He told me, 'Take your brothers, open their topknots, make plaits, and dress them in some frocks from the neighbors.' I did as I was told."

Attempts at survival were varied. Many parents tried to protect young boys from the gendered targeting by disguising them as girls, trying to decrease the immediate risk to their lives. Then they realized girls were also marked prey. Others painfully cut their children's lovingly grown and groomed hair, hoping the orders to kill were limited to identifiable Sikhs. But turban tan lines gave many away nevertheless. And no group of Sikhs was protected when the armed crowds came—came with lists and information about Sikh households and killed without discriminating between the less and more adherent.

"It was around ten AM," says Balvinder. "They attacked our colony. Our next-door neighbors, they were very nice. They had said, 'We won't let anything happen to Sardarji.' And they hid my father. But then another neighbor reported, 'The sardar is hiding here.'"

"So the mob tightens around the room where my father was hiding. My father was young, agile, knew gatkaa." Sikh martial art of gatkaa, designed for fighting boldly while outnumbered, has been taught since the time of the sixth Guru. "My father jumped out with a large stick. And at this, the stunned mob

retreated. He jumped over the wall, onto the roof. And then, they came back. And started raining stones on him. As more hit him, he fell down. He kept fighting them, with just one stick. And then from behind, someone struck him hard. And more and more gathered on top and beat him."

"We were watching. And then some men came in to me, and started grabbing. I lurched back, blocking access to my two little brothers. But colony people intervened. They said they would not let girls be raped.[61] And that the children had to be spared."

"Outside, as my father was being pulverized, my little sister and my mother were trying to intervene. My sister was hit and her head split open. Lots happened. He was killed."

She blinks. With the resolve she developed as a child, she continues, "And ten to fifteen days later, I went to school. It was important for me to go to school. I had exams. And some of the Jaat girls there said, 'So your papa was killed too?' And I would just burst out crying. And some of these girls told me, 'If this happens with us, Balvinder, you please save us, okay?' From these conversations I realized their families were the ones used, were involved, and they were now thinking about retaliation."

The stories of impending Sikh violence were spread widely by the architects of the pogrom, providing further justifications and instigations: "Sikh boys from Khalsa College are coming to rape our girls!" "The Sikhs have poisoned the Delhi municipal water supply!" "Trains are returning from Punjab with bodies of butchered Hindus!"[62]

Meanwhile, an orgy of violence was unleashed on Sikhs: politicians met mercenaries met opportunists met religious bigots.

"Rubber tires were put around Sikh necks, and they were burnt alive, as we all know." Kuldip Kaur repeats the now iconic image of November 1984. Sikh women were ferociously targeted, often in front of their families, including through individual and gang rape,[63] in some instances over multiple days.[64]

"Certain images had to be burned into the psyche," noted Ivan Fera. "How else to explain the fact that the men were not merely killed but tortured to death—limb severed from limb, eyes gorged out, burnt while they were still alive—in instance after instance, all over the city, in the very presence of their children and their wives? The killings were ritualistic: in several cases, the hair of the victim was shorn off, and their beards set on fire before they were killed."[65]

"The killers had no fear of police or the authorities in satiating their blood lust, calculatedly planned by senior Congress politicians armed with voter lists," writes eyewitness journalist Rahul Bedi.[66] The foot soldiers were the Jaats, the Gujjars (herders, often relegated to slums in urban areas), and the impoverished Dalits. The Haryana Chief Minister Bhajan Lal had further propelled the murderous storm: droves of Haryana policemen in plain clothes are said to have been bused to Delhi, joined by local strongmen and criminals, aided by the Delhi police.[67] Some poor people, formerly used by Congress strongmen to fill buses to political rallies and protests—a common practice by political parties then and now—used this opportunity to profit, and many to exhibit power over the new national enemy. Rickshaw pullers, drivers, gardeners, maids, mail-

men, had temporarily overcome their oppressed status in society and held sudden power to loot, rape, pillage, kill. Those orchestrating the crimes kept their hands milky clean, greeting world leaders for a somber state funeral.

Indira Gandhi's state funeral had been delayed three nights until November 3. "Only after her funeral things settled down," Kuldip Kaur remembers. "Even then, the trains, the buses, any sardars coming, going, they were snatched out, hacked to death."

Jaijee pursued precisely these casualties. "Civil rights groups in Delhi wrote reports almost immediately," he says. The November pogroms had taken place right under the noses of the crème de la crème of modern India's intellectuals, lawyers, artists. It could not be ignored, despite the government's best efforts. But, as heartbreaking as the Delhi reports were, they only captured a fraction of the destruction. "On trains all over India, especially those coming through Haryana, or coming into Delhi, Sikh passengers were sitting ducks," says Jaijee (Photo 10.2). "I began writing to the Governor almost immediately. And the Railway Ministry. They had logs, they had the manifests from which it could easily be assessed which passengers never arrived at their ticketed destination. And when we got a meeting with the Railway Minister at that time, he said, 'Sorry, government has told us we can't release list of Sikh passengers … only Rajiv Gandhi can.' After three or four trips that I made to his office, he did say around seven hundred or so were killed. So easily, I thought, at least two to three thousand. It was safe to at least double or triple what they were privately conceding. Again, a real death census is sorely needed!"

Not only trains from across India, but Sikhs at home in various states in India faced deathly violence. In Bihar, Uttar Pradesh, Madhya Pradesh, Maharashtra, story after story reconfirmed how Congress workers had given free rein to local criminals, strongmen, and anyone with a score to settle against any Sikh. West Bengal stood apart, a notable exception: the communist Chief Minister Jyoti Basu quickly thwarted massacres using his government's machinery. Tellingly, elsewhere too, when individual civil servants or police officers defied the general orders, civilian deaths were quickly curtailed. But the overwhelming sentiment, shared by non-Congress ministers and workers, was to allow bloodletting. For example, the Janata Party leader Chandra Shekhar, known for avoiding communal rhetoric after June 1984, was approached to lead a delegation to the Prime Minister's office to appeal for some intervention in the butchery. Shekhar meekly said, with folded hands, "I cannot do it. I don't want to be accused of ruining the late Prime Minister's funeral."[68]

Seven thousand to twenty thousand Sikhs were killed across India; at least 3000 perished in New Delhi alone.[69]

Media reports about the pogroms "could have been coming from another planet."[70] This had been a spontaneous eruption of outrage, ran the official narrative, since the masses were blinded by their anguish at the assassination of the Prime Minister. In reality, the murderers came exactly prepared, well-armed and with a standard operating procedure. Often, "the earlier mob limited itself to beating up the Sikhs till they fainted or died; the second mob burnt their bodies

Movement Against State Repression

Convener :
Justice Ajit Singh Bains (Retd.)
Chairman,
Punjab Human Rights
Organisation
22, Sector 2, Chandigarh
Tel. : 28162

Co-Convener :
Inderjit Singh Jaijee
Former Member Legislative
Assembly
314, Sector 44, Chandigarh
Tel. : 20489

Co-Convener :
Lt. Col. Partap Singh (Retd.)
President,
Bharat Mukti Morcha, Punjab
92, Sector 18, Chandigarh
Tel. : 24641, 40209

General Secretary (PR.)
Mrs. Baljit Kaur Gill
64/2, Chandigarh
Ph. : 31928

− PRIVATE AND CONFIDENTIAL − Chandigarh :

Dated 1.8.90

Subject: Sikhs killed/wounded in November, 1984
riots within the premises of Indian
Railways.

...

Dear Mr. Fernandes,

This refers to to our discussions on this subject
at Delhi. On the last occasion, you had asked me to meet
you on Monday, the 30th July. I took a trip to Delhi for
this purpose, but was unable to see you as you were busy.

As personally explained to you, a large number of
Sikh travellers were killed by Congress (I) provoked mobs,
mainly within the Congress (I) ruled States. We have been
approaching the Ministry of Railways and the Central Govern-
ment ever since to get information about these unfortunate
travellers. All that we have received in reply to our
queries was sphinx like silence or the standard reply that
this information is available with the States. The States
on the other hand are non-communicative on the subject.
The replies to our direct questions in the Parliament have
been equally evasive.

The reluctance on the part of the previous Government
to disclose this information led us to believe that more
people were killed than was known and for that reason
Government was withholding information. Our further
investigations now indicate that about a thousand people
were killed at the Railway Stations and an equal number
were killed by worked up mobs in between Stations by
stopping trains.

With the change in Government we had better hopes.
Mr. N.K. Mukerjee, the former Governor was much more
sympathetic and took up our case with you. Your response
has also been equally humane and gives us hope that all

(contd..P/2..

Photo 10.2 Letter from I.S. Jaijee to George Fernandes, Union Minister for Railways, seeking information about Sikhs killed on trains across India in November 1984. (From I.S. Jaijee personal archives)

Movement Against State Repression

Convener :

Justice Ajit Singh Bains (Retd.)
Chairman,
Punjab Human Rights
Organisation
22 Sector 2, Chandigarh
Tel. : 26162

Co-Convener :

Inderjit Singh Jaijee
Former Member Legislative
Assembly
314, Sector 44, Chandigarh
Tel. : 20468

Co-Convener :

Lt. Col. Partap Singh (Retd.)
President,
Bharat Mukti Morcha, Punjab
92, Sector 16, Chandigarh
Tel. : 24641, 40209

General Secretary (PR.)
Mrs. Baljit Kaur Gill
64/2, Chandigarh
Ph. : 31928

Chandigarh :

Dated.......................

– 2 –

this hushed up affair may now see the light of the day
and all victims are accounted for and due compensation
paid to the next of kin and, wherever possible, the
guilty are identified and punished.

As a Government claiming to be secular and
democratic, with respect for law and right to information,
you owe it to the people to disclose the following facts:-

1. Number of Sikhs killed/wounded within the
 premises of Indian Railways during 1984 riots,
 with addresses.
2. Estimated value of the property looted/damaged.
3. Relief provided up-to-date.
4. Pending claims for settlement.

While the compensation may have been paid to some
people, nevertheless, we would like to ensure that every
single case is accounted for and compensated adequately.
The crowds of hooligans were organised from outside.
Railways were not responsible for what happened; they are,
however, guilty of withholding this information from the
people. They were witness to the killings and know the
extent of the carnage. They were also in a position to
compile a list of victims if they had been more caring
for the passengers. Our request for setting up of a
Co-ordinating Cell at Delhi for this purpose was ignored.

A disclosure of casualty figures by the Railways
would be a step in the right direction for the purpose
of assuaging hurt Sikh feelings. But what is really
required is a Commission of Inquiry to investigate the
extent of damage to life and property, headed by a
sitting Judge of the High Court and comprising of a

(contd..P/3...

Photo 10.2 (continued)

Movement Against State Repression

Convener :

Justice Ajit Singh Bains (Retd.)
Chairman,
Punjab Human Rights
Organisation
2 , Sector 2, Chandigarh
Tel : 26162

Co-Convener :

Inderjit Singh Jaijee
Former Member Legislative
Assembly
314, Sector 44, Chandigarh
Tel. : 20489

Co-Convener :

Lt. Col. Partap Singh (Retd.)
President,
Bharat Mukti Morcha, Punjab
92, Sector 18, Chandigarh
Tel. : 24041, 40209

General Secretary (PR.)
Mrs. Balju Kaur Gill
64/2, Chandigarh
Ph. : 31928

Chandigarh :

Dated.........................

- 3 -

Member of the Railways and a Member from the Human
Rights Body.

Compensation should be paid on the basis of
what is being considered to be given to next of kin
of the riot victims of Delhi riots i.e. Rs.one lec
for those killed, one job to the next of kin, pension
to the widows, free education to the children etc.
The widow pension and education stipend should be
effective from November, 1984. In the matter of
jobs the Railways should also offer some jobs to
the next of kin of those killed and to the disabled.

I hope you will consider these suggestions
sympathetically,

With kind regards,

Yours sincerely,

(Inderjit Singh Jaijee)

Mr. George Fernandes,
Union Minister for Railways,
New Delhi.

Photo 10.2 (continued)

to destroy the evidence of murder," write Manoj Mitta and H.S. Phoolka in their important book *When a Tree Shook Delhi*.[71] "Far from being spontaneous expressions of 'madness' and of 'grief and anger' at Mrs. Gandhi's assassination, as made out by the authorities, [the attacks] were the outcome of a well-organized plan marked by acts of both deliberate commission and omission by important politicians of the Congress and by authorities in the administration," noted the People's Union for Civil Liberties and the People's Union for Democratic Rights.[72]

"No one could have dreamed of this happening under everyone's watch," remembers Baljit Kaur. "Obviously things had been most charged since June 1984, when Hindus generally celebrated the killings of those locked inside Darbar Sahib, lumping all Sikhs as terrorists. Remember those Hindu businessmen in Delhi who had distributed sweets to my husband in June? Well, fast-forward five months. Jagjit found himself in the same office. So now he sent the peon to get mithaii and offered it to them, that Indira Gandhi had been killed."

While many Sikhs remember reiterating to each other that no assassination should be condoned, very few remember anguish at the death of the woman who had ordered the army attack on Sikhs and their gurdwaras across Punjab earlier that year.

"But little did Jagjit know what was ahead, when he returned that mithaii favor," says Kaur. "Driving through Delhi's South Extension he saw bricks being laid in the way and the path blocked. Suddenly, there was stone pelting. All the windows of his car were smashed. My father-in-law had a farmhouse behind Qutub Minar. He got there and took out like eighty stones and bricks from his car!"

"In that area, nearby, there were just about five families of Sikhs. They gathered. And gathered weapons. They had three shotguns between them. But only eight cartridges. Soon, they were surrounded by three hundred gujjars, jaats. They were coming closer and closer. And these guys were trying to show strength, to show they had firepower, with strategic firing."

"For two days, they held off the crowd. And then, through a young boy who used to feed the cattle nearby, they got word out. He went to the police. Police came and said gleefully, 'Sardaron, aslaa rakh do, talashi de do. Sikhs, surrender your weapons, submit to a search!' So, they had just beckoned even more danger! But they were just saved by the skin of their teeth, because coincidently, the Army came right about then. Jagjit came to my older sister in Delhi two days later, very traumatized. When he was able to come back to Punjab later, he applied for an arms license … he knew an officer and got one. He was shaken to the core."

The November pogrom had witnessed a few arrests: but of Sikhs firing or fighting in self-defense. The police routinely disarmed beleaguered Sikh families, leaving them further defenseless. The Army had been deployed on paper alone. Army men, still less communalized and politicized than the local police, were desperately awaited. They remained in limbo for three days without orders to act. Then, as foreign heads of state arrived for the state funeral, the massacre of Sikhs was quelled.

* * *

Sikhs across the world reading the news, and between its headlines, were aghast. My father, living in Fairfax, Virginia, in 1984 wrote,

> By November 5 news items had started appearing which praised Rajiv for his poise and calmness, and by November 6 we were starting to learn that a well-placed Indian source had appraised foreign pressmen in Delhi that Rajiv's 'mental condition is pro-American.' Simultaneously there had appeared scholarly analyses of the 'culture of communal violence' which apparently pervades all of India and which apparently had been responsible for the riots in Delhi.

Kuldip Kaur says, "I believe this was all about the coming elections. In fact, some people say that even if Indira had not been killed, this would have happened. That she was on the lookout for an excuse to unleash violence on Sikhs, with which the Hindu and Muslim vote bank could be secured. Because, child," she says in a sweet voice belying no regret at this arithmetic fact, "Sikhs are just very few in number. We are just two percent of India's population."

Many remain convinced that the lull of October 31st could hardly have been enough time for the meticulous organizing that wreaked havoc on tens of thousands of this minority community across the country.

"The assassination of Indira Gandhi on the morning of October 31, 1984, pre-empted Indira's Operation Shanti, to commit mass scale genocide of the Sikhs all over India, by over a week," writes Dr. Sangat Singh, a retired civil servant, and former officer in the Ministry of External Affairs, India.[73] He says Gandhi's next political move to solidify her voter base was slated for "around November 8, when the Sikhs would assemble in various Gurdwaras for Guru Nanak's birthday celebrations. According to the plan, large-scale skirmishes virtually amounting to a war, were to take place all along the India-Pakistan borders. And, it was to be given out that the Sikhs had risen in revolt in Punjab and joined hands with Pakistani armed forces."[74]

"She had a plan," says Kuldip Kaur. "But given Bluestar, given Woodrose in the countryside, the anger in Sikhs was high and contagious. Her own bodyguard was provoked. And assassinated her. And so this then gave the government their desired chance!"

The popular belief is that Gandhi's long-trusted bodyguard Beant Singh had been "radicalized" on visiting bleeding Punjab after June 1984, and soon recruited Satwant Singh for his assassination plan. "Beant Singh and Satwant Singh are said to have seen a baaz and sworn to become channels of the Guru," says Baljit Kaur. Many honor these men for meting out punishment and upholding the legacy that no one who had ordered an attack on Darbar Sahib ever survived. However, several also believe Gandhi's murder was shrouded in a conspiracy deeper than the rage of the Singhs. Beant Singh was killed in a shed on the premises of the Prime Minister's compound hours later, despite having had given himself up for arrest. Questions as to what exactly happened were raised by contemporaneous media accounts.[75] But, as time passed, the

official narrative of November 1984 solidified. There was little relief for hapless civilian victims, much less for alleged assassins.

"Are you crazy?" People repeatedly asked the Punjabi literary legend Ajeet Cour, when she said she wanted to go out and help.[76] On November 3, the author had sent her driver to pick up her printer's Sikh family. When the driver returned, he was absolutely ashen. He narrated the torture and killing of all the men in the family. "This was so well planned. In South Delhi, they worried that people might ask for insurance or go to the courts, so here, only loot and commit arson. Don't kill here. Few random killings happened here. Most across the Yamuna." And Ajeet Cour remembers how a month before the pogrom, Delhi police had made rounds to Sikh homes, looking to confiscate kirpaans and any lawfully owned firearms. "It was all meticulously planned. In a taxi stand, knowing which taxi, in a whole stand, which taxi was a Sikh's—and burn that one. They had prepared the lists of all Sikhs."

Squalid emergency relief camps emerged only because of some conscientious civil society efforts. Cour describes the camps' conditions, with no toilets, no medical services, no space to even sit, much less rest. "In Sham Lal College, I saw seas of people, then someone recognized me and said, 'Lahoo de Chubuche nahin, lahoo de Samundar ban gaye!'" Her famous essay after June 1984 was titled *Lahoo de Chubuche, Troughs of Blood*. Now, said this person, these had become seas of blood.

Baljit Kaur came to Delhi to work in these camps in November. She remembers, "such a strong feeling in the camps against Bhajan Lal, Tytler, Sajjan, et cetera. When government trucks with any aid came people yelled, 'Leh jaao eh truckkk!'" Complicit politicians were now announcing relief for constituents. "It was all Rajiv Gandhi. The Sajjan Kumars and all would not have done anything if it weren't for him. But about naming him outright? Well, to tell you the truth, Sikhs were very scared, still finding their bearings."

Writes Jaspreet Singh, "Prime Minister Rajiv Gandhi, a Cambridge dropout, used really bad physics to justify the pogrom."[77] On November 19, at a rally, Rajiv trumpeted to a spirited crowd, "But, when a mighty tree falls, it is only natural that the earth around it does shake a little."

Overwhelmingly, the violence was condoned as appropriately employed against a reportedly treacherous minority community that had forgotten its place.[78] Note Uma Chakravarti and Nandita Haksar, who were part of the relief efforts and extensively interviewed citizens immediately after the pogroms, "The most typical statement of Hindu assertion throughout the months following November were, 'It'll teach them a lesson'; 'Now they have been effectively cowed down.'"[79]

The political currency of the November 1984 carnage won Gandhi's Congress a landslide victory in the following month's general elections.[80] Rajiv Gandhi took his oath on December 31, 1984; his thumping election victory remains unparalleled in India till date. Union Minister H.K.L. Bhagat, who eyewitnesses reported at the scene of many massacres, and whose constituency

saw widespread decimation of Sikhs, won with the second greatest margin of votes throughout India. The Sikh genocide was receiving electoral applause.

Sikhs from across India began flooding into Punjab. Relocating to the Sikh-majority state seemed safer. The over 50,000 new refugees in Punjab[81] brought stories of the orgies of violence from across India. A woman who relocated to the large refugee colony in Ludhiana, near where my Dadiji's sister lived, told my father K.S. Sarkaria in 1984, "Her house in Delhi was attacked by the mob. Her teenaged son managed to escape, and her husband was away on business; but her brother, who happened to be a devout amritdhari, was visiting them, and the mob got hold of him. Before killing him, the murderers did their best to humiliate him in front of his sister. They offered to let him go if he would cut his hair and pay them Rupees three hundred. He refused, and asked them to do what they wanted to do. They proceeded to torture him: eyes gouged out, one limb cut off, and so on. At each stage, an 'offer' of the above kind was made. He refused, and died murmuring the name, 'Waheguru,' which meant everything to him."

Stories of valorous preservation of principle, when nothing else could be saved, were few and far between in the general media reports. The best of media stories at best depicted Sikhs as meek, begging for their lives. Then, remorseless ridicule of the victimized community became commonplace. Being taunted walking down a street—"Yeh Sikh Kaise Bach Geya, How did this Sikh survive?" Being prodded with gibes about the recent trauma—"Sardar ab toh sirf chiriya ghar mein milenge, You'll have to go to the zoo to find a Sikh now!" Being denied employment, apartment rentals, seats on public transport, or basic politeness, all became commonplace for Sikhs: rural and urban, turbaned and not, traditional and anglicized.

"The aftereffect of this was so clear," says Kuldip Kaur. "They removed us from the mainstream entirely. In police service, from civil service, Army, they didn't let Sikhs rise. Stopped promotions. This lasted a long time."

Sikhs learnt to quieten quicker, smile easier, agree faster, and watch every word and action.

Baljit Kaur recounts her own experience with the emboldened antipathy toward Sikhs: "I was coming back on the bus to Chandigarh after November 1984. It was a Haryana Roadways bus. I didn't have a car, I would often take a bus to go to Chural. I think I was the only Sikh on board. Maybe one other. But the whole way, they ridiculed sardars. Things like, 'We taught them the lesson they needed.' The whole way. It was so bad. I could do nothing in the bus, I was the only Sikh. So I sat all the way till Chandigarh."

"When I was getting off the bus, I jumped out quickly. I was seething. And I was so afraid of them, but I said, 'Hun bol ke dikhaao … poore rastey bolde aaye ho! Hun aasi Chandigarh vich haan. Eh Haryana Naahin! You've been yakking the whole way. But now we are in Chandigarh. This is not Haryana.' And after a second, they started, 'Oh no, no, come back, listen to us, baat to suniye, just come listen to us!' I was not that brave. I grabbed my over-nighter and began to walk. I was looking for a rickshaw. And I had a strange feeling. I hopped up onto the pavement. And a second later, I realized the bus

had turned, and it was coming at speed that could have made mincemeat of me, had I not gotten off the road. They just could not take any retort from Sikhs then. Fortunately I found a Sikh rickshaw puller and two or three other people too, so the bus did not come back. But basically, yes, everybody was getting it."

For the Sikh community, November 1984 and the events thereafter deeply drove home the systemic discrimination and created unprecedented unity across Sikhs of all stations. Many Sikhs began revisiting their views on the June 1984 Punjab violence after November: what else was their government lying about?

* * *

The year 1984 was an end and a beginning.

"I remember what all I sat and thought right in this house as Operation Bluestar took place," says Justice Bains. "And then the murders after Mrs. Gandhi's murder were also a real shock. I began studying the lives of all Sikh Gurus. That was an inspiring solace. Baba Nanak had called Emperor Babar a Jaabar, a tyrant, and was jailed too. Through his life, he openly scorned the rich and power hungry and sided with the oppressed, the poor and hungry." The leftist Justice Bains stopped trimming his beard in 1984 and reclaimed his spiritual practice. The surprise of his family and friends was diminished, given the times. Explains his son Rajvinder, "Oh, did he change post 1984! Otherwise, we were branded as a Communist family. In 1984, he was hurt. Literally hurt. We didn't quite understand. He hadn't been a person of great faith. He had hardly visited Darbar Sahib. How could it hurt so much? But we felt it also. It was surprising, that a physical place, and a piece of land, can do this. ... A man who had hardly ever entered a gurdwara, had a physical reaction."

Some Sikhs took it upon themselves to speak out against the paralyzing fear. "We were just figuring out how to be helpful after eighty-four," says Jaijee. "But once we all got activated in human rights work, there was no turning back. We had thought that 1984 would be the worst that could ever befall Sikhs in the country to which they had married their fate in 1947. We were naïve."

Through the extreme and indiscriminate violence that followed 1984, most Sikh children would grow up in homes that grew quiet at the mere mention of 1984. The events had jolted the Sikh sense of self, but also generated self-doubt, self-consciousness, and rational and irrational attempts at self-preservation. Over time, the solidarity would give way under factionalism, suspicion, victim-blaming, and other trauma responses. While some Sikhs would survive by forgetting, others would flee halfway across the globe to insist on remembering, but some others would continue collaborating with the persecuting apparatus. Without resolution of any of the demands raised since the 1970s nor any post-conflict measures to respond to the violations of 1980s and 1990s, Punjab stumbled into the twenty-first century, while the government

triumphantly declared the return of "normalcy." It would become a play-ground of corrupt politicians, regressive religious leaders, drug lords, liquor barons, and an increasingly disenchanted citizenry. With the declining quality of education and rising rates of narcotic consumption as well as the highest per capita rate of farmer suicides in India, Punjab's entrepreneurial and resilient spirit would suffer deep wounds. Unsurprisingly, the Sikh community would become unable to collectively deal with its past trauma or coherently define its future.

Sikh history of the Guru period and the century after would be pridefully eulogized and sanitized. Recent Sikh history would become a source of dejection and of debate: about the mistakes made by our own as well as our more obvious detractors; from entrenched positions taken by various schools of thought; and based on evidence that has been missing, incomplete, or eradicated over the years. Yet, once the confounded children of 1984 woke up from their parents' nightmares, they began questioning the erasures, daring the official memory, respecting the varied attempts at resistance, and slowly began untangling the cat's cradle created by decades of threat to a people, their culture, their memories, and their faith and freedom. They have begun believing again in the Guru's mandate against dejection, and started imagining the possibility of an egalitarian future for the grandchildren of 1984.

Soon after the tens of thousands slipped off their shoes for a moment of solace in a shared place of worship and walked instead to a brutal death, my father began growing out his curly hair and beard. He began donning a turban like he does today, 35 years later. We lived oceans away from Punjab in 1984, the year I was born.

NOTES

1. "[T]he last one on May 26, 1984, a few days before the start of actual operations," writes Sangat Singh, *The Sikhs in History*, 2nd ed. (New Delhi: Uncommon Books, 1996), 395.
2. Khushwant Singh, *History of the Sikhs, Volume II; 1839–2004* (New Delhi: Oxford University Press, 1999), 349.
3. See, for example, Harminder Kaur, *Blue Star over Amritsar: The Real Story of June 1984* (New Delhi: Corporate Vision, 2006).
4. Khushwant Singh, *History of the Sikhs II*, 349
5. Khushwant Singh, *History of the Sikhs II*, 350.
6. See, for example, Tavleen Singh, "Terrorists in the Temple," in *The Punjab Story* (New Delhi: Roli Books, 1985).
7. See, Iqbal Singh, *Punjab Under Siege: A Critical Analysis* (New York: Allen, McMillan, and Enderson, 1985), 69.
8. See, Chap. 7.
9. Khushwant Singh, *History of the Sikhs II*, 335–36; see also Chap. 9, n. 55.
10. See, for example, Zuhair Kashmeri and Brian McAndrew, *Soft Target* (Toronto, Canada: Lorimer, 1989), 129–30.
11. Khushwant Singh, *History of the Sikhs II*, 352–53.
12. Kaur, *Blue Star over Amritsar*, 8.

13. Khushwant Singh, *History of the Sikhs II*, 356–57.
14. Government of India, "White Paper on the Punjab Agitation, a Summary" (New Delhi: Government of India Press, 1984), 105–9.
15. "All telephone and telex lines are cut. … There are no newspapers, no trains, no buses—not even a bullock cart can move." Mary Anne Weaver, "India reels as siege of Sikhs' holiest shrine comes to an end," *The Christian Science Monitor*, June 8, 1984.
16. See, N.D. Pancholi et al., *Report to the Nation: Oppression in Punjab*, U.S. ed. (Ohio: Sikh Religious and Education Trust, 1986), 66. This report was first published in India in 1985 and immediately banned by the Rajiv Gandhi government, which also charged the authors with sedition.
17. G.K.C. Reddy, ed., *Army Action in Punjab: Prelude and Aftermath* (New Delhi: Samata Era, 1984), 49.
18. "Bhaiyee" is a common and often pejorative Punjabi usage for migrant labor, especially from the states of Uttar Pradesh and Bihar.
19. See, Ram Narayan Kumar, "The Ghalughara: Operation Blue Star: A Retrospect," *The Sikh Review* 48, no. 6 (June 2000): 30–36.
20. Khushwant Singh, *History of the Sikhs II*, 362.
21. See, for example, Lt. Gen. J.S. Aurora, "Assault on the Golden Temple Complex," in *The Punjab Story* (New Delhi: Roli Books, 1985), 91–137, 100.
22. See, Amrik Singh, *Dharmi Faujis and the Blue-star Operation* (Chandigarh: Spokesman Trust, 2003).
23. Brahma Chellaney eyewitness testimony, published in Kuldip Nayar and Khushwant Singh, *Tragedy of Punjab: Operation Bluestar & After* (New Delhi: Vision Books, 1984), 162.
24. Khushwant Singh, *History of the Sikhs II*, 358.
25. See, Iqbal Singh, *Punjab Under Siege*, 73. Quoting Gobind Thukral, "The Infant Terrorists," *India Today*, September 30, 1984, 25.
26. See, for example, Subhash Kirpekar, "Operation Bluestar: An Eyewitness Account," in *The Punjab Story*, 113.
27. See, for example, Kirpekar, "Operation Bluestar," 114. "The disposal of corpses posed a great problem. So much so that seven truck cleaners behind my hotel were rounded up one morning and threatened with dire consequences if they did not do as ordered. But they stubbornly refused. So the scouts then went to contact some sweepers. They too refused. But when offered liquor and the lure of owning whatever was found on the corpse, be it [a] gold chain or ring or cash, goes the story, they agreed. Some of them have made tiny fortunes in the bargain."
28. See, Kaur, *Blue Star over Amritsar*, 46–47.
29. Sangat Singh, *The Sikhs in History*, 404.
30. 38 (Eric Silver, "Golden Temple Sikhs surrender," *The Guardian*, June 7, 1984); 42 (Government of India, "White Paper on the Punjab Agitation"), 74 (Inderjit Singh Jaijee, *Politics of Genocide: Punjab, 1984–1998* (Delhi: Ajanta Publications, 2002), 34).
31. See, Jaijee, *Politics of Genocide*, 64.
32. Originally published by *The Diplomat*, June 3, 2016, www.thediplomat.com: Mallika Kaur, "Blue Star Over Patiala."
33. "Truth on Trial—in India," *The New York Times*, October 23, 1984.
34. Satish Jacob and Mark Tully, *Amritsar: Mrs Gandhi's Last Battle* (New Delhi: Rupa, 1985), 203.

35. Kirpal Dhillon, *Time Present and Time Past: Memoirs of a Top Cop* (New Delhi, Penguin: 2013), 231–32.
36. "The government media and almost entirely communally biased Hindu press did its utmost to justify the action, extol the heroism of the army for doing an unpleasant job with professional skill and vilify Bhindranwale and his associates in language unworthy of an allegedly free press," writes Khushwant Singh. To further discredit the vanquished leader, rumors about Bhindranwale's death were circulated by the media—including of him having been killed by his own ranks, and of him having had committed suicide. Khushwant Singh, *History of the Sikhs II*, 361.
37. See, for example, The Tribune Bureau, "Big Haul of Arms, Diamonds," *The Tribune*, June 13, 1984.
38. For example, "There was a harem of village girls for the pleasure of [Bhindranwale's] brainwashed brigade. Some of these girls are said to be pregnant now." Kirpekar, "Operation Bluestar," 20.
39. See, Aurora, "Assault on the Golden Temple Complex," 97.
40. Khushwant Singh, *History of the Sikhs II*, 354.
41. On his unique contributions caring for the poor and sick and society's castaways, see, Patwant Singh and Harinder Kaur Sekhon, *Garland Around my Neck: The Story of Puran Singh of Pingalwara* (New Delhi; London: UBS Publishers' Distributors, 2001).
42. An Indian Army circular described amritdhari Sikhs as dangerous extremists, who must be immediately reported. "The Punjab Situation," *Baat Cheet*, Serial No. 153, July 1984.
43. See, for example, Harnik Deol, *Religion and Nationalism in India* (London and New York: Routledge, 2011), 108–9.
44. Former civil services officer Sangat Singh writes: "The author's enquiries in end-1984 revealed that during the first four to six weeks of Operation Woodrose about 100,000 youth had been taken into custody, and many of them were not heard of again: and about 20,000 belonging to third generation after independence escaped to Pakistan," *The Sikhs in History*, 408.
45. See, 1984 Living History Project, Ajeet Cour interview, http://www.1984livinghistory.org/2014/10/16/ajeet-caur/.
46. Khushwant Singh, *History of the Sikhs II*, 364.
47. Kashmeri and McAndrew, *Soft Target*, 49.
48. Sangat Singh, *The Sikhs in History*, 404.
49. The Tribune Bureau, "Foreign Hand Proved: Rao," *The Tribune*, June 28, 1984.
50. Nicholas Watt, "UK advised India on 1984 Golden Temple attack, William Hague confirms," *The Guardian*, February 4, 2014.
51. See Sangat Singh, *The Sikhs in History*, 416–17. "The omen of her imminent death weighed on Indira … That was uppermost in her mind when she spoke of her violent death at the public meeting at Bhubaneshwar on October 29."
52. See Ram Narayan Kumar, "The Ghalughara," 30–36.
53. U.N.I., "Demonstrations Against B.B.C.," *The Tribune*, June 23, 1984.
54. Joyce J. M. Pettigrew, *The Sikhs of the Punjab: Unheard Voices of State and Guerilla Violence* (London: Zed Books, 1995), 8.
55. Sangat Singh, *The Sikhs in History*, 421.

56. Manoj Mitta and H.S. Phoolka, *When a Tree Shook Delhi: The 1984 Carnage and its Aftermath* (New Delhi: Lotus Collection, an imprint of Roli Books, 2007), 9–10.
57. Jaspreet Singh, "Thomas Bernhard in New Delhi," India Ink, *The New York Times*, July 22, 2013.
58. See, for example, Yudhvir Rana, "Why Nobody Noticed Amitabh Bachchan Spewing Venom in India," *Times of India*, October 21, 2011.
59. Ivan Fera, "The Enemy Within," *Illustrated Weekly of India*, December 23, 1984, 16.
60. The dominant community in Haryana.
61. On rapes of young, old, pregnant, infirm, in Delhi 1984, see Madhu Kishwar, "Gangster Rule: The Massacre of the Sikhs" *Manushi* 5, no. 1 (November–December 1984): 10–32.
62. See, for example, Mitta and Phoolka, *When a Tree Shook Delhi*, 219.
63. See, for example, Uma Chakravarti, "The Law as Feminist Horizon: Challenging Impunity, Pursuing Justice," in *Landscapes of Fear: Understanding Impunity in India*, Patrick Hoenig and Navsharan Singh eds. (New Delhi: Zubaan, 2014), 254–55. See, also, Kishwar, "Gangster Rule."
64. See, for example, Mitta and Phoolka, *When a Tree Shook Delhi*, 67–68.
65. Ivan Fera, "The Enemy Within," 16.
66. Rahul Bedi, "84 Closure Is a Long Shot," *The Tribune*, December 6, 2018.
67. See, A. Singh (pseudonym), "The Massacres of 1984," on file with author.
68. People's Union for Democratic Rights and People's Union for Civil Liberties, "*Who Are the Guilty?*," November 1984, 14.
69. See, for example, Jaijee, *Politics of Genocide*, 76; Betwa Sharma, "Investigation of 1984 Sikh Massacre Continues in India," *India Ink, The New York Times*, April 11, 2013.
70. Amitav Ghosh, "The Ghosts of Mrs. Gandhi," *The New Yorker*, July 17, 1995.
71. Mitta and Phoolka, *When a Tree Shook Delhi*, 208.
72. People's Union for Democratic Rights and People's Union for Civil Liberties, "*Who Are the Guilty?*," names 16 Congress politicians, 13 police officers, and 198 others, accused by survivors and witnesses of the pogroms.
73. Sangat Singh, *The Sikhs in History*, 420.
74. Sangat Singh, 415.
75. See, for example, "Indira Gandhi's Assassination," *The Week*, November 11–17, 1984, published in *The Best of The Week* (New Delhi: Penguin Books, 2002).
76. See, 1984 Living History Project, Ajeet Cour interview, http://www.1984livinghistory.org/2014/10/16/ajeet-caur/.
77. Singh, "Thomas Bernhard in New Delhi."
78. See, for example, Harji Malik, "The Politics of Alienation," in *Punjab: the Fatal Miscalculation*, Patwant Singh and Harji Malik, eds. (New Delhi: Patwant Singh, 1985), 50.
79. Uma Chakravarti and Nandita Haksar, *The Delhi Riots: Three Days in the Life of a Nation* (New Delhi: Lancer International, 1987), 26.
80. Mitta and Phoolka, *When a Tree Shook Delhi*, 123.
81. Tully & Jacob, 7; Joginder Singh, "Sikhs in Independent India," in *The Oxford Handbook of Sikhs Studies*, Pashaura Singh and Louis E. Fenech eds. (Oxford University Press, 2014), 91.

A Chronology

Of Major Events Described

1469–1708	Growth of Sikhdom, under its ten Gurus, and as a distinct tradition, respecting but distinctly departing from South Asia's prevailing religions of Hinduism and Islam. Through these centuries, Sikh resistance to tyrannical rulers became legendary (starting with the first Guru, Nanak, till the tenth Guru, Gobind Singh)
1757	Mughal empire on decline; British expand control
1801	Ranjit Singh becomes Maharaja of Punjab
1809	Anglo-Sikh Treaty of friendship signed: Ranjit Singh's empire continues north of river Sutlej, British India south of Sutlej
1839	Maharaja Ranjit Singh dies; instability of the Sikh empire ensues; British meddling in Lahore (Punjab) court accelerates instability
1849	End of Second Anglo-Sikh War; British annex Punjab
1872	Singh Sabha Movement launched in Punjab
1913	Ghadr Party organized in California
1919	Jallianwala Bagh Massacre
1920	Gurdwara Reform Movement begins (till 1925)
1921	Nanakana Sahib Massacre
1922	Guru-ka-Bagh protest, morcha
1922	*Ajit Singh Bains born*
1931	*Inderjit Singh Jaijee born*
1935	*Baljit Kaur born*
1946	Riots on communal lines in various cities, as rumors spread of Partition after British departure
1947	British prepone departure date; at least one million lives lost in the Partition of Punjab between India and Pakistan
1948	Patiala and East Punjab States Union, PEPSU, created from erstwhile princely states of Punjab

© Mallika Kaur 2019
M. Kaur, *Faith, Gender, and Activism in the Punjab Conflict*,
https://doi.org/10.1007/978-3-030-24674-7

1950	Indian Constitution promulgated; Sikh representatives refuse to sign in protest
1955	Morchas begin for Punjabi Suba, and recognition of Punjabi language
1956	PEPSU dissolved by Center
1960	Marches for Punjabi Suba intensify
	Green Revolution agricultural experiment underway in Punjab
1966	Trifurcation of Punjab: smaller Punjab, Haryana, Himachal
1967	Nand Singh commits suicide for Punjabi Suba
1969	Pheruman commits suicide for Punjabi Suba
1970	Naxal movement in Punjab gains popularity
1973	Anandpur Sahib Resolution prepared
1974	*Ajit Singh Bains appointed Judge*
1975	Emergency declared by Indira Gandhi
	Save Democracy morchas launched from Darbar Sahib; Akalis arrested in thousands
1976	Punjab's water ordered to be significantly diverted to non-riparian states
1977	Emergency ends
1978	Nirankari protests and killings of unarmed Sikhs
	Anandpur Sahib Declaration endorsed at All India Akali Conference
1980	Indira Gandhi and Congress return to power
1981	Close to 30,000 Akalis court arrest around Anandpur Sahib Resolution
	Dharam Yudh Morcha declared by Akalis
1982	Asian Games and anti-Sikh violence in Haryana and Delhi
1983	*Justice Bains retires*
	Disturbed Area Ordinance and Armed Forces Special Powers Act enforced
	President's Rule declared in Punjab
1984	*Inderjit Singh Jaijee resigns job; moves from Delhi to Punjab*
	June attacks on gurdwaras across Punjab, under code name "Operation Bluestar"
	Indian forces comb Punjab countryside, thousands affected, under code name "Operation Woodrose"
	Sarbat Khalsa at Darbar Sahib
	Indira Gandhi assassinated
	November anti-Sikh pogroms in Delhi and across India
	H.S. Jaijee dies
1985	*Bains Committee appointed by new Punjab Government*
	Baljit Kaur resigns job
	Inderjit Singh Jaijee elected MLA

	Air India Flight 182 from Montreal to New Delhi explodes midair
	Rajiv-Longowal Accord signed
	Longowal murdered
	Baljit Kaur goes to Amnesty International, UK
1986	*Bains Committee submits report for release of detainees*
	Jaijee joins breakaway Akali MLAs in protest; dismissed from Party and Legislative Assembly
	Press conference at Akal Takht and Declaration of Khalistan
	"Operation Black Thunder I" on Darbar Sahib
	Rajiv Gandhi reneges on promised Chandigarh transfer
	Kulwider Singh, Kid, first arrested while a school student
1987	President's Rule begins (till 1992)
	Movement Against State Repression, MASR formalized
	Justice Bains renames his organization Punjab Human Rights Organization, PHRO
	Sushil Muni sent to hold talks with Akalis
1988	"Operation Black Thunder II" on Darbar Sahib
	Bidar, Karnataka student massacres
	59th Amendment passed for Punjab, extending legality of President's Rule beyond one year
	KCF original leadership begins dying in quick succession
	Justice Bains's 'Siege of the Sikhs' *published*
1989	Kulwinder Singh, Kid, killed
	Sarpanch Kuljit Singh Dhatt, Hoshiarpur, killed in custody
	Satwant Singh and Kehar Singh hanged in Indira Gandhi assassination case
	Parliamentary elections; Simranjit Singh Mann and Khalistani candidates sweep
	Simranjit Singh Mann released from jail, returns to Punjab
	59th Amendment repealed
	Jaijee elected president of Minority and Dalit Front
	UK parliamentarians visit Punjab to assess police excesses
	Kanpur students murdered at Engineering College, Patiala
	Forty sarpanches simultaneously resign to protest police excesses in Punjab villages
1990	Sit-in outside Governor House, protesting police violence
	Mukerji (December 1989–1990) resigns as Governor
1991	Election opposition by Central Congress Government
	Election postponed: 29 candidates killed
	Kaale-Kachhe Vaale looters become prominent
	Pilibhit, Uttar Pradesh bus massacre
	Chandigarh blast case; Multani abducted, killed, Bhullar family members abducted, killed
	Rajiv Gandhi assassinated

1992	Rescheduled election boycotted by militants
	Beant Singh government elected
	Justice Bains abducted by police
1993	Chaman Lal's son Gulshan Kumar abducted, killed
	Jathedar Kaunke abducted, disappeared
	Jaijee goes to UK Parliament
	World Conference on Human Rights in Vienna; Jaijee attends
	Kulbir Kaur Dhami abducted by police, kept in secret torture center
1994	Jaswant Singh Khalra discovers mass secret cremations
	Dhami exposé about fake surrender
	Pilibhit, Uttar Pradesh jail massacre
	Vinod Kumar, Ashok Kumar, Mukhtiar Singh abducted; Sumedh Saini accused
1995	Chief Minister Beant Singh assassinated
	Jaswant Singh Khalra disappeared
	Bhullar deported from Germany, arrested at New Delhi Airport
1996	*Justice Bains acquitted of all charges*
1997	Kulbir Kaur Dhami released from jail; acquitted of all charges
	Ajaib Singh consumes poison in Darbar Sahib, leaves suicide note
1998	Punjab People's Commission hearings held in Chandigarh
2001	High Court confirms sentence against policemen in Chaman Lal's son's case
	Supreme Court stays Chaman Lal's son's case
2007	High Court upholds sentences of five junior policemen in Khalra murder case
2010	Several arrests of alleged militants after seizure of RDX explosives; Narain Singh named as suspect, returns to hiding
2011	Supreme Court upholds five life sentences in Khalra murder case
2012	Punjab mass cremations case declared "complete" by Supreme Court
	Accused policemen in Kid case acquitted; Tarlochan Singh appeals
	Tarlochan Singh dies
2013	Narain Singh arrested, tortured, jailed
2014	Three policemen convicted in 1989 Dhatt case; family appeals for enhanced sentences
2016	Bhullar paroled after 20 years
	Supreme Court lifts stay on Chaman Lal's son's case after 15 years
	Chaman Lal dies two days before trial resumes
	Trial court finds 47 policemen guilty in Pilibhit bus massacre case

2017 Amar Kaur, pursuing the Saini case since 1994, dies at 102
 New evidence of 8257 extrajudicial killings across Punjab
 between 1980 and 1995 released by Punjab Documentation
 and Advocacy Project
2018 Narain Singh released on bail
 Dhatt case appeal pending in High Court
 Chaman Lal's son's case stayed again by High Court

Glossary[1]

Akal Takht Literally, timeless throne. This is the temporal seat of the Sikh nation, significantly built across the spiritual center, the Harmandir Sahib.

Akali Literally, immortal. A person affiliated with an Akali party. The Akali Dal Party was first formed in the 1920 as Sikhs organized against British rule. Has since split many times, but remains a prominent force in Punjab.

Amrit The baptism/initiation, through which a Sikh becomes a Khalsa. May be used literally for water from a spiritually significant place or ceremony. May also be used poetically as the Guru's metaphysical blessing, loving gift to a Sikh.

Amritdhari One who has received Amrit; has partaken in the initiation ceremony.

Ardaas Literally, prayer. In Sikh practice, the part of the daily prayers said standing up, briefly reciting inspirational Sikh history, recognizing blessings, and making any supplications.

Baba An elderly man. Also, someone considered, or who promotes himself as, a holy man.

Beas One of undivided Punjab's five large rivers, today entirely in India; originating in the Himalayas and running into the Sutlej River.

Betaa A child; masculine form, but often used neutrally.

Beti A female child.

Bhog Signifies the completion of the reading of the entire Guru Granth Sahib (1430 pages). This practice is undertaken on various occasions, notably after a Sikh death.

BJP Bharatiya Janata Party is one of India's two major political parties; overtly Hindu nationalist, with its roots in the right-wing paramilitary organization RSS. In coalition with regional parties, it is, under Narendra Modi's prime ministership, the ruling party in India since 2014.

Bluestar Code name for the army operation launched in June 1984 across Punjab, epicentered in Amritsar.

BSF Border Security Force.

© Mallika Kaur 2019
M. Kaur, *Faith, Gender, and Activism in the Punjab Conflict*,
https://doi.org/10.1007/978-3-030-24674-7

CBI Central Bureau of Investigation; India's highest investigative agency, based in capital New Delhi.

Chunni Long scarf traditionally worn with Punjabi women's dress.

CIA Staff Criminal Investigation Agency centers across Punjab that gained notoriety as torture sites.

Congress The oldest nationalist political party in India; came into power in 1947 and has ruled India for the majority of its existence since, often in coalition with regional parties. Starting with Jawaharlal Nehru, then his daughter Indira Gandhi, her son Rajiv, then his widow Sonia, and now her son Rahul, it has been controlled by the Nehru-Gandhi family.

Crore Ten million.

CRPF Central Reserve Police Force; paramilitary force under the authority of the central government. (Often referred to by Punjabi villagers as CRP)

Dadaji Paternal grandfather.

Dadiji Paternal grandmother.

Darbar Sahib Also known as Harmandir Sahib, or "Golden Temple" to foreigners, in Amritsar, Punjab.

DGP Director General of Police; highest ranking police officer in the state.

Dharam Yudh Morcha Literally, struggle for righteousness; protest movement launched in 1981, initially by the Akalis.

DIG Deputy Inspector General of Police.

FIR First Information Report; ordinarily a prerequisite to commencing a criminal prosecution in India.

Gurdwara Sikh place of learning, community, worship.

Gurpurab Literally, Guru's-Day. Guru's anniversary, or any date significant in Sikh Guru history: birth, death, or martyrdom.

Guru Literally, one who leads from darkness to light. Sikhs had ten human Gurus (1469–1708), and now venerate as living Guru the Guru Granth and the Guru Panth (the initiated/committed Sikhs).

Guru Nanak First Sikh Guru who was born in 1469.

Jatha Collectives or groups committed to a common cause.

Jathedaar Most commonly used to refer to the head of the Akal Takht, Amritsar, or the head of one of the four other Takhts (thrones) of Sikh political power. May be used to refer to the leader of a jatha or to a vocal activist.

Jatt Literally, farmer. The farmer caste; also the majority caste of Punjab. Once one of the "lower castes" who converted to Sikhi under the Gurus. Now Jatts are considered/consider themselves a high (even the highest) caste among Sikhs, though philosophically a casteless community.

Karaa A steel bangle. One of the five articles of faith mandated for Khalsa Sikhs.

Kaur Common last name bequeathed to all Sikh females by Guru Gobind Singh in 1699, to replace family names denoting caste, cementing a casteless community.

Khalsa Those publicly proclaiming, especially following an Amrit ceremony, their adherence to Sikh faith and community. May be used more fluidly for spirited Sikhs. May be used to refer to the Sikh people as a whole.

Kirpaan A sword. One of the five articles of faith mandated for Khalsa Sikhs.

Kirtan Sikh spiritual poetry contained in the Guru Granth Sahib, sung to the accompaniment of instruments.

Lakh One hundred thousand.

Langar Communal meal prepared in Sikh gurdwaras to feed the visitors and the hungry. It is an equalizing experience: all sit together to eat without distinction as to gender, class, or caste.

Maharaja Honorific title for a particularly powerful king or sovereign.

MASR Movement Against State Repression; human rights organization launched by Inderjit Singh Jaijee.

MLA Member of Legislative Assembly, state legislature in India.

Morcha Literally, campaign. A protest march.

Mughal Dynasty that originated in central Asia, was largely Sunni Muslim, and controlled most of the northern Indian subcontinent from the early sixteenth to mid-eighteenth century.

Naana Maternal grandfather.

Naani Maternal grandmother.

Panchayat Local government unit in a village.

Parikarma The path around a gurdwara.

PHRO Punjab Human Rights Organization.

Pitaji Father, with respect.

Saab Honorable Sir.

Sardar Honorific for a prominent, respected person. A turbaned man (employed often as a jibe post 1984).

Sarpanch Head of the village government.

Sat Sri Akaal Truth Is Eternal. Commonly used as a Sikh greeting.

SGPC The Shiromani Gurdwara Parbandhak Committee, a gurdwara management organization, was created in 1920, during the Gurdwara Reform Movement, as Sikhs responded to corruption and colonial control of their gurdwaras.

Shaheedi Martyrdom. Martyr is a bestowed honor since the first Sikh martyr, the fifth Guru, who refused to give up his faith or his fight for human rights, and was tortured to death by Mughal rulers in 1606.

Sikhi The Sikh way of life; the people and their path. Called "Sikhism" under Western influence, its definition is often limited to a spiritual faith system.

Singh Common last name bequeathed to all Sikh males by Guru Gobind Singh in 1699, to replace family names denoting caste, cementing a casteless community.

SSP Senior Superintendent of Police; usually the most senior ranking police official in a Punjab district.

Sutlej The longest of undivided Punjab's five rivers, today running between India and Pakistan.

Taksaal A seminary. Now also understood as a subset of Sikhs who follow certain discipline and practices separate from the majority.

NOTE

1. In deference to the first language of most interlocutors, Punjabi words and phrases, when employed, are not italicized in the text but explained in text and/or this glossary.

Index[1]

A

AFSPA, *see* Armed Forces Special Powers Act
Air India Flight 182, 243
Akal Takht, 69, 71, 76, 77, 81, 86, 98, 104, 165, 217, 226, 239, 260, 262, 270–272
Alienation, 16, 154, 196, 209, 241, 268
Amrit Kaur (Bains), 38, 69, 97
Anandpur Sahib Resolution (ASR), 197, 226, 228, 236
Armed Forces Special Powers Act (AFSPA), 98, 237, 245
Arya Samaj, 36, 39, 92n23, 97, 137
Asylum, 24, 27, 28, 106, 174

B

Bains, Ajit Singh, *see* Justice Bains
Bains, Rachpal, *see* Mrs. Bains
Bains, Rajvinder, 31, 48–50, 84, 89, 112, 139, 145, 194, 243
Bains Committee, 247, 248, 264
Baljit Kaur, xi, 9, 10, 14, 15, 28, 35, 43, 46–48, 51, 60, 67, 73, 76, 81, 88–90, 96, 126, 130, 134, 137, 143, 144, 146, 147, 152, 153, 156–158, 160, 161, 166, 168, 170, 172, 182, 184–186, 188, 190, 197, 198, 200, 201, 207, 210, 218, 227, 238, 240–242, 246, 248, 251, 252, 256, 267–273, 282–285
Bhindranwale, Jarnail Singh, 17, 61, 62, 64–66, 98, 219, 224–228, 235–237, 239, 240, 242, 244, 249, 256–259, 262, 263, 268, 271, 272, 289n36
Bhog, 14, 44, 133, 153, 222
Bhullar, Devinder Pal Singh, 174–176
Black Thunder, 99, 221, 249
Bluestar, 19n11, 248, 271, 274, 283
Boycott (election), 6, 16, 126–132
British, ix, xii, 5, 7, 11, 31–39, 68–73, 95, 97, 103, 105, 107, 112, 114–117, 121n41, 163, 194, 196, 197, 206, 239, 262, 273
Bus, 17, 100, 120n11, 124, 148, 165, 170, 171, 222, 237, 264, 277, 278, 285

C

Canal, 8, 35, 37, 43, 95, 104, 128, 132, 133, 186, 199, 200, 226, 227, 234, 250
Caste system, 35, 192
Cat, 27, 80, 190

[1] Note: Page numbers followed by 'n' refer to notes.

© Mallika Kaur 2019
M. Kaur, *Faith, Gender, and Activism in the Punjab Conflict*,
https://doi.org/10.1007/978-3-030-24674-7

Chaman Lal, 97–99, 108, 109, 111–113, 119, 258, 261

Children, xi–xiii, 4, 5, 13, 28, 30, 31, 40, 47, 49, 62, 63, 68, 69, 74, 76, 86, 88–90, 99, 109, 118, 119, 126, 142, 156, 168, 170, 171, 184, 198, 209, 211, 215, 220, 222–224, 238, 249, 251, 261, 262, 264, 267, 276, 277, 286, 287

Civil disobedience, 68, 164, 236, 257

Civil society, x, 8, 17, 26, 41, 46, 48, 263, 284

Colonial, ix, xii, 6, 11, 31, 33–35, 37, 39, 68, 72, 87, 113, 116, 208, 262

Committee for Information and Initiative on Punjab (CIIP), 28, 48, 141, 154, 155

Communist, 23, 42, 72, 80, 107, 115, 192, 194–196, 226, 234, 246, 247, 278, 286

Compensation, 43, 48, 52, 159, 199, 223, 245, 264

Constitution, 77, 108, 135, 138, 143, 144, 148n3, 156, 193, 197, 219, 226, 257

Conversion, 34, 139, 192

Cremations, 25, 26, 28, 39, 41–44, 48, 88, 109, 111, 113, 128, 182, 198, 199, 212, 249, 265, 266, 272
See also Mass cremations

Crematoria, 8, 24, 25, 29, 42, 48, 109, 133, 266

D

Dalit, 18, 81, 92n23, 138, 139, 177n1, 191–194, 246, 265, 277

Darbar Sahib, 16, 32, 45, 62–64, 66, 69, 98, 99, 137, 157, 189, 190, 210, 219, 221, 225, 234–237, 239, 249, 250, 256–263, 265, 267, 268, 270–274, 282, 283, 286
See also Golden Temple

Death census, 43, 278

Debt, 37, 158, 159, 234

Democracy, xii, 16, 42, 72, 117, 184, 208, 210

Dera, 83, 92n23

Dhami, Kulbir, 61, 84, 85, 88, 90, 200, 259, 261, 265, 270
See also Kaur, Kulbir

Dharam Yudh Morcha, 234–236

Dhillon, Jaspal Singh, 25, 26, 29, 41

Diaspora, xi, 16, 18, 27, 131, 194, 218, 227, 244, 251, 269, 274

Disappearance, xii, 6, 12, 13, 15, 17, 25–27, 30, 42, 45, 48, 49, 56n82, 88, 98, 102, 103, 105, 124, 147, 190, 221, 269

Dishonor, 4, 10, 62, 84, 108, 118, 158, 170, 183

E

Emergency, 207–210, 228, 229n13, 261

Encounter, 24, 25, 52, 81, 82, 87, 100, 102, 109–111, 128, 158, 171, 172, 174, 182, 195, 199, 240, 247, 248, 250

Extortion, 103, 111, 172, 183, 198, 222, 251

G

Gandhi, Indira, ix, 16, 17, 106, 132, 139, 166, 182, 188, 196, 208–210, 223, 227, 228, 229n13, 234–238, 245, 257–261, 269–270, 273–275, 278, 282, 283

Gandhi, Mohandas, x, 35, 72, 114, 117, 163

Gandhi, Rajiv, 16, 17, 127, 131, 132, 182, 183, 189, 215, 220, 242, 243, 245, 246, 257, 274, 275, 278, 284

Genocide, 17, 105, 154, 283, 285

Ghadr, 37–39, 71, 72, 91n7

Gill, Sukhjeet Kaur (Dr.), 128, 130–131, 146, 244

Ginnu, Gurinder Singh, 210–214, 222, 223, 274

Golden Temple, 16, 32, 265, 268

Green Revolution, 6, 163, 166, 195, 197, 223

Grewal, G.S., 65, 126, 143, 247, 248, 257, 259

Gurbaksh Singh (Bains), 38, 69, 72, 115

Gurdwara Reform Movement, 71, 72
Gurtej Singh, 130, 131, 166, 212, 236
Guru Arjan Dev, 259
Guru Gobind, x, 32, 157, 177n2,
 182, 183, 197, 211, 225,
 232n57, 267
Guru Granth Sahib, 24, 70, 71, 73, 96,
 165, 182, 225, 259
Guru Nanak, 32, 70, 119, 163,
 211, 283

H

Habeas corpus, 41, 85, 101, 125, 139,
 160, 174

I

Informer, 84, 104, 131, 153, 222

J

Jaijee, H.S., 73, 94, 96, 97, 113, 118,
 135, 137, 162, 201, 256
Jaijee, Inderjit Singh, xi, 4–11, 26, 27,
 65, 73, 94, 95, 118, 119, 127, 138,
 148n1, 155, 157, 163, 167, 184,
 191, 206, 208, 218, 234, 246,
 252n3, 256, 269
Jallianwala Bagh, 69, 114, 116, 262
Jaswant, Singh Khalra, 22–30, 39–52,
 53n3, 109, 112, 113, 133
Jatt, 37, 97, 138, 160, 166, 192–194, 242
Jawaharlal Nehru, see Nehru, Jawaharlal
Jodhpur detainees, 214, 264
Journalist, 10, 41, 84, 124, 125,
 144, 171, 200, 209, 220, 221, 228,
 239, 243, 244, 249, 261, 267,
 269, 277
Justice Bains, 9, 10, 14, 15, 26, 27,
 29–33, 37–39, 41, 43, 46–48, 60,
 69, 72, 82, 88, 89, 97, 102, 109,
 110, 112, 115, 117, 118, 124, 126,
 128, 132, 134, 135, 139–148,
 163–165, 168, 182, 184–188, 194,
 198, 201, 208, 209, 212, 218–221,
 237, 243–245, 247, 248, 256, 264,
 273, 286

K

Kaunke, Gurdev Singh, 98–102
Kaunke, Gurmail Kaur, 99, 101, 102
Kaur, Kulbir, 60–68, 74–82, 84–90, 200,
 259–261, 265, 270
 See also Dhami, Kulbir
Kaur, Kuldip, 210, 211, 213, 214, 222,
 223, 274–278, 283, 285
Khalistan, 62, 86, 107, 114, 125, 127,
 130, 131, 133, 139, 143, 158, 183,
 188, 196, 217–218, 227, 240, 241,
 249–251, 271, 273
Khalra, Jaswant, see Jaswant, Singh Khalra
Khalra, Paramjit, see Paramjit, Kaur
 Khalra
Kid, Kulwinder Singh, 182, 188,
 198–201, 257
Kumar, Ram Narayan, 26, 27, 47, 52n1,
 56n81, 101, 102, 120n10, 150n57,
 154–156, 220, 248, 263

L

Langar, 65, 70, 163, 262, 268
Leftist, 29, 42, 91n7, 136, 158, 167,
 192, 193, 222, 286
Longowal, Harchand Singh, 65, 234, 235,
 243–246, 254n50, 257, 258, 261, 263

M

MASR, see Movement Against State
 Repression
Mass cremations, 42, 43, 45, 48, 52,
 113, 267
 See also Cremations
Memory, xi, 10, 16, 18, 34, 38, 58, 61,
 65, 95, 223, 234, 240, 241, 250,
 271, 273, 287
Militancy, 8, 14, 16, 17, 23, 45, 66, 80,
 82, 84, 87, 104, 105, 131–133, 144,
 168, 192–194, 220, 222, 246, 250
Movement Against State Repression
 (MASR), 43, 127, 191, 218
Mrs. Bains, 125, 126, 134, 139, 142,
 145, 146, 148
Multani, Balwant Singh, 173–176
Multani, Darshan Singh, 172, 173, 176

N

Naked, 76, 79, 102, 109, 160
Nankana Sahib, 7, 70, 71
Naxal, 192, 193, 195
Negotiation, 116, 127, 130, 137, 190, 217, 256
Nehru, Jawaharlal, 97, 114, 117, 136, 138, 163, 189
Nirankari, 61, 224–228

P

Pakistan, 5, 6, 8, 28, 39, 60, 61, 64–66, 84, 88, 114, 115, 117–119, 122n45, 131, 135, 149n32, 164, 165, 177n6, 183, 189, 196, 201n4, 203n35, 235, 236, 243
Pandit Nehru, *see* Nehru, Jawaharlal
Paramjit, Kaur Khalra, 22–25, 27–30, 39–52, 258, 263
Partap Singh, Colonel, 139, 143, 144, 150n45, 218
Partition, ix, x, 5, 6, 79, 98, 115–119, 122n50, 136, 163, 164, 193, 253n31
Patiala and East Punjab States Union (PEPSU), 135, 137, 139
People's Commission, 46, 47, 147
Pheruman, Darshan Singh, 166
PHRO, *see* Punjab Human Rights Organization
Pogrom, 3, 10, 16, 17, 211, 223, 241, 274, 275, 278, 282, 284
President's Rule, 16, 127, 135, 148n3, 196, 208, 215, 219, 221, 237, 242
Punjab Human Rights Organization (PHRO), 88, 124, 125, 212–214, 218, 243, 244
Punjabi Suba, 137, 163, 164, 166, 229n12

R

Rajiv-Longowal Accord, 245, 248
Rao, Narasimha, 131, 132, 145, 273
Rape, 12, 58, 84, 90n4, 118, 157, 169, 277, 278
Refugee, 117–119, 135, 285
Remand, police, 79, 174
Reparation, 49, 80, 148, 216

Resignation/resigned, 127, 183, 184, 188, 189, 202n6, 252, 269
Reward/rewards, 15, 45, 84, 103, 104, 120n21, 133, 186, 221, 250
River water, 223, 245, 248

S

Sarbat Khalsa, 270, 272
Sarkaria, Dhoom Singh, 33, 34
Sarkaria, G. S., 32, 33, 95, 120n1
Sarkaria, K. S., 91n8, 285
Sarkaria, R. S., 32, 118, 119, 236
Sarkaria, Sardar Atma Singh, 95
Self-determination, 10, 144, 145, 188
Shiromani Gurdwara Parbandhak Committee (SGPC), 40, 41, 44, 69, 70, 88, 131, 239, 252n5
Shiv Sena, 211, 213, 214, 249
Sikhistan, 114, 137
Sikh Kingdom, 31, 34, 94, 95
Singh, Nand, 165–166
Singh Sabha, 35, 36, 40, 94
Singh, Tarlochan (Principal), 182, 198–201, 257
Student/students, xii, 22, 61, 63, 87, 136, 144, 184–186, 195, 198, 202n10, 209, 210, 212–214, 222, 223, 226, 227, 234, 240, 254n58
Suicide, 9, 45, 78, 85, 89, 234, 265, 287, 289n36

T

TADA, *see* Terrorist and Disruptive Activities (Prevention) Act
Terrorist and Disruptive Activities (Prevention) Act (TADA), 85, 86, 98, 103, 104, 131, 143, 171, 178n21, 215, 247
Third Agency, 236, 238, 243, 244, 258
Torture center, xii, 132, 157, 183, 185
Trains, 44, 273, 276–279, 288n15
Trauma, xi, 86, 98, 184, 186, 223, 269, 282, 285–287

W

Woodrose, 133, 248, 269, 274, 283, 289n44